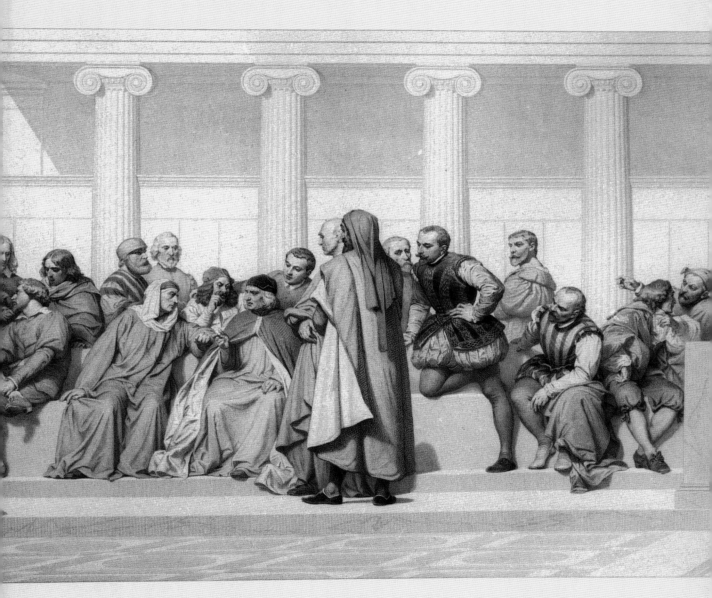

Parallel Lines

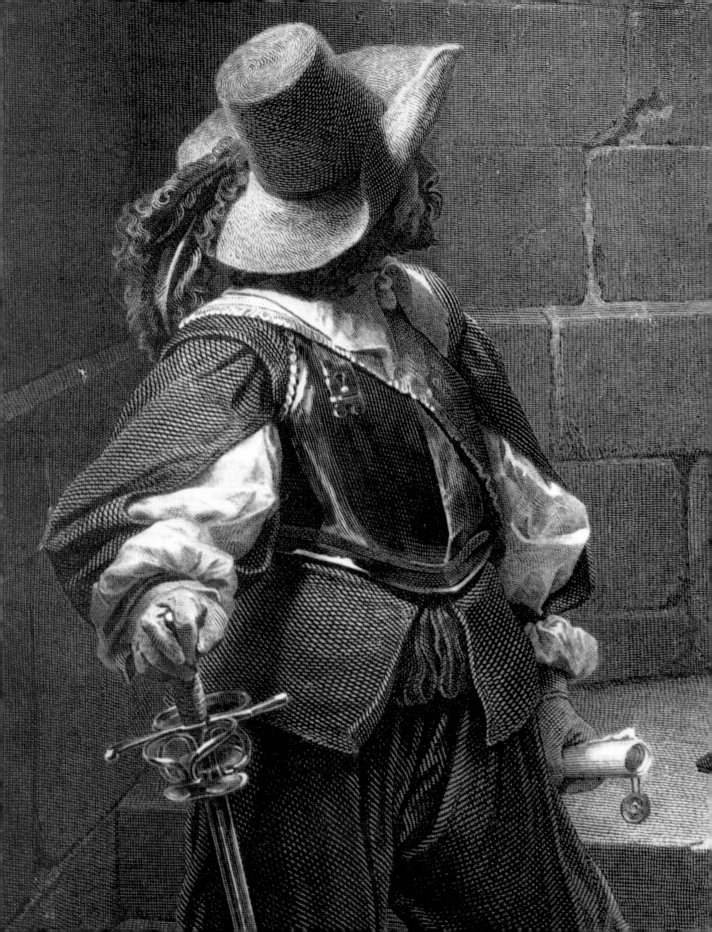

PARALLEL LINES

Printmakers, Painters and Photographers
in Nineteenth-Century France

STEPHEN BANN

YALE UNIVERSITY PRESS
New Haven & London

In Memory of H.B. 1902–1998
and E.B. 1906–2001

Designed by Elizabeth McWilliams

Printed in China

Library of Congress Cataloging-in-Publication Data
Bann, Stephen.
Parallel lines : printmakers, painters and photographers in 19th century France / by
Stephen Bann
p. cm.
Includes bibliographical references and index.
ISBN 0-300-08932-5 (cloth : alk. paper)
1. Prints, French. 2. Prints–19th century–France. 3. Painting–Study and
teaching–France–History. 4. Photography–France–History–19th century. I. Title

NE647.3 .B36 2001
769.944'09'034–dc21

00-048588

A catalogue record for this book is available from The British Library

ILLUSTRATIONS: Measurements are given in centimetres, with height preceding width;
they relate to the image as shown,
whether or not this extends to the plate-mark in the case of engravings.

Frontispiece Louis Henriquel-Dupont, engraving (1840) after Paul Delaroche, *Strafford*,
1837 Salon. Detail.
Front endpaper Louis Henriquel-Dupont, engraving (1853) after Paul Delaroche,
Hémicycle des Beaux-Arts, 1841. Left-hand print of three.
Back endpaper Louis Henriquel-Dupont, engraving (1853) after Paul Delaroche,
Hémicycle des Beaux-Arts, 1841. Right-hand print of three.

Contents

Preface vi

Introduction 1

1 In the Age of Reproduction 15

2 Battles in Paint and Print 43

3 The Inventions of Photography 89

4 Strangers in Paris 127

5 The Full Circle 169

 Notes 212

 Bibliography 241

 Index 248

 Photograph Credits 254

Preface

IN A SERIES OF SMALL OIL PAINTINGS dating from the first half of the 1860s, Honoré Daumier memorably characterised the print-lover – *L'Amateur des estampes*. Standing bolt upright, his eye caught by the luscious sanguine tint of a rococo head, or leafing industriously through bulky portfolios with his fellow enthusiasts, he is as integral an actor in the spectacle of mid-nineteenth-century Paris as the other creatures of Daumier's brush: washerwomen, mountebanks and pompous representatives of the legal profession. In one unusual variant, *Devant un marchand d'estampes*, Daumier shows us an entire family arrested by a windowful of prints in a gleaming shopfront. Only one small child tugs away from the group, perhaps more taken with the promise of the crowded boulevard.

This study is the result of a fascination with the culture of printmaking in nineteenth-century France. But it is not written from the point of view of the print connoisseur. Nor does it claim to analyse in any comprehensive fashion the issue, however crucial for the social history of the art of the period, of how a generation of enterprising print pub-lishers popularised fine engravings of contemporary work. The small child who was bored with the print shop might expect to see a print after Paul Delaroche's *Princes in the Tower* brooding sombrely upon his bedroom wall. Or so we are assured by the witty and assiduous chronicler of French nineteenth-century engraving, Henri Beraldi, who commented on the universal diffusion, within modest bourgeois interiors, of this 'cold and sad' form of decoration.

My reason for bringing the milieu of printmakers back into focus has, then, neither of these entirely respectable justifications. My own claim is, first and foremost, that the practice of printmaking was an integral part of the academic system of nineteenth-century French visual art, and that the discourse attached to it, particularly in respect of reproductive engraving, is thus of fundamental importance in clarifying the strategies of many of the most important painters of the post-revolutionary period. In one respect, reproductive engraving was a very traditional practice, which continued to reflect conventions and attitudes surviving from the previous century. In another respect, however, its ethos helped to form the basis of a new grammar of art, polemically engaged with the various competing tendencies that struggled to gain ascendancy in the mid-century period. It is no accident that Charles Blanc, probably the most influential of all academic voices in this period, was trained in an engraver's studio – and never forgot it.

Simply to direct attention to the abundant production of such forgotten figures as Blanc's two masters, Luigi Calamatta and Paolo (or Paul as he was more usually known in France) Mercuri, would be a worthwhile aim in itself. But my purpose is, at the same time, to open up the wider issues which arise when we look at the whole spectrum of

modes of reproduction in this uniquely innovative age. This study certainly does not claim to be a technical history of printmaking. However a recurrent theme of central importance will be the radical difference between traditional, 'intaglio' methods of engraving – that is to say, those involving plates with incised lines – and what have been called by contrast 'planographic' processes. To the latter camp, comprising all prints that are taken from a flat surface, belongs in particular the technique of lithography, which developed apace in France from the Restoration period onwards. If reproductive engraving was annexed discursively to the French academic tradition, lithography had, at least initially, no place within it. This, however, makes it all the more interesting to look both at the use that academic painters made of the technique – as in the case of Carle and Horace Vernet – and at the impediments faced by an artist like Charlet who founded his career upon it.

The special dividend of establishing this broad distinction between intaglio and planographic processes is that it prepares the ground for accommodating the technique of photography within the family of print media, as a new recruit to the second category. Nevertheless I am chary of accepting the deterministic readings which portray lithography as no more than a precursor to the definitive realism of the photographic image. Equally I am resistant to the attempt, represented by the influential writings of William M. Ivins, to class both lithography and photography as 'pictorial statement[s] without syntax', in contrast to all the myriad forms of traditional engraving. Understandably much of the important photographic history and theory of the later twentieth century was devoted to setting aside the long-standing and productive question of whether photography was 'art', and so divesting it of the discursive trappings which connected it to other forms of visual representation. Yet recently, and perhaps as a result of the technical and epistemological shift brought about by digital photography, it seems that the pendulum has begun to swing in the opposite direction. This study, at any rate, takes it for granted that the aims and aspirations of early photographers were generated from within the conceptual limits of contemporary art practice. Instead of attempting to separate them out, it envisages them as part of a complex polyphony, many of whose voices have been vainly waiting to be heard.

In learning to plot these elusive parallels between printmaking, painting and photography, I have been reliant upon the guidance of many friends and colleagues, some of whom I would wish to acknowledge specially here. For the study of nineteenth-century prints, the resources of the Département des Estampes at the Bibliothèque Nationale have been invaluable, and I am glad to recognise the help of Marie-Cécile Miessner, whose aid in manhandling the immense portfolio of Henriquel-Dupont's engravings after the *Hémicycle des Beaux-Arts* set me off on a long journey of discovery. Annick Bergeon and Hélène Lafont-Couturier, of the Musée Goupil at Bordeaux, welcomed me to the most illuminating of all archives of nineteenth-century print commerce on several occasions. However I was first directed there by Arsène Bonnafous-Murat, and since print collecting has been a necessary part of my research, I should make a special mention of the rare galleries that continue to hold such stock, such as Bonnafous-Murat and Paul Prouté in Paris, and the extraordinary Grosvenor Prints in London, equally unusual for the courtesy of its staff and for the tantalising chaos of its folders. Since Pierre Sanchez and Xavier Seydoux are both running a recently opened and enterprising Paris print gallery, and publishing a

new series of invaluable scholarly reference works for print research under the imprint *L'Echelle de Jacob*, they should not be forgotten.

One of the great problems in working on nineteenth-century engravings, indeed, is the fact that so little of the material is ever placed on public display. I am therefore specially grateful to Emma Chambers, of the Strang Print Room in University College London, who invited me to show a range of such works in her elegant gallery early in 1998. Over the last months of 1999 and the first of 2000, the first major show which covers all the reproductive techniques investigated here, *Paul Delaroche: Un peintre dans l'histoire*, has been open to study and reflection at the Musée des Beaux-Arts, Nantes, and the Musée Fabre, Montpellier. I learned a great deal in the course of preparation of this exhibition from my indefatigable colleagues on the *comité scientifique*, Claude Allemand-Cosneau of the Musée des Beaux-Arts, Nantes, and Isabelle Julia, of the Inspection générale des musées. I should also mention in connection with this show the vital collaboration of Pierre-Lin Renié, of the Musée Goupil, from whose unique expertise I have profited in all kinds of ways.

Among photographic archives from which I have drawn important resources, I should cite the splendid group of (primarily non-photographic) works by Daguerre in the Cromer Collection at George Eastman House, Rochester, N.Y., where Janice Madhu and Joseph Struble were very helpful, and of course the Musée Nicéphore Niépce, at Chalon-sur-Saône, where I was welcomed by François Cheval, and shown the range of materials pertaining to both Daguerre and Niépce by Christian Passéri. Eric Bourgougnon, of the Musée français de la photographie at Bièvres, helped me in the close scrutiny of one of the most intriguing documents relating to the 'invention' of photography, whilst Christophe Leribault, of the Musée Carnavalet, made available useful details on its twin. I would unquestionably have had much more difficulty finding my way around the specialised photographic journalism of the 1850s had it not been for the unstinting aid of Emmanuel Hermange.

These names by no means complete the list. I am grateful to the following curators in particular: Georges Vigne, of the Musée Ingres at Montauban, whose work on prints after Ingres was an indispensable starting point; Dominique Brachlianoff and Muriel Le Payen, of the Musée des Beaux-Arts, Lyons, who made available to me the contents of their well-catalogued print collection; Stephen Coppel, of the British Museum's Prints and Drawings Department, who was always available to help me clear up difficult points; Stephen Duffy, of the Wallace Collection, London; William Johnston, of the Walters Art Gallery, Baltimore; Joseph Rishel, of the Philadelphia Museum of Art; Jon and Linda Whiteley, of the Ashmolean Museum, Oxford; and the staff of the Getty Research Institute Special Collections in Los Angeles.

Colleagues who have helped immeasurably, in particular by providing a forum for visiting lectures and seminars, include Michael Fried, who with the other members of the History of Art department at Johns Hopkins welcomed me as Visiting Professor in the academic years 1996–98; Michael Ann Holly and Keith Moxey, who arranged for me to participate in the Getty Summer Institute of July 1998 and make use of the excellent departmental library of the University of Rochester, as well as visit the superb facilities of George Eastman House; also Jon Kear, Jocelyn Reboul, Michael Newman, Mieke Bal, Laura Marcus and Caroline Arscott. Ben Thomas directed me to a useful source for the

identification of prints. Marc Gotlieb gave me very good advice at a late state of the manuscript, as well as helping me to track down the new edition of Beraldi. Bernard and Claude Lassus's wonderful Eclipse House Party enabled me to discover valuable materials in their family collections at Auchy.

It remains for me to mention my special debt to Spencer Scott, of the Photographic Department of the University Library at Kent, who has responded willingly and ably to my constant need for high quality reproductions. The Leverhulme Foundation must have my wholehearted thanks for the award of a generous Research Grant, which enabled me to resolve many of my unanswered questions in visits to France over the spring of 1999. The Getty Research Institute, who invited me as a Visiting Scholar in spring 2000, enabled a further series of investigations to be made. Finally, Gillian Malpass, of Yale University Press, welcomed the project from the outset, and, with Elizabeth McWilliams, is to be credited with the book's highly effective appearance.

August 2000

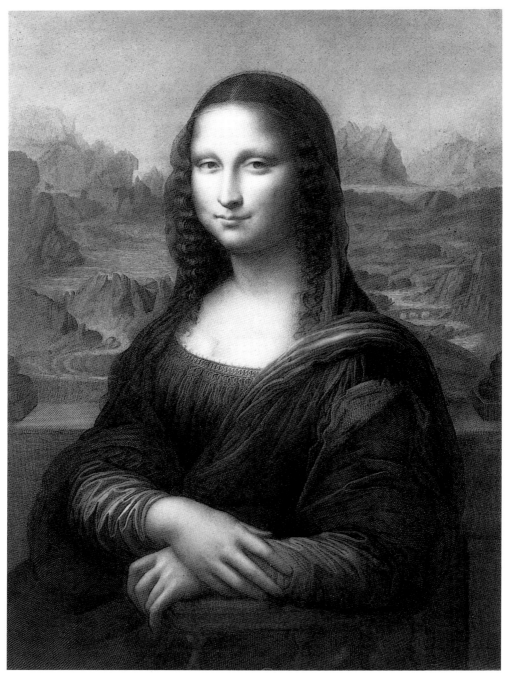

1 Luigi Calamatta, engraving (1857) after Leonardo, *Mona Lisa*. Bibliothèque Nationale, Paris:
Département des Estampes. 37.5 × 27.5.

Introduction

IN 1859 CHARLES BLANC, writing in his newly founded journal, the *Gazette des Beaux-Arts*, reminisced fondly about the printmaking studio where he himself had been a pupil more than two decades before:

> The studio of Calamatta was a large room with four windows which looked out, on the one side, over the Rue de Londres, and, on the other, over the Rue d'Amsterdam, then still at the planning stage. One of these windows was occupied by Calamatta, the other by his friend and compatriot Mercuri, who had lately become famous through his admirable little plate of the *Moissonneurs*, after Léopold Robert. The light, softened by frames of silk paper, fell, over here, upon the plate of *Francesca da Rimini* that M. Calamatta was working on at the same time as the *Voeu de Louis XIII* and the *Mona Lisa*; over there upon the *Sainte Amélie*, by Paul Delaroche, that Mercuri had sketched out, and that he abandoned from time to time to resume work on the *Jane Grey* that the House of Goupil has just finally brought to public view. At the third window of the same room there stood the son of a former director of the Academy at Rome, M. Thévenin, who was learning to engrave like me, and already knew the basic principles; finally, the fourth window, the one closest to the door, was reserved for this very young man who, in his naive ignorance of the traditions of art, had only so far cut his teeth on the etchings of Rembrandt, and smiled irreverently at the sight of the masterpieces of classical engraving, with which the room was decorated. This studio, silent for the most part, was visited by artists and well-known people. You could see there one after the other Paul Delaroche, Ary Scheffer, M. Ingres, M. Thévenin *père*, by then curator in the Cabinet des Estampes; one of the three foremost engravers of the century, Henriquel-Dupont; and Franz Liszt, and the pale Chopin who came in like a cold and polite ghost . . . and a woman then shining in all her youthful glory, George Sand; and finally the Abbé de Lamennais, whom Calamatta was drawing, and whom I can still see with his faded clerical garb, his ratine breeches, his hunched back, his parchment-like yellow face, his eyes sparkling under a forehead worthy of a genius, like the hero of the *Tales of Hoffmann*, and a little like Hoffmann himself. The first object that struck the visitor's attention was precisely the drawing of the *Mona Lisa*, placed between the two easels of Calamatta and Mercuri, opposite the door. No one could enter the studio without being attracted by this fine drawing which seemed to exercise, like Leonardo's painting, a kind of fascination.[1]

The clues which Charles Blanc provides suggest that he is referring to the period around 1835. Paolo Mercuri (usually known in France as Paul) had made his reputation as early as 1831 with the charming little print after his friend Léopold Robert's paint-

ing of the haymakers in the Pontine Marshes, one of the outstanding successes of the Salon of that year. By 1835, he would have been well advanced on his exquisitely fine engraving after Delaroche's *Sainte Amélie*, which would be published by the Maison Goupil in 1837, two decades before they finally succeeded in reproducing the *Jane Grey* – after Delaroche's contribution to the 1834 Salon – on which the engraver was working for the greater part of his professional life. As for the senior partner in this intermittently convivial studio, Luigi Calamatta was already at work on his reproduction of Ary Scheffer's *Paolo and Francesca* (Wallace Collection, London), which had created a sensation at the 1835 Salon. But he was not to produce the finished print until 1847. His first major success as an engraver would come in 1837, when the project of reproducing Ingres's great *Voeu de Louis XIII* – originally presented at the 1824 Salon – finally bore fruit. But his *Mona Lisa*, no less than Mercuri's *Jane Grey*, would be for the long haul. Mercuri was cajoled into exhibiting an unpublished version of the latter for the retrospective exhibition of Delaroche's work, held in 1857. Calamatta's tour de force was published in that same year, and became the direct pretext for Charles Blanc's gentle reminiscences in the *Gazette des Beaux-Arts* (pl. 1).

There are many aspects to the scene evoked by Charles Blanc that will come up for further discussion in the course of this study. Placed squarely on the home ground of the printmaker, and more precisely that of the reproductive engraver, we are invited to observe a world strictly parallel to that of the Salon painter, yet working to a very different timetable, and following a different set of conventions and practices. However, this is a world whose special contribution to the visual culture of France, and Europe, in the nineteenth century has become almost unrecognised over the century and a half that has elapsed. Of the painters cited here as periodic visitors to the studio where their works were being interminably inscribed on copper, only Ingres has succeeded in maintaining his high reputation; indeed this has increased, if anything, during the last few years. Horace Vernet, who appeared so quintessentially French an artist to the critics of his time, has survived as a painter of bravura battle scenes, with significant works visible at the National Gallery in London, and others restored to view in the spectacular *Galerie des Batailles* at Versailles. Scheffer and Delaroche have only recently begun to recover a little of the immense reputation which they enjoyed before the rise of Modernism. Having both been commemorated in the late 1850s by the first significant retrospective exhibitions granted to any contemporary painters, they had to wait until the bicentenaries of their respective births, in 1995 and 1997, for a new growth of scholarly interest, signified by monographs, exhibitions and catalogues.

Indeed the recent large exhibition of the work of Delaroche at the Musée des Beaux-Arts, Nantes, and the Musée Fabre, Montpellier (October 1999–April 2000), must rank as the first occasion on which a wide selection of reproductive engravings has been put on display in conjunction with many of the paintings from which they derive. In the case of Delaroche, this is specially illuminating as a strategy, not merely because many of his paintings have been lost, but because he happens to have been, without contest, the most extensively reproduced artist of his age. For so many nineteenth-century engravers to be given an airing under the sign of Delaroche – Mercuri and Henriquel-Dupont being foremost among them – is altogether appropriate. But it does not, of course, obviate the need to consider the printmakers on their own terms.

This study will therefore keep its focus on the world of printmaking in early nineteenth-century France, for the good reason that the working practices, norms and traditions of the engraving community during this period have received little or no recent attention. Even to glimpse the tools of the trade set out diagrammatically in a contemporary manual is to realise how remote this world has become (pl. 2). But my aim is not just to invert the telescope and give due attention to the assiduous artisan, rather than the star of the Salon. It is to place the productive interchange between both spheres of activity constantly at the forefront. My justification is that such close consideration of the collaboration between painters and printmakers brings some unusually interesting theoretical issues into play.

For example, it is an integral part of my argument that the very notion of 'reproductive' engraving, far from relegating the engraver's product to secondary status, implies a problematisation of the status of the image which needs to be understood globally – that is to say, as a function of the art work's philosophical and social identity, and not simply of its status as a saleable commodity. The economic relations between artists and printmakers at the beginning of this period, when they could be set down on paper, were rarely standard or simple. Even the commercial initiative of the Maison Goupil, which made artists like Scheffer and Delaroche into household names, did not succeed in regulating what continued to be – in no small part because of their success – a highly contested field. Underlying these various disputes between print publishers, painters and their heirs, however, lay fundamental issues that referred to the prior tradition of image-making in the West. If it is generally accepted that the nineteenth century revealed a decisive change in the relative status of word and image – what W. J. T. Mitchell has baptised the 'pictorial turn'[2] – it is certainly not obvious what needs to be taken into account to explain the genealogy of this transformation. This study presents an argument for the importance of printmaking – its traditions, its working practices and its aesthetic – in framing such a process of historical argument.

What further implications does this approach hold for the study of painting? I find it helpful as a starting point to refer to the fertile ideas that Michael Baxandall has developed in his essay on Picasso and Kahnweiler under the rubric of the 'Historical Explanation of Pictures'. Considering the career of Chardin in the eighteenth century, he notes that this eminently successful artist 'produced relatively few designs [in the course of his career], something in the order of two hundred, but many replicas'. Baxandall continues: 'The culture press was already strong and there were many Salon reviews but in my view more important than reviews in Chardin's market were the engravings in which his new models were widely and visually circulated.'[3]

This comparative downgrading of the Salon (and the critical reviews based on it) in favour of an artistic practice concentrating on the 'replica', and the reproductive engraving, seems all the more relevant in the light of the practice of the painters of the following century featured in this study. It might indeed be argued that what for Chardin was still a useful artisanal practice becomes, for the Romantic generation, an indispensable safeguard. Many of these artists withdrew from exhibiting at the Salon for long periods or for good (in part provoked by hostile critical reviews), and trusted to replicas and engravings to secure their reputation. Baxandall looks forward as far as the twentieth century, with Picasso, and asserts that by comparison with Chardin: 'The main new

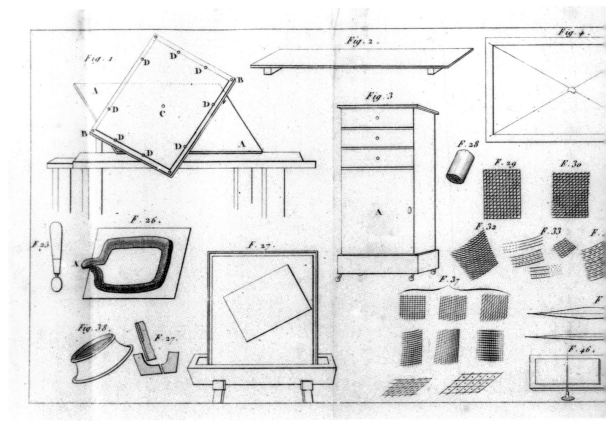

2 Ambroise Tardieu, engraving, Plate 1 from Roret, *Nouveau Manuel du graveur* (Paris, 1844: new edition). 10.5 × 33. The figures illustrate 'the engraver's studio and tools': at the top left-hand corner is his desk (Fig. 1), with a moving top which can be raised and turned in all directions; in the centre, a screen of waxed paper employed to diffuse the daylight (Fig. 4) and, below it, a series of markings indicating distinctive cuts (*tailles*) such as the 'half-lozenge' used for flesh tones (Fig. 31). To the right of the sheet are demonstrations of how the burin engraver's tool is sharpened to obtain different qualities of line (Figs 41–4) and, finally, how it is held in the hand and applied to the plate (Fig. 48).

element in Picasso's market is the greater role of dealers.' But, for the major part of the century that intervenes between Chardin and Picasso, it is precisely this 'new element' of the print publisher and dealer that assumes unprecedented importance and begins to transform the international artistic scene.

Baxandall is explicitly concerned here with what he calls Chardin's 'market'. However, the bearing of his general remarks is not to be seen as exclusively economic. What he then develops is an argument directly applicable to the terms in which Charles Blanc pictures the little printmaking studio between the rue de Londres and the rue d'Amsterdam. Blanc's scene vividly evokes the possible workings of what Baxandall illuminatingly describes as *troc*: that is to say, 'a form of relation in which two classes of people, both within the same culture, are free to make choices in the course of an exchange, any choice affecting the universe of the exchange and so the other participants'.[4] Baxandall's own area of reference for developing the concept is the milieu of Cubism, and he focuses specially on the relations between a painter like Picasso and a critic like

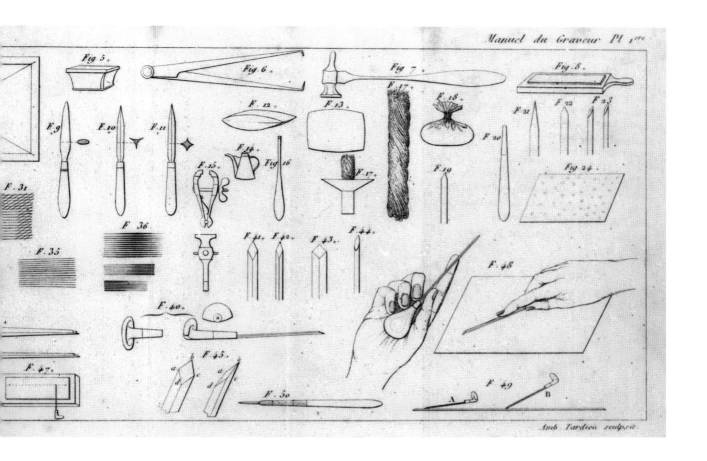

Apollinaire, who can be said to have set a 'brief' to which Picasso responded. He is attentive to the ways in which this 'brief' was developed – and could only have been developed – within specific 'market' conditions. In other words, for Apollinaire's new concept of the boundless possibilities open to the contemporary artist to make social sense, it was necessary for dealers like Kahnweiler to be emerging and taking on the role of marketing the new art.

I would propose, then, that in Blanc's image of Calamatta's studio, presenting as it does the spectacle of an exchange between printmakers and painters (as well as the selected representatives of a more general artistic culture), we have a clear pointer to a type of *troc* specific to French visual culture of the early nineteenth century. Instead of Kahnweiler, needless to say, we have the growing influence of the Maison Goupil, foremost among the print publishers who created and exploited the market for reproductive engravings on an international basis, and particularly committed to the careers of the painters (and printmakers) listed by Blanc.[5] If it is noteworthy that his list of visiting personalities does not include any of the art critics who cast their censorious eyes over the Salons of the 1830s, we can ourselves stretch a point and retrospectively interpolate the voice of Blanc himself. As a young man, he was trained by what he called those 'eminent masters, Calamatta and Mercuri, who taught us the laws and secrets of their art'.[6] As *Directeur des Beaux-Arts* after the Revolution of 1848, he devoted the larger part of the first government credits intended for the revivification of the arts to a series of projects

for the popularisation of great art through engravings.[7] In his editorship of the *Gazette des Beaux-Arts* from 1859 onwards, he provided a unique forum for engravers to reproduce both ancient and modern masters, and finally, in 1871, he endowed the Third Republic with a *Musée des copies* that exemplified, however short-lived it may have been, these long-term aims.[8]

Implicit in the *troc* exchanged in Calamatta's studio was the principle of art's reproducibility. Most of the painters mentioned could easily drop in to see the beginning of the process at work, since they lived in the Nouvelle Athènes district. It was only a short walk from the rue de la Tour aux Dames, where Horace Vernet and his son-in-law Delaroche lived in adjacent houses, and from the rue Chaptal, where Scheffer resided, to the junction between the rue de Londres and what would be the new rue d'Amsterdam. The exceptionally long period of continuous work required for a burin engraving meant that there can never have been a time, in the 1830s at any rate, when works of one or more of these painters were not in the course of being incised on copper. But it was not at this purely literal and circumstantial level of exchange that the *troc* would have operated. The hypothesis is that these painters (no doubt in varying degrees) adapted to considering their works in the light of their possible reproduction, and, at the same time, in the light of the practical arrangements necessary for their marketing. As previously noted with reference to Chardin, painters like Scheffer and Delaroche frequently engaged in the making of replicas, both with and without studio assistance. Unlike Chardin, they benefited from an international print distribution system of unprecedented efficiency to which the renaissance of reproductive engraving in the 1830s owed much of its impulsion.

Both the flourishing market for prints that first took off in the 1830s, and the powerful ideology of reproduction as an educational tool to which Blanc lent his support, marched hand in hand until well after the arrival of the mid-century, when Manet and the Impressionists began to challenge the whole basis of academic art. Blanc, who had become by the time of the publication of the eighth edition of his *Grammaire des arts du dessin* in 1889 a member of the French Academy and Professor at the Collège de France (as well as being elected to the Académie des Beaux-Arts), finds space in this all-embracing manual for the whole range of printmaking techniques, from traditional burin engraving – *gravure en taille-douce* – to a nineteenth-century technique like lithography. Even at this stage, however, he describes the work of the burin as 'classical engraving *par excellence*'.[9] Not even his early knowledge of, and thorough admiration for, the etchings of Rembrandt could lead him to give comparable status to the 'etching revival' carried out by his own contemporaries in the 1860s.[10]

Yet to personalise this issue around one theorist and commentator, however influential, is not my intention. The point is that Blanc simply reflected what was, to a great extent, the consensus view of the relative importance of engraving and other modes of printmaking within the academic canon. When, in his description of the studio, he speaks of Louis Henriquel-Dupont as 'one of the three foremost engravers of the century', this should not to be taken as a piece of gratuitous mystification. We are assumed to have no great difficulty in guessing who the other two engravers must be (and it would not be just a matter of Blanc's partisanship if one of them turned out to be Calamatta). Henri Beraldi, who reproduces the whole quotation from the *Gazette des Beaux-Arts* in his

monumental reference work, *Les Graveurs du XIXe siècle*, is even more categorical in his estimate of Henriquel-Dupont's importance. He is, quite simply, 'the most celebrated engraver of the nineteenth century'.[11]

The very fact that such unambiguous views should converge on a printmaker who virtually disappeared from sight in the succeeding century is a further convincing indication of the undeveloped state of our knowledge of the field. Tourists in China are sometimes treated to enigmatic assertions of aesthetic value which presuppose an entire system of subtle differentiations, inaccessible to the non-specialist, such as: 'This is the second most beautiful rock in the whole of China.' It almost seems as if the scale of values presupposed in the statements of Blanc and Beraldi were equally inaccessible to us today – and the specialists, if they exist at all, are certainly thin on the ground. Through directing attention, however selectively, at the achievement of Henriquel-Dupont and his peers, I hope to be setting off some further trails of interest. Simply to reproduce engravings of the quality of Henriquel's *Hémicycle* after Delaroche, Mercuri's *Moissonneurs* after Léopold Robert, and Calamatta's *Mona Lisa*, is to put up for discussion some of the most admired images of the times, which are now some of the most neglected. As Antony Griffiths puts it succinctly, in his excellent overview of the history of printmaking: 'These works, the most valuable prints of their day, are now held in unfair contempt.'[12]

In the present state of affairs, therefore, it is only in late nineteenth-century publications like the *Gazette des Beaux-Arts*, and above all in the vast and enthralling compendium of Henri Beraldi's *Graveurs* – a 'Guide for the amateur of modern prints' in twelve volumes – that one can hope to recapture the kaleidoscopic configurations of the print culture of nineteenth-century France. Beraldi begins his range of entries with engravers trained in the eighteenth century, such as the legendary Bervic (pl. 3) who completed just nineteen plates in a career extending over more than three decades.[13] He concludes with the comrades-in-arms of the Impressionists. But he maintains throughout his highly (and productively) digressive text a sure measure of the aesthetic and technical values that he is defending. This study could hardly have been written without reference to such a touchstone.

<p style="text-align:center">* * *</p>

Beraldi's twelve volumes of reference were originally published between 1885 and 1892. Forty years later, Walter Benjamin wrote nostalgically in his essay 'Unpacking my library' of an edition of Balzac's *La Peau de chagrin* that he had had the good fortune to pick up at an auction in 1914: 'The steel engravings of this book were designed by the foremost French graphic artist and executed by the foremost engravers.'[14] It is a bit of a puzzle, this assertion by Benjamin, but it is probable that he is referring in the first instance to the graphic artist signing himself Gavarni, who indeed provided a vignette for the illustrated *Peau de chagrin* of 1838. No one could accuse Beraldi of underestimating the importance of Gavarni, to whom he allots nearly eighty pages after describing him as 'the painter of manners of the nineteenth century'.[15] Nor would it be fair to accuse him of any reluctance to adjudicate on Gavarni's ranking among his peers, since he weighs in the balance the conflicting arguments of those who support Gavarni, and those who favour

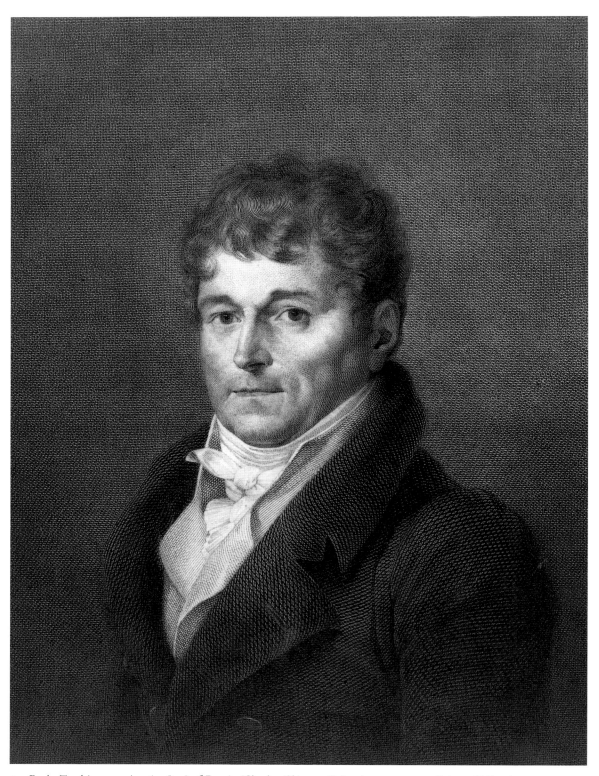

3 Paolo Toschi, engraving (*c.*1820) of Bervic (Charles-Clément Balvay). 20.5 × 15.5. Private Collection.

his rival Daumier as the preeminent witness of his times. But the prospect that the 'five thousand lithographs and vignettes' completed by Gavarni could give him a claim to dispute the preeminence accorded to Henriquel-Dupont and Calamatta would surely have been anathema to Beraldi.

Indeed the very medium of Benjamin's vignette – engraved on steel by one Jean-Denis Nargeot who certainly did not cut much ice among the printmakers of his day[16] – would have inevitably categorised it as a work of relatively minor importance beside the burin engravings on copper completed over many years by the reproductive printmakers. Benjamin is faithfully reflecting a change of view on the whole phenomenon of French visual art in the Romantic period which would entrench itself more and more powerfully as his own century progressed. Understandably, he annexes Daumier and Gavarni to a panorama of French modern life which has Manet and Baudelaire at its centre. But his judgement rides roughshod over the different criteria of achievement and importance which were being used at the time.

This mention of Benjamin also forcibly reminds us of the degree to which the historical view of French visual culture was completely reframed in the early twentieth century. The process was further accelerated in the second half of the century, not least through the quasi-canonical status acquired by his essay 'The Work of Art in the Age of Mechanical Reproduction' (1936). No one can doubt that Benjamin thoroughly immersed himself in the visual records of the Romantic period, and that the high level of connoisseurship demonstrated in 'Unpacking my library' underpins the challenging theoretical conclusions of the subsequent essay. All the same, Benjamin's stake in the aesthetic of 'everyday life' promulgated by his hero Baudelaire invariably determines what is singled out for attention in the technical development of the art of printmaking. He is ready to acknowledge what he conceives to be the progressive role of lithography: 'Lithography enabled graphic art to illustrate everyday life, and it began to keep pace with printing.' But he cannot wait to salute the new (and in his eyes definitive) technical revolution: 'only a few decades after its invention, lithography was surpassed by photography'.[17]

It may be argued that Benjamin's teleological view of nineteenth-century visual culture has already been superseded, and has no place in a study of this kind. That he will in fact figure in the present discussion, and especially in the next chapter, can be explained by two factors. In the first place, Benjamin's very insistence on the concept of 'aura', and his focus on the demythologising properties of multiple copies produced by 'mechanical' means, make it clear how much is invested in the traditional practices of reproductive engraving. It will perhaps come as a surprise that, in the very year of Daguerre's public disclosure of the daguerreotype technique, the painter Horace Vernet was claiming that engraving alone could secure the 'eternity' of an artist's work. As will be seen, this was not the plea of a person opposed to, or ignorant of, the practice of photography. Quite the opposite, for Vernet took a prominent part in diffusing knowledge of the exciting new process, as he had already done with the techniques of lithography, over twenty years before. But he could never have imagined for one moment that the photograph would usurp, or invalidate, the function of the engraving.

The second reason for returning to the terms of Benjamin's essay is that they are fundamentally akin to those underlying the altogether more sophisticated, and historically

dense, account offered in William Ivins's *Prints and Visual Communication*. By this I mean that Ivins appears to confer on all 'printed pictures in western Europe and America' the demystificatory properties that Benjamin sees in the photographic image. He rejects from the outset as a delusion 'the persistent habit of regarding prints as of interest and value only in so far as they can be regarded as works of art'. His guiding principle is that 'prints (including photography) are the only methods by which exactly repeatable pictorial statements can be made about anything'. It follows that: 'The importance of being able exactly to repeat pictorial statements is undoubtedly greater for science, technology, and general information than it is for art.'[18]

This is indeed a surprising statement if it is intended to apply, not merely to photography, but to the whole tradition of fine printmaking. It presumably relegates as entirely delusory a critical discourse for the evaluation of prints built up over several centuries, of which the words of Charles Blanc already quoted here offer no more than a foretaste. No less momentously, it entirely sets aside the reasons for which many of the painters covered in this study saw the repetition of 'pictorial statements' as entirely consistent with – indeed inseparable from – the aims of 'art'. Yet Ivins does recognise that the Achilles heel in reproductive engraving lies in the feasibility of the notion of 'translation' that was held to underpin the process of reproduction. He is himself willing to allow that these printmakers developed a 'syntax', but does not concede that this offered the possibility of genuinely 'translating' the pictorial image into the terms of the engraver's line. Consequently it is the novel feature of photography, and its precursor lithography, to offer a 'pictorial statement without syntax'. Only at this price, argues Ivins, can reproduction be liberated from the false rigour of the *buriniste*'s discipline, in a word from 'The Tyranny of the Rule'.[19]

It is worth asking at this point how far the concept of historical fulfilment through photography (defended by both Benjamin and Ivins) will come to seem a distinctive, and specific, aspect of the world-view of the twentieth century. Now that the movement away from 'analogue' to 'digital' reproduction has become a seemingly irreversible feature of visual technology, it can only appear odd to accept the arrival of the 'pictorial statement without syntax' as the culminating and definitive achievement of print culture. Conversely the backwash of interest in early prints, of which this study is undoubtedly a symptom, can legitimately be viewed as a by-product of a visual culture in which even the humble camera becomes an instrument for the electronic manipulation of the digital image.

This theoretical perspective can hardly be absent from my argument. Nevertheless it is not my main intention here to examine the convergence between contemporary attitudes and the world of prints before photography. Rather, it is to bring to light some of the integral historical features of that world, which earlier commentators have chosen to ignore. It should come as no surprise that Ivins pays no attention whatsoever to the milieu evoked by Charles Blanc's picture of Calamatta's studio. Such dedicated burin engravers, whose work extended into the second half of the nineteenth century, cannot be fitted into the narrative of a liberation from the tyranny of pictorial syntax. But this certainly does not mean that their various styles and approaches were not perceived as distinctive and innovative, according to a different perception of what was at stake in a rapidly changing visual culture.

If both Benjamin and Ivins ignore the burin engravers, they also pay no attention to the context in which photography came closest to the domain of engraving, and indeed academic painting. Robert J. Bingham, the English-born photographer who was the first to make a reputation as an expert in the reproduction of paintings and prints, is virtually absent from existing historical accounts. Indeed it could be said that reproduction photography hardly counts as photography at all, by present-day standards. The fact that universally acknowledged photographers of the first generation, such as Gustave Le Gray, did indeed practise in the field remains a blank spot in their biographies. The point that Bingham was given equal honours as a photographer in open competition with such luminaries such as Baldus, Bisson, Disdéri and Nadar may reflect a more catholic view of the purposes of early photography that will never be recaptured.[20] But it is nonetheless important to acknowledge the historical standing of a genre as far removed as it could be from the record of 'everyday life'.

This aspect certainly does not exhaust the interest to be gained from looking at the interface between photography and the traditional arts. I would claim that the focus chosen here highlights issues that have lapsed, or have never been seriously debated, either in the history of art or in the now voluminous history of photography. For example, it is accepted that Nicéphore Niépce was initially prompted to his experiments in planographic reproduction by a strong interest in the potential of lithography, which – according to his son – dated back to as early as 1813. It is also well known that Niépce and Daguerre initially maintained contact with a printmaker and dealer, Augustin-François Lemaître, who was later dropped from the collaboration. But what kind of a printmaker was Lemaître? In what way did his practice relate to the goals that Niépce was concerned to achieve? No one appears to have seriously pursued this question.

A further, much more blatant issue is the repetition *ad nauseam* of the statement credited to the painter Paul Delaroche, on seeing his first daguerreotype: 'From today painting is dead.' Perhaps because this statement so perfectly epitomises a kind of covert photographic triumphalism – as if the most celebrated painter of the age could only commit hara-kiri at the sight of the silvery plate – it has been repeated promiscuously, without the least corresponding attention being paid to the actual timetable of Delaroche's engagement with photography, and its consequent implausibility. This issue, like many others raised in the course of my enquiry, is not likely to be closed off by the provisional conclusions that I reach. But I hope at least to demonstrate that the discursive space opened up by the parallel practices of printmaking, painting and photography, and their shared involvement in image reproduction, offers a more illuminating prospect than a point of view fixated on the arrival of the last practice alone.

* * *

This study does not reflect a linear view of the history of media and techniques in visual art. Consequently the separate chapters offer no overall narrative thread, but a series of configurations in which the relationships between the three practices are treated from varying angles. It is not my aim to propose a new History of Photography. Nor am I offering an updated History of Printmaking, though the final chapter involves a conspectus of the French tradition, which will help to place in context the forgotten

artistry of Louis Henriquel-Dupont. By juxtaposing artists, whose reputation has all
but vanished, with those like Ingres and Delacroix, who have acquired a lonely eminence,
I hope to have retrieved a more balanced picture of the age that preceded the rise of
Modernism.

In line with what I have suggested to be the exemplary nature of Benjamin's argu-
ments on photography, I shall however start with a wide-ranging discussion of the whole
issue of image reproduction as it impinged upon the practice of the visual arts in the
nineteenth century. In the first chapter, I shall begin to examine the complex of differ-
ent issues – legal, economic and cultural as well as aesthetic – that constellate around the
question of the status of the pictorial image in the first industrial age. Benjamin's per-
suasive elisions need to be revisited, in order that the hierarchies of visual and especially
printed media in this period can be assessed historically, reading between the lines of his
account. In particular, I shall focus on the highly ambivalent status of the 'original' work,
in a period when artists had a philosophical as well as a pragmatic justification for
acknowledging authorship of reductions and what were referred to in French as *répéti-
tions*, that is to say replicas identical in size to the original painting. I shall also look at
the combination of similar factors that led traditional burin engraving to flourish in mid-
nineteenth-century France.

This emphasis on the French historical experience as being distinctive, and having its
reflection in the visual culture of the post-revolutionary period, is continued in chapter
two, where I follow a sequence of battle images from the early Empire to the Bourbon
Restoration, and register both their contemporary effect and the way in which this was
echoed in subsequent critical commentary. It is this sequence of images that will also
enable me to demonstrate the full range of contemporary print techniques, from the
old-fashioned collaborative strategy employed in an engraving after a drawing by Carle
Vernet, illustrating the French capture of Corsica, to the pioneering early lithographs
produced by both Carle and his son, Horace Vernet, in the immediate aftermath of the
Empire. In considering the unique and remarkable productions of the first French artist
to make his name specifically as a lithographer, Nicolas-Toussaint Charlet, I shall also
point out what his career reveals about the difficulty of accommodating this new medium
within the existing paradigms of academic art.

Chapter 3 pursues the issue of the uneasy status of the new planographic technique in
relation to the well-known saga of Niépce's experiments in image production, and the
subsequent public acceptance of the invention of his partner, Daguerre. I shall suggest
that it is necessary to fill in the artistic background both of Niépce's first collaborator,
the printmaker Lemaître, and of Daguerre himself, in order to appreciate how photo-
graphy emerged from within a wide spectrum of visual techniques. I shall also review in
detail the timetable of Delaroche's engagement with photography and, in the same
process, reveal the ideological investment in the perpetuation of his famous (but surely
apocryphal) remark. From the examination and comparison of two related paintings on
the theme of 'The Invention of Photography' by Prosper Lafaye, I will be able to expand
further on the stake that the painters held in the diffusion and popularisation of this new
and seemingly miraculous form of image production.

Although all these chapters acknowledge from different angles the prestige of burin
engraving as the summit of the printmaking hierarchy, it is only with chapter four that

attention falls on the full careers of two of the artists who excelled in this domain. Both Luigi Calamatta and Paul Mercuri produced engravings which were accepted as models for what might be achieved in this extraordinarily labour-intensive discipline. Both of them also demonstrate the advantages that accrued, for the major academic painters of the period, in having printmakers of this stature dedicated to reproducing their work. Yet the careers of Calamatta and Mercuri also indicate in a striking way the excessive, and potentially overwhelming, tensions caused by these commitments. If Calamatta made his reputation primarily as the chosen engraver of Ingres's paintings, his achievement in this respect was to some extent inhibited by Ingres's waywardness with regard to the aims and processes of reproduction. By contrast, Mercuri possessed in Delaroche an artist entirely willing to allot the printmaker a more independent role, but he himself blatantly failed to harness his talent to a practicable working schedule.

Calamatta and Mercuri were both Italians by birth, and both were more or less press-ganged into service by Frenchmen who had spotted their talents at an early age. Henriquel-Dupont (in Beraldi's estimation the leading printmaker of the century) was French by birth, and studied with Bervic, who was incontestably the major French print-maker bridging the eighteenth and nineteenth centuries. It is necessary to look at Henriquel's career, in particular, in order to gauge the delicate balance between tradition and innovation that burin engraving was held capable of achieving well into the second half of the nineteenth century. Henriquel produced a fine print after Ingres's *Monsieur Bertin*, but his most spectacular achievement – and the most admired print of the whole mid-century period – was his tripartite engraving after Delaroche's *Hémicycle des Beaux-Arts*. In the form of an authorised replica, this famous work by Delaroche also gave rise to a panoramic photograph by Robert Bingham. My objective in chapter five will be to use Henriquel's work as a basis for assessing the contemporary relevance of the long tra-dition of French fine printmaking, as it was understood in the later part of the nineteenth century. But the existence of Bingham's photograph reminds us, once again, of the type of parallel representation against which such an engraving had to be judged. I hope to have reopened a space for making such comparisons, in contrast to the ideology that merely ruled them out of court.

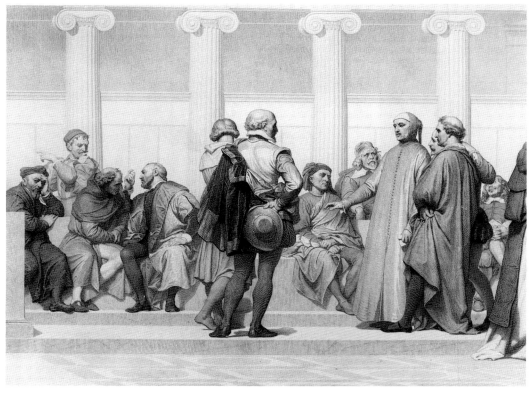

4 Louis Henriquel-Dupont, engraving (1853) after Paul Delaroche, *Hémicycle des Beaux-Arts*, 1841. Detail of left-hand print showing architects: from the right, Philibert Delorme, Baldassare Peruzzi, Erwin von Steinbach, Sansovino, Robert de Luzarches, Palladio, Brunelleschi, Inigo Jones, Arnolfo di Lapo, Pierre Lescot, Bramante, Mansart.

1

In the Age of Reproduction

UNDERLYING THE CONNECTIONS BETWEEN printmaking, painting and photography that form the basis of this study is the nineteenth-century practice of reproduction. Printmakers and, after the middle of the century, photographers reproduced paintings. But painters also reproduced their own works, and had them reproduced by others. This much may be granted. But it would be perilous to go further and assert that there was any single concept of reproduction governing the many different instances of practice. This chapter does not make any such claim. However it proposes a number of different angles from which the empirical data can be judged.

For our purposes, at any rate, reproduction is first and foremost a practice carried out by artists, whether it involves a process of conversion of the image ('repetition' or 'reduction') within a specified medium, or a transfer of the image from one medium to another. In the second place, however, it is a process governed by legal sanctions. Who has the right to reproduce? And this involves the subsidiary question: when does a converted or transferred image count as a reproduction from the legal point of view?

The latter issue cannot be settled without reference to historical chronology, however, since in the nineteenth century new techniques of reproduction were constantly pushing forward the limits of what can done to repeat and diffuse images. These new techniques served different social and cultural needs. Consequently, there comes about a third level of definition. How does reproduction function as a cultural phenomenon within the historically determined conditions of early to mid-nineteenth-century France, in particular? The commentary that follows does not claim to exhaust these complex interrelated issues. But it will seek to demonstrate their relatedness, as a necessary prelude to the detailed analysis of particular modes of reproduction that will follow in the remainder of this study.

Precisely because his brilliantly selective viewpoint has now acquired the fixity of a cliché, the work of Walter Benjamin is helpful in formulating the terms of the debate. It is in the opening passage of his essay, 'The Work of Art in the Age of Mechanical Reproduction', that Benjamin sets the scene for his claim that the nineteenth century witnessed a unique advance in this domain. Works of art, he argues, have always been in principle reproducible ('grundsätzlich immer reproduzierbar').[1] However, history shows us that techniques of reproduction do not just appear and disappear intermittently, but acquire in the course of time an 'accelerated intensity'. What he terms 'mechanical reproduction' ('die technische Reproduktion') represents the latest, irreversible stage in this process. The range of traditional print techniques, from the primitive woodcut to the development of etching and engraving by the end of the Middle Ages, has given a progressively enhanced

power of multiplication to the visual image over the centuries. But the nineteenth century brought to a triumphant new conclusion the roll call of techniques by adding, first of all, lithography and then, rapidly displacing the lithograph, the definitive reproductive process of photography. Beyond the nineteenth century, of course, lies the more and more effective harnessing of photography to the demand for moving images, and the consecration of the cinema as the most potent vehicle of mass spectacle ever experienced. Benjamin published his essay in 1936, with the plea that so powerful a weapon should not be abandoned to Fascist propaganda, but reclaimed by the Left.

Viewed from the beginning of the twenty-first century, this reading of the history of the image takes on a familiar pattern. It can be assimilated to the other 'grand narratives' which have sought to give meaning and coherence to the Western tradition in terms of a final fulfilment of long-term tendencies that could only be glimpsed in their embryonic form, as it were, along the centuries. In the recent work of Hayden White, this mythic fashioning of history has been intimately linked to the Judaeo-Christian tradition, with its emphasis on promise and fulfilment. It is this tendency that he locates in the 'Figural Realism' of Benjamin's near-contemporary, Erich Auerbach, whose celebrated study, *Mimesis*, followed 'the representation of reality in Western Literature' from Homer to Virginia Woolf.

For White, the broad Western literary tradition that Auerbach masterfully sums up is represented in the historiographical form of a pattern of progress and fulfilment: its most recent stages are, first of all, the triumphant 'Realism' of the great nineteenth-century novel, and secondly, the succeeding movement of Modernism which aspires finally to close 'the gap between history and the premodernist version of literature called fiction'.[2] It is not hard to see how a comparable pattern might be detected in Benjamin's view of the fulfilment of the reproductive project in the form of photography and the cinema. In the latter, there comes about an unprecedented coincidence between the medium and the historical present, which still leaves as an unresolved problem for Benjamin and his contemporaries the issue of how this historicity can be manipulated within a framework of political and aesthetic intentions.

Yet it is not the purpose of this study to demythologise Benjamin's influential argument, or to challenge the structurally similar thesis advanced by William Ivins. My concern is to open up the forgotten world that can be glimpsed in the interstices of these grand narratives – a world that has been largely cast into shadow as a consequence of the intense illumination directed at a few of its salient features. Take for example the theoretical kernel of Benjamin's essay, and the idea that has entered most deeply into popular mythology: that of the loss of 'aura' that affects a great work of art in so far as it becomes a vehicle for multiple reproductions. For Benjamin, this process follows a ruthless dialectic:

> [T]he technique of reproduction detaches the reproduced object from the domain of tradition. By making many reproductions it substitutes a plurality of copies for a unique existence. And in permitting the reproduction to meet the beholder or listener in his own particular situation, it reactivates the object reproduced.[3]

What interests me, by contrast, is the infinitely subtle blend of tradition and modernity to be discovered in the world of reproductive engraving. As Charles Blanc put it in his

description of Calamatta's studio, already quoted in my Introduction, the printmaker's drawing after Leonardo's *Mona Lisa* hung on the wall opposite the door and seemed, 'like the painting by Leonardo', to exercise 'a sort of fascination' on the visitors to the studio.[4] Here is the copy drawing as a middle term, neither the painting itself nor yet (and not for many years) the model for the completed reproduction. For the visitors to the studio, 'aura' was thus temporarily invested in an object that epitomised one of the specific stages of the reproductive process, rather than its input or its outcome.

In chapter 4, further attention will be paid to the extraordinary account given by Calamatta of the difficulties posed, at all stages, by this project. Simply to outline the time-scale involved is sufficient, at this point, to convey the long-term commitment required by such an undertaking. The young, so far untested printmaker must have passed the first hurdle by 1829, when Ingres's intervention enabled him to gain frequent and untroubled access to the prestigious work. Before the summer of that year, he had probably completed the preliminary drawing singled out by Blanc in his account.[5] That he began to work on the engraving in 1829, during a stay in Italy, is attested by Calamatta himself, and that he was continuing the process – *pari passu* with Ingres's *Louis XIII* and Scheffer's *Paolo and Francesca* – is made clear in Blanc's reminiscences. Yet Calamatta's reproductive engraving of the *Mona Lisa* had to wait until 1857 before it was finally published. At that point, it was able to benefit from the first successful application of the new technique of *aciérage* – the application of a coating of steel to the copper plate – which ensured an almost indefinite life for the surface, and a consequently much larger number of possible reproductions.

Of course, this brief account of Calamatta's thirty-year engagement with the *Mona Lisa* does not invalidate Benjamin's basic contention. It is still possible to argue that Calamatta's dedication to reproducing Leonardo's work – and Blanc's insistence that the precious drawing exercised a fascination comparable to the original – are vestiges of a way of seeing appropriate to an earlier period. Equally, it is possible to view the printmaker's decades of careful work with the burin, and the technical innovation that gave his plate renewed durability, as indications of how much ground the traditional practices needed to make up, now that photography was well equipped (by 1857 at any rate) to challenge reproductive engraving on its own ground.

Yet to accept this argument unreservedly, as has so often been done up to now in the Paragone-type comparisons of photography to the traditional arts, is to iron out the complexities of the historical situation. It remains the case that the quarter-century which saw the initiation and development of the 'mechanical' reproductive process launched by Niépce and Daguerre also witnessed a wholesale revival of the art of reproductive engraving, in which Calamatta played a significant role. To give this phenomenon its due weight, I would argue, is also to get closer to defining the multiple roles assumed by photography in the burgeoning visual culture of the mid-century.

<div align="center">* * *</div>

What, then, were the prevalent conventions for the reproduction of works of art in the early nineteenth century? This is an issue which needs to be considered, in the first place, from the point of view of the 'original' painting. Benjamin economically sums up what

he takes to be the three different types of reproduction in these terms: 'Replicas were made by pupils in practice of their craft, by masters for diffusing their works, and finally, by third parties in the pursuit of gain.'[6] But this neat distinction of functions does not adequately cover the range of permutations that were already observable in French artistic practice from the early years of the century.

To begin with, the replica painting, or *répétition*, does indeed imply in the first instance a painting 'made', and not simply finished by the master, who will accordingly authenticate it by his signature. In that sense, it is distinct from the studio replica, in which the master has no hand, and which remains unsigned. However there developed a tendency (perhaps particularly in the group of painters featured here) for the master to take over a painting made by a favoured pupil, finish it, and then sign and date it. Clearly all the types of reproduction mentioned by Benjamin are motivated in a general sense by the artist's desire for the 'diffusion' (*Verbreitung*) of his work. The commercial stake involved, however, is likely to be variable, since it comes to be defined by the artist's contractual relationship with a gallery owner or picture dealer. Furthermore, the 'pursuit of gain' that Benjamin darkly assigns to the activities of 'third parties' is obviously not to be excluded as a motive for the other categories of reproduction.

A case where the signed replica exists in its least complicated form can be found in the second decade of the century, when Pierre-Narcisse Guérin undertook an important commission for the Bordeaux merchant, Walter Johnston. What Johnston required for his sumptuous town residence was a set of three paintings in Guérin's accomplished neo-classical style, which repeated some of his most conspicuous successes at the Salon: *Phèdre*

5 Pierre Guérin, *Phèdre et Hippolyte* (1802 Salon). Reduced replica, 1813. Oil on canvas, 130 × 174. Musée des Beaux-Arts, Bordeaux.

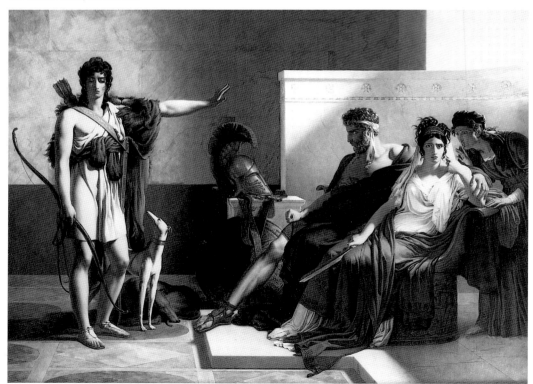

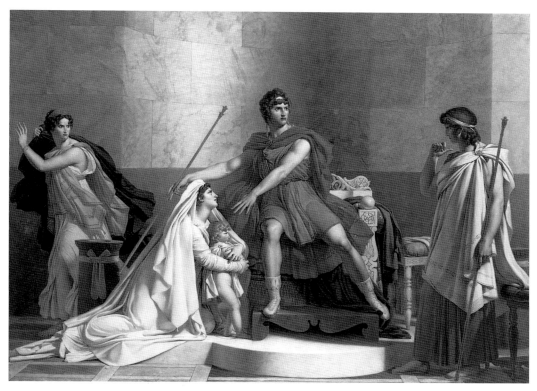

6 Pierre Guérin, *Andromaque et Pyrrhus* (1810 Salon). Reduced replica, 1815. Oil on canvas, 130 × 174. Musée des Beaux-Arts, Bordeaux.

7 Pierre Guérin, *Enée racontant à Didon les malheurs de la ville de Troie* (1817 Salon). Reduced replica, 1819. Oil on canvas, 131 × 176. Musée des Beaux-Arts, Bordeaux.

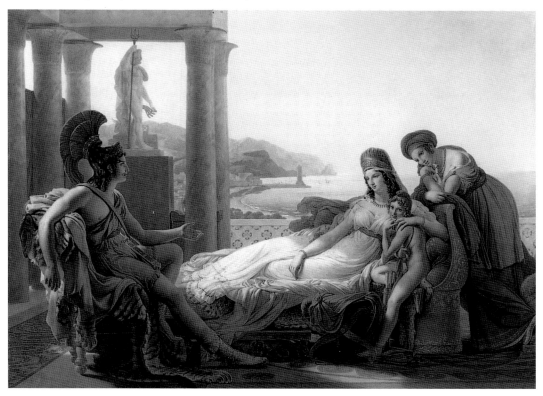

et Hippolyte (pl. 5), from the 1802 Salon, *Andromaque et Pyrrhus* (pl. 6), from the 1810 Salon, and *Enée racontant à Didon les malheurs de la ville de Troie* (pl. 7) from that of 1817. The works that were delivered to him when the commission was completed in 1819 (all currently in the collection of the Musée des Beaux-Arts, Bordeaux), were virtually identical in format, though all significantly reduced in size by comparison with their originals. The replica of *Andromaque et Pyrrhus*, larger than both the others in its original format, was scaled down proportionately to acquire dimensions close to its fellows. In this important project, probably touched off by the success of *Andromaque* at the 1810 Salon and taking the painter around seven years to complete, Guérin achieved a kind of miniature anthology of some of his most prized neoclassical works. Correspondingly, the wealthy Bordeaux merchant acquired a matching set of pictures for his reception rooms, which he could frame magnificently with gilded acanthus leaf borders to harmonise with his fashionable Empire furniture.[7]

All three of these paintings were signed and dated – with the date of the completion of the replica – by Guérin himself. This is not so, however, with the version of *Phèdre et Hippolyte* currently in the collection of the Musée d'Arras, which is of uncertain provenance, in poor condition and very unlikely to be a replica painted by Guérin himself, though it is possibly a studio work rather than a copy by one of Benjamin's 'third parties'. Nor is it the case with a long series of reproductive works which derive from a painting that achieved fame at the 1819 Paris Salon: François-Marius Granet's *Choir of the Capuchin Church in the Piazza Barberini*. It is probable that the first version of this highly popular composition was exhibited in the salon of the French Embassy in Rome in the summer of 1814, at which point Caroline Murat, Queen of Naples, and her brother-in-law, Louis Bonaparte, were vying with each other for its acquisition. This is likely to be the painting, signed 'Granet 1815', which is in the collection of the Metropolitan Museum of Art, New York. Early in the following year, Granet had already taken the decision to 'make a similar one, but with variants', which was snapped up by the British ambassador, the

8 (*right*) François Granet, *Choir of the Capuchin Church in the Piazza Barberini* (Salon of Cambrai, 1826). Oil on canvas, 74 × 44. Musée des Beaux-Arts Lyons.

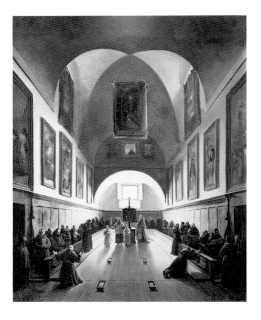

9 (*facing page*) François Granet, *Choir of the Capuchin Church in the Piazza Barberini*, 1817 (1819 Salon). Oil on canvas, 198 × 147.3. National Museum of Wales, Cardiff.

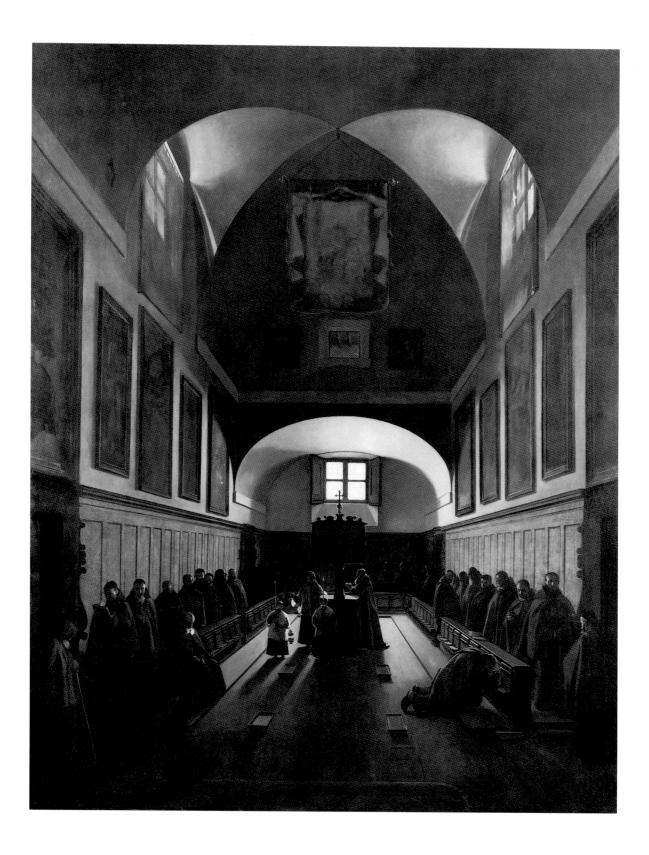

Marquess of Conyngham. Although it was only at the Salon of 1819 that the Parisian public, and the French royal family, were able to see and acclaim the next and largest of these 'variants', painted in 1817, its success was immediate. The king's brother, the future Charles X, bought it and presented it to the collection of his daughter-in-law, the duchesse de Berry. Lord Conyngham transmitted a commission for a further version on behalf of the Prince Regent, which would net 20,000 francs for Granet in 1821.

The resourceful painter was soon inundated with commissions from all over Europe. According to the estimate in Bénézit, which may err on the side of modesty, he repeated the basic formula of the work no less than sixteen times, but in different sizes and with important variations which corresponded to his patrons' requirement of individual distinctiveness. The version in the collection of the Musée des Beaux-Arts, Lyons (pl. 8), which probably received a gold medal at the Salon of Cambrai in 1826, is not only significantly smaller than the work shown at the 1819 Salon (pl. 9: National Museum of Wales, Cardiff): it is also more brilliantly lit, and incorporates changes in the attitudes of the figures. A friar can now be glimpsed behind the grille above the high altar, and an ecstatic worshipper is gesturing towards the spectator in the left foreground.

Allowing for the strong likelihood that not all these works were by Granet's hand, it seems appropriate to treat the series as a whole as a controlled sequence of rhetorical moves, designed both to confirm and to exceed the expectations of his prestigious patrons. The paucity of dates and signatures makes it virtually impossible to sort out the precise relationships between all these works, and what may well be additional variants, not planned or authorised by Granet.[8] At any rate, the contrast between the two examples that I have used here is a striking one. Guérin represents a classic and traditional solution to the problem of replication. The reduced images commissioned by Johnston could not be confused with their originals, and are designed for a specific space. But their quality is almost indistinguishable from the first Salon versions, and Guérin's hand is readily apparent in the finesse of the adapted details. Granet, however, is resourcefully marketing a visual spectacle, whose dramatic back-lit scenography uncannily anticipates the popular success of Daguerre's diorama in the 1820s. If Guérin's reproductive strategy harmonises with the aesthetic of 'translation' followed by the burin engravers, that of Granet anticipates the regime of the unlimited copy and the 'photogenic' effect.[9]

This is one respect in which practices of reproduction can be seen to bifurcate over the nineteenth century. But we must also take into account the degree of indeterminacy introduced by the need to clarify, retrospectively, the role of the painter in cases where the historical record was far from clear. A case concerning one of the most famous of all French neoclassical paintings is worth raising here, since it shows how more defined criteria of authorship were adduced towards the end of the century to resolve a problem of reproduction. On 15 June 1889, the supplement of the *Revue des Beaux-Arts* presented a damning indictment of the claim of the leading art dealer, Paul Durand-Ruel, to have for sale a *répétition* of David's *Death of Marat*. It was stated that Durand-Ruel was supporting this claim by the 'purely fantastic assertion' that David had completed a second, autograph version of the work of 1793 at the request of the revolutionary *Club des Cordeliers*. The anonymous editorial in the *Revue* peremptorily put him right. Jacques-Louis

David was indeed known to have had a copy made of this work, in order that it could be executed as a tapestry by the Gobelins factory. But this was simply a copy, and not a *répétition* by David's own hand. The writer went on to demonstrate a very broad knowledge of David and his studio by pointing out that there were in fact two copies of the *Marat*, both of which had remained in David's family (like the original) until recently, and both of which had been acknowledged by their owners to be no more than copies. The first in date, by David's Italian pupil Gioacchin Giuseppe Serangeli (1768–1852) was the work produced for the Gobelins project. The second, however, was by the younger French student of David, Jérôme Langlois (1779–1838), who received a *grand prix de peinture* in 1809 and a third class medal at the 1817 Salon. Having confounded Durand-Ruel's pretensions to have an autograph but unsigned work by David, the writer then comforted him by acknowledging that he was putting on sale not the Serangeli version, with its 'cold and grey execution', but the much superior Langlois painting. The latter could be classed as 'a work of great merit', though no more than a copy. Indeed one could not reject out of hand 'the possibility of retouching by the master'.[10]

The episode does not just demonstrate the rapacity of Durand-Ruel and the superior documentation of the *Revue des Beaux-Arts*. There was bound to remain an inherent ambiguity about the class of works known as *répétitions* (yet differentiated from mere copies) and this became accentuated over the course of the nineteenth century. The simple passage of time was one reason why provenance could not always be satisfactorily established. But, in the case of the artists of the generation following David who are featured in this study, the explanation runs deeper than that. Consequently, it is worth exploring further some of the fine distinctions and disputable cases to which the practice of reproduction gave rise.

Underlying the merits of each particular case is a basic question which should be addressed in the context of nineteenth-century visual culture: when is a reproduction more than just a reproduction? Or, to put it in a different form: on what grounds, and according to what criteria, should the line between the 'original' and its reproductions be drawn? As has been seen, this is an issue fundamental to Benjamin's thesis, and it is also integral to determining the status of media like reproductive engraving and photography as they will be explored here.

One comparatively simple example may be taken as a starting point. In the last years of his life, Delacroix – concerned for the future of his reputation – completed a number of replicas with variations after some of his own well-known paintings. In a letter, probably dating from 1862, he explains that he has completed 'the repetition which you requested from me of the picture of Medea', but regrets that he has been delayed by the lack of access to the original, 'which might have shortened my work'. He trusts, however, that his patron will not be 'astonished at the slight variations which may be found in this work, to which I have moreover given all my attention'.[11] Perhaps disingenuously, Delacroix implies here that only the absence of the original has prevented him from making a 'repetition' identical to the earlier work, and that the 'variations' are merely an index of his imperfect memory. Yet this presumption of an implied latitude given to the artist by his indulgent patron cannot be taken as resolving the issue of the status and reception of the replica. Nor should it be seen simply as indicative of Delacroix's cava-

lier attitude to mimetic accuracy.[12] As can be shown in the case of a very different painter, Ary Scheffer, the occasion could easily arise for an open comparative judgement to be made on the 'original' painting, matched against its successor.

This is indeed what took place with one of Scheffer's most celebrated and widely reproduced paintings, which appeared in a number of different versions. Scheffer probably began to work on the composition usually called in English *Francesca da Rimini* around 1822–4, and it is generally agreed that it was his knowledge of Flaxman's illustrative engravings to Dante's *Divine Comedy* that led him to conceive it through the memorably sensuous motif of two drifting, entwined figures. Scheffer had completed the first version (Wallace Collection, London) by 1835, and the passage from Charles Blanc quoted at the outset of this study attests that he almost immediately gave the responsibility of engraving it to Calamatta, who would eventually publish his reproductive print in 1843.

In parenthesis, it should be emphasised that a highly successful Salon painting such as this, purchased from the 1835 Salon by the duc d'Orléans, heir to the French throne, would inevitably disappear from public view until the lengthy interval necessary for the production of a burin engraving was complete. But the painter could choose to keep its celebrity in the public eye through making replicas. Scheffer appears to have completed a number of autograph *répétitions* of *Francesca da Rimini*, among which is the version currently in the collection of the Louvre. Signed and dated 1855, it provoked direct comparison straight away with the Orléans version when it was included in the major retrospective of the artist's work in 1859 (the Orléans picture being by then in the collection of Prince Anatole Demidoff, in the Florentine villa of San Donato). Philippe Burty had both paintings clearly in mind when he declared in his review of the exhibition in the *Gazette des Beaux-Arts*: 'It is a *répétition* less warm in colour, but tighter in design and modelling, done by Scheffer himself, and on which he was still working in his last years.'[13]

Some useful points emerge from this example. Although the 1835 painting might be portrayed simply as the 'first version', it did at the same time remain the touchstone by which the other replicas were judged. On the other hand, it could be argued in this case that the status of an 'original' has only an approximate usefulness when assessing two different types of pictorial treatment. It oversimplifies, if it does not actually falsify, the historical context of the artist's practice. There can be no doubt that Scheffer was intermittently concerned with the composition of *Francesca da Rimini* from his early years as a painter until almost the end of his career. What he achieved in his ultimate version was not a pale reflection so much as a timely reinterpretation, which placed the plastic emphasis on *disegno*, rather than colour, and in so doing, reflected the aesthetic preferences of Charles Blanc and the critics of the *Gazette* in the 1850s, rather than the more florid taste of the Romantic period.

A further question emerges in this context about the place of the reproductive engraving in this fluctuating hierarchy of originals and copies. Although Burty does not specifically single out Calamatta's 1843 reproductive engraving of the work for comment, there is little doubt about where he drew the line in the matter of where a reproduction degenerates into a mere copy. A few weeks after reviewing the Scheffer retrospective, Burty turned his attention to a very different type of exhibition, in a critically contested field:

the third annual show of the Société française de photographie. He is confident enough to be quite categorical about the claim of photography to enter the domain where traditional modes of reproduction have previously held sway. 'Photography', in his view, 'is impersonal; it does not interpret, it copies; there is its weakness as well as its strength, for it renders with the same indifference the superfluous detail and the scarcely visible, scarcely sensible nuance that gives soul and likeness.'[14]

Burty does not let the opportunity pass, in this lengthy review, to emphasise that he has no intention of putting reproductive engraving in the same boat as the impersonal photograph. According to his prediction, photography will soon succeed in killing off 'poor quality engraving and lithography, produced without conscience for the needs of those people lacking in delicacy'.[15] But it will certainly not remove the demand for superior prints. Indeed Burty brings forward the hyperbolic (but in that period not surprising) claim that a truly great engraver like Henriquel-Dupont can succeed in surpassing his pictorial model: the example chosen is his tripartite print after Delaroche's *Hémicycle des Beaux-Arts*, in which he has achieved according to Burty 'something more complete than the original, by giving this composition the powerful unity that its hardly epic colouring detracts from in places'.[16]

Judgements of the type made here by Burty will come up for closer examination in the last chapter of this study, where Henriquel-Dupont's *Hémicycle* prints will be a central focus of attention. Further instances of Delaroche's practice of the replica, which is comparable to that of Scheffer, will follow shortly here. But Scheffer should not be dismissed without the airing of some interesting evidence for his receptivity to the new reproductive processes: the photograph of his painting, *Le Coupeur de Nappe* (1851), that bears both the stamp of the well-known French photographer, Gustave Le Gray, and the full signature of the artist himself (pl. 10). Further consideration in chapter 3 will attempt to place in context what still remains an object possibly unique for its date, in bearing both these forms of authentication. For the moment, it may at least be suggested that Scheffer did not hold the same rigorous view of the secondary status of photography as was maintained by Burty.

In turning to the painter whom Burty so explicitly judged inferior to his engraver in some respects, Paul Delaroche, we reach what must surely be one of the most complex examples of the difficulty of differentiating conclusively between standards and qualities of reproduction. This is because the problems associated with Delaroche's status as the most widely reproduced artist of his age spill over from his role as a progenitor of innumerable engravings and reproductions into the details of his own studio practice.[17] Yet this quantitative aspect of Delaroche's production does not prevent some qualitative comparisons being made between his mode of working and that of the other artists under discussion. Scheffer's diligent chronicler, Leo Ewals, has given a general definition of the differences between replicas and copies that holds good – at least as a starting point – for discriminations within the whole milieu of French nineteenth-century painting under consideration here:

> In theory, it is easy to make a distinction between a replica and a copy. A replica is a repetition which has been made by the master himself or by an assistant under his direction. In this event, one speaks of a studio replica. A copy is a repetition painted by a third party. Replicas are always made in the lifetime of the artist; copies can be

made during as well as after his life. Replicas are often signed by the master; in prin-
ciple copies are not, or at least they are signed by the copyist who joins his name with
that of the painter being imitated. Copies always reproduce the original faithfully, if
not they are not copies. Replicas sometimes show slight differences with regard to the
original, but if these differences are quite important, one should rather speak of a new
version.[18]

As a text to be glossed by examples from Delaroche's production, this is certainly very
helpful, even to the final nuance about the point where an embellished replica differs
from a 'new version'. Of the two works by Delaroche shipped to the Liverpool merchant
John Naylor in 1852, one was described in the account books of the Maison Goupil as
a '*peinture-répétition*' of his *Napoleon at Fontainebleau* (1845), and presented no obvious dif-
ferences from the original version. The other, quite understandably, was described as a
'*deuxième tableau*' since it repeated the theme of his 1831 Salon success, *Princes in the Tower*,
whilst entirely shifting around the composition.[19]

It can be noted that Ewals's formulation accords closely with Benjamin's list of the
different agencies involved in such reproductive tasks: the master, the assistant and the

10 Gustave Le Gray, salt print (*c*.1851) after Ary Scheffer, *Le Coupeur de nappe*, 1851. Dordrechts Museum.

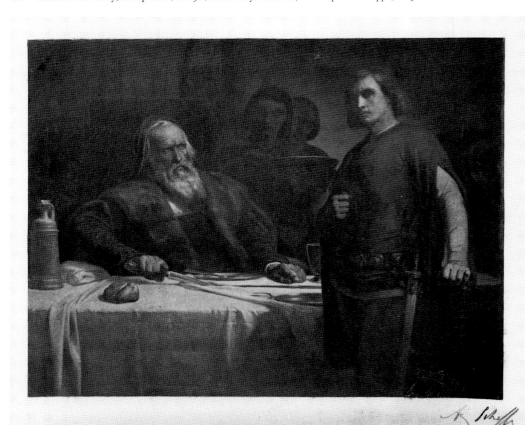

'third party'. But there are a number of further nuances which need to be taken into account in a broader assessment of Delaroche's studio practice. Like both Ingres and Scheffer, he did indeed follow the procedures ingrained in the French academic tradition, and engaged his pupils, or ex-pupils, as 'assistants' on 'original' works as well as on reproductions. It is on record that his *Strafford*, painted for the Duke of Sutherland in 1835, was sketched in by his pupil (and later secretary of the Académie des Beaux-Arts) Henri Delaborde. Jean-Léon Gérôme, another pupil, provided the preliminary sketch for a large painting of *Charlemagne crossing the Alps*, commissioned for Louis-Philippe's historical museum at Versailles in 1838 and brought to completion only as a result of this necessary aid in 1847.[20]

Neither of these cases involved reproduction, of course, but in Delaroche's case studio assistance also involved the farming out of replicas of his well-known paintings to young artists of his circle. Delaroche would finally add the 'slight differences' that justified him in appending his signature. It is highly likely that this was the case with the Baltimore version of the *Hémicycle* that will be discussed in my last chapter. This is a 'reduction', certainly, though it could scarcely be described as amounting to a 'replica' of the vast semi-circular painting at the Ecole des Beaux-Arts that ranked as Delaroche's most important work. Originally conceived as a version that would aid the engraver Henriquel-Dupont in the preparation of his reproductive engraving (a feature shared by many such 'reductions'), it has slipped gradually over the years into the condition of being recognised unequivocally as a Delaroche (understandably so in view of its prominent signature), though the account books of Maison Goupil list it under the name of an ex-pupil, Béranger.[21]

One significant example of the subtle differentiations that were apparent to contemporaries – though they inevitably became blurred with the passage of time – can be found in the fortunes of another notable composition by Delaroche, which originally shared pride of place with the *Princes in the Tower* at the 1831 Salon. *Cromwell and Charles I* (Musée des Beaux-Arts, Nîmes) was a work bought by the State which arrived late at the Salon, and created a brief sensation. Possibly through the intervention of the statesman François Guizot, it was officially allocated to a provincial museum in his native city of Nîmes, where the experience of the Revolution had been particularly violent. It was then jealously guarded there by its new custodians who, in 1857, refused to allow it to travel to the retrospective show of Delaroche's oeuvre at the Ecole des Beaux-Arts in Paris. Their justification for the refusal is worth hearing. Quite apart from their concern over the inadequacies of the available transport, the Conseil Municipal reasonably pointed out to the organisers of the retrospective that they had already given their authorisation for a 'copy signed by the author' to be made of their work, which had appreciably diminished the value of the original. The artist who had been charged with making the copy was none other than the local luminary, Charles Jalabert, a favoured ex-pupil of Delaroche, and the council not surprisingly suggested that this copy be exhibited instead![22]

The existence of this copy prepared by Jalabert is significant because it must presumably be the very same '*répétition*' that the artist Henri Decaisne viewed in Goupil's gallery early in February 1849, and about which he wrote immediately to Delaroche, then at his winter studio in Nice: 'Goupil showed me yesterday his repetition of your Cromwell; there is only you in the world who could so remake from the idea a picture done long

ago whose details might seem to have escaped your recollection.'[23] This enthusiastic reaction presents quite a conundrum. Was Decaisne simply unaware that Delaroche had merely finished the work begun by Jalabert, and had Goupil been conniving at a deception? This seems intrinsically most unlikely, since Decaisne was a member of Delaroche's close circle, and not a client to be bamboozled. But the alternative possibility is that Decaisne was acclaiming the consummate skill with which the master supplied the necessary finishing touches, as opposed to the preliminary groundwork by Jalabert who might easily have taken Henriquel-Dupont's reproductive engraving as his compositional guide.

It is entirely apt to file all of these examples of the art and craft of reproduction under the economics of picture dealing. Reductions and repetitions were not done gratuitously, but invariably met a specific demand. This however makes them no less worthy of detailed historical attention. The House of Goupil (as we shall see) went through a number of stages, initially making relatively informal agreements with its artists, and later adopting contracts that stipulated an agreed distribution of profits between the various parties. By around 1870, when the original name had been supplanted by that of its successor house, Boussod et Valadon, the account books reveal what was by then probably standard practice for the copying of Salon paintings which were in heavy demand. The following arrangement was noted when Cabanel sold a copy of his acclaimed *Birth of Venus* for 20,000 francs on 2 August 1870: 'Mr Jourdan was paid 1,500 francs for the copy, and it was agreed with Mr Cabanel that he would retouch it and sign it and we would share the profit.'[24]

Yet the fact that such reproductions were underwritten by sound commercial logic does not dispense us from looking any less closely, and from a broader cultural perspective, at the implicit assumption behind their fabrication. In the case of Delaroche and his circle (which would include the engravers in Calamatta's studio), there is strong evidence of the emergence of a distinctive new philosophy of visual communication – developing simultaneously with, though in some ways antithetical to, the modernist aesthetic – that places the concept of reproducibility in the forefront.[25]

Henri Decaisne alerts us to this point when, in the letter just quoted, he congratulates Delaroche on his new version of *Cromwell*. He does not write of Delaroche as simply having consulted his memory, but as having successfully 'rema[de] from the idea' (refaire ainsi d'idée) the earlier work. Used in this specific context, the term 'idea' would surely have connoted the central role played by this particular concept in the aesthetic philosophy of Victor Cousin, whose relevance to Delaroche's work was noted by his contemporaries.[26] Cousin had written in his immensely influential text, *Du Vrai, du beau et du bien*, that 'the foundation of art is the idea; what makes art is above all the realisation of the idea, and not the imitation of such and such a form in particular'.[27] Delaroche's sympathetic eulogist, the academician Fromenthal Halévy, laid stress after his death on the degree to which he had been influenced, as his career progressed, by Cousin's notion that art should aspire to 'moral beauty'.[28] He may well also have been influenced, however, by the consistent devaluation in Cousin's aesthetic writings of the traditional concept of 'imitation' to which contemporary classicising theorists like Quatremère de Quincy and Emeric David adhered. For Cousin, the artist's task was always to be seen primarily as a question of communication, rather than imitation. 'The problem of art', as he famously declared, 'is to arrive at the soul by way of the body.'[29]

It should be added here that, in the absence of any widespread awareness in France of the achievements of German aesthetics, Cousin's only major competitor as a philosophical theorist of art during this period was the character whom Charles Blanc, in his description of Calamatta's studio, had compared to 'the hero of the *Tales of Hoffmann*': the shabby but charismatic Abbé de Lamennais. And Lamennais himself entirely endorsed Cousin's view that art was a matter not of form, but of the 'Idea'.[30] This singular figure, who had gained great prestige among French intellectuals after the papal condemnation of his progressive newspaper, *L'Avenir*, in 1832, points to the high level of *troc* taking place around the engravers' studio in the mid-1830s. No one was in a better position than Charles Blanc to notice this, since he was an invaluable patron, at least in those early years, of the Socialist pioneer, Louis Blanc, the brother of Charles. He also secured the collaboration of Calamatta's friend George Sand for *Le Monde*, the radical newspaper that he began to edit in 1837.

In Lamennais's writings on art, published as the third volume of *Esquisse d'une philosophie* in 1840, there was little to compare with Cousin's extensive knowledge of the French painterly tradition. Lamennais has indeed been accused of seeing art purely as an emanation of religion. However, the purpose of recalling his views here is not to claim that he – any more than Victor Cousin himself – had worked out a coherent new aesthetic comparable to the systems of the German contemporary philosophers. It is to suggest that their concept of art as 'idea' may well have found a resonance in a milieu where the traditional academic theory of imitation had become associated with the political stance of the neoclassical remnant in the Académie des Beaux-Arts. Among the many crosscurrents of progressive thinking which swept across France in the years of the July Monarchy, from Lamennais's liberal Catholicism to Saint-Simon's Utopian Socialism, it was easy to find powerful support for the argument that visual works of art should be disseminated to the maximum extent.[31] The logical consequence was that a high priority should be placed on developing the possibilities of reproduction.

It is in this sense that we might speak of many of the artists mentioned here as having a 'philosophy' of reproduction. Perhaps we could go further than this and argue that such an admittedly confused amalgam of religious, aesthetic and political ideas indicates a turning point in the theory as well as the practice of image production in Western society, whose consequences have only recently begun to be drawn in full. Marie-José Mondzain intends just such a genealogy of the image to be worked out when she subtitles her remarkable study of the aesthetic doctrine of the Eastern Church 'The Byzantine sources of the contemporary *imaginaire*'. Her argument focuses in part on the reinterpretation of the contemporary mythologies that have grown up around an object like the Turin Shroud. She is also concerned to situate historically the important debates of contemporary theorists of photography, from André Bazin onwards, who have sought to relate the indexical dimension of photography to the tradition of the image 'not made with hands', as with the imprint of Christ's face on the veil of St Veronica. However, the guiding concept brought out by her approach is the fundamental difference between the Western tradition of image-making, in so far as it has been dominated by the Greek notion of *mimesis*, and the Eastern concept of the divine *economy*, defined as the manifestation of God in human history. Where Platonic *mimesis* notoriously represents the artistic image as a form of double derogation from the purity of the Idea, Byzantine *economy* is epitomised by the act of God in offering the image of his Son as a model for

action. To quote from Mondzain: 'economy is an operative concept which is defined by its living fecundity'.[32]

It would be rash to claim that this awareness of a radically different philosophy of the image – submerged, as it were, within the disavowed part of Christian culture – was part of the experience of early nineteenth-century artists. In fact, it is only in the recent past that commentators from many different intellectual backgrounds have begun to point out the relevance of the Eastern tradition to the formidable acceleration of visual culture that characterises our own age. One example would be the co-editor of a recent anthology of texts on 'Law and the Image', who quotes Mondzain and other recent writers on Byzantine art in a fascinating essay which asserts that: 'Byzantium was the first empire to use aesthetics to create and propagate an all-inclusive perception of the world.'[33] Much more work will have to be done to establish a convincing connection between the doctrine of the image built over many centuries by the fathers of the Eastern Church and our contemporary 'society of the spectacle'. But the present growth of studies concerned with the discovery of Byzantium by the West in the nineteenth century points in the right direction.

My own argument, however, runs along different lines. One of the reasons for choosing Benjamin's work as a focal point in this introductory chapter is that he explicitly associates the coming of the 'Age of Mechanical Reproduction' with a crisis in religious art, touching on its 'cult value'. For him, there is a necessary opposition between such 'cult value', which involves hiding the work away, and 'exhibition value', which is the public manifestation of the work and is exemplified in the contemporary world by photography and film.[34] Yet it is precisely this polarity that is denied by the Byzantine notion of 'economy'. Instead of accepting a view which is premised on the opposition between 'cult' and 'exhibition value', original and copy, I want to place the emphasis on the 'fecundity' of processes of reproduction. This option cannot be divorced from the fact that Scheffer and Delaroche, and indeed to a lesser extent Ingres, were all preoccupied at different stages in their careers with the problem of reinventing a new religious art for a new age. But it is not primarily a question of religious subject matter and iconography. On the contrary, one might argue that the very 'fecundity' of the proliferating modes of image-making, and the consequent blurring of the hierarchies between media, was in itself indicative of the reinvestment of the image with philosophical and religious potency. This phenomenon cannot, however, be explained by aesthetics or religious doctrine alone. In France, particularly, it is inseparable from the coming of age of a post-revolutionary society.

* * *

As a conclusion to this investigation of the practices of image reproduction in early and mid-nineteenth-century France, I need at this stage to look more carefully at the explicit ways in which French law defined the issues pertaining to reproduction. Here there is strong, positive evidence of the artists themselves contributing to, and indeed initiating, debates about the status of particular types of image. One persistent theme which is highly relevant to this study is the question of where the line might be drawn in nineteenth-century practice between 'good copies' and 'bad copies', or more exactly

between what was *merely* a copy and what was regarded as a genuine 'translation' of the pre-existing work. Philippe Burty's comments on reproductive engraving vis-à-vis photography leave us in no doubt where he stood on the matter. He drew the line between the engraving, which left ample room for personal interpretation, and the 'impersonal' photograph. But the existence of such a line certainly pre-dated the emergence of photography, just as it would be extended, by critics coming after Burty, to include within the fold some of the black and white sheep sired by Daguerre. As demonstrated by the previously cited anthology *Law and the Image*, issues of law can be especially illuminating in throwing into relief unspoken assumptions about the boundary lines that hold good within the wider cultural field. What I propose to do in this final part of the chapter is to look at three successive examples of the workings of French law with regard to images. Spanning the years from 1812 to 1878, they cover the entire period under investigation here.[35]

In the 1812 edition of his long-running *Annales du Musée*, the painter and critic Charles-Paul Landon took time off to inform his readers of an acrimonious legal dispute about his editorial use of line engravings that had recently been settled in his favour. The printer, Pierre Didot l'aîné, had brought an action against him alleging forgery (*contrefaçon*) on the grounds that he had published in his *Annales* of 1807, 1808 and 1809 images which had already appeared in various of Didot's editions. The issue was not straightforward. The burin engravings (*en taille-douce*) that Didot had used were based on original drawings which, in Landon's judgement, had ceased to be the printer's property. The implied concession is that it was indeed these drawings that Landon and his engravers had used for reference in the preparation of the plates. However, the editor's defence against the grave accusation of forgery was to point to the contrast between his own derivative images and the superior quality of the earlier engravings. Landon claimed to have embellished his illustrated anthologies with no more than a 'line drawing' (*trait réduit*) of the works featured. He went on to sum up his defence as follows:

> I was able to point out to the judges that my plates, reduced to *line*, were not copies of the prints finished by M. Didot, but simply extracted from the original compositions, and these originals being at that time the property of a third person, only the owner would have had the right to prosecute me, if my extracts could have been considered as the forgery of these drawings.[36]

The case was in the first instance decided in favour of Didot, though without the substantial damages that he had claimed. Only on appeal by both parties was the final judgement made in Landon's favour. But it is relevant to point out that Landon was able to mobilise significant support within the artistic community for the simple premise that a line engraving should escape the normal provisions of copyright. One of his supporters was Adrien-Jacques Joly, Director of the Cabinet des Estampes of the future Bibliothèque Nationale and Delaroche's cousin. Among the others were several painters belonging to the Académie des Beaux-Arts. Most telling of all, and quoted by Landon, was a letter of support from the foremost reproductive engraver of the age, Bervic, who declared:

> The work by M. Landon entitled *Annales du Musée* is a journal in which he renders, and in which he is obliged to render, account of all the productions of the fine arts

Monsiau pinx.ᵗ Mᵐᵉ Soyer sc.

11 Mme Soyer, engraving (1814) after Nicolas-André Monsiau, *Prédication de St Denis*, 1814 Salon.
21.2 × 14. Private Collection.

which are exhibited to the public . . . This account, as he presents it, is to the arts what in literature the extract of a work is to the work itself. I declare in consequence that the simple line drawing of a work of art, complete in all its parts, cannot constitute a forgery.[37]

Of Bervic's concern to police the frontier between his own expert practice and the other, more menial forms of engraving, we shall see more evidence in the next chapter. What is striking in the present statement is the apparent anomaly of resting the case upon a parallel between Landon's line engravings and the 'extract' of a literary work – which Bervic further complicates by stating that the visual 'extract' can still be 'complete in all its parts'. Underlying both statements is, no doubt, a traditional assumption about the complementary aspects of description – the traditional genre of ekphrasis – in which visual and literary means are reciprocal. Is the engraved line drawing to be viewed as a mere supplement to Landon's written commentary? Clearly not. However, the precise limits of the image's descriptive reference need to be defined, not only to avert accusations of forgery, but because literary description assumes the task of evoking what the line drawing necessarily lacks. When discussing Monsiau's *Prédication de St Denis* in his 1814 *Annales*, for example, Landon suggests that 'just the inspection of the engraved line is sufficient to convey its lay out' (*ordonnance*).[38] Mme Soyer's engraving is there to prove the point (pl. 11). But he then goes on to mention the specifically plastic features like chiaroscuro and colouring that pure line cannot convey.

At this early stage in the nineteenth century, then, the engraved line drawing is being annexed to critical description, and thus gains legal exemption from the penalties attached to unauthorised reproduction. It is worth noting that, as the century progresses, this free space for legitimate copying will expand as the illustrated popular press develops the possibilities of wood engraving. Landon's publications required the separate printing of each image from an individual copper plate, and, as the prints had to be on a slightly heavier paper, considerable labour was involved in binding the finished book.

By the mid-1830s, however, miscellanies of text and images could easily be assembled using wood blocks incorporated into the typographical layout of the printed page.[39] Although a small proportion of these images – especially those reproducing classical works of art – retained the eighteenth-century style of line engraving, the vast majority exploited the medium to produce increasingly striking tonal effects. Following the Salon of 1834, both the *Magasin universel* and its rival, the *Magasin pittoresque*, rushed to commission wood engravings of Delaroche's popular exhibit, *The Execution of Lady Jane Grey* (National Gallery, London). The print that appeared in the former publication was noticeably more attentive to the characterisation of the faces, conveying some of the pathos of the central figures (pl. 12). That of the *Magasin pittoresque* sacrificed the nuances of physiognomy in the interests of a crude, but visually effective, distribution of highlights (pl. 13). It is possible, however, that both images originated with the same drawing, and that the additional effects were supplied by different engravers.

Both these images of Delaroche's painting were, of course, for immediate consumption in the aftermath of the Salon. They had a very different status – legally and artistically – from the authorised reproductive engraving that was commissioned from Paul

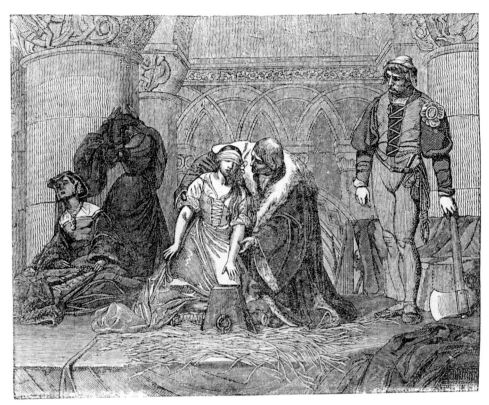

12 Wood engraving after Paul Delaroche, *Jane Grey*, 1834 Salon, from *Magasin pittoresque*, 1834. 14 × 16.5.

13 Wood engraving after Paul Delaroche, *Jane Grey*, 1834 Salon, from *Magasin universel*, 1834. 14 × 16.5

Mercuri in 1835, and brought to completion no less than twenty-two years later. Consistent with Bervic's firm distinction between the higher and lower grades of reproduction, the print by Mercuri would eventually cost 40 francs, whereas the hardback volume of the entire first year of the *Magasin universel* – over four hundred profusely illustrated pages – could have been had at the time for 7 francs. This vast disproportion only highlights the point that, by the time that Mercuri's engraving was completed in 1857, the qualitative distinction between modes of visual reproduction so integral to the prestige of traditional engraving had become highly anomalous. The reproductive engraving, however fine, was after all no more than a reproduction. If it continued to assert its residual claim to superior status, both as an artistic achievement and as a service to the art-loving public, this was because it aspired to be the definitive reproduction.

Indeed this is the aspiration in which many of the engravers featured in this study can be shown to have succeeded, at least within the confines of their own period. Théophile Gautier, an altogether more powerful critic than Landon, has more than the humble *trait* of a line engraving to guide his review of Ingres's great retrospective exhibition of 1855. He can write with an eye to the common stock of retrospective images that his audience will have in their minds (and possibly on their walls). 'The *Voeu de Louis XIII*', he explains, 'has been popularised by the fine engraving of Calamatta; it is therefore pointless to describe it here in detail.'[40] By this stage, the balance has swung right away from the situation of the engraver in Bervic's time, when a leading practitioner would be expected to devote much of his life's work to the reproduction of classical and Renaissance masterpieces. Artists like Calamatta, Mercuri and Henriquel-Dupont were being given credit for perpetuating the memory of notable contemporary works, whose conditions of access were often exceptionally difficult, if not impossible, for the majority of citizens.

It is not, however, the writing of the critics that most convincingly demonstrates the high stakes invested in these traditional methods of reproduction. The artists themselves recognised their interests, and defended them with considerable passion. In 1841 Horace Vernet published, with the full approval of his colleagues at the Académie des Beaux-Arts, a pamphlet originally written in 1839, and entitled *Du Droit des peintres et des sculpteurs sur leurs ouvrages*. The occasion for his eloquent pleading was a bill adopted by the Chambre des pairs in 1839 on the issue of literary and artistic ownership, or what has come to be known as copyright. In the French bicameral system of the July Monarchy, the bill required the vote of the Chambre des députés to become law, and its initiator, the literary critic and historian Villemain, only advanced his proposal to this stage in 1841. Hence Vernet's publication was a direct intervention, on behalf of the community of visual artists, in a political debate which would have had serious consequences for all of them.

Villemain's proposal, which was inserted without consultation in a bill concerned primarily with literary copyright, envisaged a drastic change in the state of the law by 'transmitting to the buyer of a work of art the right to reproduce it in any fashion, according to his fancy', except where there was a specific agreement to the contrary. This was tantamount to abolishing the existing situation in the visual arts, according to which, in Vernet's words:

The painter has two means of drawing pecuniary gain from his picture, namely: the sale of the picture itself, and the assignment of engraving rights. No doubt it will not be denied that a painter who has ceded the right to engrave his painting is just as much the owner of the picture. It is clear that he can sell it to another individual, without the engraver being justified in complaining. In so acting, the painter conveys two distinct objects, namely: an intellectual object consisting in the right to reproduce the painting by engraving; and a material object consisting in the canvas that his brush has brought to life.[41]

It is relevant that Vernet's statement was a reflection of his own practice, which thrived upon the freedom permitted by the existing state of French law. He had many commercial dealings with the engraver Jean-Pierre Jazet, who could indeed be described as the official engraver to the Vernet family: in 1842 Horace Vernet was just about to receive the substantial sum of 2,000 francs from Jazet for the right to engrave his *Napoleon reviewing the Guard in the Place du Carrousel* (1838).[42] Vernet's own argument showed that he had consulted legal opinion, and knew very well that recent judgements in the matter invoked a decree of the revolutionary government, dated 19 July 1793, according to which authors, composers, painters and draughtsmen 'who have pictures or drawings engraved' were allowed to 'sell and distribute their works in the territory of the Republic, and to cede proprietorship in them in whole or part'.[43] This provision, which additionally granted the same rights to the heirs or '*cessionaires*' for ten years after the artist or author's death, had been confirmed by an imperial decree of 1810, and tested in the courts of the Restoration and July Monarchy.

Vernet's pamphlet reaches its most passionate pitch when he expands on the implications of his contention that the painter produces both a 'material object' and an 'intellectual object'. The chief point is that the right to engrave must not be given up lightly, for it is nothing less than the painter's passport to immortality:

Engraving is the means of propagating and giving eternity to the painter's work. Is it not engraving, in fact, that is for most of the time the most active agent in the painter's reputation? . . . Engraving is, so to speak, to the picture, what printing is to the manuscript: it is the thing that multiplies it; it is the thing that propagates and popularises it; it is the thing that gives eternity to the work; it is the thing that immortalises the genius of the painter.[44]

Here we can observe, on the one hand, that Vernet's assertion is recycling a cultural commonplace about the historical role of the engraving. Valentin's contemporary popularising account of the history of Western painting, *Les Peintres célèbres*, makes an admiring reference to Leonardo's *Last Supper* in Santa Maria delle Grazie, 'which all Europe knows, and engraving has immortalised'.[45] Vernet refers to just the same damaged fresco painting, and also to the lost drawing by Raphael for his *Massacre of the Innocents*, to justify his exclamation: 'How many masterpieces, through not being engraved, are for ever lost! How many others would have been if it were not for the help of engraving!'.[46]

But, on the other hand, Vernet wants to testify to the substantial importance that fine engraving retains for the painters of his own period. He is well aware that new conditions for the creation and distribution of reproductions are beginning to establish a public for

art that is already broadly 'European', and is destined to extend even further afield. His own work already testifies to the fact – he was due to spend the major part of the years 1842–3 as the personal favoured guest of the Tsar of Russia, who was well aware of his reputation and that of his son-in-law, Delaroche.

Unequivocal evidence for this new European-wide celebrity can indeed be found in the case of Delaroche. When the Italian critic, Giuseppe Rovani, writes in 1853 that Delaroche 'sits by universal agreement at the summit of all living painters',[47] he is making a judgement that could only have been framed from within the universalising visual culture that Vernet was defending more than ten years before. Renaissance painting, it had to be admitted, only transmitted the memory of its vanished masterpieces in a selective and haphazard way. But the nineteenth century could learn from the happy example of great engravers like Raimondi. Nineteenth-century art had an unprecedented opportunity to preserve and hand on the totality of an artist's work, in a form that translated but most definitely did not traduce it.

From my vantage point, it seems a curious coincidence that Vernet composed his pamphlet in 1839, the very year of the successive revelations of the secrets of the daguerreotype process to the French scientific and artistic establishment. In chapter 3 I shall have much more to say about the central role played by Delaroche, and by Vernet himself, in what might be called the painterly reception of the daguerreotype. But a plausible point may be made straight away. Even though Villemain's bill took absolutely no account of Daguerre's invention, the agitation raised by Vernet and his colleagues over the rights of reproduction can hardly be seen in isolation from the tumultuous arrival of the new 'mechanical' process. A provisional conclusion would be that Vernet's argument is noteworthy, among other things, because of its complete refusal to acknowledge the existence of a differential hierarchy of modes of visual reproduction: it relies implicitly on the assumption that burin engraving, with its high professional standards and its lengthy period of execution, will remain the preferential method. Landon's court case under the Empire elicited the acknowledgement by Bervic that a simple *trait* could not be counted as a reproduction, subject to copyright. Vernet appears to have no sense, at this primitive stage in the development of photography, of the threat (or opportunity) presented by the 'immortalising' potential of the 'mechanical' image.

In spite of the arguments of Vernet and his fellow academicians, his views were not accepted by the French legislative body in the short term. Only in 1863, the year of his death, did a commission on literary and artistic property set up by the government of Napoleon III finally recommend that, in the case of the sale or gift of a work of art, 'the reproduction rights are reserved for the author, except in the case of a stipulation to the contrary, without the owner of the statue or picture being in any way affected in their possession'.[48] But this provision did not settle the subsidiary question raised in the original decree of 1793: namely, the entitlement of the artist's heirs to reproduction rights after his or her death. In 1878, a third legal dispute of some significance was brought to court to settle this question. The plaintiffs were Horace Vernet's widow, the two sons of Delaroche (also Vernet's grandsons) and the widow of Ary Scheffer. The defendants were the House of Goupil, which had been so active in initiating and disseminating prints after the works of all these artists during their lifetimes, but were now accused of infringing upon the rights of reproduction vested in their heirs.

It is very likely that the commercial motive was uppermost in the prosecution of this case. The various heirs wished to reassert their control over what they conceived to be the valuable printmaking industry that Goupil had developed out of the works of their relatives. Yet they seem to have been ill advised in their suit. Goupil's lawyer raised from the start the inconvenient point that an imperial decree of 1810 had extended the period after which the heirs of an artist could resume their rights of reproduction from ten to twenty years. He argued that, by this criterion, the claim of the Delaroche brothers, originally submitted less than twenty years after their father's death, was not allowable in law.[49]

In the final judgement of 26 July 1878, the court found in favour of the defendant, the House of Goupil, and awarded all costs to the plaintiffs. However, the legal outcome of this case is clearly less significant, for our purposes, than the fascinating historical material which was unearthed in the course of the opposing pleas. What Goupil were obliged to put forward in their defence was an explanation and justification of the whole history of their involvement with the artists concerned. This entailed not just an explicit statement of the working agreements entered into, but a resounding vindication of the social and aesthetic role of the reproductive engraving.

The first point of interest that emerges is in fact the special position that such a reproductive method holds vis-à-vis the reproduction of sculpture by the traditional techniques of moulding and casting. Though sculpture was not explicitly excluded from the categories of art works considered in Vernet's pamphlet, the plaintiffs in 1878 had to reckon with a recent judgement involving the sculptures of James Pradier, in which Maison Susse had been debarred from making copies of the dead artist's work. Goupil's lawyer began accordingly with a sharp distinction between the two operations:

> That one cannot equate the reproduction of a statue by moulding or bronze-casting with the reproduction of a painting by means of engraving;
> That the moulder takes part in an easy operation, which costs little and is essentially mechanical and impersonal, and requires only the skill of a workman and a short period of work;
> That the engraver, by contrast, creates a personal work of art beside that of the painter and, for its execution, this work requires a special talent and often considerable time;
> That it is enough to cite in the present trial the engraving of Jane Gray [sic] which demanded from the engraver Mercuri twenty-three years of work and cost the Maison Goupil more than 100,000 francs.[50]

The defending lawyer cannot be reproached for having brought up the most hyperbolic instance of the time and expense required to bring a notable engraving to completion. As it happens, he has also picked a case in which the original division of rights between artist and purchaser was far from clear. More will be said in chapter 4 about the long years of incubation of one of the most celebrated reproductive engravings of the century. But the general point made by the defence is already obvious. Goupil wishes to demonstrate that the house has enjoyed a long and productive relationship with the painter Paul Delaroche: it has accepted what can only have been a very heavy financial burden, while enabling him to achieve immortality through the prints of his

paintings. It is thus entirely unreasonable of his heirs to try to reappropriate the profits of this long-term investment. As the defending lawyer casuistically pointed out, it is conceivable that Delaroche might have died the day after he conceded the rights for the reproduction of *Jane Grey* to Goupil. Would it then have made sense for his heirs to resume the rights after ten years, when the engraving was still no more than halfway to completion?

With regard to Delaroche, at any rate, the case of Maison Goupil comes across as a very strong one, and not only in the strict legal sense. Although it is true that not all the works engraved after his paintings were covered by specific legal agreements, the defence was successful in demonstrating a continued complicity on his part with the marketing strategies of Goupil (the evidence for a productive and long-standing *troc*). Goupil offered Delaroche the opportunity to become the best-known contemporary artist in Europe, indeed the whole Western world, and Delaroche thankfully took it. One could say that his publisher and dealer made it possible for him to be a new kind of artist, working always with a view to *reproducibility*.

One of the most striking revelations of the trial, with regard to the financial arrangements between Delaroche and his publisher, was provided in the summing up of the *ministère public*, who revealed that the painter ceded the reproduction rights of his masterpiece, the *Hémicycle des Beaux-Arts*, for a mere 500 francs, just a third of what had been asked for the rights to the earlier painting of *Strafford* (1836).[51] There is no need to seek far afield for the reason why so little was paid for the rights that were to result in Henriquel-Dupont's highly acclaimed three-part print. Delaroche well recognised that an exceptional investment was necessary for such an undertaking, and was willing to forego anything but a token payment in order to ensure its viability.

As will be seen, Delaroche represents the paradigm case, in this study, of a painter well attuned to contemporary possibilities of reproduction. At the other end of the spectrum, and for that reason most illuminating by comparison, is the case of Ingres, who never fully resolved the problem of how to ensure the appropriate reproduction of his works – though he was luckier than he could have imagined in the fortuitous appearance of Luigi Calamatta! Ingres's constitutional uncertainty in the face of the possibilities of reproduction is, of course, no less instructive than Delaroche's life-long concern to utilise them productively.

Ingres is no doubt vindicated by the fact that his original paintings and drawings have retained an immense celebrity, fuelled by the new possibilities of colour reproduction, whilst even the best engravings after his work have fallen into near oblivion. Nevertheless, from a historical point of view, it is Delaroche who most clearly illustrates the stakes invested in the reproduction of the image at this earlier juncture. It is his career that vindicates the strength of the cultural assumption (made explicit by Goupil's lawyer) that: 'The body is the picture; the soul is the artistic property, the composition, it is what we call the effort of genius, the superior creation.'[52] As one of Delaroche's favoured pupils, Joseph-Nicolas Robert-Fleury, made clear in a letter submitted to the court, his master was ready and willing to vest his chance of artistic immortality in the perpetuation of the 'soul' of his works through reproductive engraving:

You ask me for my memories concerning M. Paul Delaroche's preoccupations relative to the engraving of his works. This preoccupation was constant, one might almost say

acute. His naturally morose spirit was as concerned for the future as for the present. He understood that the future of a painter does not reach the masses except through diffusion by engraving, and that the masses of today are tomorrow's posterity. He felt in the end that engraving was the sole means of guaranteeing his fame against the disappearance of his works, their annihilation by fire, or simply their acquisition by art lovers whose galleries are necessarily barred to the public. He often used to reiterate on the subject that he wished, through engraving, to raise a monument to his memory in his lifetime.[53]

* * *

I have been following up some of the implications of Benjamin's description of the 'Age of Mechanical Reproduction' as it was briefly summarised at the beginning of this chapter. My concern has been to enlarge with additional historical examples the concept of 'reproducibility' as it was developed there, and to suggest that nineteenth-century artistic practices in France were far from being regulated programmatically by the distinction between the 'original' and the 'copy' that is basic to his theme. Among the domains that have been under review, the practice of the replica or *répétition* can be seen at the very least to have blurred this distinction, leading to a kind of recuperation of the copy by the 'original' author that was consistent with the philosophy of the primacy of the artistic 'idea'.

Reproductive engraving, as it was generally received and evaluated, involved an even greater apparent paradox, since it was common critical practice to compare the engraving to its original, and not unusual, at least among the critics associated with the *Gazette des Beaux-Arts*, to assert that the 'translation' was superior to its original. Much more will be said in subsequent chapters about the particular nuances of aesthetic judgement that supported such critical evaluations. For the moment, it may however be suggested that this traditional mode of engraving – which its exponents and supporters took care to differentiate from inferior or purely functional types of engraved image – puts into suspension the categories taken for granted in Benjamin's notion of reproduction.

This is highlighted most vividly through the artistic positions taken up by Horace Vernet in his defence of the artist's copyright, and Delaroche, if we are to accept the testimony of his pupil, Robert-Fleury. Even if we grant the commercial logic that is being advocated by Vernet, it still stands as a significant fact that contemporary artists attached very high importance to the existence of fine engravings after their work, in the belief that these alone would guarantee its permanence. Fully aware of the good fortune enjoyed in this respect by earlier artists, Delaroche seems to have consciously banked on a strategy of *reproducibility*, in the conviction that only this could assure the immortality of his work. The fact that Delaroche also became the first contemporary artist to be treated, after his death, to a catalogue raisonné with extensive photographic documentation – and Ary Scheffer the second – is an indication of how such ambitions were also fulfilled in a way that neither of them could have predicted.

Since all of these issues are embedded in an intricate series of aesthetic, economic and even theological factors, it should be clear by this stage that there can be no simple and comprehensive formulation of the concept of reproduction as it developed in the nine-

teenth century. Richard Shiff has given careful theoretical consideration to the cluster of terms involved here, with special attention to nineteenth-century France, and concluded that 'pure original and perfect copy must be situated very close together . . . They occupy nearly the same position, while each maintains its unattainability'.[54] For our own purposes, it is perhaps appropriate to recall Nietzsche's comment on the multifarious meanings of the term 'punishment' from his *Genealogy of Morals*, and so affirm: 'It is impossible to say with certainty today *why* [pictures are reproduced]. All terms which semiotically condense a whole process elude definition; only that which has no history can be defined.'[55] This study has been written in the belief that we can proceed a good deal further in the specifically historical elucidation of the conditions and conventions of reproduction in nineteenth-century France, within the overall framework of a rapidly evolving visual culture. The next chapter will thus serve as a broad overview of the range of printmaking techniques deployed over the period, and a guide to the many different social, technical and aesthetic functions that they served. It has a continuing thread in the coverage of three generations of the Vernet family, whose exceptionally varied production spans a century of headlong change.

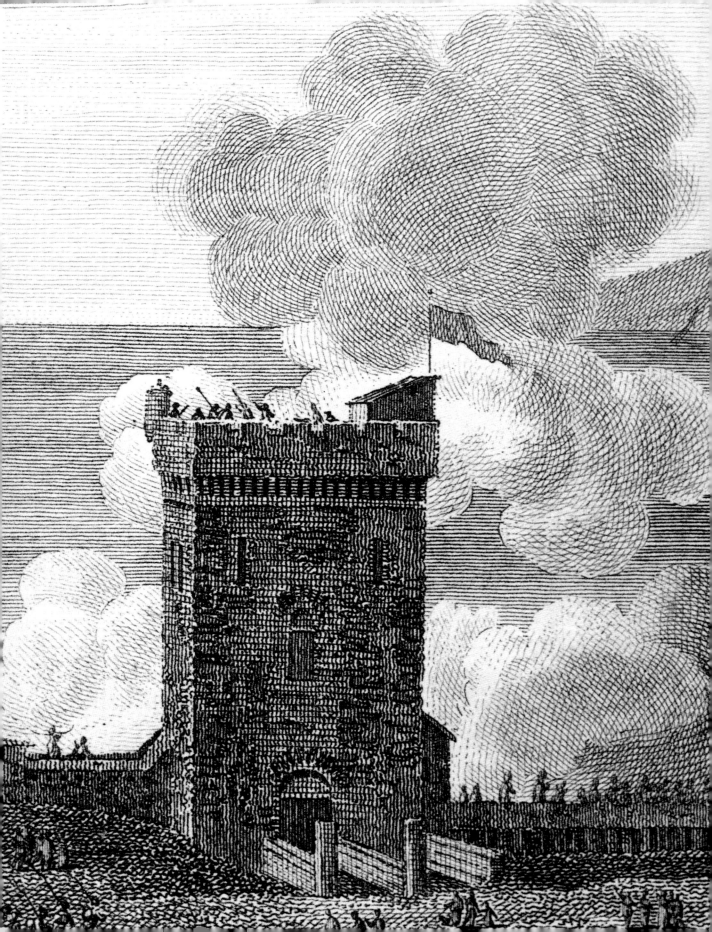

2

Battles in Paint and Print

'FOR OVER A CENTURY,' wrote F. Valentin in the early 1840s, 'France has gloried in the Vernet family.'[1] Fifty years later, when the title *Une famille d'artistes* was chosen after Charles Blanc's death for the re-edition of his lives of the Vernet dynasty, the record was even more impressive.[2] In the course of nearly two centuries, they had set up a family tradition that was unequalled for its longevity among French painters, rivalling in this respect the great dynasties of engravers like the Cochin and the Tardieu. The first of the line, Antoine Vernet (1689–1753) was a provincial artist who did not stray far from his native Avignon. Like Ingres's father in pre-revolutionary Montauban, his work lay broadly in the applied arts; the Musée Calvet of Avignon exhibits sedan chairs and carriage panels decorated by his brush. His son Claude-Joseph, however, established a national and inter-national reputation as a marine painter. Born in 1714, he benefited from his local con-nections to make the journey to Rome as a young man. There he studied the Claudian landscape manner and also experimented with the more dramatic mode of the Nea-politan painter Salvator Rosa, in a series of striking shipwrecks such as *Le soir ou la tempête* (Louvre). In 1750 his rising fame led to a commission from the marquis de Marigny, *Directeur-général des Bâtiments de France* and brother of the King's mistress, for the inno-vatory series of large paintings of the major French ports that was to occupy the most productive years of his life.

Joseph Vernet arrived at Marseilles in 1753, and took the next ten years to work round the French coastline completing the fifteen pictures in the series, before he finally tired of the itinerant life and set up his studio in Paris. His critical reputation quickly peaked, but did not decline throughout his lifetime. Almost uniquely among his contemporaries, he was credited with being a practitioner of landscape whose simultaneous ability to rep-resent human action attained the superior dignity of history painting. The penetrating criticism of Diderot, who compared him to Apelles and to Raphael among other great artists of the past, focused however on the compelling light effects of his sunlit vistas.[3] To this extent, Vernet could be seen as a forerunner of the new forms of spectacle, such as the panorama and the diorama, that were to galvanise an ever-growing public in the half-century following his death in 1789.[4]

Joseph's son, Carle, was born in 1758 and died in 1836. Aided by his father's celebrity, he achieved an early *entrée* into French court society, where his sartorial elegance and excel-lent horsemanship counted for as much as his artistic gifts. His painting of 1788, *Le duc d'Orléans et son fils le duc de Chartres* (Musée Condé, Chantilly), is one of the conventional hunting scenes through which he made his name. It also testifies to his easy familiarity with the progressive cadet branch of the Bourbon family: the father shown in the paint-

ing, known as Philippe-Egalité, was to die at the guillotine, whilst the son would ascend
the French throne as Louis-Philippe after the revolution of 1830. This Vernet connection
to the royal family was inherited by his son, Horace, born in 1789 from Carle Vernet's
marriage to the daughter of the well-known engraver Moreau le jeune. In common with
the prestige of the Vernet name, it helped to give Horace a distinctive position of inde-
pendence in French artistic and cultural life over the period that concerns us.

At the time of the Bourbon Restoration, both Carle and Horace took their seats among
the fourteen painter members of the Académie des Beaux-Arts, Carle being elected in
1815 and Horace in 1826. But their influence was by no means limited by their partici-
pation in this august but conflict-ridden body, which, with the aid of Horace's son-in-
law Paul Delaroche, they would later seek to reform.[5] Stendhal asked rhetorically in 1824,
after an episode in which two of Horace Vernet's battle scenes of the Revolution and
Empire had been banned from the Salon by the timorous representatives of the Bourbon
government: 'In fact, which is the only painter who, in 1824, can become rich through
his talent and in a manner absolutely independent of the State budget?'.[6] The answer
could only be Horace Vernet.

However, this exceptional degree of social (and financial) independence accruing to the
Vernet clan is not in itself significant as a reason for focusing on them at this stage in
my study. If a painter like Géricault gravitated towards their circle, this was because their
off-centre stance was underscored by a lively professional interest in new artistic tech-
niques and developments. The prime example is their commitment to the new medium
of lithography, which Carle can be credited with opening up at a time when very few
other French artists appreciated its full potential, and which Horace refined in such a
way as to form a stream of invention parallel to his paintings. Much of the theoretical
interest of this chapter will, in fact, consist in tracking the variable connections between
painting and printmaking in the light of the innovative dimension brought to the visual
arts by the lithographic method of printing. It will involve, in addition to the Vernets,
probably the most spontaneous and gifted of all the lithographic artists of the younger
generation, Nicolas-Toussaint Charlet (1792–1845), a disciple of Carle Vernet and close
friend of Géricault, whose career demonstrates in particular the gulf, over the whole
period, between criteria for success as a printmaker and traditional concepts of pictorial
achievement.

But there is another, complementary reason why the Vernets, and indeed Charlet,
should feature at this stage in my argument. Besides their adventurous sorties into new
aspects of visual culture – typified by the role that Horace would adopt as spokesman for
the daguerreotype in 1839 – these artists were also all contributing to the development
of one of the most well-established national genres, that of the battle painting. To this
extent, their work emerged from, and can be directly compared with, a tradition that
had been massively reinvigorated by the official patronage of Napoleon during the
Empire. After the Revolution of 1830, it was under Horace Vernet's direction that a new
generation of painters filled the *Galerie des Batailles* at Versailles with scenes of histori-
cal conflict to rival the triumphs of the school of David. In writing of Horace Vernet's
Barrière de Clichy (1821), Charles Blanc was to comment many years later: 'Our history
. . . is a *battle-history*, to use the phrase of Monteil, and battle, which was for so long the
genius of Gaul, was also the true talent of Horace Vernet.'[7] Battle painting will provide

us with a way of tracing, through the careers of successive members of the Vernet family and their connections, the response within successive forms of printmaking to the demands of a nationalist iconography.

<p align="center">* * *</p>

Gilles Deleuze has chosen to use the 'battle' in his *Logic of Sense* as a demonstration of the tensions inherent in the very notion of the 'event'. 'If the battle is not an example of an event among others,' he comments, 'but rather the Event in its essence, it is no doubt because it is actualized in diverse manners at once, and because each participant may grasp it at a different level of actualization within its variable present.' This being so, he continues to argue, nineteenth-century writers like Stendhal, Hugo and Tolstoy make the attempt to let their readers 'see' the battle through the eyes of their heroes. But the battle nonetheless '*hovers over* its own field, being neutral in relation to all of its temporal actualizations, neutral and impassive in relation to the victor and the vanquished . . .'.[8]

Deleuze does not address, in this connection, the specifically visual problem of how to represent a battle, although his metaphorical use of the word 'seeing' inescapably brings this to mind. Stendhal, Hugo and Tolstoy were, of course, all very familiar with the attempts of painters who had tried to represent the battle as a historical event in specifically visual modes: not as a function of the metaphorical 'point of view' of a fictional hero, but in accordance with the point of view of the spectator, achieved through the pictorial construction of perspective; not in terms of the narrative sequences of the novel, but in accordance with the prescriptions of legibility defended by the Academies in the name of 'history painting'. It seems inherently likely – and will be assumed here – that the technical innovations introduced by such major writers did not develop in isolation from the visual experiments of printmakers and painters. But, first and foremost, it is important to acknowledge the special constraints, and possibilities, that governed the determination and resolution of the visual field, perhaps more markedly in the case of the battle painting than in any other genre.

It is, however, important to qualify this implication for the specificity of visual art. The battle painters of the early nineteenth century may, or may not, have devised modes of vicarious visualisation that influenced the writing of narrative accounts. But it is certain that they themselves had to work with a specific narrative in view. A battle was, by definition, not an event about which the artist could exercise complete freedom of interpretation. It was a political event of major importance, whose outcome was closely relevant to state policy, and whose visual description had to cohere with the received and acceptable version of how that outcome had been secured. Ever since the Renaissance, painters had been able to combine the function of clarifying and securing the intelligibility of battle scenes with the exercise of intellectual skills that advanced their own artistic prestige. (Paolo Uccello's tripartite series of paintings depicting the Battle of San Romano is a case in point.) But it was hardly conceivable that a battle painter could depart from the implicit contract to show a victory as a victory, and thus to visualise the key movements and developments that were supposed to have determined the outcome in each particular case.

Napoleonic battle painting formed, as has been said, a specially important sector of imperial patronage, and it has recently received a great deal of careful scholarly attention. Susan Siegfried's pioneering article on 'The Rhetoric of Military Painting in Postrevolutionary France' has brought out the difference between two fundamentally different approaches to the assignment of representing the triumphs of the First Consul and Emperor that belong, in essence, within the differing cultural frameworks of High Enlightenment and nascent Romanticism. A senior artist, Louis-François Lejeune, sees the role of the battle painter as one of 'rational mapping', whilst the representative of the next generation, Antoine-Jean Gros, learns to focus on 'immediacy of experience'.[9] It goes without saying that these two visual strategies are not necessarily dependent on actual experience, or the lack of it. Lejeune was indeed an artist who had had a long and distinguished career in the army, after volunteering for military service in 1792. Gros had had the accidental good luck of falling in with the young General Bonaparte during his Italian campaign in 1796. But he was not present on the morning after the fateful Battle of Eylau during the Russian campaign of 1807, which he was to represent in his superb painting of 1808. His response to this official competition, though it could not afford to neglect the requirement that this dubious victory be shown in a positive light, was at the same time thematically and visually attuned to depicting the suffering of the vanquished.

To appreciate Gros's achievement in this work, we need to be aware that his brief had been set for him in the most specific terms by the publication in *Le Moniteur* on 24 February 1807 of the '58e Bulletin' of the *Grande Armée*. Michael Marrinan has written illuminatingly of how such 'texts which shaped current events for millions of readers across Europe' formed at the same time 'the basis for . . . a new kind of history painting'.[10] His method for calculating the effects of this unprecedented situation on Gros is to analyse minutely the 'semantic space' of the Eylau bulletin – its 'armature of . . . possible readings' – and to correlate these with the practice of Gros in his sketches and his finished work. However, he reaches an exceptionally interesting conclusion when he proposes that the very protocol of perspective in the end rebels against semantic determination, in so far as it sets up a to-and-fro movement between surface and represented space that cannot fail to generate fantasy. His argument is worth giving at length, since it is so directly relevant to my theme:

> The painter's deictic gesture of pointing out objects may be masked and rendered nearly invisible, but perspective remains a discursive system which requires – above all else – that the canvas be physically visible *in order* to efface itself. Paradoxically, the canvas supports the painter's marks but remains limpid, the way a mirror is impossible to 'see' except when reflecting its environment. In exactly the same way the illusion of a pure historical *récit* dissolves when the narrator becomes visible, the illusion of perspective cannot tolerate a 'painterly' trace without breaking down, for the materiality of such a trace would disrupt the mirroring process required to mask the painter's presence . . . I use 'painterly' to mean the visible surface discontinuities generated by the material instances of paint marks which neither simply describe forms 'in' the space nor sit simply 'on' the surface, but resist both of these uses to describe a space of flux between them: following Lyotard, I will call *figural* this space of 'in-between' and will suggest it is where dreams and desires take form – a space of the unconscious.[11]

The way in which Marrinan raises this question of the unconscious determinations of the perspective system has a particular relevance to the sequence of battle scenes that will be examined here, though not directly in the way that he envisages. For his concern is primarily with oil paintings, their distinctive facture and their special conditions of exhibition. His analogy with the limpidity of the mirror reflection is specially relevant there, since David himself challenged his audience to make the same equation when he arranged a paying exhibition, between 1799 and 1804, with a mirror placed in such a way as to reflect, from a distance, his *Sabine Women*. Charles-Paul Landon commented at the time that such an arrangement 'produces such an illusion that one is about to forget that one has before one's eyes a work of art'.[12] Clearly the print is not of a sufficient scale or suitable facture to provoke the effect (as another critic put it) of figures in the painting appearing to be identical in colouring with those actually in the exhibition room. But Marrinan's point is also fundamentally about the response to *surface*, and the way in which it provokes fantasy by interacting with perspective. In so far as my account will refer to two very different treatments of the surface in printmaking – the traditional intaglio method of engraving and the new 'planographic' method of lithography – it will bear in mind this potentially anarchic feature.

My first example is an engraving from the collection *Tableaux historiques des campagnes d'Italie*, published in Paris in 1806. The full title of this unwieldy repertoire suggests that it was intended to be a thoroughly comprehensive anthology of Napoleonic propaganda, bringing the public up to date with the imperial coronation of 1804, and including the official *Bulletins* of the *Grande Armée* for the recent German war which had resulted in the Battle of Austerlitz (1805) and the Treaty of Pressburg.[13] But the range of visual material, requiring as it did the careful coordination of a number of printmaking skills, has not succeeded in keeping pace with the more recent escapades of the victorious French army. It is restricted to the young General Bonaparte's Italian campaigns of the previous decade, and seemingly dependent above all on the painstaking research undertaken *in situ* by Carle Vernet: 'The views have been for the most part taken on the spot, and the prints are engraved after the original drawings of Carle Vernet.'[14]

A number of Carle Vernet's original designs for these compositions have survived. They are in sepia wash on paper, and support Charles Blanc's assertion that he was creating a 'new genre', not simply (in Siegfried's terms) reproducing the 'rational mapping' of Lejeune, or indeed anticipating Gros's novel emphasis on 'experience', but combining aspects of both approaches. Blanc notes the 'local physiognomy' of the locations: 'The nature of the terrain, the aspect of the mountains, are very well observed.' Vernet has not, however, in his view, reverted to the bird's eye prospects of the eighteenth-century battle painter Van der Meulen, which seemed to imply a 'spectator in a balloon'. On the contrary, he has given the spectator a lively scene to divert his attention. 'The foreground planes are always composed of groups that have been wittily arranged' and the movements of the figures rendered in a fashion both 'just and picturesque'.[15]

Although Blanc does not mention it, there is an obvious precedent for Carle Vernet's tour of the battle sites of Italy, namely his father's lengthy and systematic study of the Ports of France. I mean this not simply in the sense that both artists had to come to terms with the need for repetition and variation inherent in a planned series, but also in relation to Carle's manner of composition. Indeed there is a telling comparison to be

drawn between *Délivrance de la Corse*, the print on which I shall focus, and Joseph Vernet's *La Rade d'Antibes* (pl. 15). Antibes does not offer the same dramatic mountain scenery as Bastia, but the way in which the picturesque landscape is used as a vehicle for intelligible action is a common feature of both compositions. Joseph has presented a full panorama of the town, with its port, its chateau and its churches in the background, at the moment when a troop of soldiers from the garrison is entering one of the town gates before nightfall. Carle has also organised his panoramic view around a town gate, with a waggon trundling leftwards that recalls that of his father progressing in the opposite direction, and he gives similar close attention to the grouping of small knots of animated figures (pl. 16).

But the first, and obvious, point to be made about such a comparison is that it falters when we register the different expressive potentials of the two techniques employed. Joseph's oil painting of *Antibes* is designed specifically to show off the evening shadows falling across a Mediterranean prospect – for this reason, it looks unduly dark in the foreground, when reproduced in black and white. Carle's Bastia is shown with a view to the specific possibilities of engraving in *taille-douce*, and its landscape effects have had to be engineered through a complex technical sequence of operations involving several different agencies. In reproduction, its effect is heavily dependent (as are all prints to a certain degree) on the proportion to which the original is enlarged or diminished in the secondary image, and the extent to which the constituent techniques are correspondingly obscured or revealed.

This being said, one of the different agencies involved in the production of Carle Vernet's print comes clearly into view if we compare the finished work with an early state

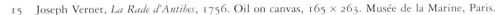

15 Joseph Vernet, *La Rade d'Antibes*, 1756. Oil on canvas, 165 × 263. Musée de la Marine, Paris.

DÉLIVRANCE DE LA CORSE,
le 29 Vendémiaire An 5.

16 Jean Duplessi-Bertaux and others, engraving after drawing by Carle Vernet, *Délivrance de la Corse*, from *Tableaux historiques des campagnes d'Italie*, 1806. 19 × 38.5. Private Collection.

17 Early state of pl. 16. Bibliothèque Nationale, Paris: Département des Estampes.

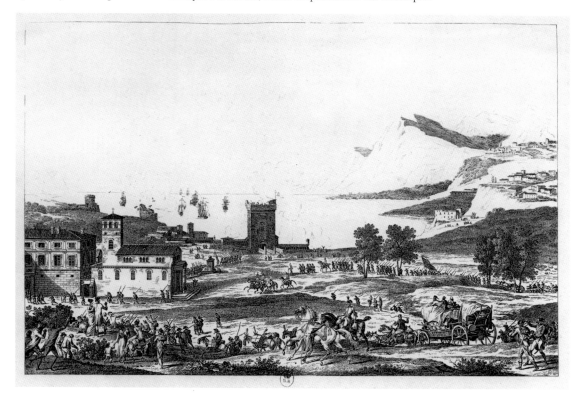

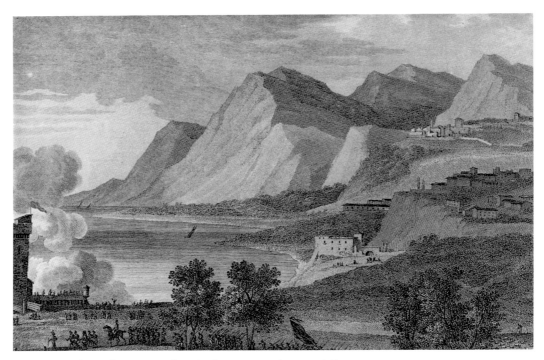

18 Detail of pl. 16: engraving by Claude Niquet and Victor Pillement.

in which the sky and the mountain ranges on the right are left blank (pl. 17). The completed version acknowledges this contribution with a laconic credit on the right of the lower border: 'Terminé par Niquet et Pillement'. Beraldi allows us to locate with some confidence this pair of engravers who performed the last, and most mechanical, stage of fine printmaking by covering these areas with a delicate interlacing of fine parallel lines (pl. 18). Claude Niquet, otherwise known as Niquet l'aîné, usually worked with his younger brother on the different stages in the preparation of the plate, with the latter specialising in the etching process and he himself supplying the 'finish'. Victor Pillement (d.1814) rates a slightly less obscure biography, since he was probably the son of Jean Pillement (1728–1808), a decorative painter based in Lyons who acquired a European reputation for his formulaic *chinoiserie* landscapes and flower studies.[16]

 Such engravers as Niquet and Pillement represented a necessary, but lowly level in the hierarchy of printmaking, and of the visual arts in general, which had its base in the eighteenth century and before. That this distinction was still clearly maintained among printmakers (though perhaps less regarded by those outside their circle) is demonstrated in an interesting letter written by the great Bervic in 1804, the year after his election to the Académie des Beaux-Arts. The burin engraver is undertaking to take charge of the preparation of a plate on the basis of a drawing which he anticipates receiving from a 'colleague' in Rome. (There is no positive indication of who his correspondent might be, but both the date and the character of the undertaking would actually fit with one of the battle engravings of Carle Vernet.) He offers to involve 'Pilment [sic] who would varnish [the plate] and engrave the landscape.' He regards himself as qualified to trace the outline of the drawing as a preliminary to the remaining work. But he regrets: 'What I cannot do is the etching [*eau-forte*] of the figures; I have no experience at all in the area and I

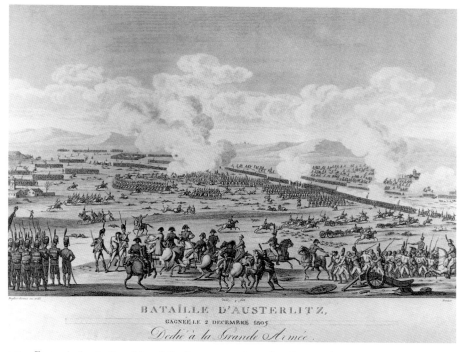

BATAILLE D'AUSTERLITZ,
GAGNÉE LE 2 DÉCEMBRE 1805
Dedié à la Grande Armée

19 François-Louis Couché and Bovinet, engraving after drawing by Jean Duplessi-Bertaux, *Bataille d'Austerlitz, c.*1806. 28 × 40. Private Collection.

would do it very badly. But as I judge that it would be good for the little figures at the bottom to be done in etching, I would be able to engage an engraver called Pocquet who engraves small figures very well by etching.'[17]

For Bervic, who goes on to complain in the letter about his 'lengthy and tedious *métier*', it is inconceivable that a printmaker could be a jack of all engraving trades. He himself is totally committed to a purity of technique and a rigorous selection of subject matter that fulfils the highest traditions of the art: even as early as 1804, it is possible that the great undertaking of the *Laocoon* (finally to appear in 1809) was already monopolising his attention. In this venture he was tackling one of the privileged subjects that had engaged the skills of reproductive engravers from the early Renaissance onwards. Faced with such a challenge, he was more than ever likely to be constrained by what Ivins terms 'The Tyranny of the Rule'.[18]

Whether or not Carle Vernet first addressed himself to a preoccupied Bervic, he was fortunate in eventually obtaining as his main collaborator on the *Tableaux historiques* a most versatile and adaptable figure. Jean Duplessi-Bertaux (1747–1820) takes the central credit in *Délivrance de la Corse* as Carle Vernet's engraver *à l'eau forte*. He appears to have had a colourful career, like Lejeune seeing service in the revolutionary armies before recording their exploits.[19] But his compositional skills were clearly inferior to those of Carle Vernet. His print of the Battle of Austerlitz, where he himself supplied the original drawing, leaving the etching to Couché *fils* and the finishing to Bovinet, suggests hasty production for a market that must in any event have soon become saturated with similar images (pl. 19). Beraldi remarks acidly that, of a thousand prints worked on by Bovinet, not one stood out from the rest.[20] *Bataille d'Austerlitz* seems in any case to have remained in the hands of 'Bance aîné, Md d'Estampes, rue St. Denis' until the

20 Detail of pl. 16.

Restoration, since the legend in the example illustrated has been deftly censored to remove the words that originally flanked the date of the battle: 'Gagnée par le grand Napoléon . . . Anniversaire de son couronnement'.

In *Délivrance de la Corse*, however, much greater care has been taken, not only with the animated figures in Carle Vernet's foreground, but also with the range of tones which indicate the light and shade falling across the extensive landscape (pl. 20). Comparison with the early state shows that Duplessi-Bertaux worked on the fine detail of the figures and the exquisitely drawn buildings in the left foreground before substantially deepening the tonal range of the middle ground with further exposure of the plate to acid (pl. 21). His *Austerlitz* did not have such minute treatment. On the other hand, the role played by poor Bovinet is strictly parallel to that of Niquet and Pillement in the *Corse*. His treatment of the explosions punctuating the battlefield, and the clouds sailing across it, errs by making their masses and textures so similar that the intended effect of perspective is partly compromised.

Duplessi-Bertaux's task in his *Austerlitz* is simply to convey the decisive moment of the Emperor's victory. The broad movement across the plain from left to right illustrates the thrust of the *Grande Armée* in the direction of the heights of Pratzen that succeeded in cutting the Austrians and their Russian allies in two. However, he has also introduced a frieze-like movement from right to left in the foreground, with the Emperor and his staff confronted by a single, humiliated foe, whilst a cavalcade of further captives enters from the left behind a broken gun carriage. These two visual registers present two different levels and possibilities of reading. The first, occupying the whole of the continu-

21 Detail of pl. 16.

ously sloping middle ground, aspires to topographical accuracy with its sparse buildings and denuded trees; its main feature, however, is the detailed registration of the wheeling troupes of cavalry, the serried ranks of infantry and the advancing trains of artillery that make up the French attack. The second, foreground procession, however, invites thoughts about the human relations between victor and vanquished. One hand pressed to his head in despair, and the other raised in supplication to the victorious Napoleon, the privileged captive is cast as a rhetorical figure who requests and receives his mercy. With out-stretched arms, the French officers designate the future recipients of their commander's magnanimity.

Beraldi took pains to point out the oddity of Duplessi-Bertaux's elongated figures, and Adhémar has repeated his claim that this was the result of his extraordinary admiration for the work of the seventeenth-century engraver Jacques Callot, whose *Temptation of Saint Anthony* he was reputed to have drawn at the age of nine.[21] The effect is certainly a little bizarre in such works as his vignettes for the *Tableaux historiques de la Révolution française* (1804). His representation of the suicide of Condorcet, for example, seems all the more incongruous as Levachez's stylish bust in profile surmounts the angular body of the dying man and the gawky reactions of those who discover him (pls 22, 23). But Duplessi-Bertaux was not just trying to be archaistic. On the contrary, one suspects that the attrac-tion of Callot lay precisely in the fact that his mannerist figuration was, so to speak, *hyperdeictic*. Long legs bent and flexed could more vividly convey motion, and long arms signal the various emotions of the soul, in the theatre of great events to which Duplessi-Bertaux was imperatively called.

This is the code also pressed into service for Carle Vernet's *Délivrance de la Corse*. There is the same slightly febrile use of the authorised vocabulary of gesture, as originally used by Poussin and ratified by the French Academy. On a knoll in the left foreground, a gentleman in a frock coat with a hat and pigtail comforts the apprehensive young woman who takes his arm, while raising his right hand in astonishment. Immediately to his right and below him, a seated figure points out the wonder of the scene, whilst his neighbour a little to the right raises his arms in thankfulness. These figures run through the gamut of possible responses to the great event. But there are also the phlegmatic and undemonstrative participants. A countryman mounted on a mule with a nosebag approaches the previous group. He is lethargically smoking a pipe, but his animals are all sporting cockades.

22 Jean Duplessi-Bertaux and Levachez *père et fils*, engraving of the suicide of Condorcet with a portrait bust, from *Tableaux historiques de la Révolution française*, 1804. 18 × 18. Private Collection.

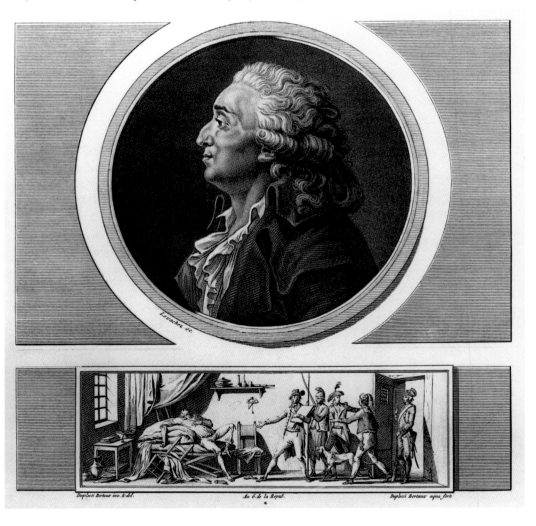

Duplessi Bertaux inv. & del. An 6. de la Repub. Duplessi Bertaux aqua forti

23 Detail of pl. 22.

What then precisely is this event described as the 'Deliverance of Corsica' and dated 29 Vendémiaire An 5? In the absence of an official *Bulletin* to describe it, the editors of the *Tableaux historiques* have appended material from the despatches of Bonaparte's generals to the Directoire in Paris. These record the message, on the 26ᵗʰ of the month: 'We hasten to give you the happy news that the English . . . have evacuated the island.' There follows the rousing account, dated 10 Brumaire An 5, of the exploits of a troupe of *gendarmerie* that supposedly arrived on the island on 26 Vendémiaire:

> Next day, the troupe was joined by a quite considerable number of patriots of the country, and, with this force, it betook itself rapidly to Bastia, where it arrived the 29ᵗʰ in the morning. Master of the heights, and strongly supported by the citizens of the town, it summoned the English, who still held the fort, to give themselves up within an hour. They were three thousand in number; they had in the harbour a few vessels that threatened to bombard the town: but the fear of seeing the passage which led them out to sea cut off hastened their departure; they were throwing themselves in disorder into their vessels when General Casatta attacked them with the forces he had brought together; he succeeded in taking eight to nine hundred prisoners . . .[22]

This is a rather surprising account of the events surrounding the English retreat from Corsica in September 1796. Indeed Horatio Nelson – the commander of the English squadron – reported to his superiors that 'every soldier and other person {were} brought off with perfect good order from the north end of the Town'.[23] There is no gainsaying the point that the evacuation of Bastia was the direct result of a decision taken in London, and Nelson, at any rate, gave no hint of having witnessed the concerted uprising to which the French report gives credence. The English had, in effect, been invited to oversee the government of the island by 'patriots' who were fearful of the ambitions of their earlier governors, the city of Genoa, as well as of the French. But the rise to power of the Corsican General Bonaparte, and his disconcertingly successful Italian campaigns, had soon

24 Detail of pl. 16.

made their strategic position untenable, and reinforced the French commitment to a *Descente en Corse*.[24]

The French version of events, however, determines the course of the action as it is registered in Carle Vernet's design and Duplessi-Bertaux's engraving. The billowing smoke around the town gate and fort on the left represents the explosion of the powder magazines as a result of the bombardment by Nelson's ships lying at anchor in the harbour (pl. 14). The animated foreground is intended to show a point of juncture between an advancing column of French *gendarmerie* and a representative sample of the Corsican population, anxious to see the backs of the English (pl. 24). Vernet has set up the scene accordingly, but with more than an eye to the kind of picturesque landscape panorama in which his father had so excelled. He has not been able to resist positioning in the very middle of the foreground what might be called his trademark, a black horse and a white horse played off against one another in contrasting attitudes – one wild and the other docile – whilst the motley cavalcade of liberation passes-by.

* * *

Délivrance de la Corse was not by any means Carle Vernet's most admired print of the series. Beraldi singled out for praise his depictions of the ceremonial entry of the French troops into Milan and Venice. Charles Blanc mentioned the picturesque qualities of the

Battle of Millesimo, and the Crossing of the Po by Piacenza, but in any case saw the whole enterprise as a dress rehearsal for a large oil painting showing Bonaparte's hard-fought victory over the Austrians at Marengo in June 1800.[25] Yet, for our purposes, the record of the English disengagement from Corsica is worth studying precisely because of the intrinsic difficulty of the subject, and the instability of the different generic components. Vernet and his engravers had to compensate for the lack of any very precise anecdotal material to flesh out the over-enthusiastic hearsay report of the French authorities across the water in Livorno. They had to show incoming fire from Nelson's ships, met by a cross-section of the newly converted Corsican population expressing the whole range of suitable emotions. It is not surprising if the viewer becomes confused by the intricate scenario of the foreground and simply enjoys the landscape prospect. Beraldi remarked of the whole series: 'Vernet has evidently decided to characterise battles by the aspect of the places where they were fought.'[26] The fact that no battle had actually been fought at Bastia made the topographic focus all the more perceptible.

However, a second reason for looking closely at this print is that it shows, like all the others in the series, the diversity of the skills and talents involved in creating a landscape effect through the medium of traditional engraving. Carle Vernet, for his part, was expert in none of the contributory engraving techniques, but he would certainly have been familiar with the fine reproductions of his father's landscapes by eighteenth-century printmakers such as Jeanna Francesca Ozanne, who employed a similar range of techniques for the rendering of aerial perspective. In these early days of the Empire, when there was a thirst for images to convey the scenic background of the Emperor's victories, he would have recognised the necessity for different types of craftsmen to be enlisted to contribute their specific skills. Even if he was a little disconcerted with Duplessi-Bertaux's tendency to turn almost every human figure into a matchstick manikin, he would have seen the benefit of a skill that permitted the acid to bite deep and create a broad chiaroscuro.

Yet it must be stressed once again that the printmaking milieu mobilised by the editors of the *Tableaux* was not representative of the highest contemporary standards, or what were so regarded. Bervic, so eager to point out to his colleague his total unfamiliarity with the techniques of etching, maintained a lonely vigil on behalf of burin engraving throughout the period of the Revolution and Empire. Himself a pupil of Diderot's friend Wille, he had been allocated a lodging in the Louvre in 1787 and was elected to the Académie des Beaux-Arts in 1803. In 1819, three years before his death, he received a special decoration for having 'reanimated by the superiority of [his] works the taste for the study of engraving'. However, as has been mentioned already, his total oeuvre over these years consisted of just nineteen plates.[27] During the new century, as has been already noted, he was at work essentially on just one major engraving, his study of the *Laocoon* after a drawing by Bouillon, which was finally published in 1809 (pl. 25). With its resonant dark ground and its prodigious effect of sculptural relief, this work undoubtedly comes across as a technical tour de force. In the light of this uncanny simulation of the carved marble surfaces emerging from the gloomy niche, it becomes hard to accept Ivins's strictures about the arbitrary syntax of traditional burin engraving. But one may still wonder whether Bervic's real achievement in this – the last of his major works – has not been to create an allegory for the extreme exertions of his own struggle with the medium.

Bervic

25 Charles-Clément Balvay (known as Bervic), engraving (1809) after drawing by Pierre Bouillon of *Laocoon* (Vatican Museum, Rome). 34 × 28. Bibliothèque Nationale, Paris: Département des Estampes.

MICHEL DE MONTAIGNE.

Cocaskis pinx. *1818* *Alex.ᵈ Tardieu Sculp.*

26 Alexandre Tardieu,
engraving of Montaigne
after 'Cocaskis', 1818.
14 × 9.

The career of Alexandre Tardieu, who succeeded Bervic in his seat at the Academy in 1822 and was regarded with almost equal veneration, was significantly more eclectic. Tardieu indeed epitomised, through the rise of his family, the growth and ramifications of the craft of engraving over the early modern period in France.[28] He could trace his line back to Nicolas Tardieu, a Parisian coppersmith of the seventeenth century whose descendants had advanced into specialised areas like the engraving of maps as well as the more academic domain of portraits and history paintings. His nephew, Ambroise Tardieu (1788–1841), provided the extensive maps for the Atlas accompanying Augustin Thierry's *Histoire de la Conquête de l'Angleterre par les Normands* (1839 illustrated edition), as well as the technical plates for Perrot's *Manuel du graveur* (1830). Alexandre himself specialised in portraiture after old masters and contemporaries: his damaged engraving after David's lost *Lepelletier de Saint-Fargeau* (1793) is a powerful evocation of this mythic revolutionary work. During the Restoration he adapted himself to the historicising trends of early Romanticism, providing a bust of Montaigne after a mysterious 'Cocaskis' for the 1818 edition of the *Essais* (pl. 26). Despite the ill health of which he complained when declining service in the *Garde Nationale* in 1815,[29] he also found time and energy to produce a final classic example of reproductive engraving, after Domenichino's *Communion of Saint Jerome*, which was shown at the Salon of 1822. In looking back on his career from the end of the century, Beraldi uses the example of Tardieu to take to task the modern prejudice that devalues the reproductive engraving in comparison with the 'artist's' print. His distinction between the two is worth quoting: 'There is nothing in common between the reproductive engraving, which is the true *engraving* (engraving is *cutting* [*la taille*]), and the original engraving, which is properly speaking a particular mode of *drawing* and should be considered as an annex of painting . . . one must know how to appreciate both of them.'[30]

The issues raised by the work of these two reproductive engravers, whom Beraldi saw as having jointly contributed to 'assuring the permanence of our art of the burin, and taking it across the perilous pass of the revolutionary period',[31] will be raised again here in the chapters dealing with their successors in that domain: Calamatta, Mercuri and Henriquel-Dupont, whose engraving after a drawing by Ingres of Alexandre Tardieu (first published the year after his death in 1845) is a suitable tribute to his independence and his longevity (pl. 27). But the particular point about the 'artist's', or 'original', print – and its kinship with drawing – concerns us immediately, as it applies with even more force to the major technical innovation which transforms the popular side of printmaking in the second quarter of the century, and offers unprecedented oppor-tunities to the painter. With the new art of lithography, it is no longer necessary for a painter like Carle Vernet to have his sketches processed through the grille of diverse engraving techniques in order to create a multiple edition. The technique offers itself, in an almost unmedi-ated fashion, as a vehicle for rapid, spontaneous drawing with the crayon, and produces an almost equally swift result, compared with the long haul of burin engraving.

It is generally agreed that the lithographic process was invented by the German Aloys Senefelder in 1798, making use of the special type of close-grained stone that could only be found in Bavaria. Its surge in popularity, in France as in other European countries, came only in the 1820s, and the peak of its renown in France is associated with the years of the July Monarchy, between 1830 and 1848, when artists like Gavarni and Daumier success-fully exploited its suitability for caricature and political satire. My concern in this chapter, however, is to examine first of all the origins of lithography in France in the opening years of the Restoration. It will be seen that one major development brought about by lithog-raphy was a revolution in the treatment of themes relating to the wars of the previous decades, and this affected not only established artists like Carle and Horace Vernet, but also a young practitioner like Charlet, whose unique career would have been unthinkable if the new medium had not been available to him. Lithography not only indicates how this new technique of printmaking feeds into the parallel development of battle painting, but also, in Charlet's case, discloses the very medium itself as a bearer of fantasy.

The series of campaigns on which Bonaparte embarked as First Consul and later Emperor was not conducive to the free exchange of artistic techniques. Nevertheless, the artist and general Louis-François Lejeune is reported to have sketched a Cossack in Senefelder's studio while passing through Munich in 1806, and to have vainly attempted to attract the emperor's attention to the new medium. In 1809, the director of the Louvre, Dominique-Vivant Denon, also visited the studio and briefly experimented with the technique. But no progress was made in establishing studios in Paris until comte Charles de Lasteyrie, the brother-in-law of the American revolutionary hero Lafayette, took the trouble to visit Sene-felder and familiarise himself thoroughly with the necessary materials and processes.[32]

A rival claim was later made by the lithographer Engelmann to have arrived in Paris before Lasteyrie's plans were complete, and the competition does indeed seem to have been close. Lasteyrie opened his *atelier* at 54 rue du Four-Saint-German on 15 April 1816, whilst Engelmann was established in the nearby rue Cassette by the end of June 1816. However, it would be misleading to imply that this was an ill-tempered rivalry. Lasteyrie at any rate showed his liberal inclinations when he refused to apply for an exclusive fifteen-year licence to practise lithography, which would have covered the whole of France.

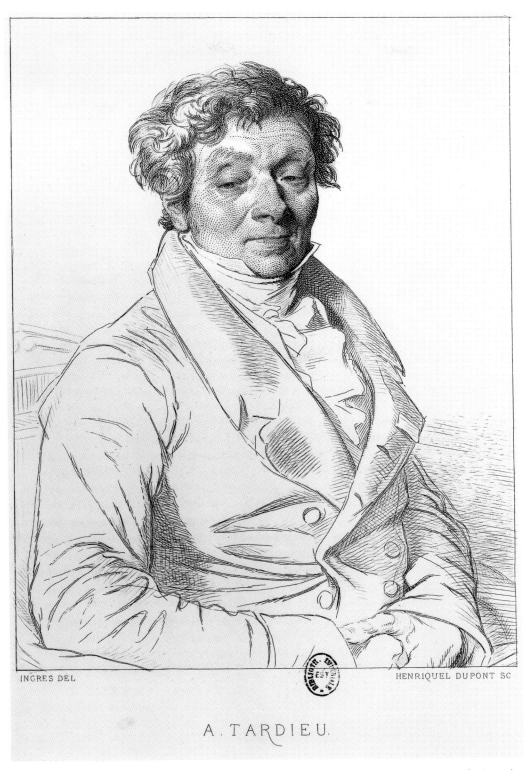

INGRES DEL HENRIQUEL DUPONT SC

A. TARDIEU.

27 Louis Henriquel-Dupont, engraving (1863) after drawing by Jean-Dominique Ingres of Alexandre Tardieu, 1845. 26 × 17. Bibliothèque Nationale, Paris: Département des Estampes.

He believed that 'the exercise of a new art had to be free, that without that progress would be slow and difficult, and he had no wish to deprive his country of the immense benefits produced by competition'.[33] As will be seen, artists attracted by the possibilities of lithography seem not to have invariably cultivated a single publisher, but to have done the rounds of the *ateliers*.

From the start, lithography attracted the most senior and prestigious of French painters. Engelmann presented his first *tirages* to the Academy in 1816. Pierre-Narcisse Guérin worked with him briefly, having been nominated a member of the commission set up by the Academy to investigate the technique. But his fastidious neoclassical style did not translate effectively to the crayon.[34] It was towards the end of 1816 that Horace Vernet completed his first lithograph, in an edition of around eleven copies distributed to friends, after a drawing of Mme Perregaux dated 24 November.[35] His father cannot have been far behind, as both contributed plates to an 'Album lithographique', which was exhibited in the second Salon of the Restoration, opening in April 1817.[36] As Amédée Durande remarked, in a disparaging way that points up its suitability nonetheless, the technique could have been made for him:

> This type of work was best suited to his lazy nature; in this way he could make use without trouble of the impulsive qualities of his spirit and improvise in putting on charming scenes that required of him none of the persistence and care that would have been required by the thousand and one details of painting. Moreover he was no colourist, and the greyish tint of the stone did not shock his eyes. He had therefore every interest in utilising a process that left him with his good qualities, while taking away the most obvious of his faults.[37]

Given this judgement, there is a special resonance to be found in Carle Vernet's *La Tempête, d'après Joseph Vernet*, published around 1817 by Chabert in the rue Cassette. Carle has taken one of the most characteristic of the shipwreck compositions of his father's early years in Rome – quite possibly the work now in the collection of the Louvre (pl. 28) – as his model. However, it seems as if he has worked out free variations on the original composition in the very process of drawing with the crayon (pl. 29). If it is indeed the Louvre composition which is the base, he has not bothered to correct for the right-left reversal produced by the printing operation. He has placed his mass of craggy cliff, with its clinging trees, on what turns out to be the left, and moved the despairing figures and storm-tossed ships accordingly. What he seems to have enjoyed enormously, in this playful experiment with a paternal prototype, is the creation of lightning, wind and rain through the strokes, shadings and soft rubbings coaxed from his instrument.

This little work is a poignant reminder of Carle's relationship to his illustrious father (and it can be noted that the copy illustrated here belonged to the collection of prints in the possession of his family, which was handed down to their Delaroche-Vernet descendants). However, it was his spirited re-entry into the genre of battle painting that secured his reputation as a lithographer. Baron Gros, another of the leading academic painters to be attracted by the medium, progressed a long way beyond Guérin in his charmingly exotic *Arabe du désert* (pl. 30), one of two lithographs published for him by Lasteyrie in 1817. But where Gros relied on the piquant anecdotal detail of the Arab mare providing milk to its oriental attendants, Vernet was content to revel in the vivid sense of move-

28 Joseph Vernet, *La Tempête*, c.1750. Oil on canvas, 78 × 156. Musée du Louvre, Paris.

carle Vernet, d'apres Joseph Vernet

29 Carle Vernet, lithograph (*c.*1817) after Joseph Vernet, *La Tempête*, c.1750. 20 × 33.2.

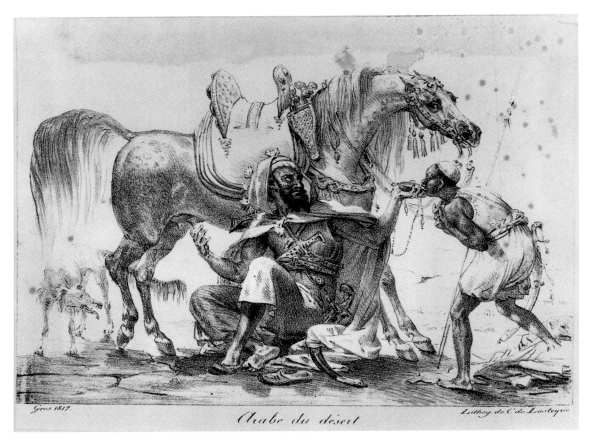

30 Antoine Gros, *Arabe du désert*, 1817. Lithograph, 20.5 × 27.5. Bibliothèque municipale, Nantes.

ment that he could give to scenes indirectly reminiscent of the battle paintings of the Napoleonic period.

His *Hussard sabrant en sautant par dessus un affût* (Hussar with drawn sabre jumping over a gun carriage), published by Engelmann in 1817, comes across as a sharply observed close-up, in which even the subsidiary figures moving in different directions are fluently interconnected (pl. 31). As Duplessi-Bertaux's *Austerlitz* indicates, the broken gun carriage is a *topos* of the battle scene. But Vernet's bright idea of showing the hussar jumping over the obstacle gives an accentuated onrush to the left ward movement in the very process of impeding it; one should note also that his companion-in-arms to the right rides a charger that rears up in excitement or fright to balance this accelerating exit. The framed image is complete in itself as an amalgam of dynamic tensions. But, of course, it allows us to figure out next to nothing of the overall context in which the battle is set. For the first time, no doubt, through lithographs of this kind, war is communicated via the powerful synecdoche of the detached, instantaneous frame.

It is important to remember, however, that lithography did not become an overnight sensation. That is to say, it was necessary for the possibilities of the new medium to be subjected to a process of experiment and review before the path of its future development could become apparent. Indeed there is a close parallel here with Daguerre's invention of the daguerreotype, and its public reception after 1839. In both cases the academic author-

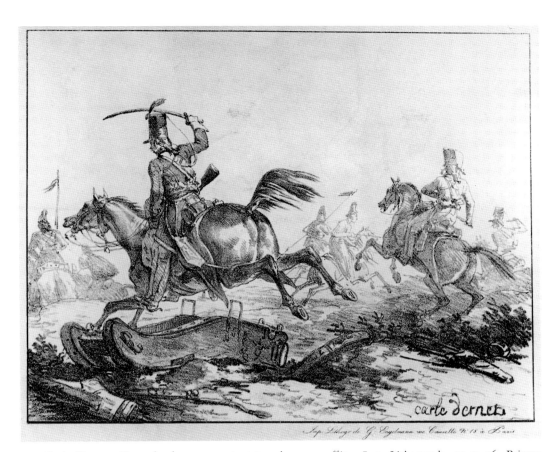

31 Carle Vernet, *Hussard sabrant en sautant par dessus un affût*, 1817. Lithograph, 21 × 26. Private Collection.

ities took a keen interest in the new phenomenon. As we have seen, Guérin's commission was set up to consider its utility, and artists of the stature of Gros and Guérin himself tried their hands with lithographic crayon. The young Horace Vernet made his first lithograph at the exceptionally early date of October 1816, just as, twenty-three years later, he was to take a role in publicising the possibilities of the daguerreotype, and set sail for the Middle East before the year of 1839 was out, with photographic equipment in his baggage.

However, one distinctive feature of the way in which lithography developed over the period of the Restoration was its dependence on the network of small-scale *ateliers* established in the area of Saint-Germain-des-Prés in the wake of Lasteyrie and Engelmann. These carried out the task of printing from the precious stones, and their owners were also legally responsible for the content of the images. There exists in the collection of the Bibliothéque Nationale a copy of Charlet's *Mameluck* (originally published in 1819)[38] which bears the date 24 August 1822, with the attestation of the printer Villain that 'this example is in conformity with all those that have been printed up to this time'. The lithographs were marketed, to an increasing extent over the period, by printers who also specialised in publishing like Delpech, and sold through the small print shops that were also often located in the Latin quarter. The shop in the rue Mazarine of Augustin-François Lemaître, to whom Niépce addressed himself for a supply of prints for copying, is a case in point.

It is hardly surprising, given these conditions, that the status of lithography during this early period was difficult to ascertain. The lithographic exercises of well-known painters like Gros, Guérin and the Vernets were indeed shown in the 1817 Salon, under the general heading of engravings ('gravures'). But they attracted no critical comment from Landon's *Annales du Musée*, otherwise very exhaustive in its acknowledgement of the different genres and media on view. In the 1831 Salon, the official *livret* does contain a separate section for lithography, sandwiched between engravings proper and architectural drawings. But, significantly, a number of the entries are placed as they had been in 1817 under the names of lithographic printers like Engelmann and Motte, with the artists themselves only featured in small type. Delpech's entries, for example, make no specific mention of the lithographic artists involved. Two of them feature 'portraits extracted' from large biographical dictionaries, the *Iconographie des contemporains* and the *Iconographie française*. The third reads simply: 'Lithographies, d'après MM. Ingres, Lawrence et Mme Lebrun'.[39]

Such a laconic entry masks one of the minor problems in Ingres studies, namely the issue of whether he himself was the artist of the lithograph of the *Odalisque* published by Delpech, which simply bears the inscription 'Ingres 1825' (pl. 32). Georges Vigne is of the view that, in any case, this work is by the same artist as another lithograph after Ingres published by Engelmann in the same year.[40] This artist may or may not be Ingres himself. But the confusion suggests, at the very least, that the different roles of the agencies concerned in producing the print – so painstakingly registered in the case of the traditional engraving – were in this case not thought to be of very great moment. It suggests that, to a certain degree, the lithographic process evaded the legal and conceptual issues of authorship.

Yet, if in this respect lithography anticipated photography in shading off into a nebulous zone of production where authorship was not an issue, it also lent itself at the same time to the creation of a new mythology of the inspired artist that was fully consistent with the ideology of the Romantic movement. Precisely because the lithographer was held to work spontaneously, in a fever of creation, he belonged in a very different category from the laborious burin engraver. Whilst the latter toiled for years over the unforgiving copper plate, the former could expect to see his ideas take wing almost before his eyes. We can observe this myth taking shape, during the first decades of lithography, in connection with the fascinating figure of Nicolas-Toussaint Charlet (1792–1845). Indeed Delacroix's essay on his work, though published in the *Revue des deux mondes* as late as 1862, is an extraordinary exercise in retrospection. It is as if, in the year before his own death, the supreme Romantic painter were conjuring up the archetypal example of creation unfettered by the lowly requirements of technique. This retrospective view is, however, not unfaithful to the image that Charlet acquired in his own time. If we examine a series of his early works, and mark the transition to his sole important achievement as a battle painter, we gain a striking impression of the interaction between the development of artistic techniques and the changing character of historical imagery in post-revolutionary French society.

Charlet came from a modest social background. His father, who served as a dragoon in the army of the Revolution, died in action, leaving his family penniless, and he was brought up by a long-suffering mother who hero-worshipped the emperor.[41] In 1817 he

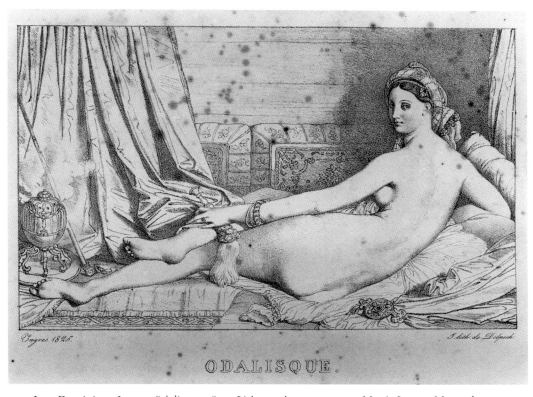

32 Jean-Dominique Ingres, *Odalisque*, 1825. Lithograph, 32.7 × 49.7. Musée Ingres, Montauban.

entered the studio of Gros, and features in Louis-Léopold Boilly's sketch of his students in 1820 as a tousle-headed young man fixing the spectator's eye from under his heavy brow.[42] Gros seems to have treated him with a certain indulgence, and it was presumably through Gros that he gained an introduction to Charles de Lasteyrie early in 1817. For the next few months he must have virtually lived in the *atelier*, learning the use of the lithographic crayon and starting to generate an inexhaustible flood of images from his imaginary world.

First of the group in La Combe's catalogue entry on 'Costumes militaires', and dated 16 June 1817, is the print bearing the title *Recrue à l'exercice* (pl. 33).[43] The young recruit has a uniform that is several sizes too small for him, an incongruously perched 'bonnet de police', and a handkerchief binding his right knee. Behind him, facing in different directions as if to suggest that the drill is proceeding a little anarchically, are a shaven-headed, and possibly bare-footed, comrade with an even more rakishly arranged bonnet, and a pipe-smoking veteran missing an arm and a leg whose face holds no more animation than a skull. The scene reverts, we may imagine, to the last days of the Empire, when the final emergency of Napoleon's reign called out younger and younger recruits to face the threat of invasion. But it also pinpoints Charlet's personal investment in these recent events. He had himself inherited from his father, as he later recounted, nothing but some skin breeches, war-stained boots and an unpaid laundry bill.[44] Just too young

33 (*right*) Nicolas-Toussaint Charlet, *Recrue à l'exercice*, 1817. Lithograph, 32 × 22. Private Collection.

34 (*facing page*) Nicolas-Toussaint Charlet, *Déroute des Cosaques*, 1817. Lithograph, 24.5 × 34.5. Private Collection.

himself to serve in the imperial army, he had rallied to the flag in 1814, when the Allies threatened Paris, and served (like Horace Vernet) under Marshal Moncey in the last delaying engagement by the Barrière de Clichy. The downcast face of the handsome young recruit with a Napoleonic physiognomy surely dramatises his sense of a subjectivity estranged from action, but obsessively concerned with the *image* of military glory. Charlet will build up his repertoire from the very pathos engendered by the unanswerable challenge of the past.

In a sense, the very process of lithography seems to have provided a form of physical compensation for him. Delacroix recalls how he was continuously at work, 'less to augment his modest resources than to obey the imperious requirement to produce'. His spontaneity in execution was matched by a capacity for instant self-criticism that drove him to interrupt and recommence his designs. 'He often became disgusted with a work that he had begun, and was mistaken about the value of what he had thrown onto stone or paper.'[45] But Delacroix's observations clarify the reasons why lithography and draughtsmanship provided a satisfactory working-out process that painting, by contrast, failed to offer. In the former practices, he could and did destroy an image, and 'begin his drawing again on

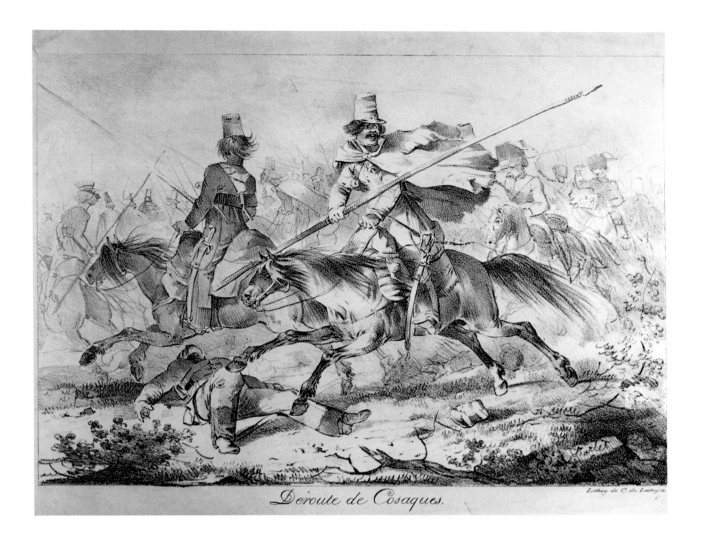

Déroute de Cosaques.

Lithog. de C. de Lasteyrie.

a different stone', giving rise to innumerable new starts and variations. In painting, however, the comparative ease with which mistakes could be corrected, by scraping or over painting with the brush, made it 'more difficult for him to satisfy himself'.

The picture emerges of a psychological and even therapeutic engagement with the medium that must have made the young Charlet a spectacle to be observed. Lasteyrie must have been astonished at the whirlwind produced by the demands of the new technique, and all his indulgence must have been needed to sit it out. *Déroute de cosaques*, published by him around September 1817, shows Charlet manipulating a complex scene of battle, rather than a simple combination of figures (pl. 34). It seems likely that he was acquainted with Carle Vernet's *Hussar* lithograph, since the general composition and, in particular, the drawing of the left-hand horse and rider, are strongly reminiscent of it. But Charlet's imaginary episode from the Russian campaign is nonetheless quite different in its concept, as well as in its pictorial mechanics. These exotic, long-haired cavalry men with their preposterous lances are in full retreat, dashing away from a French attacking force that can be glimpsed in the right background. Instead of the gun carriage, Charlet has slipped in the foreshortened body of a soldier, whose placing between the

35 Nicolas-Toussaint Charlet, *Mendiants*, 1819. Lithograph, 12.2 × 16.5. Private Collection.

hooves of the fleeing animals creates an accentuated impression of menace. It is probably from Carle Vernet that Charlet has learned to sketch in the terrain with vigorous shading effects, and broad scooping marks to indicate foliage. But while Carle Vernet achieves a documentary effect, Charlet works on the edge of caricature. It is as if the representation had to be virtually parodic in order to accord with the intensity of the mental image.

It was with Lasteyrie that Charlet produced what appears to have been his most commercially successful lithograph, in March 1818. This was the fiercely patriotic *Grenadier de Waterloo*, which is rare in the first state since the lithographic stone was broken, and the composition was redrawn, with a small variant in the position of the aggressive British officer's sword. In the following year, however, Charlet was exploring more traditional and tranquil themes, in a smaller format that possibly reflected the commercial prudence of his new printer and publisher, Delpech. Proofed from the same stone, and probably dated 1819, are the two studies *Mendiants* (pl. 35) and *Les Deux compagnons* (pl. 36). The first uses Charlet's sentimental resource of the juxtaposition of artless youth and brooding old age to create a delicate genre study that recalls Le Nain. The second, however, incomparably deepens the effect by showing the sleeping boy in company with the old soldier whose grim, moustachioed profile stands out against a far-off landscape. It is characteristic of Charlet that, in both, a scene of instruction is used to dramatise the unbridgeable gap between the innocence of the child and the bitter memories of adulthood.

36 Nicolas-Toussaint Charlet, *Les Deux compagnons*, 1819. Lithograph, 12.2 × 16.5. Private Collection.

Also from 1819, and under the auspices of Delpech, comes the large lithograph *Infanterie légère montant à l'assaut*, which must be one of his outstanding achievements, and a true tour de force for someone who had not yet left the master's studio (pl. 37). Charlet has configured the scene in such a way that the right foreground provides a 'witness' figure in the true Albertian tradition: in the words of La Combe's catalogue, 'a surgeon dresses the leg of a sergeant who looks at his comrades and regrets not being able to follow them'.[46] Beyond this knot of foreground figures, all attentive to the drama of the assault, the column of light infantry is breaking through the palisades and scrambling up the steep escarpment to reach the enemy ramparts. Both the group around the sergeant and the vigorously handled, dark-toned stretch of ground that projects along the lower edge serve as a *repoussoir* to set off the soft grey mass of the advancing troops. Charlet has however managed to endow even the lightest crayon strokes, in this impenetrable mêlée, with definition and purpose. The arduous upward movement, ending with a final heave up on to the white rocks, is fully and finely indicated.

Besides providing an illustration of the fact that Charlet works best when he can, so to speak, see himself seeing the action, this lithograph also brings to mind the telling way in which Delacroix characterises his feeling for the medium. Charlet attacked the stone, he implies, in just such a way as to elicit the varied and eloquent figuration that we see in this case:

Before this entirely white stone, on which he traced just a few points in order to get his bearings, it often happened that he began his drawing by a head or any other part,

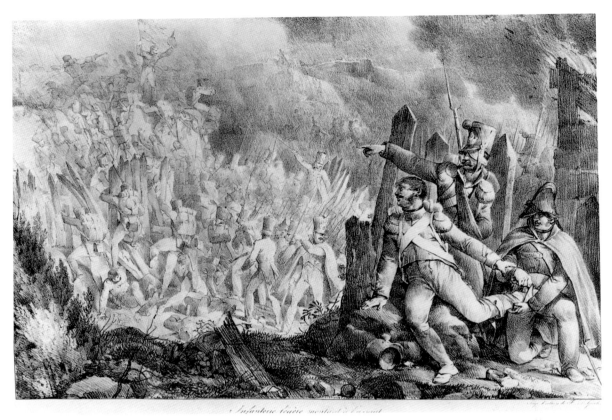

37 Nicolas-Toussaint Charlet, *Infanterie légère montant à l'assaut*, 1819. Lithograph, 34.5 × 49. Private Collection.

which he completed almost without going back on it. Character, movement seemed to come to him by themselves, and he caught them with as much assurance as if he had been rendering a model posed in front of him . . .[47]

Delacroix goes on to explain how he did, in fact, use models. But these were the people whom he had met in the ordinary circumstances of his life – 'his invalid soldier, his cuirassier or his hussar' whom he had searched out, sat down with at table, and not abandoned until he 'surprised in their confidences and on their faces everything necessary to give life to his drawing'.[48] It is hardly to be wondered at that Delacroix, whose own tentative engagements with lithography in 1819 show a distinct leaning towards costume and the exotic, should have preserved a lasting memory of the uniqueness of Charlet's method.[49] Nor is it odd that Géricault should have chosen as his companion on his English trip of April 1820 what the oddly named journal, *Le Conservateur littéraire*, described as 'a young draughtsman, known for a prodigious number of military sketches'.[50]

For the older Delacroix of 1862 – the year before his death – Charlet could serve, at least in retrospect, as an unrivalled example of spontaneous artistic production. Lithography had offered him the perfect means to develop his astonishing talent, offering as

it did the vast possibilities as well as the perils of rapid, easy execution. Commercial considerations took second place with Charlet to the demands of his own impetuous character, as when (so Delacroix tells us) without warning he scraped clean all the twelve stones of his *Vieille Armée française*, incidentally creating future rarities out of the existing proofs. But Delacroix does not simply salute him as a prodigy who had happened upon the ideal technique. In the last resort, he values him as a satirist who has delivered exceptional insights into the human condition, in the distinctively French – though not primarily visual – tradition of Molière and La Fontaine. He is 'in the lineage of those immortal scoffers who attack ridicule and vice more effectively than those who preach virtue'.[51]

At the time, Delacroix was perhaps not so convinced of Charlet's lasting achievement. There is a telling entry in his journal for 31 March 1824 which records a criticism by a third party: 'Dufresne said about Charlet that he was not sufficiently simple in his way of working: that he makes you feel his cleverness and his processes. Something to think about.'[52] The comment that struck Delacroix was, of course, delivered several years after the pioneering works that have been discussed up to now, and does not necessarily apply to them. But it is important to look closely at its implications, and at the unresolved tension in Charlet's method that the older Delacroix does not mention. This could be expressed in the following series of questions. How is a printmaker committed to originality able to sustain both sales and reputation over an entire career? How, if at all, will he compete on equal terms for public favour and academic esteem with painters, and indeed printmakers, who are more firmly placed within the system? In simple terms, what can he aim for? One can safely assume, after all, that he is not aiming to be the equal of La Fontaine and Molière.

The first, and most prosaic, answer to these questions is that Charlet quickly graduated from one-off experiments to collections of prints, with generic titles like *Costumes militaires* and the aborted *Vieille Armée française*. By the mid-1820s, he was combining quite eclectic subjects – satires on contemporary French manners with recollections of the imperial war machine – in collections titled *Fantaisies* or simply *Album lithographique*. By 1835, the need for unity within such a collection was being met by a governing concept such as *Alphabet moral et philosophique à l'usage des petits et des grands enfants*; each plate had a title, from A to Z, and a short caption to explain it further.

It is not surprising that Charlet learned to work within these particular constraints. In the next generation, Daumier and Gavarni were similarly placed, although a more enterprising and politically committed popular press gave them greater opportunities to make their mark. But Dufresne's comment does not apply solely to this aspect of Charlet's mode of production. What he hints at can be discerned in the pictorial mechanics of the lithographs themselves, strikingly new in 1817/19, but inevitably beginning to lose their novelty five years later. It is interesting to compare the print previously discussed, *Infanterie légère montant à l'assaut*, with *Marche de troupes françaises dans les Pyrénnées*, from the album of 1826 (pl. 38). Much smaller in format, the latter still gains much of its effect from the achieved equation between the formidable mass of the mountain in the background and the inherent disposition of the lithographic stone that Charlet has skilfully cultivated. In particular he has managed, simply through leaving parts of the stone blank and complementing them with light shading, to convey a tonal range no less effective

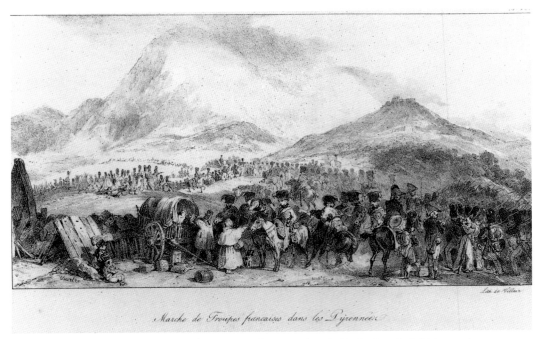

Marche de Troupes françaises dans les Pyrennées

38 Nicolas-Toussaint Charlet, *Marche des troupes françaises dans les Pyrénnées*, 1826. Lithograph, 12.5 × 23. Private Collection.

than the sedulously ruled lines of Niquet and Pillement. But this comparison with the classically composed *Délivrance de la Corse* also brings out the fact that Charlet cannot draw on the dark tones of etching to give solidity to his foreground and middle ground. He has, simply, the resources of his crayon. He has therefore bridged the intervening space between the mountains and the immediate foreground with the structural device of an interminable, winding procession, which becomes no more than a broken line as the column approaches the foothills. The published description, relieved of the burden of any *bulletin* or official account to follow, is as charmingly vague as the scene itself: 'To left and right, high mountains; numerous troops armed in all sorts of ways. In the middle of the print, hussars have stopped by the cart of a field kitchen and are having drinks served by the *cantinière*.'

Charlet's lithographs, even when they display their processes as obviously as this example, testify to a new print aesthetic which would rapidly displace the traditional, collaborative practices of engraving. At the same time, they help to make it clear why Charlet himself was not wholly content with being a lithographer. His highly partisan biographer, La Combe, relates that, in 1828, he tried to learn etching, but was 'not patient enough to surmount the difficulties' involved in learning the technique. His proofs showed that the acid had either 'bitten too much or not bitten enough'.[53] He could not modulate the tonal range as finely as he had learned to do in lithography. For a parallel reason, as La Combe suggests, the prints made by other printmakers after his drawings were almost always destined to be failures. 'Charlet proceeds by fine and delicate touches, and the spirit of his figures, the originality of his manner, can be captured only by a trained eye.'[54] Even

the renowned English printmaker, S. W. Reynolds – the earliest author of engravings after Delaroche – could not (in La Combe's view) rise to the opportunity.

Yet there is no doubt at all that Charlet aspired to succeed at the most prestigious of all media of visual art, the Salon painting. It is probable that, right from the beginning of his career as a trainee lithographer and, at the same time, a student with Gros, he produced oil sketches as an activity directly parallel to his printmaking. Most of these indeed turn out to be direct transcriptions from a known lithograph into a coloured image of similar size. But, by the early 1830s, his aim becomes more ambitious. *Episode de la campagne de Russie* (c.1835: Musée Denon, Chalon-sur-Saône) is much amplified from the original lithograph in his *Alphabet* collection of 1835, and although essentially monochrome, its painterly treatment of the snowy wastes of Russia under an ominous yellow sky shows considerable skill. The caption for the lithograph fills in specific detail, while making clear at the same time the system that Charlet has followed: 'In the background, column of troops above which we see a cloud of crows hovering. In the foreground, several soldiers among whom a grenadier of the Guard, covered with furs, has managed, in spite of his misery, to keep his rifle.'[55]

This small work, however, has inevitably been drawn into the gravitational field of Charlet's most ambitious, and successful, painting, exhibited at the Salon of 1836 under the same title. The Chalon work has sometimes been described as a sketch for the larger one. However, in this case, the common title is probably confusing. Admittedly the lithograph of 1835, which apart from the change of medium is identical to the Chalon version, was originally titled *Episode de la retraite de Russie*, and *Retraite de Russie* is also the short title used by such critics as Alfred de Musset and Delacroix in discussing the Salon work. But it seems safe to conclude that, given Charlet's previous practice of reinterpreting his lithographs in paint, the Chalon version (wherever sited chronologically in relation to the Salon painting) is no more than an enlarged print. The large *Episode de la campagne de Russie* (Musée des Beaux-Arts, Lyons), by contrast, is an undertaking on a much larger scale and with quite different intentions (pl. 39).

It is relevant to note, in connection with this confusing duplication of titles, that the previous Salon of 1833 had included a work dated 1832 by Edouard-Alexandre Odier (1800–1887), which now bears on its frame the title *Episode de la retraite de Russie (1812) – Dragon de la Garde Impériale* (Musée des Beaux-Arts, Amiens). Odier, who was a friend of Delaroche and would accompany him on his first visit to Italy in 1834, has produced a study of a single wounded dragoon, with his stricken horse, that owes much to Géricault's *Wounded cuirassier* (1814, Louvre), though he does also incorporate a sketchy convoy of troops in the background. The fact that an engraving after this painting by Vogel bears the simple title 'Un dragon de la garde (Russie 1812)' indicates that Odier's original work acquired its more specific title retrospectively, perhaps as a consequence of the sensation created by Charlet's painting in the Salon of 1836.[56] But, even so, it is fair to assume that a work like Odier's might have stirred Charlet to action. This was the territory that his lithographic work had covered for fifteen years, and the increasing gap between the contemporary world of the July Monarchy and the last, heroic years of the Empire offered a theme of undiminishing potential.

In his 1836 painting, Charlet has undoubtedly drawn on subject matter and compositional techniques that were used in his lithographs. Even the little *Marche de troupes*

39 Nicolas-Toussaint Charlet, *Episode de la campagne de Russie*, 1836 Salon. Oil on canvas, 195 × 295. Musée des Beaux-Arts, Lyons.

françaises seems relevant, if we take note of the sinuous winding columns and the supply cart – wrecked and covered with snow in the painting. In a more subtle way, one might say that he has transposed into the appropriate language of oil paint the technical felic-ities that lithography allowed him to exploit with much greater ease. The range of colours is not as depleted as in the Chalon version. Nevertheless, the lowering sky covers more than half the area of the painting, and a swathe of territory cutting from the left to the middle foreground is covered with snow. It is precisely this sense of snow covering with a thin crust the miscellaneous wreckage – human and mechanical – of the *Grande Armée* that must have gripped the imagination of spectators. Musset, indeed, sums up the effect in a graphic sentence: 'The crows hover above the snow, full of human forms.'[57] Charlet's experience of the lithographic stone, and his practice in using the undrawn areas to signify distance as well as projecting fantasy, must have helped him to animate this snowy surface, replete with its frozen corpses.

It is worth mentioning that the painting was praised for what might be called its his-toriographical revisionism, as well as for the pathos of its human detail. Charlet's master, Gros, had shown in his *Battle of Eylau* (1808) the corpses lying in the snow, with drops of blood frozen to the tips of the bayonets. But he had, of course, offset the sinister spec-tacle with the figure of the magnanimous emperor, riding across the scene of victory. Charlet, in the words of the anonymous critic of *L'Artiste*, presents the truth 'in all its crudity, with all its horrors, and we understand the sombre fatefulness of the Russian campaign better than in the doleful account of M. de Ségur'.[58] As late as 1877, the Lyons

museum catalogue sums up in a succinct paragraph the extent to which Charlet's work functions as a protest against the intelligibility of battle painting, though it is not without its own, perhaps consequential sub-plot:

> In this crowd of unfortunates lacking in everything, the ranks are confused. Generals, officers and soldiers, for the most part unarmed, can hardly be distinguished by the remains of uniforms in shreds. In the foreground, a Jew is struck by a gun shot at the moment when he was robbing an abandoned chest containing gold intended for the pay of the troops. You make out here and there in the countryside the debris of gun carriages and corpses that the snow covers while preserving their form.[59]

The detail about the pillaging 'Jew' is not to be found in Musset's criticism of 1836, which simply refers to 'brigands'. It is, however, substantiated by the bonnet and costume of the exotic figure with upraised arms who provides the foreground focus of the right-hand corner of the painting, and there is at least a possibility that Charlet's reference – politically more charged from the perspective of the end of the century – might have picked up the biblical allegory implicit in his master's work. Gros's *Pest-ridden of Jaffa* (1804, Louvre) had showed Napoleon in the guise of Christ curing the sick. Charlet's suffering army en masse could be experiencing a Judas-like betrayal.

Delacroix's article of 1862 essentially repeats Musset's judgement of three decades before when referring to this painting, and does so in very similar language. This is no 'episode', but 'a complete poem', in which 'the army of Austerlitz and Jena has become a hideous horde, without law or discipline, with no link but common misfortune'.[60] Nevertheless, he is also subtly attentive to the connections between Charlet's technique in oil painting, and the lessons that he has learned from his previous experience:

> In this canvas scattered with poignant details, nothing distracts the mind from the powerful unity of its conception, and the execution is full of vigour and truthfulness despite the experimentation that we have spoken of. What gives the paintings of Charlet as much freedom as his other works is the fact that, instead of retouching separate parts or completing them, he preferred to begin large sections entirely afresh, and so rediscovered in the finish, so to speak, all the drive that he had brought to the project at the outset.[61]

Whatever doubts Delacroix may have had about Charlet's working processes in 1824, the painting of 1836 must have removed, since the judgement vindicates his deeply held view that a painting should be worked over consistently, as a whole, rather than as an amalgamation of sections. The opposite practice was indeed precisely the way of working that Baudelaire, schooled by Delacroix's example, detected as a major flaw in the paintings of Horace Vernet and Delaroche. They secreted in their studios, as Baudelaire put it, 'vast pictures, not sketched out, but begun, that is to say absolutely finished in certain parts, whilst others were only indicated by a black or white contour'.[62] Charlet's painting was, by contrast, a seamless creation that betokened the consistent intention of its author.

Yet in 1836 it was precisely the question of whether Charlet had, or had not, made the necessary transition from printmaking to Salon painting that preoccupied a number of critics. Not all were of the same opinion. Etienne Delécluze, writing in the *Journal*

des Débats on 3 March 1836, felt just about able to reassure those who wondered if 'the author of so many lithographs and watercolours would make equally good use of painting'. His answer was positive: 'M. Charlet has made a very good picture.'[63] The critic of the *Revue des Lyonnais*, perhaps less well informed since he described the work as Charlet's first oil painting, concluded however in 1842 that, though he had not jettisoned any of the 'happy qualities' demonstrated in the other media, 'they are not enough for a history painter'.[64]

This had, one imagines, also been the issue when, in 1836, Charlet was spurred by the successful reception of his *Russie* at the Salon to present himself as a candidate for the seat in the Académie des Beaux-Arts left vacant by the death of Carle Vernet. He may well have thought the place of Carle Vernet was an apt one for him to occupy in his turn, since his early lithographs testified to Carle's benevolent example. That he did not abandon this ambition when his initial application was refused is demonstrated by the rather cavalier letter that he sent to the academician François-Joseph Heim in 1837. He confessed to Heim that he had hoped the Institut might open its doors to 'a man of genre', but conceded: 'if every member of the Academy has to be a painter of ancient history, I can only cool my heels'.[65] Heim, it should be mentioned, was mainly a painter of biblical, medieval and early modern historical subjects, and the approach appears tactless, to say the least.

In fact, since La Combe is not the only admirer of Charlet to comment on his failure to enter the charmed circle of the Academy, it is perhaps worth underlining how much of a misunderstanding was involved in presenting his candidature at this stage. There were eighteen painters who wrote to propose themselves as candidates for Carle Vernet's seat. All of them, except Charlet, gave specific lists of works to justify their claims, and ten were short-listed at a meeting of the Academy that took place on 24 December 1836. On the last day of the year, the vote was held and François-Edouard Picot was elected at the second ballot.[66] Of the other members of the short list, three were elected subsequently when vacancies occurred in the years 1837, 1838 and 1839. Virtually all these strong candidates had contributed paintings to the interior of the recently completed church of Notre-Dame-de-Lorette, and most were already working for the *Galerie des Batailles* at Versailles. Picot himself, the son of Napoleon's *brodeur en titre*, had had an honourable career, winning a Prix de Rome in 1813, and gaining success at the 1819 Salon with his neoclassical *L'Amour et Psyché* (Louvre), before proceeding to large commissions for the Louvre, various churches and the *Galerie des Batailles.*

There can be little sense here in contrasting the Academy's worthy, but uninspiring, choice with the great artist whom they might have admitted. The point is that Charlet's evident lack of knowledge about the functioning of the Academy, and his rather casual way of declaring himself a candidate, underline the oddity of his position as probably the most celebrated contemporary exponent of a new, but problematic, medium. No one in the Academy could have failed to recognise Charlet's excellence as a lithographer, and the fact that artists like Ingres, Delaroche and Horace Vernet had all experimented with lithography meant that they were all conversant with its technical difficulties. But Charlet's fame as a lithographer did not confer on him the academic status that traditional engravers held of right, with their four reserved places. Even though Charlet had indeed produced a painting of substantial merits for the Salon of 1836, this did not

change the essential basis of his claim: the 'oeuvre' to which he elliptically referred in his letter to the Academy covered many media, but concentrated in the lower forms of lithography and watercolour. A 'genre man', as he put it – perhaps deliberately avoiding the claim to be a 'genre painter' – could only be irremediably disadvantaged by presenting such claims.

<center>* * *</center>

It became conventional in the later part of the nineteenth century to make comparisons between the different lithographic styles of Charlet and Horace Vernet, with these comparisons inevitably leading to broad characterisations of the ways in which they differed from one another as artists. Beraldi described Horace's temperament as having 'spice rather than vigour', and went on to express the divergence succinctly: 'For subject matter, he goes straight to the soldier, without being capable of taking him to the epic level as Géricault and Charlet have done in their lithographs.'[67] Charles Blanc made a similar comparison, with Géricault firmly placed in Charlet's court: 'But where Charlet and Géricault placed an accent of passion, a dramatic emotion, a feeling of pride, free and sometimes bitter, Horace brought nothing but a dash of wit, a free and fleeting motivation, a line of comedy with nothing caustic or sour, or even malicious about it.' This seemingly slighting reference is however modified by Blanc's admiring mention of the fidelity to appearances achieved by Horace's quicksilver technique: 'His light crayon brushed the stone, but with a sureness that astonished Géricault. He excelled in putting a soldier on his feet, and right away he imprinted him with the desired movement, he characterised him by a gesture that went straight there, I mean to the likely expression.'[68]

More committed to a historical account in the section on engraving in his *Grammaire des arts du dessin*, Blanc interprets this sovereign lightness of touch as a stage prior to the manhandling of lithography into the condition of an art brought about by Géricault: 'Horace Vernet dares not rub hard on the stone; as he brushes across, he traces scarcely shaded silhouettes of lancers in starring roles, soldiers pilfering and poachers . . . There comes a powerful and proud master, Géricault: he, roughly treating the stone with a magisterial hand, makes the robust mounts of soldiers and the people stamp and rear'[69] In this all too accurate estimate of the kinship, on each side, between lithographic technique and preferred subject matter, there lurks however an ideological statement about the path which lithography has to take in order to substantiate itself as an art. The stone had to be 'roughly treated', and, as Blanc goes on to suggest, 'the crayon stubbed with brutal impetuosity', almost as if the planographic nature of the process were a deception, and the 'master' needed to mimic the traditional engraving techniques of gouging with acid, or cutting with the burin before the medium could be taken seriously.[70] Needless to say, this contrast helps to explain, on the other hand, Horace Vernet's later sense of kinship with the new medium of photography: not only the fact that he was to become an enthusiastic advocate and indeed practitioner of the daguerreotype, but also that his particular and acclaimed mode of capturing a likeness was habitually described in terms closely comparable to the unmotivated registration of the light-responsive photographic plate.

This aspect of Horace Vernet's visual sense will, however, be discussed more fully in the chapter that follows. In the context of the present argument, it is not intended to make an overall judgement on his voluminous and neglected oeuvre, let alone to try and salvage the reputation of the figure whom Baudelaire described with particular brutality as 'the absolute antithesis of the artist'.[71] I want simply to pursue the ideas suggested in my discussion of the relation between lithography and painting, with regard to Charlet, and to suggest the existence of a similar equation in the work of Horace Vernet, which nonetheless works out very differently.

A clue to this contrast can be found in the critiques by Delacroix and Baudelaire already quoted. Delacroix rightly singles out the determination of Charlet to work through his *Episode de la campagne de Russie* as a whole, 'instead of retouching separate parts or finishing them'. Baudelaire, on the other hand, stigmatises Delaroche and Horace Vernet precisely for their practice of finishing certain sections of their paintings, whilst leaving other parts blank. It does not need much insight to guess that the practices of Delaroche and Vernet were closely linked to the studio system, with favoured pupils often completing large sections of the work, and leaving it to be finished by the master. But, quite irrespective of studio practice or the evaluative connotations attached to Charlet's single-minded 'drive', there is a further point to be made. This is that the planning of a painting in terms of part and whole can easily be accommodated to a working method that comprises both lithographic prints and oil paintings. The lithographic subjects will be of the same type as the separate 'details' within the painting, and a productive interaction can thereby be set up. This is approximately what occurs in the case of Horace Vernet, who is able to use his lithographic subjects as, in a sense, trailers for his large-scale paintings, and to transpose the flavour of these larger works into lithographs broadly associated with them.

A good example of how this process worked for Horace Vernet can be found in the case of one of his most celebrated works, the *Barrière de Clichy* (1821) (pl. 40). As it happens, both Charlet and Vernet were present at the glorious last stand of Napoleonic France against the allied armies in March 1814, when Marshal Moncey organised a token resistance by the toll-gate on the heights of Montmartre. The comment of Amédée Durande on this personal act of witness powerfully confirms the myth that Vernet had only to see the events in order to be able to transpose them – seemingly with effort – onto canvas: 'he had only to carry on the canvas the impressions that he had experienced during that terrible day to produce one of his best paintings, one in which the note is truest and the composition both simple and grandiose'.[72]

The engagement at Clichy was not exactly a battle, but a confrontation that enabled the citizens of Paris to make a final patriotic gesture in a desperate military situation. Equally, although Vernet's painting acquired notoriety from being excluded as too inflammatory from the Salon of 1822, it was a work completed for a private commission. The goldsmith Claude Odiot, Colonel of the National Guard in 1814, wished to have his brave exploits commemorated, and the resultant painting only entered the national collection when Odiot presented it to the Chambre des pairs in 1835. This intermingling of public and private could also be seen to be part of the message of the work itself, as a compositional structure. In the centre, the marshal, mounted on his frisky horse, gives orders to the splendidly caparisoned goldsmith, whilst gun-smoke billows out beyond

40 Horace Vernet, *Barrière de Clichy*, 1821. Oil on canvas, 97.5 × 130.5. Musée du Louvre, Paris.

the palisades and threatens to obscure the sign above a Montmartre hostelry. But the eye
inevitably travels from the central subject downwards, to the right foreground, where
two wounded soldiers have collapsed, exhausted, and a countrywoman anxiously nurses
her baby beside a mildly distracted goat.

 This little vignette was what the public noticed, and what secured the work's success.
Horace Vernet had, as it were, transplanted a motif reminiscent of one of his lithographic
subjects into the stirring arena of military action, without diminishing the effect of indi-
vidual pathos. A similar, though less resigned, message springs out from one of the innu-
merable lithographs that he completed for publishers like Delpech over the same period.
Gredin de sort! (1823) displays a wounded soldier propped up against a tree, with his
right hand clenched in a feeble gesture of defiance, whilst his other hand tries to disen-
cumber an unpleasant flesh wound in his left leg (pl. 41). Where Charlet, in *Infanterie
légère*, showed the wounded sergeant straining every limb to follow the assault of his troop,
Vernet has detached the soldier from the events taking place around him, and given him
the ironically cursing line: 'Damned bad luck!'. The lightness of touch with the crayon
so often remarked upon has, however, enabled him to sketch in the background a whole
nebulous world of military movement: partly obscured by the smoke or mist that is the
effect of the blank white page, these spectral marches and counter-marches seem as unin-
telligible to the main subject as they are to the spectator.

GREDIN DE SORT!

41 Horace Vernet, *Gredin de sort!*, 1823. Lithograph, 15 × 21. Private Collection.

In the passage quoted at the beginning of this chapter, Gilles Deleuze writes of the battle 'hover[ing] over its own field', and points to the success of nineteenth-century novelists like Stendhal in conveying the complexity of the experience of war as an event. The classic example comes, of course, from the narrative of the Battle of Waterloo in *La Chartreuse de Parme* (1839), as told by the young Italian volunteer, Fabrice del Dongo, who finds himself unable to follow or respond to the development of these great events. Stendhal conveys this bemusement partly by deft touches of landscape description:

> This field was bordered, a thousand feet away, by a long range of willows, very bushy; above the willows there appeared a white smoke that sometimes raised itself towards the sky with a swirling motion.
> If only I knew where the regiment is! said the *cantinière*, in embarrassment.[73]

Compared with Niquet and Pillement's engraved explosions of the powder magazine at Bastia, or indeed the thick billows of smoke that rise against a cloudy sky in the *Barrière de Clichy*, Horace Vernet's blank passages unstained by the lithographic ink are technically null, except that they make their effect in conjunction with the delicacy and lightness of touch that pervades the whole inked surface. It is tempting to see a connection between images such as these and the elliptical narratives of one of Vernet's most sympathetic literary commentators.

Imp. Villain, Paris.

OURAGAN.

Ô! homme vain! mais non superbe, tu fais ton Ajax, tu menaces le Ciel......
Mais la divinité souffle, et tu roules comme le grain de sable du désert.

Alliance des Arts, 140. r de Rivoli.

42 Nicolas-Toussaint Charlet, *Ouragan*, 1835. Lithograph, 14.5 × 17.5. Private
Collection.

Charlet works in a very different vein. We might call it 'epic', but it is also more
familiarly romantic than the wry commentary of Vernet (or Stendhal). His *Ouragan*,
published in the *Alphabet* collection of 1835, revolves around the figure of a smartly
dressed bourgeois who has been tipped out of his carriage in the eponymous storm,
and rails impotently against his fate (pl. 42). The lines appended are almost absurd in
their classicising invocation of the traveller's impotence: '. . . like Ajax, you threaten
the Heavens . . . But the gods blow, and you roll like a grain of sand in the desert.'
Where Vernet is content to let his little scene convey its matter-of-fact heterogeneity,
Charlet animates the white rocks and the straining saplings so that every object seems
to be caught up in the fateful hurricane. Vernet's soldier has laid his helmet prosaically
on the ground. The bourgeois traveller's topper is airborne and travelling rapidly off
to the left.

 This comparison is not at all arbitrary, as it could be argued with some justice that
Charlet used *Ouragan*, in addition to some of his other lithographs, in the planning of
the *Episode de la campagne de Russie*. We see the same motif of a cart on its side, and the
gnarled boughs reminiscent of grasping hands (just above the precipitated bourgeois), if
we focus on the left-hand edge of the painting, with its sinister tree that seems to clutch
greedily at the wrecked supply cart. Nonetheless, the relationship of the lithograph to
the painting is not, as in Vernet, that of a potentially commutable motif which will

43 Nicolas-Toussaint Charlet, *Merlin de Thionville à l'armée du Rhin*, 1843. Oil on canvas, 65 × 81. Musée du Louvre, Paris.

supply a focus of special interest in a large composition. Charlet must have worked incredibly hard, in his *Episode*, to attain a unity of conception and execution. His wife's testimony is there to assure us how much his ambition to secure a triumph at the Salon finally cost him.[74] In one of his infrequent later paintings, produced two years before his death, he resolved the problem of composition simply by taking a leaf from an earlier book. *Le Conventionnel Merlin de Thionville à l'armée du Rhin* (1843) shows the same apparently rushed and spontaneous composition – and even apparently the same impulsive horse – as the *Déroute des Cosaques* of twenty-six years before (pl. 43; cf. pl. 34). The ageing representative of the people who flung himself into battle at the Siege of Mainz in 1793 is brought back to life by an almost comical characterisation that recalls the shaggy Cossacks of 1817.

Charlet almost always makes us aware through his figurative idiom that his vision of the revolutionary period is founded on estrangement from the original action, and a consequent need to compensate through the strategy of rhetorical excess. Vernet, however, succeeded in convincing his contemporaries, and many of those who outlived him, that he had reconciled the requirements of rich and comprehensive visualisation with those of historical accuracy, and was thus qualified to promote a wide-ranging, collective reverie on the past, present and future of the French nation. In order to do that, he had to act, on the one hand, as the descendant of his grandfather, industriously pursuing sequences

44 Horace Vernet, *Château de Ligny*, 1815. Wash drawing. Bibliothèque municipale, Nantes.

of paintings that displayed the fruits of considerable documentary research; and on the other, as the friend and patron of artist-impresarios such as Langlois, who were carrying forward the development of popular spectacles like the panorama in ways that would finally supersede his own style of work.

For reasons closely connected to this intermediate position between past and future, Horace Vernet came to be remembered particularly for the battle paintings completed in the early stages of his career, when his experiments with lithography were acting as a spur to vivid and immediate visualisation. Apart from the special case of the *Barrière de Clichy*, he was particularly remembered in the later nineteenth century for the series of four large, panoramic paintings of battles of the revolutionary and Napoleonic wars that now hang in the National Gallery, London. We know that he visited the sites of the Waterloo campaign shortly after it had taken place, and recorded in a rapid wash drawing the ruined castle that had been at the centre of the Battle of Ligny, on 16 June 1815 (pl. 44). But instead of commemorating this last successful engagement of the French troops before the debacle of Waterloo, he chose for the last battle in his historical series the earlier campaign of 1814, when Napoleon had defeated the invading Russian troops at Montmirail on 11 February.[75] This was the high point of Napoleon's resistance before his first abdication and exile to Elba. But in scarcely more than a month the allied troops would be on the heights of Montmartre.

45 Horace Vernet, *The Battle of Montmirail (1814)*, 1822. Oil on canvas, 178.4 × 290.2. National Gallery, London.

It was this final painting of the series, *The Battle of Montmirail (1814)* (1822), that impelled Henri Delaborde to write, in 1853, the poignant ekphrastic text later quoted by Charles Blanc (pl. 45). There was no doubt that, if the history of France from the earliest times was a 'battle-history', Horace Vernet was its visual chronicler:

> The moment chosen is the one when the chasseurs of the old guard, under the orders of Marshal Lefevre, throw themselves upon the enemy and through this supreme effort decide the victorious outcome of the day. The horizon, which the shades of evening have already encroached upon – the vestiges of a wan light that a sad winter sun, half hidden behind the clouds, extends across the countryside and across the last batallions that cover it – all of this, as far as the very cross that gunshot from the two armies has shaken on its base, as far as the leafless tree whose branches appear to flutter sadly beneath the blasts of the wind and the grapeshot – all of it has a melancholy solemnity, an expression of sinister grandeur that conforms with the historical character of the scene. It is still the image of a victory, but of a victory without celebration, a glory without exaltation, a triumph without a tomorrow. Joy is missing from all these heroic hearts which are tenanted solely by memories of the outraged fatherland, just as radiant light is absent from the theatre of struggle, and as the sun of Austerlitz is absent from the sky of Montmirail.[76]

Two years after Delaborde wrote this text, *Montmirail* was exhibited together with Horace Vernet's three other battle paintings from the Restoration period at the Paris

Exposition Universelle. *Valmy (1792)*, *Jemappes (1792)* and *Hanau (1813)* kept it company in Vernet's antiphonal celebration of the hopeful dawn of the revolutionary wars, and their fateful aftermath. The fact that France was by 1855 engaged in the Crimean War, which was the first major confrontation of the European powers since the Congress of Vienna, must have given this retrospective an unforeseen timeliness. Vernet's reputation as a painter was consecrated by his major presence in this exhibition, alongside the equally extensive displays of the works of Delacroix and Ingres.

Yet this chapter is not primarily concerned with the long-term fortunes of Vernet's battle paintings. Nor does it examine the novel effect of his contribution to the record of the Crimean War that has a central place in the argument of the chapter that follows. Although the subject matter considered here has been the varied imagery of modern warfare, the central purpose has been to develop an extended comparison between the different techniques of printmaking available for its representation. Two major points stand out here. On the one hand, we are witnessing the demise of the kind of collaborative printmaking, involving several different types of technical expertise, which brought together Carle Vernet, Duplessi-Bertaux and their collaborators. On the other hand, we are seeing the emergence of lithography as a new medium that will insistently claim a place for itself.

Lithography's role, however, is not at this stage simply to harness itself to the depiction of everyday life. In the case of Charlet, we see the rapidity and spontaneity of the process lending itself to a high degree of subjective investment, as the young artist looks back on the campaigns that he could never have fought. For Delacroix, this combination results in a unique artistic fusion: his mode of working on the 'white stone' can be portrayed as an ideal marriage between vision and technique. But this ability to carry through 'the powerful unity of the conception', though visible in the exceptional pictorial achievement of the *Retraite de Russie*, does not convince the Academy. Charlet remains an outsider, and for that reason particularly cherished by Delacroix.

At the other end of the scale, burin engraving remains the academic technique *par excellence*. It has featured hardly at all in this chapter because of its obvious intractability where any project of rapid reportage is concerned. Engravers like Bervic and Tardieu had the academic respectability denied to Charlet. Their reproductive techniques, however, required a heroic effort of self-denial, and a commitment undertaken for a substantial period of years which would only in the long term bring any significant financial reward. From any brief overview of the career of Bervic, it might appear almost incredible that such a practice as reproductive engraving could survive into the nineteenth century. Yet, as the previous chapter has already made clear, its salvation lay in the insistent demand for high-quality reproductions generated by many of the most successful painters of the period, and in the ability of dealers like Goupil to finance and publish them.

Yet this recuperation of a traditional technique implied no widening gap between high and low culture. As the next chapter will show, the very painters who were most attuned to this market were at the same time most assiduous in their attention to the possibilities of the new medium of photography. Meanwhile, for its pioneers, Niépce and Daguerre, the photographic image had to be assessed initially by close comparison with the broad range of printmaking and graphic techniques before it could be recognised that its destiny lay in differentiation.

46 Louis-Jacques-Mandé Daguerre, *Gothic Ruins*, *c.*1826–7. Sepia drawing with candle smoke ('Fantaisie à dessin fumée'), 7.7 × 6.

3

The Inventions of Photography

THE HISTORY OF THE DEVELOPMENT of photography in early nineteenth-century France is a fascinating one, and it has received an enormous amount of attention during the past few decades. To the pioneering general histories of the photograph have been added specialist studies with a precise focus on particular issues. It might be thought that little more remains to be said on the broad issue of how photography took its place among other practices of visual art, from the popular to the academic, and to what degree this place was demarcated by the existing conventions of visual culture. Or at any rate, it might seem over-ambitious to claim to say anything new on the subject in one chapter of a broader study of this kind.

It has been my intention, however, to define the overall parameters of this investigation of parallel practices in the visual arts in such a way as to offer new possibilities of access to the phenomenon of the photograph. In particular, I have been arguing that new attention to the neglected medium of the reproductive engraving, and to its place within the domain of printmaking in general, unlocks a whole range of questions pertaining to the social and cultural valuation of the image in these times. Photographic historians have understandably been keen to stress the novel nature of the photographic print, and the radical difficulties that it posed to previous concepts of reproduction. Helmut Gernsheim, for example, warns the reader against the 'confusing and at times even misleading' terms used by the Niépce brothers in discussing their experiments; they were still enmeshed in 'the nomenclature of the older arts, especially of engraving'.[1] Of course he is right to insist that taking a 'proof' (*épreuve*), as they expressed it, is a term that has to be stretched if it is to mean, not the traditional practice of the printmaker, but the trace of light rays on paper. But it remains true that the vocabulary used by the pioneers is a faithful guide to the conceptual basis from which they undertook their investigations. And the same goes for the connections fostered by Niépce and Daguerre within the diverse, yet orderly spectrum of the arts to which they had recourse during their experiments.

To enquire further into the milieu in which photography developed is not, moreover, a mere archaeological exercise. Following Benjamin's essays in the inter-war period, there were a number of remarkable theoretical statements on the distinctive ontology of the photographic process in the third quarter of the twentieth century, Ivins's concept of the 'pictorial statement without syntax' and Roland Barthes's of the 'message without a code' being prominent among them. Yet the decision to emphasise what Barthes called the 'anthropological revolution' of photography has had the unfortunate side-effect of collapsing its historiography into an impossible moment: the 'invention' of the photograph.[2] Even the great portrait photographer, Nadar, who lived through the period of public dif-

fusion of the daguerreotype process, is guilty of encouraging this tendency when he writes, at the beginning of his essay on 'Balzac and the daguerreotype': 'When the rumour spread about that two inventors had just succeeded in fixing on silvered plates any image presented to them, there was a universal stupefaction of which we could not form any idea nowadays, accustomed as we have been for many years to photography and made blasé by its vulgarisation.'[3] The general point is well taken. But what exactly can be deduced from Nadar's statement about the timetable according to which the 'rumour spread'? If it is indeed a question of 'two inventors', and he is conflating the career of Niépce, who died in 1833, with that of Daguerre, who presented his results to the public in 1839, then what accounts for the delay in the 'universal stupefaction'? There could be no clear answers to these questions, and it may appear unduly pedantic to ask them. But the fact remains that Nadar has deliberately, and for his own perfectly good reasons, decided to portray photography as a mythic revelation of a new visual world.

The more prosaic approach would be to hold that photography had two very different processes of coming into being, which have been historically documented in ways that are appropriate to each in turn. In the case of Nicéphore Niépce, we have a period of perhaps twenty years, between 1813 and his death in 1833, when the indefatigable country squire from Chalon-sur-Saône was involved with the concepts and processes of 'mechanical' reproduction. These years are, however, broadly covered by his extensive correspondence, and historians have been able to piece together a coherent account of the twists and turns of his fortunes throughout the period. A certain amount of interest concentrates around the question of when Niépce produced the 'first photograph': that is to say, the first image permanently fixed from nature, as opposed to the 'photo-engravings' that employed his process to copy prints by direct contact. But Gernsheim effectively settled this issue when he unearthed the precious pewter plate imprinted with the view from the window of Niépce's manor house at Le Gras.[4] Thanks in large measure to the first director of the museum that bears his name, Paul Jay, the record of Niépce's years of travail is now fully and handsomely documented.[5]

In the case of 1839, however, the record is much less clear, despite – or perhaps because of – the fact that we are dealing with a sequence of mainly public events, extending over the period from January to August, in the course of which Daguerre's process underwent successive steps of public validation and exposition. I have found it necessary to return to the simple newspaper record of these events, in the well-informed newspaper *Le Courrier français*, in order to reconstruct this series of stages. The extent to which it is important to have the sequence of events clear can be gauged from the fact that a visual document of the first importance – and one exceptionally relevant to my project – is still shrouded in a certain amount of mystery. In the collection of the Musée Carnavalet, Paris, there is an evocative oil painting by Prosper Lafaye (1806–1883) entitled *Conférence dans le salon de M. Irisson sur la découverte de la photographie, en 1839*. As the museum label indicates, this image depicts an evening in a fashionable salon in the rue d'Antin, in the course of which Horace Vernet is informing the assembled company about 'the discovery of photography as it had just been presented by Arago to the Academy'.

There is also a full-size watercolour related to this painting in the collection of the Musée français de la photographie at Bièvres, which benefits from a complete key to the guests shown in the salon, and a short description of the significance of the event. The current hand-sheet at Bièvres improves upon the rather vague description previously

quoted by spelling out the context of the event depicted in much more detail: 'The scene takes place on the evening of 19 August 1839 in the home of the comtesse Irisson when the two academicians Paul Delaroche and Horace Vernet recount the great news of the day: the revelation of the secrets of photography at the Institut by Arago.' Yet this dating is clearly inconsistent with the contemporary text accompanying the sketch itself, which attributes the briefing given by Vernet and Delaroche to 27 January 1839 – a very different juncture in the publicising of the new invention.

Who knew what and when? The crux presented by the dating of the event in Lafaye's two pictures will lead me to ask this old question, not simply for historical reasons, but because it raises in an acute form the question of the relationship between academic painting and the 'invention' of photography. As it happens, the pioneering work on the relationship between the two forms of visual representation, Aaron Scharf's *Art and Photography* (first published in 1968), scores a spectacular own goal where Vernet is concerned. Scharf describes the joint sitting of the Académie des Beaux-Arts and the Académie des Sciences on 19 August as taking place without 'two of [the former's] most important' painter-members: 'Ingres was in Rome and Horace Vernet in the near East'.[6] But though Ingres was indeed absent, Vernet embarked at Marseilles for his Eastern journey only on 21 October 1839. He had had ample time to be at the centre of debate about the new process since the beginning of the year, and Lafaye's work can be seen as the index of his involvement.

The reference to Paul Delaroche in the Bièvres hand-sheet raises a more far-reaching question, since it touches on the provenance of the remark that has served more than any other to fix the relationship between painting and photography in a condition of mythic stasis. To quote the hand-sheet again: 'Paul Delaroche declares: "Photography is born, painting is dead"'. It will be shown that the written commentary attached to Lafaye's sketch makes no reference to this much quoted remark, and indeed leads us off in a quite different direction. Gernsheim's invaluable monograph on Daguerre (1956) correctly established that no earlier source than a popularising and nationalistic survey of photography dated 1873 could be found for Delaroche's declaration, more usually quoted as 'From today painting is dead' (*La peinture est morte à dater de ce jour*). Gernsheim also disputed Tissandier's attribution of the remark to August 1839, and suggested that such a comment could only have been made 'towards the end of 1838', when Daguerre must have approached Delaroche personally to gain support for his invention.[7] As will be argued here, Gernsheim is almost certainly right about this earlier dating of a remark so inconsistent with Delaroche's well-documented public position. If it was made at all, it was made then. But it is unfortunate that Gernsheim does not also make the point in his more general history of the origins of photography (first published in 1955), where Delaroche's 'hysterically' delivered interjection is inserted in the text straight after the account of the joint meeting of the Academies on 19 August.[8]

This chapter will therefore centre upon the positive aspects of the painters' reception of photography, supported by a clear chronology which clarifies the role of Delaroche and Vernet. It will propose a reading of Lafaye's two linked images which also emphasises his own attitude as a painter. Finally it will conclude with some preliminary discussion of the neglected issue that relates directly to this role of mediation: the part played by photographers of the second generation (often trained as painters in the academic tradition) in the reproduction of contemporary paintings.

Here it will be necessary to take into account the conflict of interest brought about, on a commercial as well as a critical level, with the traditional reproductive engravers. Gernsheim uses Delaroche's dire prediction to alert us to the 'profound consternation . . . among painters and engravers, who quite understandably feared to lose their means of livelihood, considering that anyone could now do in a fraction of the time what had taken an artist all day, or even longer'.[9] The issue of reproductive engraving versus reproduction photography was, however, much the most pressing one in the whole sector of pictorial production. Whether they were reproduced by prints or photographs, paintings still retained their priority. At the same time, however, the disparity between the almost instantaneous process of photography, and the labour of many years that was necessary for a large burin engraving, could not fail to bring about a crisis, in which traditional critical values, as well as commercial practices of long standing, were called brusquely into question.

<p style="text-align:center">* * *</p>

Such is not the case, emphatically, with the photographic experimentation of Nicéphore Niépce. On the one hand, his unremitting attempts to harness the power of sunlight in the service of pictorial reproduction took place themselves over many years, and never reached a technical level where they could be seen to compete directly with the existing, non-mechanical processes. On the other hand, there is every reason to suppose that Niépce collaborated eagerly and in good faith with his professional collaborators, who themselves were intrigued, in different ways, by the possibilities that he opened up, but never envisaged the likelihood that his invention would drive other types of image-making out of business. It has been suggested, by Paul Jay, that by 1827 Niépce must have seen his two principal collaborators, Daguerre and Augustin-François Lemaître, as being in a certain sense in competition with each other.[10] Certainly it is true that Niépce's correspondence shows a certain embarrassment at the potential conflict of interest between his two Parisian contacts, and Daguerre was later to argue successfully for the removal of Lemaître from the contractual agreement for the furtherance of the photographic process. But it will be argued here that Daguerre and Lemaître were essentially from the same printmaking milieu, with the same optimistic and eclectic approach to the challenge of new technologies. If Daguerre was eventually able to contribute to the partnership his distinctive and precious knowledge of lens-making, Lemaître had already familiarised Niépce with the range of current modes of printmaking, and presented a field of possibilities against which he could measure his own efforts.

Niépce's own enthusiasm is fuelled, from the start, by a combination of commercial opportunism and scientific curiosity, both increasingly linked in his own case (though not the case of his unfortunate brother)[11] with the reproduction of images.[12] Already in 1811, at the age of forty-six, he was being complimented by the imperial government for his zeal in responding to the national demand for pastel as a colouring agent, during the interruption of overseas supplies as a result of the English Continental Blockade. His son later claimed that he was inspired as early as 1813 by the example of lithography 'recently imported into France' to experiment with analogous methods of planographic reproduction.[13] The date must be suspect, since lithography made no significant impact until after the Bourbon Restoration (as was seen in the previous chapter). It is possible,

however, that Niépce had got wind as early as this of the new technique – Vivant Denon, who had used Senefelder's technique in 1809, was a Chalonnais.

What is more firmly attested (and supported by the correspondence) is his son's statement that he had the idea of replacing the precious Bavarian stones with broken pieces from the local Burgundian quarry of Chagny, which were being used for the repair of the highway to Macon.[14] The fine grain of the stone did not however produce an adequate result. By August 1817 Niépce had abandoned lithography. He subsequently began the process of experimenting with metals – in the first instance, polished pewter – which promised to perform more satisfactorily. One of his first trials, again according to his son, was with the printing of music, up to then always a costly process since the notes and bars could not be set in moveable type, but relied on the freehand skills of the burin engraver on copper.[15]

Niépce would certainly have been aware of the range of popular printmaking techniques available for many centuries in provincial France, as well as of the more refined skills practised in the larger cities. As it happens, Chalon itself had a lively tradition of wood engravings of religious scenes, now preserved as an example unique in France, since all other localities obeyed the order of the revolutionary government to destroy such vestiges of superstition.[16] He would have been aware that pear-wood was the preferred material for printing these naive and popular scenes, which were often derived from well-known academic engravings on copper. He probably saw lithography as having a vast potential for multiplying and diffusing images in a similar fashion. But his transition from stone to differently treated metal surfaces, and his genial intuition that the registration of light itself could take the place of burin or crayon, opened the dazzling prospect of going one better than lithography.

It is important to recognise that Niépce was by no means the only Frenchman conducting research, over this period, into the technology of printmaking. The very success of lithography, which was dependent from the outset on the import of costly Bavarian stones, gave rise to many attempts to discover alternative supports for the tracings of the crayon. The Académie des Beaux-Arts took official note of these, just as it was later to give its approval to the invention of the daguerreotype. Indeed in 1834, the year after Niépce's death, it was to approve the development by one M. Beugnot of 'a new process tending to replace the lithographic stone by plates of zinc', which would ensure that 'the five-thousandth proof came as sharp and vigorous as the tenth'.[17] Nor was Niépce unique in observing that the rays of the sun could be utilised in the process of reproduction. There is a mysterious print in the Musée Ingres at Montauban dated 1819, after a drawing by Ingres for his *Henri IV et ses enfants* (1817, Petit Palais, Paris). This answers to the tantalising description of 'Essais de Gravure Hélio-chimique' and was apparently produced by Charles Thévenin, the friend of Ingres who was then Director of the French School in Rome and who fathered in precisely the same year the son who would later be a pupil in Calamatta'a studio.[18] Unfortunately it is not possible to work back from the strangely bulbous line of the engraving to the solar conditions and chemical recipes which, in some way or other, must have served to produce it.

Niépce's reputation rightly rises above these limited initiatives because of the tenacity and breadth of vision with which he pursued his research over many years. He deserves the accolade of having produced, probably in 1827, 'the world's earliest . . . photograph from nature', eight years before Henry Fox Talbot produced his first paper

negative of the lattice window at Lacock Abbey.[19] However, it is important for our pur-
poses to recognise that the potential of the photographic process to realise 'points de vue'
(as he put it) was far from being his only motivating factor. Niépce did describe as early
as May 1816, in a letter to his brother, the aim of using the camera obscura for the obtain-
ing and fixing of such viewpoints, and it was a considerable triumph for him to have sur-
mounted the various technical problems involved in the decade that followed.[20] But much
of this intervening time was taken up with the parallel activity – no less important in
his eyes – of using the heliographic process to copy engravings onto photo-sensitive plates
and to take proofs from them. It was here that he engaged most directly with the com-
mercial and aesthetic conventions of the existing community of artists and printmakers,
and was therefore bound to seek advice and collaboration.

Niépce's first attempt at *troc* in this milieu was with the Parisian lithographer, engraver
and printseller Augustin-François Lemaître, whom he approached out of the blue in the
summer of 1825 to see if it was possible to convert two of his treated copper plates
so that a print could be taken from them. The experiment was a failure, and Niépce
acknowledged that he was pursuing two simultaneous objectives that were hard to
reconcile: the varnish applied to the plates had to be light-sensitive enough to take an
impression, but it also had to be thick enough to take the acid (*eau-forte*) and resist the pres-
sure of the engraving process.[21] By February 1827, however, he had made enough progress
to receive a moderately favourable report from his collaborator on a further set of plates,
now made from hardy pewter rather than soft copper. One contained a reproduction of just
the same type of generic religious print from the previous century that the local wood-
block printers of Chalon had adapted for their purposes. Lemaître gave his approval to the
'relationship of contours and purity of engraving (*taille*)' in this *Holy Family*, but thought
it useless to try and print from it, since the image would only 'come through in places'.[22]

Another reproduction, after a portrait of the seventeenth-century engraver Isaac Biot's
Cardinal Jacques d'Amboise, was much more promising. Lemaître speculated that, as it was
more deeply engraved, it would present when printed the same effect as 'a plate worn by
heavy printing'. He praised the accurate registration of the *tailles*, 'above all, the half-
tones of the cape and the toque' of the cardinal, but still criticised the rendering of the
shadows.[23] This judgement accurately reflects the achievement of what has probably
become Niépce's most frequently published reproductive photo-engraving. At the Musée
Niépce in Chalon, it is instructive to see the image through its successive stages: a copy
of the original, seventeenth-century work by Biot; a (reversed) copy of the same which
has been rendered translucid by Niépce for heliographic reproduction; a pewter plate
bearing the (reversed) image derived from the previous one; and finally, a print taken
from the plate, which reverses the image back to its original appearance.[24] If Lemaître's
reservations do indeed apply to the quality of the images produced in this sequence of
operations, they have less force in the case of Niépce's second plate (Royal Photographic
Society, Bath) which he took with him to England in the autumn of 1827, and presented
to Francis Bauer, Vice-President of the Royal Society. Nor do they apply quite so force-
fully to the print in the Gernsheim Collection (Harry Ransom Humanities Research
Center, University of Texas at Austin), though the rendering of the background is cer-
tainly patchy compared with the fine texture of the original print.

As Niépce's journey to England demonstrates, he was willing to cross the Channel to
obtain authoritative scientific support for his various projects. Augustin Lemaître,

47 Augustin Lemaître, engraving (1831) after Achille-Etna Michallon, *Mort de Roland*, 1819 Salon. 42 × 55.8. Biblio-thèque Nationale, Paris: Département des Estampes.

however, was the first person who offered him collaboration and contact with the artistic world, the first who could be trusted to criticise and carry further the strictly reproductive side of heliography. As stated already, he had been in contact with Niépce for around six months when, in January 1826, Daguerre wrote to express an interest in the new developments, having been roused by a tip-off from Niépce's camera maker, François Chevalier. Lemaître must undoubtedly take second place to Daguerre in any estimate of the long-term contribution of Niépce's collaborators, judged in terms of their role in the subsequent development of photography. But, at the same time, the virtual absence of any serious attention to Lemaître, in the voluminous literature on Niépce, indicates a lack of concern with the printmaking dimension of his activities that needs to be corrected here.

In the first place, Augustin Lemaître was demonstrably not, as Victor Fouque expressed it in his important study of Niépce published in 1867, 'one of the most celebrated and the most able engravers in Paris'.[25] He was born in Paris in 1797, and so only a young man of twenty-eight when he made his first contact with photo-engraving. Moreover, he

was still a debutant artist who had just executed a recent, and significant, change of career. Up to the beginning of 1822 he was a pupil of the brilliant young landscape painter, Achille-Etna Michallon, who had won the first Prix de Rome offered by the Academy for historical landscape in 1817, and consequently spent the next few years in Rome at the French School.

Michallon died of pneumonia on 24 September 1822. But Lemaître showed a long-term dedication to his memory by executing in the last years of the decade a technically remarkable etching of Michallon's *Mort de Roland* (Salon of 1819), which was to be his chief contribution to the 1831 Salon (pl. 47).[26] Lemaître had presumably learned his basic engraving skills from the studio of Claude Fortier, who had worked on the landscape backgrounds of several of the engravings after Carle Vernet for the *Campagnes d'Italie*, and ranks very low in Beraldi's hierarchy.[27] If Michallon's death doubtless deflected the career that he had planned for himself as a landscape painter, this impressive piece of work (on which he was probably working for at least some of the period of his contact with Niépce) was not to presage a brilliant future in reproduction printmaking. For the rest of his life, Lemaître was mostly occupied with the illustration of travel books and the provision of visual accompaniments to architectural and archaeological texts. Both his son and his daughter followed him in the profession.

In fact, it would seem that the celebrity Fouque claims for Lemaître was largely reflected back from the measure of prestige that he acquired after 1839, as one of Niépce's former collaborators. This did not come immediately, as is suggested by the fact that his name is wrongly spelled and his role depreciated in the misleading statement by Daguerre which was reported to a meeting of the Académie des Sciences on 23 September 1839: 'It seems to us very clear, from M. Daguerre's own statement, that M. Niépce, in his repeated attempts, did not make an engraving from a proof obtained in the camera obscura. Even if he had produced one with M. Lemaire [sic], the matter remained unknown.'[28] This item no doubt testifies to the embarrassment felt by Daguerre, in the full flush of the public disclosure of his invention, over the vital contribution of Niépce to the discovery of the photographic process. More will be said at a later stage in this chapter about the historical reappraisal brought about after 1839 by the protests of Niépce's family at Daguerre's apparent attempt to sideline his role. That Lemaître also wished to assert his role in the early history of photography is attested by his membership of the Société Héliographique – the first photographic society – from its inception in January 1851. Like many of its members, he does not seem to have practised photography on his own account.[29]

If the young Lemaître was not at all 'celebrated' in 1825, he did offer helpful access to the variegated world of visual reproduction that Niépce wished to explore. What he may have lacked in terms of professional experience and esteem, he made up for in the broad and enterprising nature of his activities. In fact, he was a typical product of the ferment produced in the domain of printmaking by the recent emergence of lithography, and the corresponding demand for lavish illustrated editions to satisfy the visual tastes of the Romantic public. One of his earlier, undated lithographs, published by Engelmann, is a dry and meticulous rendering of the façade of a church in Toulouse, erroneously captioned as *Eglise de la Dalbade* (pl. 48).[30] But he pulls out all the stops when he contributes a very charming lithograph (dated 1823) to the second volume of *La Normandie*, in Charles Nodier and Isidore Taylor's *Voyages pittoresques* (pl. 49). Lemaître has

48 (*left*) Augustin Lemaître, *Façade de l'Eglise de la Dalbade* [*sic*], *c*.1825. Lithograph, 44.5 × 30. Musée des Beaux-Arts, Lyons.

49 (*below*) Augustin Lemaître, *Galerie de l'Hôtel de Bourgtheroulde*, 1823. Lithograph, 19 × 25.5. Private Collection.

adopted the 'house style' of this pioneering enterprise in travel publishing. Like Bonington and the other lithographers who contributed, he ornaments the surface of the sheet with a rich texture of finely drawn crayon lines, creating a topographical stage for a chivalric encounter. The Hôtel de Bourgtheroulde, in the place de la Pucelle at Rouen, had been built only in 1506, and would hardly have played host at that date to such splendidly caparisoned knights – unless they were off to play their part in the neo-chivalric Field of the Cloth of Gold. But this is indeed what the lower range of bas-reliefs on the Galerie d'Aumale of the Hôtel – in full view on the print – was intended to represent, in counterpoint to the *Triumphs* of Petrarch on the top range. Lemaître has made a sophisticated play between levels of historical subject matter, in a print which testifies to his skilful participation in perhaps the most ambitious publishing venture of the early Romantic period.

Lemaître never advised Niépce to try and reproduce a lithograph by his process. As a planographic form of printing, lithography would have offered no sharp lines for the specially prepared plates to pick up; none of the soft registration of detail in the *Hôtel de Bourgtheroulde* would have transferred to a proof. When, in March 1828, he wrote to Chalon enclosing eight prints for Niépce to experiment with, he had obviously experienced trouble in making the selection from the stock in his print shop at 32 rue Mazarine. None of the prints could afford to be very large, because Niépce possessed only small metal plates. Of the eight that he had chosen, for the modest total of 13 francs, four were in aquatint or mezzotint (*manière noire*), and the other four (which he declared to be 'very beautiful') were etchings and burin engravings. In view of the fact that the method involved varnishing and making the print transparent, he had sought out proofs on the thinnest paper available.[31]

It is interesting to find one print after Charlet in the batch, especially as it falls into the category of *manière noire*, which Lemaître predictably ranks less highly than the traditional methods dear to French engravers (pl. 50). Brought to a high standard as a technique through the English mezzotint production of the later eighteenth century, this method implied from the start a clear departure from the more labour-intensive linear approach, since the entire copper plate was roughened to a texture resembling sandpaper with a 'rocker', before the engraver worked on the prepared surface to create velvety half-tones. During the 1820s, English engravers like S. W. Reynolds entered the French market with prints produced from this technique, and Reynolds himself employed it in some of the earliest prints after paintings by Delaroche. This particular work is not by Charlet (as Jay states), but a print after Charlet's drawing *Le Joueur*, by Reynolds's star pupil, George Maile, a friend of Constable who established himself in Paris between 1824 and 1840, and was originally published by the English print publisher John Arrowsmith.[32] Maile was undoubtedly a pioneer in the diffusion of new printmaking techniques, since before leaving Britain he had completed the first set of mezzotints ever to be printed from steel plates, for the 1822 edition of Izaak Walton's *Complete Angler*.[33]

Le Joueur, as transferred to Niépce's plate – in this case possibly made of zinc – is not a notable success, since it loses the intense black tones and the intimate lamp-light effect that Maile has conjured up in his expressive little print. But, aside from this being a further instance of a disappointing outcome for Niépce's efforts, it is worth recalling that steel engraving, as practised by Maile, opened up the possibility of multiplying by a huge

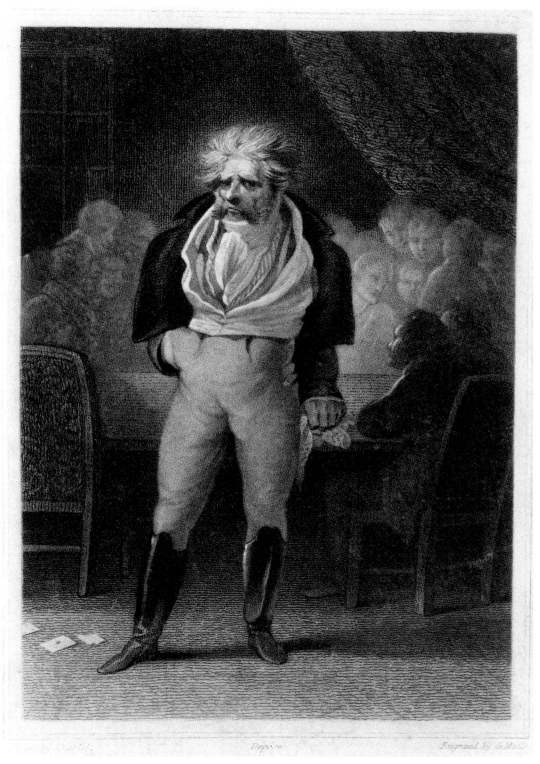

50 George Maile, mezzotint (*c.* 1826) after drawing by Nicolas-Toussaint Charlet, *Le Joueur*, *c.* 1825. Musée Nicéphore Niépce, Chalon-sur-Saône.

factor the number of prints that could be taken from a single plate. Perrot calculates that, at most, a copper plate (*cuivre rouge*, as opposed to *cuivre jaune*, or brass) could produce 2,000 copies of an engraving possessing 'delicacy'. By contrast, a steel plate could rise to 40,000 without being worn out.[34]

Such astronomically high runs may have appeared at first irrelevant to those who wished above all to sustain the tradition of fine printmaking. But, by the mid-century, it had become possible to combine the artisanal features of the *taille-douce* on copper with the industrial advantages of the steel plate by treating the engraved surface with a steel coating. This *aciérage* was successfully applied for the first time in 1857 (as has been mentioned) in the case of Calamatta's masterpiece, the *Mona Lisa*. It was also used at roughly the same time to strengthen the plates which Goupil used to print Paul Mercuri's engraving after Delaroche's *Jane Grey*. No doubt the company felt that an engraving which had taken over twenty years to complete and cost them 100,000 francs merited the insurance of extra longevity!

One could argue that Niépce's basic project of using the camera obscura to create multiple print images of a high quality was bypassed, in the medium term, by technical developments such as this one. Only in the long term, by the last quarter of the century, would photographic reproduction be sufficiently developed to pose a cheap and effective alternative to steel plate printing (for fine engraving) and wood-block printing (for the illustrated press). In the short term, therefore, the aim of competing directly with lithography, mezzotint and other existing modes had to be acknowledged as a failure.

This recognition seems to have come, for Niépce as well as for his two main collaborators, in the autumn of 1829, when both Daguerre and Lemaître were able to discuss and report on the engraved heliographic plate showing the courtyard at Niépce's country manor of Le Gras. Daguerre went right to the heart of the matter, when he remarked on the crudity of the shadow effects, and the restricted tonal values. 'In the present state of things,' he argued, 'this process would have no success in the arts, I mean to say simply in the context of engraving, since the discovery would not appear any the less extraordinary for that.'[35] It was precisely the 'mechanical' nature of photography – its relative lack of dependence on manual skills – that disqualified it from competing effectively with forms of printmaking. To do so, it would have needed 'some form of perfection': that is to say, a means of signalling its high quality as an image in ways that challenged direct comparison with the aesthetic effects of existing types of print.

Lemaître, in his letter of 12 October, was broadly in agreement with Daguerre. In particular, he picked up a point that must have appeared specially sensitive in view of his own successful attempt, in the lithograph of the *Hôtel de Bourgtheroulde*, to depict shadows cutting in sharply from one side. 'We noticed that two faces of the house which ought in nature to be parallel and opposed turn out to be lit at the same time in your subject, which is a nonsensical effect . . . We put this circumstance down to the length of the operation, during which the sun must necessarily have changed direction.'[36] Niépce confirmed that this was indeed the case, though he jibbed at Lemaître's reference to his plate as being 'engraved', insisting that he had not employed 'acid of any sort'.[37] The issue was important since both Niépce and Daguerre were beginning to believe, from their different perspectives, that the very comparison between the new invention and traditional printmaking processes was a red herring, and an obstacle to further progress. In a further letter of 15 November 1829, Daguerre made his most categorical statement in favour of

treating photography as an entirely new medium, a tabula rasa on which nature should be allowed to write without impediment:

> I also saw M. Lemaître. I did not hide from him that I did not believe the matter advanced enough to bother with the methods of engraving and secondly, in my view, the aid of the burin would only become necessary to the extent that it were impossible to succeed in any other way; in fact, the moment it becomes indispensable to have the talent of an engraver involved, the discovery will lose all its interest. Nature has its naiveties, which one must take good care not to destroy; it will simply be a matter of choosing, in accordance with the available means; the extensive experience that I have in using the camera obscura will offer you what is necessary in this respect.[38]

Daguerre's prescient statement implied that Lemaître should be given his marching orders. When Niépce proposed a legal agreement shortly afterwards, for the exploitation and development of his invention, Daguerre questioned the wisdom of 'having a third party in our confidence'.[39] The agreement was therefore drawn up between Niépce and Daguerre alone, and formed the basis for the latter's continued refinement of the process up to 1839, six years after the death of his senior collaborator.

Daguerre was right to imagine that his unique expertise in the manipulation of light, developed through the public spectacle of the diorama, qualified him preeminently to work side by side with Niépce. Before the latter's death, he had indeed (in the words of Jacques Roquencourt) 'completely fulfilled his side of the contract' by developing the first genuine photographic lens.[40] By comparison, Lemaître had little to offer. But it is worth looking a little further, before passing to the events of 1839, at the exceptional position of Daguerre as an artist, both within and outside the context that has already received attention here. In many respects, he fitted perfectly into the Romantic milieu. In a few, however, he was exceptional.

Daguerre's small painting, *Intérieur d'une chapelle de l'Eglise des Feuillants* (1814, Louvre), can be regarded almost as a manifesto for a new kind of visual image, attuned to the sensibilities of the Bourbon Restoration. He would not have forgotten that this Parisian church had played a highly prominent role in the art of the revolutionary period. David was granted permission to use its vast space to work on his monumental project of the *Oath of the Tennis Court* between 1791 and 1803. Daguerre has, however, placed his work in clear succession to the movement of David's breakaway students known as the Lyons School (and sometimes as the *peintres troubadours*). It recalls, for example, the back-lit Gothic chapel of Fleury Richard's *Un Chevalier se préparant au combat* (1805, Musée des Beaux-Arts, Lyons). Daguerre does not yet feature the striking characterisations of religious ritual which will enable Granet – a close ally of the Lyons School – to shine at the Salon of 1819 with his *Choir of the Capuchin Church*. But he does give ample proof of his ability to satisfy the growing contemporary taste for the depiction of historic, often ecclesiastical, buildings in light conditions conducive to poetic associations. Ten years later, he will be producing much larger and more ambitious paintings in the same vein, like *Ruins of the Chapel of Holyrood* (1824, National Galleries of Merseyside), but by that stage only as by-products of the same scenes presented as public spectacle in the diorama.

It is a curious coincidence that Daguerre's *Eglise des Feuillants* was in fact engraved by Augustin Lemaître, who was in the process of finishing it in February 1827 when Niépce

enquired if they were acquainted. At this point Lemaître merely acknowledged that he had met Daguerre at evening parties 'some years ago'. Both Daguerre and his chief assistant in the creation of the diorama, Charles-Marie Bouton, had however contributed lithographs, like Lemaître, to the great publishing enterprise of the *Voyages pittoresques*, which offered exceptional opportunities for *troc* between the young artists and printmakers of the Romantic generation. Bouton's papers in the Cromer collection (George Eastman House, Rochester, N.Y.) give a vivid insight into the excitement of such printmaking assignments, which entailed joint expeditions throughout the French provinces, as well the ensuing opportunities to excel in the virtuoso use of the new graphic medium. Bouton's lithograph *Le Monastère*, for example, probably derives from a rumbustious excursion to Normandy recorded in his papers.[41] It is also, incidentally, a bizarre exercise in lithography, probably made in imitation of the etching techniques used by the English printmaker J. S. Cotman, for his *Architectural Antiquities of Normandy* (1819–22).

Daguerre did not himself try to extend the possibilities of lithography. But he displayed a constant interest throughout his career – and far beyond 1839 – in a variety of traditional media that would enable him to register architectural spaces and landscape effects with suggestive delicacy. In his last years he became proficient in pastel and watercolour. Around 1827, however, he was specially taken by a recondite technique then known as *dessin-fumée*, which allowed him to achieve tonal effects of intense, and technically inscrutable, chiaroscuro. As one of his first gestures of cooperation with Niépce was to send him one of these works, it is appropriate to close this section with a brief examination of their significance.

Niépce was quite baffled by the strange little work. He wrote in a letter to Lemaître dated 3 April 1827:

I forgot to tell you, in my earlier letter, that, just when I thought I would have no further relations in future with M. Daguerre, he wrote to me and sent a little drawing in a very elegant frame, made with sepia and finished with the aid of his process. This drawing, which represents an interior, produces a great deal of effect, but it is hard to determine what is uniquely the result of the application of the process, since the brush has intervened. Perhaps, Monsieur, you would already know about this type of drawing which the author calls *dessin-fumée*, and is sold by Alphonse Giroux.[42]

Almost certainly Daguerre did not invent the technique of *dessin-fumée*. The Cromer collection has what might be called comparative examples of exotic landscape drawings from the same period, in which the black tones have indeed been created by candle smoke, but the use of white body-colour as a contrast creates a phoney picturesque effect.[43] Daguerre's work is instantly recognisable by its choice of distinctive subjects already tackled by the artist in other media. His *Gothic Ruins* (George Eastman House, Rochester, N.Y.) is a typical vista of the shaded choir of a ruined church, with small figures outlined in the doorway (pl. 46). As Cromer describes it, it is a 'drawing with sepia, darkened in places by the smoke of a candle, its margins being masked by a card during the process of fumigation'.[44]

This is an accurate account of the process, and the masking is evident from the way in which the edges of the image bleed off. But it compounds Niépce's problem, which was precisely that the spectator could not determine where the effect of the smoke began, and that of the brush finished. In an even more tantalising work in the collection

51 Louis-Jacques-Mandé Daguerre, *La Procession*, *c.*1826–7. Drawing with white body-colour and candle smoke (*dessin fumée*). Musée Nicéphore Niépce, Chalon-sur-Saône.

of the Musée Niépce, which has been titled *La Procession*, the lugubrious night scene of an interment in a graveyard lends itself to metonymic elaboration of the *dessin-fumée*: smoking torches are borne aloft by the cowled figures, and the whiteness of the smoke is conveyed through tiny scratches in the smoke-darkened surface, as well as by little touches of body-colour (pl. 51). It remains virtually impossible to separate out the different techniques used to produce the image, and the fact that these drawings were necessarily sealed behind glass, to prevent abrasion of the unfixed smoke deposit, still adds to their fascination.

More than twenty years later, and as a long-term result of his meeting with Niépce, Daguerre could present to his public another type of small image, framed and glazed, fixed by fumes of mercury, in the creation of which crayon, burin, pencil and brush had played no part whatsoever.

* * *

Up to now I have been alluding to a long and complicated process: the interaction between Niépce and his collaborators over many years involving several changes of direction. It makes little sense to ask, in relation to this story: when, precisely, was photography invented (despite the precedence accorded retrospectively to what we can call the 'first photograph')? In the case of the daguerreotype, however, events conspired to create the myth of photography's 'invention'. This was given authority by the French state's desire to have such an innovation unequivocally associated with their national genius, but it also testified from the start to the kind of definitive cultural and epistemological shift later to be acknowledged by Benjamin. No clearer sign of the early currency of the myth can be found in the nineteenth century than Delaroche's much quoted remark: 'From today painting is dead.' The first instance of its publication, in the chemist and aeronaut Gaston Tissandier's *Les Merveilles de la photographie* (first edition, 1873) is well worth quoting in full. In Tissandier's colourful account, the two academies of Arts and Sciences are in joint session at the Palais Mazarin on 10 August 1839; when 'Paul Delaroche saw Daguerre, he tore from his hands a plate impressed by light. He shows it all around crying out: "*La peinture est morte à dater de ce jour*".'[45]

This account given by Tissandier abounds with problems and inconsistencies. For a start, nothing of the sort happened on 10 August. The meeting of the two academies was in fact held on 19 August 1839. On this occasion, moreover, Françcis Arago quoted from a memoir specially written at his request by Delaroche, in which the advantages of the new technique from the painter's point of view were fully and fairly discussed. Why would the notoriously restrained Delaroche have made a scene that involved snatching the offending object and brandishing it in front of this distinguished assembly? And what pos-sible significance can be attached to the temporal marker 'from today'? Had there not been discussion in Paris of the implications of Daguerre's 'very surprising discovery' even before the first meeting of the Académie des Sciences first took note of the development – at their session of 7 January 1839?[46]

In other words, the tale is deeply implausible on several levels. But what it does faithfully indicate is the involvement of Delaroche, by that time among France's most celebrated painters, in the public discussion and manifestation of the new technique, and perhaps not only as Arago's fine art consultant. His involvement is further demonstrated by the existence of a visual document hardly less problematic than Tissandier's truncated account, which however presents an altogether more credible and interesting scenario. This is the undated oil painting by Prosper Lafaye (1806–1883) entitled *Conférence dans le salon de M. Irisson sur la découverte de la photographie, en 1839* (pl. 52). Lafaye's painting would, however, be destined to keep many of its secrets for ever if it were not for the existence of a watercolour of similar size, with several important variants and a series of informative inscriptions, in the collection of the Musée français de la photographie at Bièvres (pl. 53). The title of the oil painting is tantalisingly imprecise. But the sketch clearly indicates, under the title *L'Invention de la Photographie*, that this is a briefing being conducted, after an academy meeting, by Paul Delaroche and his father-in-law, Horace Vernet. The two texts under the title read as follows:

Horace Vernet

The evening of 27 January 1839, still very impressed on leaving the Academy, where he had heard the report on the discovery, known then under the name of Daguerreotype, the people assembled in the salon of M. I. to whom he communicated this news were unable to understand the extraordinary developments that people seemed to expect from such an invention.

Paul Delaroche

Intervened and sought to make perceptible comparisons such as, for example, the possibility of fixing images reflected in a mirror on paper or any other body, offering the aspect of an engraving; the astonishment grew as the demonstration came to be understood.[47]

Quite a number of remarkable features emerge straight away from this visual and verbal rendering of Delaroche's intervention. It should be noted that Horace Vernet is the first person to secure the interest of the animated salon. In the sketch, Delaroche is standing beside him, whilst in the painting he is seated rather obscurely in the background. But the inscription leaves us in no doubt that he managed to convey to his audience the revolutionary effect of the photograph, by citing the possibility of a medium akin to engraving that would permanently fix the fugitive mirror image. In complete contrast to Tissandier's account, this explanation seems to take place without there being an actual daguerreotype as an exhibit to convince (or alarm) the audience – though it is clear that daguerreotypes were on hand at the academy meeting of early January.[48] But both Vernet and Delaroche have obviously seen examples, and Delaroche, at any rate, already seems to envisage possibilities that go beyond the potentiality of the daguerreotype in its specific form as a unique print, since he refers to the hypothetical registration of the photographic image on paper or other suitable surfaces.

Yet there are difficulties involved in taking Lafaye's two pictures at face value. Just as with Tissandier's version, the dating initially appears suspect. He ascribes the event to 'the evening of 27 January'. Yet there can be no doubt that the crucial session of the Académie des Sciences, at which Arago made his decisive announcement about Daguerre's 'invention', took place on 7 January 1839. It is possible that Lafaye's caption refers to a subsequent meeting held by the Académie des Beaux-Arts. But this is unlikely as 27 January was a Sunday, and their meetings habitually took place on a Saturday.

Equally inconvenient at first sight is the specification of the audience. It is certainly quite plausible that Delaroche and Vernet might have paid an evening visit, on their way back from the Palais Mazarin on the Left Bank to the Nouvelle Athènes quarter, to comte Augustin-Guillaume d'Irisson d'Hérisson and his wife, Dorothée-Julie-Ernestine (née Maurice-Allard), at their residence, 10 rue d'Antin (later to be destroyed in the *percement* of the avenue de l'Opéra). But the boy indicated in the key as Maurice I., who is lolling over his brother's knee in the left foreground, can hardly be their son, the future soldier and publicist comte Maurice d'Irisson d'Hérisson, since he was only born in September 1839.[49]

These are small pinpricks of inconsistency within a scenario that has an overall plausibility. However, they alert us to the fact that this pair of works was certainly painted

52 (*above*) Prosper Lafaye, *Conférence dans le salon de M. Irisson sur la découverte de la photographie en 1839*, 1844. Oil on canvas, 71 × 98. Musée Carnavalet, Paris.

several years after the event, and that they reflect a particular viewpoint – implicitly also a painter's viewpoint – on the great issue of the Invention of Photography. At the conclusion of this section, it will be necessary to look with care at the background of the artist Prosper Lafaye himself, and review the convincing arguments that have been put forward to establish the dating of the two works. For the moment, however, I intend to pursue the question of the sequence of events in 1839, which has to be more fully investigated before we can definitively ascribe the salon performance of Delaroche and Vernet to the beginning of the year. This will be done, as previously indicated, through summarising the reviews of the sittings of the Académie des Sciences as reported in the *Courrier français*. I shall also take the chance to pick up various items of report and publicity that help to fill out the general artistic context of this exceptional year.

Arago's statement of 7 January 1839 to the Académie des Sciences came at a time when the artistic significance of Daguerre's discovery was already an issue of some public debate. To quote more fully the *Courrier* report of 11 January: 'People have been talking for some time in Paris about a most surprising discovery by M. Daguerre, the clever artist and author of the Diorama, which discovery was bound radically to change all the existing processes of painting.'[50] Arago's message (as summarised by the *Courrier*'s reporter) was thus intended, at least in part, to reassure the artistic community: 'Let us try to make

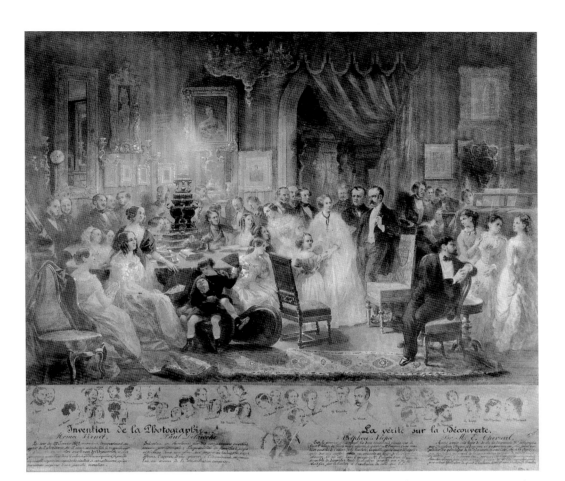

53 Prosper Lafaye, revised version of pl. 52, c.1878. Watercolour. Musée français de la photographie, Bièvres. The key at the bottom specifies, among the most prominent members of the group: (centre right) Louise (Vernet) Delaroche holding hands with the young Alice Irisson, Paul Delaroche (identified by the characteristic lock of hair across his forehead) and Horace Vernet, who is gesticulating with a raised index finger. Nicéphore Niépce, who was, of course, dead by 1839, is treated to a medallion portrait between the two blocks of text, and his cousin, Abel Niépce de St-Victor, is the figure interpolated in the background between the two Delaroche.

known, at least in the part that is not secret, the processes with the aid of which M. Daguerre seems to threaten the art of drawing with a total revolution.' The essential feature of his technique could be summed up by Arago in a graphic turn of phrase that would soon become (by the time of Gautier's commentary on Bingham) a critical commonplace. 'It consists simply in this: he has found the means of making light itself become an artist, and of reproducing on a given background the details of a vast landscape with all the marvellous delicacy of such a brush.'[51]

Of the technical details, the 'secret' part, of the process, there is nothing in this first presentation. The *Courrier* reporter establishes very clearly that there are two aspects to Daguerre's discovery: the 'well-known property of the camera obscura' and the process of 'fixing the image in a stable manner' so as to 'leave a durable trace'. The recipe for the latter remains, for the moment, Daguerre's own. But if the assembled scientists and *savants* had the challenge of speculating on the chemistry of the daguerreotype process

after the meeting of 7 January, they also received the gratification of seeing some of the actual products of Daguerre's ingenuity. 'They were above all struck by two views within Paris, one taken from the Pont des Arts and the other from the Pont Saint-Michel.'[52] Arago commented on the fact that these intricate views had been obtained through an exposure time of eight or ten minutes, and suggested that the artists who had accompanied Napoleon on his Egyptian expedition would have had their labour spared if they had possessed this invaluable equipment.

Perhaps Arago succeeded in planting the idea that was to lead Horace Vernet to embark on his own Egyptian expedition, with daguerreotype equipment, before the end of the year. Or perhaps he was reflecting his own awareness of a debate about the possible uses of the new process already taking place among artists. In either event – though it is impossible to state categorically that Vernet and Delaroche attended the meeting of 7 January – the second speech of the day, by the physicist and astronomer Jean-Baptiste Biot (1774–1862) establishes beyond doubt that Delaroche had already had occasion to deliver an opinion. Biot, who was a distinguished polymath and at that time Vice-President of the Institut (comprising the different academies), reported that he had visited 'this new gallery of light drawings (*dessins de lumière*) at the same time as the famous history painter M. Delaroche'. He assured his audience: 'this artist not only shared the admiration of the academicians, but believed as well that this genre would furnish the study of the distribution of light with the most instructive effects which it would be almost impossible to make evident to students by any other means'.[53]

All the indications are that, at this meeting of the scientific establishment, a pre-emptive move is being made to forestall the possible objection that the Institut is endorsing an invention that will bring destitution upon painters and engravers. Delaroche, as a prominent member of the sister academy and Professor at the Ecole des Beaux-Arts, has already been enlisted in the attempt to quieten any such suspicion. He continues to fulfil this role when he compiles, at Arago's request, the report on the daguerreotype that the latter will quote at the joint meeting of both academies on 19 August 1839. In this document, Delaroche first of all sums up the utility of Daguerre's 'drawings' from the painter's practical point of view: 'The painter will find in this process a rapid means of making collections of studies that he could not obtain otherwise except with a great deal of time and effort and in a much less perfect manner, however talented he might be.' Then he goes on (in a section not actually quoted in Arago's speech) to the specific case of the engraver: 'The engraver will not only have nothing to fear from the use of this process, but indeed he will succeed in multiplying its results through the means of his art. The studies that he will get to engrave from will be exceptionally interesting for him.'[54]

There appears, then, to be a striking contrast between the role that Delaroche was actually playing at this stage and the melodramatic incident presented by Tissandier. Far from predicting the demise of painting, he seems to have envisaged a highly useful future for the photograph within the parameters of the existing academic system. But we should not dismiss lightly the sense of crisis to which Tissandier alludes. There may have been as yet no sense that the new technique was likely to infringe the artist's right of reproduction – in defence of which Horace Vernet was even at that moment honing his polemical skills. But there were quite a number of other aspects of the new development that must have caused concern over the year 1839. This may to some extent explain why Delaroche was credited with making a dire prophecy that his public positions explicitly disavowed.

In the first place, the year 1839 marked a point of irreconcilable difference between conservative and progressive forces within the Académie des Beaux-Arts. After the Salon of 1837, Paul Delaroche had effectively abandoned his agitation for reform of the Salon jury, and decided to exhibit his own work no longer.[55] As the critic Alexandre Tardieu pointed out in his first article on the Salon of 1839, published in the *Courrier* of 3 March, this was an exhibition lacking in any paintings by Ingres, Delaroche, Cabat, Camille Roqueplan, Charlet or Paul Huet. In other words, it featured neither the most acclaimed history painters of the decade, nor the leading lights of Romantic landscape painting. As Tardieu went on to explain further in a subsequent article, major paintings submitted by Delacroix had been refused, with his work *Le Fou* (showing the poet Tasso in prison) being contemptuously dismissed as 'something disgusting'. All that Tardieu could find to praise unequivocally was a group of five paintings by Ary Scheffer.[56]

Delaroche himself would not have been unduly troubled by the fact of not showing his work to the public in this déclassé exhibition. He was advancing towards the completion of his huge painting of 'artists of all ages' in the *Hémicycle des Beaux-Arts*. Indeed the *Courrier* of 11 August announced the limited opening to the public of the architect Félix Duban's new *Palais des Beaux-Arts*, where the work was being situated.[57] He was no doubt fully occupied with the direction of this highly prestigious project, which involved several of his brilliant pupils from the Ecole des Beaux-Arts as assistants. But he must have been concerned all the same with the educational implications of the obdurate blockage of career opportunities for young painters by the surviving neoclassical faction in the academy. Against this background, it is not difficult to see that he would be committed to emphasising the future of painting rather than its past, and consequently ready to put his weight behind the endorsement of Daguerre's invention as a specific pedagogic tool. The fact that a significant number of major French photographers of the first generation were trained in Delaroche's studio (as will be mentioned later in this chapter) should be understood within this overall context.

Delaroche's mention of the utility of the daguerreotype for engraving can also be seen as an intervention in a different, though related area of cultural politics. He certainly shared his father-in-law's view of the importance of engraving – and the possession of reproduction rights – for the furtherance of an artist's reputation. The evidence given in chapter 1 gives ample proof of that. By 1839 he could see the fruits of his close association with the publisher Goupil bearing fruit, as the fine burin engravings of his major works began to reach publication: his portrait of Guizot (1837), engraved by Calamatta, was already available by 1839, and both Henriquel-Dupont's engraving after *Strafford* (1837) and Forster's after *Sainte Cécile* (1836) would follow suit in the subsequent year. The *Courrier français* gives the impression, in a number of news items, that the engraver's trade was prospering in 1839, whatever the state of the Salon. A notice of 27 January announces the completion by the notoriously rapid Jean-Pierre-Marie Jazet of his engraving after Horace Vernet's *Assaut de Constantine*, which actually appeared in advance of the painting's appearance at the Salon: the view is expressed that 'this pretty print deserves a place in our apartments'.[58]

On a less mundane level, Charles Blanc writes extensively, in an article of 21 March 1839, of the current diversification of engraving methods into mezzotint (*manière noire*) and aquatint.[59] This article is perhaps the first piece in which the former apprentice in Calamatta's studio (and future editor of the *Gazette des Beaux-Arts*) shows his abilities as

a thoughtful and sophisticated critic, and it will receive closer attention in the chapter that follows. But the basic message can be stated without ambiguity. Engraving is well established enough to welcome and assimilate new technical developments, with no fear of the tried and tested methods being abandoned.

Is there then any sign in the events documented by the *Courrier* of the 'universal stupefaction' mentioned by Nadar? Can we detect panic reactions to photography within the artistic and critical community? This question may seem loaded, but it prompts a further scrutiny of the sequence of events. At the successive sittings of the Académie des Sciences, Arago raises (and after due consideration dismisses) the issue of the alternative claim of Fox Talbot to have discovered the photographic process; his conclusion is that the Englishman has undertaken 'a series of researches parallel to those of MM. Niépce and Daguerre, and the latter have priority'.[60] He also communicates, at the sitting of 27 February, 'quite new details on the experiments of M. Daguerre', which enable the technical comparison with Fox Talbot's process to be made without giving away all of Daguerre's secrets.[61] Shortly afterwards, a dramatic event occurs. As reported in the *Courrier* of 10 March, the Paris Diorama is burned to the ground, taking with it Daguerre's photographic laboratory, his materials and forty of his precious daguerreotypes.

There can be little doubt that, from Daguerre's point of view, this event was not an unmitigated disaster. A government committee, advised by Delaroche, decided on appropriate compensation for the loss of the Diorama, and Arago took immediate steps to secure a pension both for Daguerre and for the son of Niépce. It was Arago who continued as spokesman for Daguerre's discovery when this new financial provision made it appropriate for the scientific details to be finally placed in the public domain. Daguerre was indeed present at the joint meeting of the academies on 19 August, but he was not willing to speak, and it was Arago who stepped in to satisfy the curiosity of the 'vast crowd of listeners and members of the Institut'. Arago explained 'the mysteries of this invention in a very lucid improvisation, which captured to the highest degree the attention of the assembly where all our *savants* and artists had gathered together'.[62]

Daguerre did not retire from the lists completely. An account in the *Courrier* from 8 September 1839 shows him demonstrating the process of the daguerreotype in a room at the Hôtel du Quai d'Orsay – well placed to obtain the kind of view across the Seine featured in his earlier prints.[63] But this was clearly an occasion aimed at promoting the sale of the photographic equipment, which was advertised in the *Courrier* on 26 August as being available from Alphonse Giroux et Cie – precisely the same company as had sold Daguerre's *dessins-fumée* over ten years before. The loss of his previous large collection of daguerreotypes could never be made up, and this must account in large measure for the curious hole in photographic history where the productions of so important a pioneer ought to be compared with the voluminous output of his English rival. At a meeting of the Académie des Sciences of 28 June 1841, it was noted that they had 'at last' heard from Daguerre, who had gained the reputation of being like 'Achilles resting in his tent'.[64] But the substance of the communication was an interesting technical improvement, resulting in a decrease in exposure time rather than a promise of new works.

This record still stands at the time of Daguerre's death, on 10 July 1851, when the *Illustrated London News* reported in its obituary that he 'never did much towards the improvement of his process'.[65] In fact, Daguerre did extend his expertise in several traditional artistic techniques during his retirement. Of his dated works in the Musée

54 Louis-Jacques-Mandé Daguerre, untitled country scene, 1848. Watercolour. Musée Nicéphore Niépce, Chalon-sur-Saône.

55 Louis-Jacques-Mandé Daguerre, diorama in the Church of Bry-sur-Marne, *c*.1850.

Niépce, there is an ambitious watercolour sketch from 1848 showing two peasant children in a brilliantly lit courtyard (pl. 54) and an accomplished landscape scene in pastel from 1850 which subtly blends the red and lemon tints of the sunset.

Daguerre also worked in his last years on a miniature diorama for the small church near his residence at Bry-sur-Marne, which surprisingly extends the modest classical building with a perspective of a full-scale Gothic choir when the curtain behind the High Altar is drawn back (pl. 55). He even produced a garden design for his neighbour Mademoiselle de Rigny, which Cromer accurately compared to an earlier *bistre* drawing of a tree (George Eastman House, Rochester, N.Y.). Ironically this drawing of *Grotte et ruines dans le Parc de Bry* no longer exists, and is preserved only by way of a late nineteenth-century photograph.

These five-finger exercises by Daguerre are not important in themselves. But they do return us once again to one of the main questions posed in this chapter, which is the difference between the levels of investment in the photographic image of the many practitioners involved with its propagation. Daguerre gracefully abandons his invention to

others. But the preoccupation of professional painters and engravers with the conse-
quences of photography continues long after the intensely packed time table of 1839 has
become past history. Photography then begins to generate its own mythology, loosely
based on the historical facts, but distorting them so as to reveal subterranean currents of
fear and doubt beneath the technological optimism that lies on the surface.

This is one way of looking at Tissandier's anecdote about Delaroche. It cannot be
squared with any concrete evidence about the public attitude of Delaroche to the inven-
tion of the daguerreotype. Yet it picks up, in a certain way, the inhibitions which
Delaroche and many other members of the artistic community must have felt about the
future of academic painting in a rapidly changing artistic and cultural world. Its very
celebrity, up to the present day, has helped to concretise a myth that has recurred in
Western painting ever since the Renaissance, but is not inappropriately associated with
a painter poised on the cusp between tradition and modernity.[66]

Prosper Lafaye's painting of the Irisson salon is also, in a sense, a mythic rendering
of the history of the invention of photography in 1839. But it is one that has received vir-
tually no attention from photographic historians, and one that presents an altogether more
complex view of events. In the light of the fuller discussion of chronology that
has been given here, we can perhaps move towards making some general points about its
significance, without aspiring to clear up the many difficult points of detail that it raises.

In the first place, I see no reason to question the basic point that both the painting
and the watercolour relate to a specific event, when Horace Vernet and Delaroche did
indeed extemporise a little introduction to the properties of the new medium in the recep-
tion rooms of their friends in the rue d'Antin. It is inconceivable, however, that this could
have taken place as late as August 1839, when only the specifically technical details of
the daguerreotype process remained to be communicated. In view of the clear indication
in the *Courrier* that rumours relating to the remarkable new invention were circulating
in Paris before the meeting of the Académie des Sciences on 7 January, it seems highly
likely that January is the month, though the date of 27 January given in the sketch is
probably a misprint for an earlier one.

What needs to be established is the lapse of time before Lafaye painted the two works.
Here the research of the staff of the Musée Carnavalet, initiated by an article by Jean
Vallery-Radot, seems to me to be decisive. The watercolour, in the first place, is not a
sketch for the oil painting, as might first appear likely. On the contrary, it was most prob-
ably completed close to the end of Lafaye's life, around 1878, and destined to be shown
in an exhibition dealing with the history of photography. This would account for the
presence at the extreme right-hand side of the watercolour (though not in the paint-
ing) of a young woman identified in the key as 'G. Lafaye', who must be the artist's
daughter, Geneviève, together with her two married sisters, Madame Montreuil and
Madame Mondain. Lafaye has made his family into honorary bystanders at the social and
intellectual event. He has also included, fifth from the left against the left-hand wall,
one 'Tissandier' who must be the self-same person as the broadcaster of Delaroche's
apocryphal remark.

The watercolour remained in the possession of Lafaye's family until it was donated to
the museum at Bièvres by the artist's great-granddaughter. One may also infer that the
oil painting, on which it was so closely based, remained with Lafaye until this late stage
in his career. But what was its original purpose? Who was it intended for? Here again the

research of Vallery-Radot leaves no room for doubt. Lafaye's diary for 1844 records the various sittings in which he sketched the close friends of the Irisson family. He had evidently been commissioned to record a typical evening of entertainment in their luxurious salon. Thus the portraits of the Irisson children, including Maurice as a pudgy five-year-old on the knee of his brother Georges, were quite in order. However, the commission must have metamorphosed, at some stage, into a request to record a specific event: the appearance of Vernet and Delaroche in the salon with their historic message. Lafaye records in his diary a visit to Vernet, in which he agrees to pose in the painting for Irisson.[67]

Lafaye has therefore celebrated a moment in which a historic event impinges on a gathering of family and friends. The count is shown in profile in the middle background, beneath what may be one of his family portraits, in both painting and watercolour, though he is silhouetted with more emphasis in the former. The countess appears in the painting as a seated figure, listening attentively to Horace's speech, in the middle foreground. In the watercolour she is less frontally placed, and it looks as if her son Georges may have seized her fan to chastise his brother Maurice. In both versions, the most prominent central figure is Louise Delaroche, who listens to her father's speech while keeping the attention of the more modestly behaved little Alice Irisson. The major change from the painting of 1844 to the watercolour of around 1878 is, of course, the increased centrality given to the two painters who are explaining the mysteries of photography.

It seems that it was a quarrel between Lafaye and his patron that interrupted the completion of the oil painting, and prevented it from passing out of his possession. Whatever may have been the reason for this contretemps, Lafaye did not have an encouraging career in the mid-1840s. After 1847 he ceased to exhibit at the Salon, and an entry in an American encyclopedia compiled shortly after his death wrote of him as being 'confined . . . chiefly to glass decoration' from 1850 onwards.[68] But if only because this moderately successful mid-nineteenth-century artist took a position on the 'Invention of Photography', it is worth looking a little more closely at the stake which may have been involved there for him.

Prosper Lafaye (1806–1883) was a Burgundian by birth, the cousin of the great lithographer Gavarni, who gave him lodging when he arrived in Paris in the 1830s. Lafaye, however, commenced his artistic career in a traditional academic manner, as a pupil of Auguste Couder. His first assignments were battle paintings which contributed to the acreage of national subjects in the Musée historique de Versailles. He also painted in his early years *Le duc d'Orléans traversant la place du Châtelet, le 31 Juillet 1830* (Musée Carnavalet, Paris), which offers in its temporality, its title and its facture a modest sequel to Vernet's *Le duc d'Orléans quitte le Palais-Royal pour se rendre à l'Hôtel de Ville* (Louvre). But he soon inclined towards the treatment of contemporary interior scenes, specialising in shops, theatres and salons, such as the *Vue du Salon de la Princesse Marie d'Orléans aux Tuileries* (Musée des Arts décoratifs, Paris, 1842). This is an obvious precedent for the Irisson salon painting.

Lafaye's change of direction in the 1840s could be said to derive logically from the technical preoccupations of his interior scenes. Another painting in the collection of the Musée Carnavalet, the *Chapelle de la Vierge à l'église Saint-Gervais*, displays light filtering through the ancient stained glass in a way which provokes comparison with his lamp-lit salon scenes. In fact the very lack of finish in the Irisson painting – whether or not it was due to the cancellation of the commission – suggests a special interest in the way in which

soft ambient light flattens the features and provides an opportunity for lively brush work in the representation of light clothing materials. Although it would not make art-historical sense to mention Turner's interior studies at Petworth in this connection, Lafaye seems to have little affinity with French artists of the July Monarchy in this respect.

Nearly twenty years later, Manet's *Music in the Tuileries Gardens* (National Gallery, London, 1862) offers another ciphered gathering of Parisian personalities, with the dappled light of tree shade providing the pretext for a similar dissolution of features and forms. By this stage, however, Lafaye had begun to move from the painterly evocation of coloured light to its architectural instantiation. Work in the neo-Gothic church of Sainte-Clotilde and, above all, the great rose window in the west front of Victor Baltard's iron-framed masterpiece Saint-Augustin (opened in 1879) attest to his achievement.

Just as Lafaye shifted the emphasis of his artistic career over the period in question, so the two versions of his work on the invention of photography turn out to have significantly different meanings according to the changing historical context. In the oil painting of 1844, there is an implicit sense (despite the non-fulfilment of the commission) of the artist's conviction of the future that lies in front of painting. It will take on new tasks associated with the record of modern life, while renewing the vitality of traditional genre opportunities. In these works, assuredly, the painter is still in control, whether in the *énoncé* of Vernet and Delaroche mediating the new invention to the public, or in the *énonciation* of Lafaye's own painterly style. Vernet's raised index finger denotes the opening of a discourse that will make sense of the new invention. Delaroche is on the point of clarifying the issue with his convenient analogy of the reflections in a mirror. In the water colour, it becomes apparent that there is a mirror opposite to the two painters, on the left wall, which is clearly picking up the reflection of another mirror on the opposite side of the room. The performative function, in other words, circulates between the narrativised elements of the scene and the agency of the artist's brush which, in the oil painting at any rate, has acquired primacy.

However the watercolour, with its elaborate key, tackles the issue of historical record in an explicit fashion. It includes, beneath the image, two further paragraphs on 'The Truth about the Discovery' attributed to the well-known scientist Eugène Chevreul, which complement the material on the 'Invention of Photography' already discussed. In effect, this testimony amounts to a rehabilitation of Niépce as the true inventor of photography and a downgrading of the role of Daguerre. Niépce is held to have been the first to 'fulfil the two conditions necessary for fixing the image of the camera obscura', while Daguerre, 'in associating himself with [Niépce] to exploit the advantages of the discovery, only brought to the association his personal talent in the practical knowledge of painting as demonstrated by the works of the Diorama'.[69] Chevreul's text goes on to credit two further figures, the English scientist William Hyde Wollaston – inventor of the periscopic camera obscura – and Niépce's Parisian supplier of optical apparatus, Charles Chevalier, with a further important role in perfecting the camera obscura, 'entirely irrespective of the invention of heliography'.

Lafaye's late watercolour with commentary is thus, in sum, an attempt to set the record straight, by endorsing the authoritative statements of both scientists and artists. In this respect, it challenges the vulgar historical account already current at the outset of the Third Republic. As previously noted, one of the company anachronistically present and identified in the key is a young and bearded 'Tissandier' who (we have assumed) is the

scientific populariser responsible for the appearance in 1873 of the crudely nationalistic *Les Merveilles de la photographie*. The propagandist who proudly announced that 'photography is indeed a French science' had little incentive to linger on the diversity of its origins. He was obliged to focus, to the exclusion of all else, on the official adoption of Daguerre's process by the French state. The notorious remark that he attributed to Delaroche at the session of 10 August 1839, whatever its origin, served its purpose as an introduction to his own grandiloquently banal vision of photography's destiny: 'The art of Raphael and Michelangelo was not dead; on the contrary, it had found, in the inspiration of a great inventor, new resources, and Science had held out its hand to Art.'[70]

<p style="text-align:center">∗ ∗ ∗</p>

In the final section of this chapter, I will not seek to further the debate initiated by Tissandier on whether, or from what point of view, photography is art.[71] The approach of this study has been avowedly relativistic, in that I have attempted to comprehend how the various artistic practices current in France in the first half of the nineteenth century related to an overall concept of reproduction that had legal and cultural, as well as technical, ramifications. As we have seen, the initial way in which 'heliography' was accommodated within the academic framework was as a form of drawing, and so the early defenders of the photographic process were obliged to demonstrate that it facilitated the painter's task by cutting out the need for laborious free hand studies. In his public statements, Delaroche did precisely this. But a further issue arose, of a quite different order, if photography was seen as a means of reproduction analogous to, and potentially in competition with, reproductive engraving. This was a challenge, not to the traditional understanding of the range of academic techniques, but to no less a factor than the visual artists' passport to immortality, enshrined during their life times (and beyond) through the legal definition of reproduction rights. The fact that a burin engraving took many years to complete, whilst the photograph was registered in a matter of minutes, made it inevitable that there would be an eventual conflict.

Indeed, the photographer did not even have to reproduce the painting itself. A copy could be made directly from the reproductive engraving, thus capitalising on the huge investment of time, skill and money made over a long period by the engraver and the publisher. Anthony Hamber has written incisively about the 'piracy' of original engravings by photographers from around 1860 onwards in the opening section of his study *Photographing the Fine Arts in England 1839–1880*. He has chronicled in an admirably thorough way the social, legal and cultural context in which such photographic reproductions of engravings succeeded, nonetheless, in establishing their artistic credentials.[72] However, Hamber's invaluable study deals chiefly with England, with only the occasional side-glance to the other side of the Channel. On the French side, the milieu of photographers dealing primarily in art reproductions has received little attention. Even the art reproductions of acclaimed photographers who have become famous for their 'points of view' from nature have tended to be seen as an insignificant side-line to their other activities, unworthy of special attention. Consequently, any prospective study of the relationship between reproduction photography, on the one hand, and reproductive engraving, on the other, comes under the disadvantage of having to find connections between two virtually untouched fields.

It will be part of the task of my remaining chapters to look at French reproductive engraving in a broad context, and this will inevitably involve some attention to the ways in which photography affected the viability of the practice. In the present chapter, concerned specifically with the early years of photography, I want to conclude by trying to answer a very precise question. At what point, and with what degree of success, did the photographer specialising in art reproductions emerge as an established practitioner, recognised as such by the artist, and possessing both a market and a critical audience? This is a question that will be pursued in relation to the small group of painters who form the core of my study. But the answers will stress their diversity in this respect, and the unique case of Ingres, in particular, will be left till the next chapter.

It goes without saying that the question only arises in an acute form for those painters who took a consistent interest in the engraved reproduction of their works. Delacroix remains here, as in other respects, the exception to the rule. It is typical that he should have noted wryly in his journal, apropos of artistic reputations: 'Happily, fragile though it is, painting, and in default engraving, conserve and put before the eyes of posterity the trial documents.'[73] According to Théodore Silvestre, Delacroix only realised late in his career that his reputation might depend on the availability of prints reproducing his works, and bemoaned the lack of suitable engravers to interpret and disseminate his manner.[74] In practice, the 'default' case for Delacroix, whether based on his own engravings or the relatively scarce engraved reproductions after his works, has never had to be heard. The advent of commercial colour photography has, of course, transformed the situation, and made him one of the most frequently – and sumptuously – reproduced of modern artists over the last fifty years.

Delacroix's personal interest in photography was, however, engaged on quite a different level. Perhaps one of the first painters of his time to be photographed by the daguerreotype process, as early as 1842, he also possessed at least one album of studies from the nude, probably by the photographer Eugène Durieu (1800–1874). These images (as Sylvie Aubenas has put it) helped him to practise his drawing skills like a pianist playing his scales.[75] They were certainly in his hands by May 1853, and it is possible that they were the subject of a lively letter to a photographer dated 2 February 1853 (George Eastman House, Rochester, N.Y.), in which Delacroix acknowledges the 'magnificent photographic prints' and adds: 'I am very happy to be obliged to you for these beautiful samples which are treasures for an artist, and which the happy chance of discovery puts at their disposal.'[76]

Such studio studies from the nude represented, of course, a quite different technical application of photography from that required by the reproduction of paintings. Indeed there is evidence to suggest that several photographers were already trying, but failing, to obtain satisfactory reproductive prints in the early 1850s. The case of Gustave Courbet is especially interesting in this respect, since he was (in Michael Fried's terms) one of the first artists to appreciate the connection between photography and the Realist aesthetic.[77] In a letter of May 1853, Courbet writes that he has been busy having photographs taken of three of his works exhibited in the Salon, but so far without success: 'Nothing is so difficult as the procedures. We have had three or four photographers try to take them but they could do nothing.'[78] Other letters by Courbet from the subsequent year suggest that he did eventually obtain satisfactory images. But these have not survived, and there is no trace of their existence in contemporary periodicals or exhibition catalogues. Ten

years pass before Courbet appears to have finally found a photographer with whom he could work, and this will be the specialist in photographic reproduction most prominently featured in this study, Robert Jefferson Bingham.[79]

Yet before passing to the figure who was without doubt the master of the first age of reproduction photography, it is worth pausing on the work already mentioned, by a photographer whose reputation has since far outstripped that of Bingham: Gustave le Gray. Like his equally famous contemporaries, Charles Nègre and Henri le Secq, Le Gray was a former student of Paul Delaroche. It is possible that he collaborated, as his friend Le Secq certainly did, on the great work of the *Hémicycle des Beaux-Arts*, completed in 1841. After the closure of Delaroche's studio in 1843, however, he began to undertake the experimental study of photographic processes that led him, in 1850, to publish his *Traité pratique de photographie sur papier et sur verre*.[80]

In common with all the new photographers of his generation, Le Gray based his experiments not on the daguerreotype process, which resulted in one object and one image only, but in the negative/positive conversion process derived from the calotypes of Fox Talbot. Le Gray was particularly innovative in promoting waxed paper negatives. This was the technique used for his photographic facsimiles of the engravings of the Italian Renaissance master Raimondi, published in 1853. If Raimondi was (as we have seen) the prime example of the power of the engraver to confer immortality on vanished masterpieces, Le Gray extended that power by enabling artists and connoisseurs for the first time to acquire a 'Marcantonio' for a few francs.[81]

It is clear that Le Gray was already reproducing works of art before 1850. His *Treatise* of that year invokes 'larger applications of photographic processes . . . [such as] landscapes, monuments, portraits, and reproductions of paintings and drawings'.[82] Hamber notes that he was photographing in the studio of Gérôme (another Delaroche student) as early as 1848.[83] The reproduction photograph of Ary Scheffer's *Le Coupeur de nappe* (pl. 10) cannot however date from before 1851, since the painting was completed in that very year. And it is very unlikely to date from after 1853, since by that stage the large painting had been sold to the De Kat collection in Dordrecht. When it briefly returned to Paris in 1866 for a sale at the Hôtel Drouot, Scheffer had been dead for six years.[84] Yet the photograph bears not only the studio stamp of Gustave Le Gray in the bottom right hand corner, but also, as mentioned before, Scheffer's autograph signature.

What we have, therefore, in this print from a waxed-paper negative, is a rare example of a reproduction photograph from 1851–3, by a leading photographer, which has been endorsed by the artist. The signature may possibly be there in view of a presentation, since it is unlikely that at this early point there would have been an obvious commercial outlet. Alternatively, the reproduction may have been made simply for the artist's own purposes of record.

Scheffer had painted this extraordinary composition, in which the old Count of Württemberg cuts the tablecloth to express his displeasure at his son's military failure, to serve as a companion piece to a new version of one of his most acclaimed works, *Le Larmoyeur*: the latter shows the old man bitterly regretting his harshness at a later stage, after his son has returned to the battle and died in action. The original version of *Le Larmoyeur* had been seen at the Salon of 1834, and continued to be on view among the select group of contemporary French works on show at the Galerie du Luxembourg. *Le Coupeur de nappe*, however, was not shown at the Salon, since Scheffer had ceased to exhibit there

after the Revolution of 1848. It may have been this combination of circumstances that led Scheffer to arrange for a photograph to be made.

But Le Gray's photograph is certainly more than just a record. It is printed on thin, salted paper, which has a decided grain. Although in black and white (or more exactly, a dark sepia), it convincingly reproduces some of the tonal features of the original. Le Gray cannot catch the brilliance of the white tablecloth, or the highlights upon pitcher, knife and sword-belt as they gleam in the oil painting. Nor can he make the red cloak of the young count form a sombre contrast to the fur cape of his father. But there are aspects that work in favour of the photograph, particularly if we judge the two images by their present-day appearance. Le Gray's print throws the young man's head into relief with a light area above his right shoulder, and clearly distinguishes the silhouettes of two serving men. The painting as it appears today, however, seems to have darkened considerably in the background, with the effect that the head of the young man merges into the shade, and the far side of his distinctive coiffure is hardly visible.

From our contemporary point of view, it is impossible to dismiss the question: in what respects is a photographic print from this period a more accurate record of the original state of the painting than the work as it appears today? But from the historical point of view, it is necessary to subsume this issue within a more all-embracing question. Given that such reproduction photographs presented obvious disparities, in scale as well visual appearance, from the original painting, was it at all possible to develop criteria for deciding what might be a satisfactory 'match'?

The evidence seems to corroborate what common sense would in any case suggest. Courbet condemned the attempts of his photographers, at least in 1853, as failures. Scheffer on the other hand approved, by his signature, the reproduction that had been made up to two years previously. But it must be obvious that, once criteria for such judgements began to be developed in a formal or informal way, the uncomfortable parallels with reproductive engraving would begin to rise to the fore. There was already a well-developed discourse for critic and connoisseur to express the achievement of the reproductive engraver (and a major part of the next two chapters will be devoted to testing it against specific works). But photography was in the position, at least initially, of having no special criteria to evaluate what was, in commercial terms at any rate, a directly competing practice.

To a remarkable extent, the progressive development of these criteria can be observed simply by following the career of one photographer, Robert Jefferson Bingham. Little is known about Bingham's early life in England. Although he later used as his studio stamp the rising eagle crest of the Bingham family of Melcombe in Dorset, he cannot be located in the direct pedigree of the owners of this estate.[85] He was probably born in 1825, and in 1850 he described himself as 'Late Chemical Assistant in the Laboratory of the London Institution', when publishing the seventh edition of his technical treatise on *Photogenic manipulation*. This highly competent guide to the theory and practice of photography contains advanced material about the possible use of the collodion or wet plate process, which Bingham anticipates as being 'equal in sensitiveness to the Daguerreotype'.[86] His prediction was fully borne out when Frederick Scott Archer published the first full account of the wet plate process in March 1851, without putting any patent restrictions on its use, and so effectively sounded the death-knell of Daguerre's invention.

Bingham's decision to settle in France gave a strong impetus to his career, in part because of the continuing interest of the Académie des Sciences in matters of photo-

graphic technique, and in part because of the parallel development of a specialised photo-graphic press. The periodical *La Lumière*, edited by Ernest Lacan and the first to feature *héliographie* on its masthead, took note in its report on the Great Exhibition of 1851 in London that Bingham had shown nineteen prints in the photographic section. By May 1852, it was reporting his detailed exposition of the collodion process to the French Academy of Sciences. Presumably by this stage his studio was already established in the rue de la Rochefoucauld, in the Nouvelle Athènes quarter of Paris, where Delaroche, Scheffer and Vernet all had their residences. *La Lumière*'s first major reference to his work comes in October 1855, when admiring remarks are made about his collaborations with his compatriot Warren Thompson. The two English photographers have used an 'immense lens, to obtain life-size [portrait] images', which French artists have compared to the effects of drawing with stump (*estompe*). If the final verdict on these images is uncertain, because of the disconcerting 'exaggeration' given to skin blemishes and the coarsening of facial features, the enterprise of the pair is very positively endorsed.[87]

Bingham comes across in these early years as an able technician, with considerable expertise in the collodion process and a willingness to explore further possibilities, who has not yet found his direction. He was to find it when Delaroche died at the end of 1856, and the Maison Goupil decided to take the unprecedented step of publishing a catalogue raisonné of his work, illustrated throughout with photographs. Having finally brought to a close the twenty-year saga of Mercuri's *Jane Grey* by including an unpublished proof in the retrospective exhibition of Delaroche's work in 1857, Goupil was ready to commit himself to this entirely new and extremely costly way of commemorating their most successful artist.

There was already a brief history of photographic documentation of art works in book form dating back to Fox Talbot's collaboration on William Stirling's *Annals of the Artists of Spain* (1847).[88] However these experiments had only served to draw attention to the considerable technical and logistical difficulties in making any such survey involving scattered and disparate objects. These were, as *La Lumière* put it when reviewing Bingham's achievement in June 1859, 'known to all practitioners; but it would appear that they did not exist for the able artist of whom we are speaking'.[89] He had coped with the problem of the inaccessibility of certain paintings by photographing directly from the stock of reproductive engravings already published by Goupil. He had even managed to give permanent form to the huge charcoal drawing of Napoleon at Saint Helena that was present, but in a necessarily transitory fashion, on the wall of Delaroche's studio at his death.

As far as was possible at this stage in the history of photography, Bingham had already established himself as the uncontested master of reproductions from paintings. By November 1858, the year of the publication of the monumental *Oeuvre de Paul Delaroche*, the *Chronique* of *La Lumière* was confirming his celebrity: 'The beautiful reproductions of the masterpieces of painting, and particularly those done after the paintings of Paul Delaroche, by M. Bingham, now adorn the studios of artists.'[90] Ary Scheffer had died in June 1858, and when his death was followed, as Delaroche's had been, by a special retrospective exhibition, Goupil took care to commission the *Oeuvre de Ary Scheffer reproduit en photographie par Bingham* (1860), to complement the *Oeuvre de Paul Delaroche*. In March 1860, *La Lumière* placed at the head of its list of new photographic publications, before Baldus, Bisson *frères* and Nadar, the announcement that Bingham had added to his photographs of the works of Delaroche and Scheffer – 'and a good proportion of the pic-

tures which were shown in the last salon' – a further collection of the principal paint-
ings of the rising star of academic art, Ernest Meissonier.[91]

As a specialised photographer of paintings, Bingham thus had a contemporary repu-
tation quite comparable to the great photographers from 'nature' whose work has long
since eclipsed his own. But it is important to recognise that there was always something
of a paradox about such an achievement, and a critic with the perspicacity of Théophile
Gautier was well placed to express it. His article for *L'Artiste* on the Delaroche collection
goes to the heart of the problem, since he realises instantly that a photographic repro-
duction implicitly brings into play the notion of imitation established by reproductive
engraving. 'However exact an engraving may be, it does not offer in an irrefutable and
mathematical way the work of the master.' Goupil has therefore, in Gautier's estimation,
had recourse to photography in order to 'obtain a definitive facsimile of the canvases and
drawings that he admires'. But he has reckoned without the 'capriciousness' of the Sun,
who 'is not always exact and sometimes lies like a human'.[92]

It should be noted that Gautier does not, like the specialised press of *La Lumière*, expa-
tiate on Bingham's technical skill or artistic judgement. He writes as if it were simply a
matter of Goupil, the publisher, invoking the Sun's help to perpetuate the memory of
Delaroche! In part, this must have been an ironic reference. Gautier and his audience
would have been well aware of the caricatural habit of portraying the Sun as the master
technician of photography. But there is a further good reason for his strategy. Gautier
himself had set the precedent, in his critical essays from the late 1830s, of pricking the
bubble of Delaroche's public success with shrewdly directed darts of criticism. It is with
a cleverly calculated irony – but more than a grain of truth – that he salutes the photo-
graphic album for finally realising the works that Delaroche had failed to perfect as a
painter:

> Realising that it had to compete with Mercury [sic], Calamatta, Henriquel-Dupont,
> Blanchard, Forster and the elite of the burin, photography was on its mettle, and to
> match M. Goupil's confidence, it really performed magnificently; even in an excess of
> zeal it changed quite mediocre canvases into very beautiful pictures . . . Each canvas is
> thus reproduced with lucky accidents and felicitous touches that one has difficulty in
> not believing to be the result of intelligence.[93]

Gautier's comment, intentionally or unintentionally, minimises the technical com-
plexity of Bingham's achievement. In fact, a good proportion of the photographs were
not derived directly from canvases (mediocre or not), but from engravings, and indeed
specially commissioned drawings, after Delaroche's works. Bingham's achievement was
precisely the equalisation of these different 'originals' in such a way that a seamless pro-
gression through the sequence of such works could be obtained (pl. 56).[94] From Gautier's
point of view, however, this feature is as irrelevant as is the name of the photographer.
What fascinates him is the way in which all the images testify to the possibility of a new
visual aesthetic: what could be termed the 'photogenic'. Gautier's other critical writings
indicate the discernment with which he greeted the arrival of this distinctive visual
quality, which is specific to the photograph.[95]

From our point of view, however, Gautier's judgement casts an unexpected new
light on the new opportunities open to the artist who paints with a view to being repro-
duced, at the same time as it throws into sharp relief the potential competition between

56 Robert Jefferson Bingham, albumen print (1857) after engraving by Alphonse François (1857) of Paul Delaroche, *Marie-Antoinette* (larger than actual size), 1851. 16.2 × 12.5. Private Collection.

engraver and photographer, whose roles Gautier judiciously proclaims to be equally useful, and indeed complementary: 'with a beautiful engraving and a good photograph one has the master almost all of a piece'.[96] Much more will be said in the next two chapters about the possible pitfalls, as well as possibilities, existing in such a relationship. However a telling further example of the capacity of the Sun's handmaid to transform a painting, and perhaps eradicate its faults, can be adduced straight away in respect of Delaroche's father-in-law and fellow expositor of the 'Invention of Photography', Horace Vernet.

There is every reason to think that Horace Vernet took a more robust, and less deeply pondered, view of the significance of photography than Delaroche. He had what one might call a natural inclination to the process, since his visual memory was notorious for being phenomenally accurate. Eugène de Mirecourt's little biography of 1855 quotes 'his most intimate friend' Géricault as saying: 'His head is a chest of drawers. He opens it, looks, and always finds every memory in place.'[97] He also cites an anecdote to show that Vernet could recall the set of a holster on the saddle of a mounted guard more accurately than his brother-in-law, a general, who thought to have caught him out on this picto-rial detail.

These stories, which must have circulated since his youth, were summed up in Charles Blanc's biographical sketch by the statement: 'Horace's eye was like the glass of the photographic lens; it had its astonishing properties, but also, like the instrument of Daguerre, it saw everything, he reproduced everything, and all of this without selection or preference. He repeated the detail as well as the whole, indeed much better, since the detail in his case always took on an exaggerated importance'.[98] As we have seen, in the case of the *Barrière de Clichy*, this strategy of singling out configurations within the overall composition, which paralleled the vignettes of his lithography, was effective with a popular audience. But it displeased a critic like Blanc.

It may be fortuitous that we have no contemporary photographic portrait of Delaroche, whilst Horace Vernet was memorably portrayed by Bingham in a print exhibited at the second annual exhibition of the Société française de photographie in 1858. Delaroche had died, of course, just at the stage when portrait photography had come of age, with the outstanding achievements of photographers like Nadar, and (as we have seen) the early experiments of Bingham and Thompson. Nevertheless, it seems appropriate to contrast the very different styles and temperaments of the two men by juxtaposing the pitiless and penetrating image of the old dandy with the intensely sympathetic engraving of Delaroche after a drawing by his student Eugène Buttura, dated 1849, and published towards the end of his life, in 1853 (pl. 57). Vernet is exposed to view with a pitiless immediacy, nervously alert even to the tips of his waxed whiskers (pl. 58). But Delaroche, the master mediated through his pupil's drawing, and also through the burin of Henriquel-Dupont's pupil, Jules-Gabriel Levasseur, comes over as a benevolent and reflective presence, refined by the effect of a deferred temporality.

Also among Bingham's works exhibited in 1858 was a reproduction photograph of Horace Vernet's *Bataille de l'Alma*, showing a scene from the recent Crimean War. Vernet had originally made his reputation as a battle painter of the revolutionary and Napoleonic wars. He had presided over the assemblage of the *Galerie des Batailles* at Versailles during the July Monarchy, and he had commemorated the French colonial wars in Algeria. The Crimean War was no doubt an irresistible opportunity to revive his special talent. As the first major war fought by the great European powers among themselves since the Treaty of Vienna, it was also a testing ground for the military prowess of France under the Second

57 Jules-Gabriel Levasseur, engraving (1853) after drawing by Eugène Buttura of Paul Delaroche, 1849. 28 × 21.5. Private Collection.

58 Robert Jefferson Bingham, *Horace Vernet*, 1858. Albumen print. Bibliothèque Nationale, Paris: Département des Estampes.

Empire. Particular pride was taken by the French in the engagement with the Russian troops towards the end of the war which led directly to the evacuation of Sebastopol in September 1855. The French general MacMahon, with his first brigade of Zouaves, succeeded in capturing a defensive position known as the Malakoff on the outskirts of the city, and planted the tricolour on its summit.[99] This was to be the particular subject of a second painting by Vernet, which Bingham also photographed: *Prise de la Tour de Malakoff, 8 Septembre 1855* (pl. 59: Musée Rolin, Autun).

Vernet would almost certainly have been familiar with the remarkable series of panoramic photographs, taken from the Malakoff barely two months after the battle and in extremely difficult conditions, by his former pupil, Jean-Charles Langlois (pl. 60).[100] Despite technical problems due to the difficulty of access and the extreme cold of the Crimean winter, Langlois had managed to complete his 360 degree survey from the destroyed gun emplacement when it was still littered with sandbags, cannons and shells. Vernet has reconstructed, as it were, the full centre that corresponds to the empty periphery glimpsed in the panorama. Viewed from below, at the very moment when the Zouave is about to plant the French flag on the summit, the scene also probably conflates with that action the moment of MacMahon's celebrated response to the enquiry as to whether he could hold the position: 'Tell your general that I am here and that I am staying here.' Langlois could presumably take for granted the popular awareness of what had taken place at the Malakoff, when he showed a scene completely bereft of human beings, dead

59 (*right*) Horace Vernet, *Prise de la Tour de Malakoff, 8 Septembre 1855*, 1857. Oil on canvas, 219.5 × 144. Musée Rolin, Autun.

60 (*facing page left*) Jean-Charles Langlois, single photograph from panorama taken at the Tour de Malakoff, November 1855. Musée d'Orsay, Paris.

61 (*facing page right*) Robert Jefferson Bingham, albumen print of pl. 59, *c*.1857. Musée Nicéphore Niépce, Chalon-sur-Saône.

or alive. But Vernet has attempted to graft an intense documentary realism onto a narrativised moment that is still consistent with the traditions of history painting.

Charles Blanc, in his *Grammaire*, disputed the very possibility of this type of synthesis. He was harsh towards Vernet's aspiration to paint battles in this contemporary form, considering that it could never have more than 'an anecdotal value'. Coupling him with the lithographer Raffet, he declared:

> They have realised that it would be ridiculous to transfigure soldiers whom one might have met in the streets of Paris, between two battles, and, not hesitating between the insipidity of allusion and the energy of truthfulness, photographed in this case by the mind, they have found it piquant to paint heroism in kepis and greatcoats, as they have found it appropriate to illustrate, at the same time as the popular leaders, the great collective man who is the regiment. Unfortunately, such a respect for bulletins and reports lends an excessive importance to small truths, small things, to buttonholes, straps, aglets, piping and gaiter buttons, without the artist being permitted to forget these details and silence them, since the topical interest of his work comes at this price.[101]

Blanc has put his finger unerringly on the problems inherent in a 'photographic' approach to painting. He has also identified the operation of what might be called a photographic paradigm in the late battle pictures of Vernet, which borrow their aesthetic frame not so much from the landscape vistas crafted by his father and grandfather, but from the pitiless close-up vision of the photographer's lens. Everything has become detail in the painting of *Malakoff*, even down to the enactment of the French general's well-

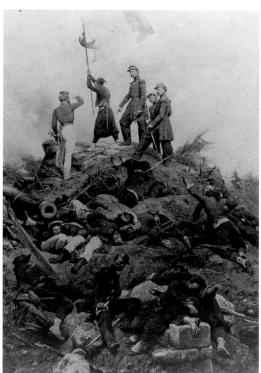

known retort. But it is possible to argue that Bingham's photograph, which homogenises the tricolour into monochrome and reduces the scarlet uniforms to a tonality not far from that of the brown earth, lends a secondary level of aesthetic unity to Vernet's composition (pl. 61). Photography has once again been put on its mettle, in this case in the service of the artist who so forthrightly greeted its invention.

Horace Vernet thus presents a fascinating paradox for students of the visual culture of his period. By the time that Blanc is writing, it has become commonplace to judge the success of paintings according to the standards of photography, and indeed to indicate that broader aesthetic parallelism which I have termed the photographic paradigm in art. Without doubt, Vernet's career did not take a sudden new turn after 1839. Rather, he remained attentive, as he had always been, to the developing forms of visuality – lithography, diorama, panorama, daguerreotype – while resolutely committed to creating his own pictorial effects through the traditional medium of oil paint. Yet what in Blanc and other contemporaries is a novel perception of the relevance of photography to his painting becomes, after a while, a tired cliché. Photography becomes the ultimate test of a faithful reproduction, and the equilibrium of original and copy achieved in the engraver's mode of 'translation' is finally lost. Vernet's reputation has suffered from the fact that his work fits the new standard of faithfulness all too neatly. The full story of his engagement with the visual technologies of the nineteenth century still remains to be written.

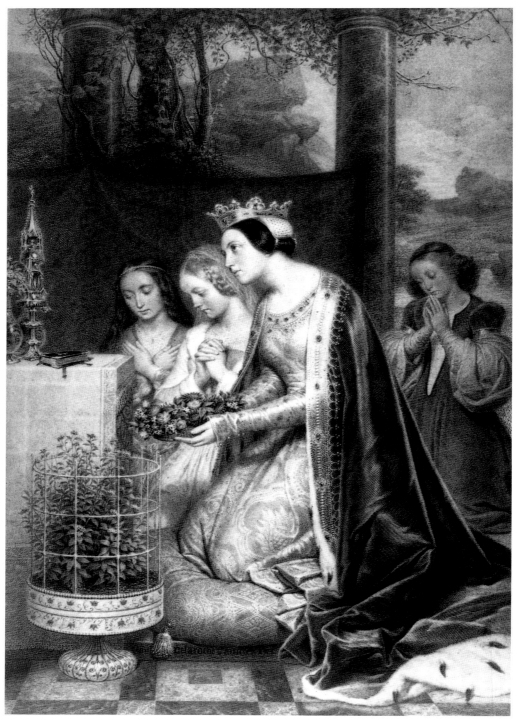

62 Paul Mercuri, engraving *avant la lettre* (1837) after Paul Delaroche, *Sainte Amélie, Reine de Hongrie*, 1831. 19 × 13. Private Collection.

4

Strangers in Paris

THIS STUDY OPENED WITH Charles Blanc's retrospective evocation of the studio of his masters Calamatta and Mercuri. George Sand, whom Blanc describes as 'shining in all her youthful glory' among their habitual visitors, also left her own picture of the charms of the engraving studio in the Passage Tivoli:

> The chance of a portrait that Buloz had engraved to put at the front of one of my editions led me to make the acquaintance of Calamatta, an able and already respected engraver, who was living in dignity and simplicity with another Italian engraver, Mercuri, to whom we owe, among other things, the precious little engraving of the *Moissonneurs* by Léopold Robert. These two artists were bound by a noble and fraternal friendship. I simply saw and greeted Mercuri, whose timid character could not communicate at all with my own timidity. Calamatta, more Italian in his manners, that is more confiding and more expansive, soon warmed to me, and bit by bit our mutual friendship became established for life.
>
> In fact I have met few friends as faithful, as delicate in their concern and as steadfast in the agreeable and sound continuation of the relationship . . . Calamatta, an amiable companion to laugh with and to enjoy the to and fro of an artist's life, is a serious, meditative and balanced soul who can always be found taking a good and wise path in the appreciation of matters of feeling.[1]

Sand is spontaneous and sincere in her tribute to the lifelong friend who also became a member of her family when his daughter Lina became the wife of her only son, Maurice Dudevant. She is also, no doubt, faithful to the recollection that this little gathering of dedicated artists was a special haven for her in the turbulent years when she had recently separated from her husband and was making her own literary career in Paris. But this train of thought also leads her to meditate on the special character of the medium practised by the faithful Calamatta and his timid partner. 'Engraving is a serious art at the same time as it is a hard and exacting craft, in which the way of working, antithetical to inspiration, can really be called the genius of patience.' Sand concedes that, for painters as well, there are difficulties of a technical nature to surmount. But the painter can indulge in 'the emotions of free creation', whilst the engraver (and by this is meant implicitly the reproductive engraver) has his enjoyment marred 'by the worry of letting himself be overtaken by the craving to become a creator himself'.[2]

It is not surprising that George Sand, who had met and confided in Delacroix by the end of 1834 (and had already been the lover of Alfred de Musset and Chopin, among several others) should have been impressed by the self-restraint imposed on the repro-

ductive engraver by the very nature of his practice. But she also testifies to the fact that, at the height of French Romanticism, the special status of reproductive engraving as a domain relatively barred to self-expression was an issue of lively comment. People frequently debated, so she avers, the question of which tradition should be followed: that of engravers like Gérard Edelinck and Bervic who 'faithfully copied the qualities and the faults of their model', or that of Marco Antonio Raimondi and Gérard Audran, who 'copied freely, giving rein to their own genius'.[3]

Other nineteenth-century writers concerned with printmaking confirm this view of an endemic conflict between these two historical traditions. But this was not necessarily to the benefit of the latter. Writing on Gérard Edelinck, who was born in Antwerp in 1640 but spent almost all his working life in France, Henri Delaborde distinguished him as an engraver from his French contemporary Audran, who 'had something of a painter about him' and from Raimondi, who was 'something of a sculptor'. Edelinck, by contrast, is a purist: he is 'invariably opposed to what is not specifically in the domain of engraving'.[4]

Edelinck is thus, for Delaborde, the engraver *par excellence*, who does not stray outside the bounds of his own medium, and he is also the 'simple translator' who will not presume to alter or overinterpret the works that he engraves. George Sand herself also had occasion, in her excursus on the working practices of her friend Calamatta, to cite this *topos* of the engraver as translator. But she was not sure that it resolved the question of what fair measure of interpretation should be admitted in the reproduction of an artist's work. As she reasonably argued, using the analogy of a literary translation from a foreign language, there would be one law for masterpieces which she 'would be content to render in the most servile way possible', and quite another for 'useful, but obscure and badly written works [which she] would be tempted to write in the best way [she] could, to make them as clear as possible'. She did not discount the likelihood that, in the second case, she would attract the displeasure of the author, 'it being in the nature of incomplete talents to prefer their faults to their qualities'. But she could envisage the possibility that an artist interpreted in such a way by an engraver would esteem at its true value the contribution that the latter had made: 'perhaps only a painter of genius could pardon his copyist for having had more talent than he'.[5]

Nineteenth-century commentators like Sand and Delaborde are, of course, always writing with one eye on the practice of their contemporaries. As we shall see in this chapter, with regard to the relationship between Delaroche and Mercuri, it was by no means inconceivable that a painter widely credited with genius should look to his engraver to amend his faults. Yet the mention of such a concrete instance is a reminder that the critical discourse surrounding the practice of engraving is apt to appear simply paradoxical, or at least impoverished in its use of well-worn binary terms of opposition, unless it is referred to the works themselves, and their individual conditions of reception. There were not just two antithetical ways of being a reproductive engraver in nineteenth-century France. Indeed it is only through taking into account the fine variations in engraving technique and aesthetic approach that we may enable such terms as 'translation' and 'interpretation' to acquire a communicable meaning.[6]

Calamatta and Mercuri are well placed to launch this investigation. Their careers run parallel, and both of them establish considerable reputations in the French context,

working for the most part on the reproduction of paintings by living French artists, but also paying significant acts of homage to the Renaissance tradition. Both, however, spent the years of their youth in Italy, having been educated and receiving their initial training as artists at the same establishment in papal Rome. Both were, in a certain sense, adopted by enterprising Frenchmen who noticed and developed their talents, bringing them from their native country to live and work in Paris. Both retained a strong affection for Italy, and peppered their correspondence with Italian expressions. Both were ultimately obliged to look for employment outside France, Calamatta from 1837 as Professor of Engraving at the newly founded Royal Belgian Academy in Brussels, and Mercuri, after 1848, at the papal print collection, the *Calcografia camerale*, in Rome.

Yet George Sand's description of their widely differing temperaments could also be extended to the radically different character of the works that they produced. Calamatta was the first (and arguably the last) engraver to establish a consistent working relationship with Ingres, and his superb reproductions span the long interval between the *Voeu de Louis XIII* (1823; engraving published 1837) and *La Source* (1856; engraving published the year before his death in 1868). Mercuri, by contrast, produced very few engravings in the course of his career, and notoriously spent twenty-two years working on the reproduction of Delaroche's *Jane Grey*. Calamatta's fruitful relationship with Ingres will be my main focus of attention at a later stage, and it will lead to a more general reassessment of the issue of reproduction as it affected this most idiosyncratic and fascinating of nineteenth-century French painters. The career of Mercuri, however, forms a necessary prelude. Precisely because he challenged the limits of what was reasonable and acceptable in engraving – because he was seemingly incapable of setting and following a normal routine – Mercuri repays close attention. He reveals a quasi-obsessional *other side* to the engraver's discipline.

* * *

The story of Mercuri's discovery, and the beginning of his extraordinary career, is told with great gusto by the French costume historian who first enlisted his talents, Camille Bonnard. The time to which he refers must have been around 1823, when Mercuri (b.1804) was not quite twenty:

> I then met an unknown young man, without a name or any support, who was leaving the school of San Michele, where he had distinguished himself by the most brilliant capabilities, and who aspired to become one of the foremost painters of our period ... I offered him the chance, instead of earning 25 or 30 centimes an hour with some obscure engraver performing the mechanical work of entering lines, of devoting himself exclusively to the engraving of my costumes; this would be for him a chance to get himself known and to exercise his talent more agreeably, while waiting to obtain the commissions that he had been led to expect for some altar paintings. Mercuri had an extreme antipathy for the art that nonetheless rightly gave him his due place among the most famous of engravers. He accepted, but reluctantly, and in the hope of soon leaving his points and burins to take up brush and palette. Sad, apathetic, discontented with everything, yielding to all discouragements, lacking in both resolution and energy, Mercuri became my everyday companion; I encouraged him, I stimulated him,

63 Paul Mercuri, fourteenth-century Italian costumes, from Camille Bonnard, *Costumes*, 1828. Coloured engraving, 22.2 × 15. Private Collection.

64 Paul Mercuri, fifteenth-century Venetian costumes after Gentile Bellini, *Miracle of the True Cross at the Bridge of San Lorenzo*, from Camille Bonnard, *Costumes*, 1828. Coloured engraving, 21 × 15.5. Private Collection.

but could not triumph over the limpness of character that made me despair and held up the regular schedule of my publication.[7]

Bonnard's unusually frank evaluation of the young collaborator responsible in no small measure for the critical success of his collection indicates a character prone to temporising. In his further description of the young engraver 'remaining inert and pensive in the presence of a copper plate that he could have finished in a few hours', we can anticipate the inordinate delay over *Jane Grey*.[8] But it is important to set beside this indictment the exquisitely fresh appearance of the plates in Bonnard's *Costumes* (pl. 63). In Venice, the two collaborators must have lingered for quite a time to record the wealth of splendid costume material to be found in the paintings of the Venetian artists of the Renaissance. Mercuri captures with panache the dandified figure of a young member of the *Compagnia della Calza* in Carpaccio's *Miracle of the Relic of the True Cross at the Rialto Bridge* (Accademia, Venice). His presentation of the Queen of Cyprus and her ladies in Gentile Bellini's *Miracle of the Relic of the True Cross at the Bridge of San Lorenzo* (Accade-

mia, Venice) is even more striking because of the attention given to representing the contrasting textures of the elaborate bodices and coiffures (pl. 64). In this case Mercuri enters his name as author of the drawing, but he has enlisted the etching skills of another printmaker, who signs himself J. J. Leroy.[9]

The first edition of the *Costumes* was published in Rome in 1828, and this use of another artist's expertise shows that Mercuri had not yet, at this stage, joined forces with his childhood friend from Rome, Calamatta. Within three years, however, both were established in Paris, at the engraving studio in the Passage Tivoli. How then did Mercuri graduate in so comparatively short a time from making the piquant but simple line illustrations for the *Costumes* to receiving commissions for more technically demanding modes of printmaking? As early as 1830 he made his debut as an independent artist with two lithographs, one of which, called *La Prière*, is no more than an elaboration of one of the illustrations to Bonnard.[10] It may, however, have helped to draw the attention of Delaroche to his work. From his *Sainte Amélie* stained-glass project of 1830–1 to the figure of Antonello da Messina in the *Hémicycle*, Delaroche seems to have drawn on the fund of costume studies in Bonnard's collection.[11]

Yet it was Mercuri's prior acquaintance with another celebrated painter of the day that gave him the subject for his first outstanding success. The path that his artistic aspirations initially took perhaps derives from his long-standing friendship with the Swiss painter Léopold Robert, who was established in Rome between 1818 and 1831, and regularly sent back work to be exhibited at the Paris Salon. At any rate, it was with his small engraving of Robert's *Les Moissonneurs dans les Marais pontins* (pl. 65) that Mercuri first came to public notice. Robert's painting was one of the major successes of the Salon of 1831, and, in Horace de Viel-Castel's account, 'almost alone attracted the attention of the crowds' until it was upstaged by the late arrival of Delaroche's *Cromwell*.[12] For once Mercuri must have worked overtime to capitalise on this notoriety, which earned him a commission for a reproductive print from the newly published journal *L'Artiste*. The engraving which appeared under these auspices featured two locations and two dates: Léopold Robert Rome 1830 / P. Mercuri dis. e inc. in Parigi 1831.

One is tempted to read into this minimal message a sense of Mercuri's nostalgia for his Italian homeland. As Viel-Castel expressed it, Robert's work was 'a painting made to order, on a fine summer evening, in the Roman countryside where everything is a subject for painters'.[13] Mercuri keeps his inscription in Italian, and even renders the name of Paris similarly, in this way dramatising his foreign identity – or so we could imagine. But what only comes across after further close scrutiny is the eccentric but extremely skilful treatment which this young Italian has lavished on the print, to a degree which was highly unusual in comparison with the other, often quite sketchy, illustrative prints appearing in the early numbers of *L'Artiste*. Charles Blanc emphasised its distinctiveness when, in 1839 – not long after leaving the studio of Calamatta and Mercuri – he had to compare the little work by Mercuri with its much larger successor, commissioned by Rittner and Goupil from a pupil of Bervic, Zachée Prévost, who had used the aquatint technique rather than the pure burin:

> M. Mercuri achieved a masterpiece, of which no similar example can be found among the old masters. It is a little marvel which had no need, to be passed on to posterity, of the extraordinary value that circumstances have given it. But it is a work that stands

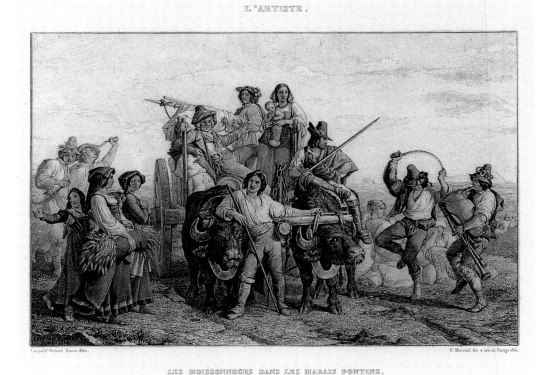

L'ARTISTE.

LES MOISSONNEURS DANS LES MARAIS PONTINS.

65 Paul Mercuri, engraving (1831) after Léopold Robert, *Les Moissonneurs dans les Marais pontins*, 1831
Salon. 21.5 × 28.7. Staatliche Graphische Sammlung, Munich.

apart, not only because of its dimensions but also because of the processes used by M.
Mercuri, unusual processes of which he alone holds the secret. It would be necessary,
therefore, in order for these two works to be placed in parallel, for M. Mercuri not to
take the credit for a difficulty overcome, an immense difficulty, since it was a question
of giving an air of grandeur to figures as small as the head of a pin, and keeping the
character of grave purity and majestic elegance of these imperceptible profiles of
Roman women, while touching the very limits of what is possible in the genre. As
M. Mercuri practises it, engraving has all the advantages of drawing, without losing
any of those qualities that are specific to it; it is as soft as wash; while remaining much
firmer, it is as smooth as the pencil, with much more brilliance.[14]

This eloquent passage is a tribute by the young Blanc to one of his revered teachers.
But it also gives more than a hint of the excessiveness of Mercuri's approach, which entails
that a working lifetime of forty years will have to be spent in producing a print of the
dimensions of that of Prévost. It also prepares the reader for Blanc's biographical comment
on the special investment which Mercuri had in Robert's subject: 'He is a Roman, he
translates with passion, with love, this page of Italy where he finds once again the
admirable physiognomies that he keeps in his memory.'[15]

Mercuri's idyllic little print of the *Moissonneurs* received due acknowledgement when it was exhibited at the Salon of 1834, receiving a second medal for engraving. But its quality had already been recognised by the newly established print publishers Henry Rittner and Adolphe Goupil, who in 1832 commissioned a steel engraving after Paul Delaroche's *Sainte Amélie, Reine de Hongrie* (pl. 62). The association of the two publishers with Delaroche was at that stage only just beginning. Indeed, an amusing anecdote told at the previously mentioned trial of 1878 suggests that the introduction was made in 1830 by a mutual acquaintance, Feuillet de Conches, who laid a bet with Delaroche that he would find a publisher for his portrait of the retired opera singer, Mlle Sontag.[16] Whether or not this story is literally true, the likelihood is that the new publishers had developed an interest in the possibilities of engraving after this rising star of French historical painting before 1830, and they would shortly take over the plates of engravings after Delaroche already commissioned and published by Daguerre's brother-in-law, John Arrowsmith.[17]

The decision to select the small-scale and little-known *Sainte Amélie* for Mercuri to engrave was, at first sight, a surprising one. It was, however, a recognition of the distinctive style which the young printmaker had achieved in the *Moissonneurs*. The contract stipulated that, for the sum of 2,000 francs, paid in monthly instalments of 150 francs, he would 'engrave on steel the picture by M. P. Delaroche . . . in the same genre as the engraving done by him of the *Moissonneurs* of Robert'.[18] But whereas Robert's work was a Salon painting on a considerable scale, whose reduction (as witnessed by Blanc) appeared a surprising feat, Delaroche's *Sainte Amélie* was preconditioned, so to speak, for Mercuri's treatment. It was a design for a stained-glass window, commissioned by Delaroche's first patron, now Queen Marie-Amélie of France, for the private chapel of the Orléans family at the Château d'Eu in Normandy. Although the painting itself has been lost, and the window is at present undergoing restoration, the surviving sketch (British Museum, Department of Prints and Drawings) shows Delaroche's minute attention to the medieval clothing and decorative appurtenances of the Queen's patron saint.

I have suggested elsewhere that Delaroche probably took his composition from a late medieval manuscript like the *Book of Hours of Anne de Bretagne* (Bibliothèque Nationale, Paris), and that he may have taken note of Mercuri's *Queen of Cyprus* plate in the *Costumes* of Bonnard. In any event, Mercuri now had the opportunity to refine and develop his miniaturising style, with reference to a design which allowed him to linger lovingly on the surface sheen of precious metals and the luxuriant textures of rich materials. Blanc's previously quoted passage on the brilliance (*éclat*) achieved by his method applies nowhere more forcefully than in the case of this print.

The Maison Goupil had laid down a strict timetable in their contract with Mercuri, which envisaged the completion of the plate within ten months. The fact that it was published no less than five years later suggests that Mercuri was demonstrating, as he had done with Bonnard, a total disregard for the commercial schedule. But, on this occasion, he had more justification in the amount of work which went into the preparation of the final print. Beraldi, saluting his *Sainte Amélie* as 'justly famous because of its unbelievable finesse', speaks with awe of the discovery of thirty-two successive states, numbered by Mercuri's hand, which were turned up by a Paris dealer in the 1880s. As he admits, 'the last twenty proofs are only very slightly different from one another, and one

66 Paul Mercuri, engraving *avant la lettre* (1857) after Paul Delaroche, *Jane Grey*, 1834 Salon. 43 × 28. Private Collection.

must have the practised eye of a man of the craft to recognise the work which has been added or modified'.[19] In this obsessive perfectionism, Mercuri was appealing, not just to the taste of the bourgeois public of the July Monarchy, who might be expected to pay 20 francs for an image enhanced by royal and historical associations, but to an elite of fellow practitioners and print connoisseurs, who possess the trained eye to discern almost imperceptible progress in the successive stages.

Mercuri's *Sainte Amélie* provoked from Gustave Planche, one of the most forthright art critics of the period, a comment to which Beraldi understandably takes objection. Saluting the extraordinary 'finesse and elegance' of the print, Planche remarks: 'Unfortunately the plate was engraved after Paul Delaroche'. Beraldi sees this comment, quite legitimately, as implying that the engraver should never bother with the art of the contemporary period, since what Planche calls 'the most revered works of the Italian School' should always take priority.[20] But he does not perhaps account for the point that, in a historicising work of this kind, the reference to previous styles and modes of art was

already abundant. It thus made sense for printmakers like Calamatta, and indeed Mercuri, to pay homage (and refresh themselves) at the common source. Beraldi also fails to acknowledge the problem that a painter who falls into disrepute – as Delaroche did in the last quarter of the nineteenth century – inevitably took with him even the most distinguished of reproductive engravers, to the extent that they had devoted much of their career to that painter's work.

Yet one of the objectives of the present study must be, in defiance of these arguments, a justification of Beraldi's position. Printmaking's connection with contemporary painting, and other existing modes of visual culture, is after all the grille through which the printmaker has to approach the art of the past, and the notion of unmediated access to 'the Italian School' is itself bound to be a figment. Planche's denunciation of the use of Delaroche as a model has perhaps now run its course, and the confident stridency of the Romantic period has given way to the feline irony of the editors of the current catalogue of prints in the Bibliothèque Nationale, who commented on the achievement of the two brother engravers, Alphonse and Jules François: 'It is difficult for us not to smile today at the dithyrambic eulogies of Beraldi. [François] and his brother have done much . . . to diffuse the works of Paul Delaroche. It remains to be ascertained if they could not have been occupied more usefully.'[21] Such an attitude will surely soon begin to appear as quaint as it is fundamentally unhistorical.

Mercuri's proofs must have convinced Goupil and Delaroche that the *Sainte Amélie* was making good progress, since in 1835 he was commissioned in a further contract to make a reproductive engraving after the painting of Delaroche's *Jane Grey* (pl. 66), which had vied with Ingres's *Martyre de Saint-Symphorien* (Cathedral of Autun) for the accolade of being the most discussed work of the 1834 Salon.[22] In passing, it should be noted that Ingres's painting, which was claimed by the Burgundian cathedral not long after the Salon, had to wait until 1872 for a fine reproductive engraving to be made from it. The author was the aforementioned engraver schooled in prints after Delaroche, Alphonse François, who insisted on making it one of the supporting elements for his successful candidature for a seat in the Academy.[23] Goupil and Delaroche had hoped to have a more rapid schedule for *Jane Grey*. But Mercuri's exceptionally dilatory mode of working caused a delay which was surely unprecedented, even by the standards of other, remarkably protracted gestations for reproductive prints in the same period.

Jane Grey did not, however, have the same favourable status as the little *Sainte Amélie*. It had passed after the closing of the 1834 Salon directly into the possession of its proud owner, the Russian count Anatole Demidoff, who complained after only a few months of Mercuri's lack of progress, and drove a hard bargain before finally conceding the reproduction rights (a sign that, for this work at any rate, Delaroche had not insisted in retaining them). This is the conclusion to be drawn from the brief letter, dated 11 February 1835, in which Demidoff wrote to Delaroche of having had 'a long conversation' with the two partners, and agreed that the total edition of 50 proofs *avant la lettre* should be reserved for him exclusively, and distinguished by his coat of arms.[24] Maison Goupil would then sell for their own exclusive profit the remainder of the edition. It becomes clear from both this letter and its predecessor that Demidoff is in no way in dispute with Delaroche – nor indeed with the choice of Mercuri, whose drawing for the print he undertakes to purchase, provided that it is 'reasonable' in price. But the experience may have

persuaded Goupil to draw up a formal contract with Delaroche for the assignment of reproduction rights when, in the next year, they decided to commission Louis Henriquel-Dupont to engrave *Strafford* as a pendant to *Jane Grey*.[25]

Demidoff was surprised to learn in 1835 that Mercuri would not be able to begin *Jane Grey* for 'three or four years', presumably because he needed to finish *Sainte Amélie*. Thereafter it becomes difficult to check on the timetable for completing the engraving for some time. In 1840 *L'Artiste* reported that he was hard at work, but unlikely to finish it by the next year.[26] By early 1848, however, on the eve of Mercuri's departure for Rome, he appears to have been checking the latest proof against a reduction of the painting, also owned by Demidoff, and promising imminent results to the understandably impatient pair of publishers, who were anxious to see *Jane Grey* join the more speedily completed *Strafford*, available since 1840.

Pressure continued, though with even less hope of success, when Mercuri left for Rome, taking the plate with him. He had to wait some time before being able to set up his studio there, and in October 1850 was assuring the publishers that he still had to achieve 'les derniers perfectionnements' but was undertaking no other work which might interfere with this goal.[27] With commendable resourcefulness, and no doubt because the work could be regarded as a national priority, Goupil then arranged for him to send proofs back to Paris every few months through the diplomatic bag, and after another long period of waiting, a proof did finally make its way back to Paris in the summer of 1853. Delaroche, by this stage a sick man, commented that he was pleased with it, but (in Goupil's words) 'in seeing the results of nearly eighteen years, could not avoid being sorry that an artist of your talent had produced so little when he was capable of working so well'.[28]

From 1854 onwards, the dialogue between Paris and Rome does finally become a matter of detailed criticism, rather than alternating recriminations and excuses. But it may be doubted whether this criticism was altogether constructive. In October 1854 Goupil complains about 'the lack of freshness in the engraving; it seems either that the plate is worn or the impression a bad one'.[29] In November 1855, just a year before his death, Delaroche sent by way of Goupil a lengthy list of points to be corrected in almost every section of the print, with the slightly disingenuous reservation that he 'knew nothing of the possibilities of engraving to follow his observations', and therefore trusted Mercuri to accept or reject his points as he thought fit.[30] It does indeed seem that Delaroche set a great deal of store, in this last year of his life, on the survival through engraving of perhaps his most famous Salon painting.

In fact, Delaroche was quite explicitly relying on Mercuri to correct his own mistakes of more than twenty years before. In relation to the outstretched arms of Lady Jane Grey, for instance, Goupil noted the general reaction of the artists who had seen Mercuri's latest proof, that 'the two arms were too heavy'. 'Is it M. Delaroche's fault?' asked Goupil. 'He fears it is and trusts in the talent of M. Mercuri.'[31] It is difficult to assess in detail how Mercuri reacted to the almost impossible demands placed upon him by this devastating letter, which indeed cast him as no mere interpreter but as the artist capable of raising Delaroche's imperfectly realised concept to the level of perfection. But it is only fair to Mercuri to note that Théophile Gautier, commenting on the final appearance of the print in January 1858, signalled among other improvements on the original the fact that 'the

outstretched hands of Jane Gray are no longer hands of wax'. Gautier's general estimate of the success of the engraving, despite its deliberately paradoxical form, does coincide remarkably with the brief that Goupil and Delaroche had privately supplied to the engraver:

> The plate of M. Mercuri gives the idea of a much more perfect picture than the original that it represents. The draughtsmanship of the engraving is firmer, more learned, more masterly. The burin has almost everywhere corrected the brush; a fine, controlled workmanship, varying according to the objects that it must render, giving its value to everything, subduing the too vivid and as if tin-coated tones of the painting, nourishing the shadows with fine hatchings, has removed the faults that so shocked us once and made us insensible to the real merit of the work.[32]

Gautier makes amends for his earlier strong criticisms of Delaroche by hailing both photography and engraving as revelations of a superior Delaroche, hitherto veiled by the inadequacy of his painterly technique. But if it is the sun itself that performs the photographic miracle in the first case, in the second it is an artist who must be credited with the achievement. In the case of both *Jane Grey* and *Sainte Amélie*, argues Gautier, Mercuri's 'betrayal' has allowed Delaroche to surpass himself.

Since *Jane Grey* was the chief occupation of Mercuri's mid-career as an engraver, and one of the most universally admired prints of the century, it has been important to look carefully at the correspondence relating to it, and the critical comments which accompanied its long progress to completion. As we shall see, the favourable view of Gautier was not universally shared. But before looking at more hostile comments, it is worth turning briefly to two of the lesser works which Mercuri completed in the 1840s, since these display the same fastidious technique, again carried almost to the point of excess.

Mercuri's portrait medallion of the eighteenth-century philosopher Condorcet was commissioned for a new edition of the *Oeuvres complètes*, published by Didot in 1847. It seems very likely that Mercuri relied for his original image on the vigorous but cruder print produced by Levachez for the *Tableaux historiques de la Révolution française* (1804) (pl. 67). But he took pains to locate the original drawing on which this work was based, or so we may infer from the fact that the attribution given in the final print differs from that given in the preceding proofs.[33]

The five successive states, which even this minor commission involved for Mercuri, show off his technical perfectionism in the way that engraved line has coaxed the philosopher's abundant curls into dynamic movement – with a very different effect from the heavy locks clamped into place by Levachez (pls 68, 69). With regard to the flesh tones, Mercuri again shows his departure from the earlier engraver, who probably built up texture through the technique of stipple (a dotted textural effect produced with the aid of a mace-head or *mattoir*). Mercuri has achieved a lighter and more elegant effect by burnishing the plate to soften the parallel lines of the burin, and so enables the white surface of the paper to shine through more clearly.

This habit of taking repeated proofs was not simply a printmaker's affectation. Copies could be dedicated to friends and patrons – as in the case of the earlier proof illustrated here which bears Mercuri's own autograph dedication to 'Madame Giraudeau'. Goupil was in the process of developing a market for the so-called *épreuves avant la lettre*, taken,

67 Levachez, engraving of Condorcet (detail of pl. 22).

that is to say, before the title and other details were added, and these, which by defini-
tion were the earliest pulls from the plate and the freshest impressions, would habitually
be sold at a premium by the 1850s. But, in the particular case of the Condorcet medal-
lion portrait, the variations between the different states become virtually imperceptible,
as far as the treatment of the bust is concerned, after the first two of five. This does not
mean, of course, that Mercuri was not continuing to allot time and attention to the proof-
ing process. His drawing of Charles Blanc's brother, the Socialist pioneer Louis Blanc,
dated 1845, was finally engraved by Jules François, possibly as a pedagogic exercise at
this early stage in the young engraver's career, but also no doubt because Mercuri lacked
the time to engage with more projects than his *Condorcet* and the omnipresent *Jane Grey*
in tandem.[34]

Most exquisitely curious of all Mercuri's prints, perhaps, is the tiny portrait medallion
of *Madame de Maintenon* (pl. 70), published as a frontispiece for the duc de Noailles's bio-
graphical study of the last mistress of Louis XIV in 1847, the year of his departure for
Rome. In its second state, it possesses a filigree border of decorative work enclosing a
floral wreath, and the inscription 'P. Mercurj [sic] d'après Petitot', referring to the cele-
brated painter of miniatures on enamel, Jean Petitot (1607–1691). It is often alleged that

CONDORCET.

68 Paul Mercuri, engraving (1847) after drawing by J. P. Lemort of Condorcet, 1786. 29 × 21. Private Collection.

69 Early state of pl. 68.

the short-term effect of the invention of the daguerreotype was not to assassinate painting in general, but at least to kill off one of its minor genres, the portrait miniature, which through its dimensions most closely duplicated the new, commercially viable photographic technique. But neither the daguerreotype nor, at this stage, the calotype were capable of providing frontispieces for printed works. Mercuri has revelled in producing an engraver's equivalent for the precious enamelled image, varying the textures between the silk robe and its fur lining, the lustrous pearls and the delicate ringlets of the governess turned mistress of the ageing king. Only with the aid of a magnifying glass is it possible to discover how all this delicate precision resolves itself – but on a level almost imperceptible to the human eye – into a structure of dots and lines.

The comparison between the engraving and the miniature that is provoked by Mercuri's work also leads to a further question about scale, and one that is pertinent to the history of the photographic image in the present period. As can be seen in the work of a contemporary portraitist like the American artist Chuck Close, the expectations attached to photography may be useful in revealing to the spectator that the image is, after all, made up of traditional brushmarks on a flat surface. A painting like *Self-portrait* (1976/77, Museum Moderner Kunst, Stiftung Ludwig, Vienna), which is originally derived from a

70 Paul Mercuri, engraving
(1847) after portrait of Madame de
Maintenon by Jean Petitot, *c*.1680.
12 × 8. Musée des Beaux-Arts,
Lyons.

photograph, diffuses when looked at closely into soft, grey watercolour marks deposited
by a loaded brush onto paper. A decade later, however, Close is imitating both colour and
black-and-white photography in such a way that the near view effects a dissolution of the
image into a pattern of apparently arbitrary dots and squares. It is as if the image had
originally derived from a coded, non-mimetic system, whereas in fact – our foreknowledge
tells us – it is drawn ultimately from the non-coded registration of the photograph.

 This paradox is present, no doubt, in a rather different form with the burin engrav-
ing, when it becomes available for comparison not simply with the original painting, but
with the original painting as photographed (and here we must bear in mind that the *Jane
Grey* of Mercuri was exhibited in public for the first time just a year before the publica-
tion of the photographic record of Delaroche's oeuvre by Bingham). The photograph is,
at this stage, necessarily a reduction of the large Salon painting – though we should
remember that Bingham's portrait photographs of the mid-1850s achieved a *grandeur
naturelle* comparable in their emphasis on skin texture and blemishes to the blown-up
black-and-white images produced by Close today. The photograph is, in its original form
at any rate, not dependent on a subliminal visual coding. The engraving, on the other
hand, is the visible product of a configuration of lines made by burin, *mattoir* and a
number of other similar tools. Even if it conceals this origin when seen from an appro-
priate distance, it reveals on closer inspection the fact that it is constituted of these dis-
tinctive and identifiable marks. In a word, it is visibly the result of an analytic operation,
but it also achieves a synthetic effect on the phenomenological level.

One may imagine that it was precisely this capacity to demonstrate both the analytic and the phenomenological levels alternately – in response to both near and distant views – that formed the appeal to connoisseurs of portrait medallions like *Condorcet* and *Madame de Maintenon*. They were ready to pay as much as 100 francs (Beraldi tells us) for a proof of the latter before the border had been added.[35] But, where it came to *Jane Grey*, Delaroche's former model, student and studio assistant, Henri Delaborde, questioned the value of this miniaturist's approach to the reproduction of a large-scale painting. Delaborde was in total disagreement with Gautier's high estimate of the remedial powers of Mercuri's engraving. In his view, it was not so much a disclosure of the unrealised potential of the painting, but, more insidiously, a manifestation of 'the extraordinary patience of [the engraver's] hand'. Instead of offering a prospect to be viewed, it tempted the eye to stray among the infinitely fine, technically perfect details that Mercuri's persistence had achieved. In stark terms, then, it made the image unviewable.

Delaborde's critical remarks are worth quoting, since they set the scene for Calamatta's rather more balanced attempts to 'translate' the paintings of an artist who, as opposed to Delaroche, was hardly at risk of being upstaged by his engraver:

> The new plate engraved by M. Mercuri registers too clearly the effects of this propensity to extreme analysis. If one examines the details one by one, there is no doubt that one can appreciate the care and talent with which each object is rendered, each accident of form studied and defined; but when one searches, among these thousand details, for the point which will determine the effect and sum up the spirit of the scene, the gaze does not know where to attach itself to. Everything beckons it, nothing arrests it. The figure of Lady Jane Grey, whose central importance should have been picked out by a unity of aspect, is itself broken up and as if interrupted in its general physiognomy. The face, the neck, the arms, are burdened with work so complicated that the modelling almost disappears under the half-tints, whilst certain parts of the dress, those that cover the knees for example, shine with so vivid a glare as to become completely isolated from the rest . . . Will it be said that we should impute this lack of harmony to the model, that one cannot without injustice make the engraver responsible for the errors committed by the painter? The excuse would not be an adequate one.[36]

<center>* * *</center>

The careers of Paul Mercuri and of his compatriot and friend, Luigi Calamatta, appear to have an almost perfect complementarity. Mercuri spent over twenty years towards the end of his career completing an engraving of a picture that had fascinated the Salon audience of 1834, but was rapidly losing critical esteem by 1858, when the print was published. Although the print itself gained instant celebrity, Mercuri's obsessional method had left its mark, and Delaborde's mordant critique was reasonably justified. On the other hand, Calamatta launched his career with almost a decade of work on the *Voeu de Louis XIII*, which not only made his reputation on its appearance in 1837, but established his position as the foremost engraver of the paintings of Ingres. Calamatta was, for Beraldi, 'one of the fortunate ones in the world of engraving, this world in which ordinarily careers are so difficult and unrewarding'.[37] By the same token, Mercuri seems

to illustrate in the fullest measure just how difficult and unrewarding such an engraver's career could be.

This neat comparison, however, is more convincing in broad retrospect than if we look at the detailed historical record. Beraldi, and before him Charles Blanc, had Calamatta's complete career under review. From Blanc's vantage point, he did indeed seem to be perhaps the most telling contemporary example of an engraver 'made for' a great painter.[38] Raphael himself was known to have retouched the engravings of his work by Raimondi, and the close relationship between Ingres and Calamatta facilitated a similar interactive process in the production of the latter's prints. But even Blanc was ready to concede that the course of cooperation with Ingres did not always run smoothly. There had come a time when Calamatta was obliged to present his great model with an ultimatum. Either Ingres stopped interfering in the process of engraving the *Voeu de Louis XVIII*, or Calamatta would abandon it![39] The perpetual and, in an inconvenient sense, creative anxiety that impelled Ingres to tinker with his compositions was a nightmare for those deputed to reproduce them.

If it is wise to avoid idealising the relationship between Ingres and Calamatta overmuch, it is also inappropriate to play down the importance of his more introverted colleague, Mercuri. The insecure George Sand confesses that she warmed immediately, on her visit to the Passage Tivoli, to the ebullient and outgoing Calamatta. But Mercuri seems to have played a necessary role in sustaining the life of the studio and acting as a foil to his charismatic colleague. The correspondence of Mercuri with Goupil and Delaroche may be painful to follow, as the engraver's explanations for his inordinate delay are padded out with details of domestic disorder and personal tragedy. But the intimate correspondence that he kept up with Calamatta, over the period of the latter's absences in Brussels around 1840, vividly intersperses sketches, caricatures and gossip about the goings-on in artistic Paris with practical questions and answers about the business of the studio. A letter of 28 May 1839, for example, refers to Goupil's intervention with the politician comte Molé to obtain the loan of his portrait by Ingres, in order that Calamatta can proceed with his engraving. It concludes with the affectionate message that 'Nino' (Thévenin) is working, Charles (Blanc) is working and keeping well, and all send their greetings, including his sister who has 'kissed the little pigs' for him.[40] It is likely from the context that this is a reference to small children, but not impossible (judging from Calamatta's reference to gastronomic matters in the correspondence with his Italian patron, Cardinal Tosti) that the piglets are being fattened for Christmas.

In fact, Mercuri's affectionate letters, invariably written in Italian, remind us to what extent the two expatriate engravers remained men of the Mediterranean world. There is a later enquiry by Mercuri about the weather in Brussels, probably no better than the 'wolves' weather' (*tempo di lupi*) that he is experiencing in Paris in the winter of 1841.[41] Mercuri himself was to return to Rome in 1847, and spent his last years with his daughter in Bucharest, dying there in 1884. Calamatta chose the moment of Italy's emancipation from Austrian rule in 1861 to make his return, as Professor of Drawing at the Academy of Milan. His fervent Italian nationalism, which almost led him to enlist with Garibaldi despite his age, was undoubtedly one of the main motives for his long self-exile in Paris during the greater part of his working life. On the point of his return, he writes to Cardinal Tosti, his former patron in Rome, of the distasteful news of the

exile from the papal dominions of a mutual friend, the eminent neoclassical architect Pietro Camporese, who has committed no other crime than to share the nationalistic views of 'twenty-two million Italians'. He adds that it is 'a great misfortune for Rome not to be at the head of Italy'. Such views must have been acceptable to this unusually liberal prince of the Church, though Calamatta adds that he is fearful that 'not even letters sent to a Cardinal are respected by the post'. He concludes with a nostalgic reference to the 'wonderful dish of paupiettes of salmon' that he has eaten at the cardinal's table, and ventures to hope that he will soon be able to enjoy them there again.[42]

I emphasise this side of Calamatta's life in order to bring out the point that he was, no less than Mercuri, a stranger in Paris. These two colleagues were not the only print-makers from Italy who went north to learn engraving skills that had virtually died out in their native country. As early as 1809, Paolo Toschi (1788–1854) had left Parma for Paris to study with the renowned Bervic, and he made his reputation in France with a burin engraving after Gérard's *Entrée de Henri IV à Paris* (Salon of 1817). But Toschi returned to Parma in 1819, and concerned himself no further with contemporary French art. His lifelong achievement was the engraving of the famous frescoes by Correggio in the Duomo and the Monastery of San Giovanni in his native city, as a result of which he acquired international celebrity. The two graduates of the Roman College of San Michele began by taking the same itinerary. Indeed Beraldi comments on the irony that prizewin-ning young French engravers were sent to Rome to learn their craft by contemplating the Renaissance masters, whilst talented young Italians took the path in reverse! However, the continuing engagement of both Calamatta and Mercuri with contemporary French painting gave them a stake in the development of new reproductive techniques that Toschi never possessed.

It needs to be underlined, moreover, that Calamatta became assimilated into French literary and artistic society at its highest levels. This gave him an authority that few, if any, foreign artists living in Paris at the time can have possessed. In 1840 he married Josephine Raoul-Rochette, a talented painter whose mother, Claudine Houdon, was the daughter of France's most celebrated eighteenth-century sculptor, Jean-Antoine Houdon (1741–1828), and whose father was the archaeologist Désiré Raoul-Rochette, from 1840 to 1854 *secrétaire-perpétuel* of the Académie des Beaux-Arts. Both were close friends of Ingres, who produced drawings of the whole family. Twenty years later, the daughter born of this marriage (and god-daughter of Ingres), Lina Calamatta, married Maurice Dudevant, the only son of George Sand, thus cementing the friendship that had begun with the novelist's first visit to the studio in the Passage Tivoli around a quarter of a century before.

All these contrasting themes need to be drawn together in setting the scene for Calamatta's achievement as an engraver concerned in particular with the work of Ingres. The final piece of good fortune attached to his legacy is the fact that he benefited from an especially well-informed and acute contemporary commentator to evaluate his career, in the person of his former pupil, Charles Blanc. He also left a personal autobiographi-cal sketch (hitherto unexamined) which adds much to Blanc's account, and corrects it in some important details. Finally, he was the recipient of twenty-five letters from Ingres, between 1829 and 1864. These are noticeably warmer and more effusive than most of the letters which Ingres directed to his fellow artists, and enable us to eavesdrop on the

history of several of their joint projects. The account that follows will be woven from these three different threads.

Calamatta tells us that he came of a Maltese family, established in Civita Vecchia since his grandfather Michel was summoned there to rebuild the lighthouse and part of the port. Born in 1801 and orphaned in his childhood, he held property in the city which had been granted by the papacy in recompense for his services, but his guardians neglected to pay the annual charge to the papal works department and it was taken away from him. Calamatta's later virulent dislike of the papal government can be attributed to this experience: 'I, like a little fish, had to make the journey of Jonas. I naturally lost the lawsuit that I brought against the priests' shop, which was judged by priests under the government of priests.'[43] After losing his family fortune, Calamatta was given a place as an intern in the College of San Michele to study drawing, and rapidly progressed to engraving under his 'excellent teacher', Professor Giangiacomo. A revealing sidelight is cast on his whole career (as it was in the case of Mercuri as well) by the fact that his early ambitions to be a painter were frustrated: the prelate who directed the college forbade the students to leave the grounds, and so made it impossible for them to sketch and study in the museums and collections of Rome. However, the high standard of technical teaching enabled him to develop fast as an engraver, completing his first reproductive plate at the age of sixteen under the guidance of 'the celebrated Professor Riccioni'.[44]

Calamatta soon outgrew the college which had fitted him for his future career. After leading a protest about the standard of the communal food (that took him as far as the office of the papal secretary of state, Cardinal Consalvi) he was expelled forthwith, at the age of nineteen. However, his youthful promise rapidly brought him to the notice of the Roman community of artists. Domenico Marchetti, 'one of the foremost engravers in Rome', gave him modest working space, whilst 'the foremost sculptor', the Danish neo-classicist Bertel Thorvaldsen, thought sufficiently well of his reproductive drawings to agree to purchase some of them.[45]

These details about Calamatta's early life and training are especially valuable in that they highlight the unique collision, in the Roman cultural milieu, of traditional, craft-based skills and new, cosmopolitan ideals of artistic achievement. Calamatta began to engrave a Raphael *Madonna*, no doubt in the shallow manner developed for the passing tourist trade. But he was stopped in his tracks by encountering the young French engraver André Taurel, who was in Rome after winning the Academy *grand prix* for engraving in 1818. Taurel, a former pupil of Bervic, epitomised the classic manner of the French burin, and his proposal to Calamatta that he should work on his plates threw the young Roman into a fever of hesitation: 'When I saw these engraved lines, deep and shining, this manner of engraving so different from our own Roman manner, I became feverish; it seemed impossible for me to succeed and I was fearful of ruining his work.'[46] That he rapidly adapted his talents is attested, however, by Taurel's invitation to accompany him back to Paris and work in his studio. Thorvaldsen opposed this plan, no doubt anxious to retain a superlative copyist. But Marchetti urged him to accept: 'Go on, you are young, it is good to see and get to know another manner of engraving and the French are famous in that art.'[47]

Taurel was a close friend of Ingres, and arranged for Calamatta to see the *Voeu de Louis XIII* in Florence on his way to France. Whether on this occasion he met Ingres, who was

working on it there between 1821 and 1824, is not revealed. But Calamatta does tell us that he conceived on his own initiative the ambitious project of engraving this highly prestigious painting, which possessed the 'essential qualities for engraving, firmness of drawing and variety of objects'.[48] His chance to propose this suggestion came when Ingres, another stranger in Paris, came to install his painting at the Salon of 1824 and stayed with Taurel in the rue du Bac. Calamatta considerately 'gave up [his] little room' for Ingres, and camped out in the kitchen.[49]

It was perhaps from this position of moral superiority that Calamatta felt authorised to press his claims as an engraver! The autobiographical account does not, of course, put it in this way. Still, the general tenor of what Calamatta writes about the commission rings true. Charles Blanc assures us that 'several artists' were on hand to undertake it, but that Ingres had 'Italian ideas' in painting and so favoured the young Italian.[50] Against this must be set the specific assurance in Calamatta's account that Ingres was waiting – fruitlessly – for the Baron Desnoyers, a member of the Academy and the first engraver to be ennobled, to make an offer.[51] In all events, the novice had to engage in a long campaign to persuade Ingres to give him his confidence. On his first request, he was turned down flatly. But he was granted the space of a month to make a drawing from the picture, it being understood that all that time was necessary to finish 'the contour and complete a portion' of it. Calamatta's subsequent description of the moment of truth is too good to omit:

> On the day appointed I had finished one of the large curtains. Ingres came and . . . it was one of the happiest days of my life. He looks at the drawing – looks at me and looks all round the room as if to see if someone else had perhaps done what he saw, so surprised and pleased he was. At the end of five months of work, the drawing was complete. Ingres said to me: I cannot pay you but I don't want to let it go either. You will have to be satisfied with 600 francs. I was paid over the odds by the eulogies and encouragements that he gave me. No one is able to stimulate and intoxicate an artist like him; he knows how to lift you above the modern mediocrity and he opens your eyes to make you see our true Gods Phidias and Raphael.[52]

Calamatta's account is revealing not only as an indication of the extraordinary personal impact of Ingres, but also as a pointer to the substantial obstacles which lay in the path of a large burin engraving. Even the preliminary drawing – whose perfect accuracy is essential when the painting itself can no longer be used for reference – costs five months of work. The actual work of engraving has to be measured in years. And who will finance the engraver? Ten years later, the Maison Goupil might have been able to come to the rescue, but in 1825 Ingres was clearly unable to make the investment himself. His friend and patron, M. Marcotte d'Argenteuil, advanced the 15,000 francs that Calamatta judged necessary to support him over the long years of labour on the engraving. Even so, the schedule did not run at all as planned. Calamatta fell ill after 'three or four years of assiduous work', and so missed the chance of having this 'Bourbon work' appear within the period of the Bourbon Restoration, when the minister of the *Maison du Roi* had committed himself to a lavish recompense. This did not prevent the liberal-minded engraver from welcoming the July revolution of 1830.[53] The engraving was finally published only in 1837, under the Orléans dynasty, but its official and critical success was immediate

71 Luigi Calamatta, engraving (1837) after Jean-Dominique Ingres, *Voeu de Louis XIII*, 1824 Salon. 78.8 × 55.9. Musée Ingres, Montauban.

(pl. 71). In a letter from Rome dated 28 September 1837, the delighted Ingres could salute as his 'confrère en chevalerie' the colleague who had just been decorated with the Légion d'honneur.[54]

This was, all things considered, a happier outcome than with Mercuri's *Jane Grey*, and Charles Blanc's detailed criticism confirms the spectacular success of Calamatta's individual style of engraving. But before considering this, it is important to place the work in context by looking at some of the other major printmaking projects that Ingres's work initiated in these years. Calamatta was fortunate in having won Ingres's confidence at an early stage, and no doubt in having to copy a painting that was already quite securely in the public domain. Even so, as already noted, he had to threaten Ingres with abandonment of the project, if he continued to interfere. In some other cases, Ingres seems to have treated the engraving process as a way of advancing his compositional ideas in subjects that he returned to again and again in the course of his career. The engraving was not allowed to be simply reproductive, since his continual revision of motifs could affect the development of the engraved image. It can easily be imagined that this made the lot of the engraver a very difficult one.

A good example of this unusual creative process can be found in the engraving *Tu Marcellus eris*, published by Charles-Simon Pradier in 1832. There are two major paintings by Ingres which bear this title, the one generally supposed to have been first in date (Musée des Augustins, Toulouse) having been commissioned by the French general Miollis, governor of Rome during the French occupation and an ardent Virgilian; the second, showing only three figures, having being bought from Ingres's studio sale by the Musées Royaux de Belgique, Brussels. This chronology, however, leaves several questions unanswered, and Daniel Ternois has suggested that there may originally have been a larger work, commissioned for the Palazzo Quirinale, which was cut down, leaving the Brussels version. However this may be, the Toulouse version, which was bought back by Ingres in 1835 and developed further in his studio – though still remaining in an unfinished state – is the best surviving comparison to the Pradier engraving.[55]

The Toulouse version, then, places the scene of Virgil reading the Aeneid to Augustus in an ample interior setting, while the Brussels version shows nothing but the three figures of Augustus, Livia and the fainting Octavia. But this relationship between the unfinished painting and the engraving is exceedingly complex, possibly involving Ingres's reminiscence of an earlier, differently proportioned project, and certainly involving a series of drawings which prepare the transition from the Toulouse painting to the print. Ingres clearly attached a special importance to the project, as a fulfilment of an ambitious subject only partially conveyed in the painted versions. In particular, he was evidently struck with the idea that the young member of the imperial family, whose death Virgil inadvertently alludes to, should be represented in a statue, behind the main figure group. He should moreover cast a 'great avenging shadow' on the wall.[56] This intention has been carried out in Pradier's engraving, though it necessarily involved a complete change in relative dimensions and a reappraisal of (or reversion to) the original composition (pl. 72).

As Beraldi noted in respect of this work, Ingres was 'extremely tiresome for his interpreters'. 'He himself retouched it during the engraving process, each day bringing some correction made on tracing paper.'[57] In Pradier's case, he also seems to have intervened on proofs of the print, sketching in pencil lines to define as yet unworked areas of the

72 Charles-Simon Pradier, engraving (1832) after Jean-Dominique Ingres, *Tu Marcellus eris*, 1812. 80.7 × 63.8. Musée Ingres, Montauban.

73 Early state of pl. 72, with drawing by Ingres. Musée Ingres, Montauban.

composition (pl. 73). The result was, of course, in every sense a new variant work rather than a reproduction. Pradier was being enlisted as a co-author, rather than a simple interpreter. Indeed Ingres seems to have then adapted the Toulouse painting in its turn to accord with aspects of the new composition, possibly employing his students to add the two attentive figures of Maecenas and Agrippa, who end up in the painting after making their first appearance as pencilled additions to Pradier's proof.

For Ingres, therefore, the idea of a reproductive engraving seems to have been inherently problematic, except in so far as it fostered the process of refining and rethinking his stock of motifs. The idiosyncrasy achieved almost comic proportions when, in 1851, his former pupil Magimel succeeded in publishing what was intended to be a retrospective overview of his life's work to date, *Oeuvres de J.A. Ingres, gravées sur acier*. Magimel confesses in his preface that it was only 'after a long resistance' and 'after very vigorous requests' that Ingres agreed to endorse this 'general and chronological collection' of his works.[58] But he does not intimate that some of the steel engravings modified and (no doubt in Ingres's view) improved upon their originals. It is interesting to refer, in this connection, to the catalogues raisonnés of Delaroche and Scheffer published with Bingham's photographic record before the end of the same decade, in relation to which Magimel's collection has a highly ambiguous status. The wider issue of Ingres's relation

to photography will, however, necessarily come to the fore at a later stage in this chapter, when Bingham's brief connection with him comes under review.

One might conclude that the very duration of the engraving process made it difficult for Ingres to avoid interfering. By the same token, the very rapidity of lithography forestalled his intervention. However, Ingres was well served in this domain by his fellow south-westerner, Jean-Pierre Sudre (1783–1866), an ex-student of David who brought the art of lithography as close as it ever came to academic respectability, and was classed by Beraldi in terms directly parallel to Calamatta: 'the lithographer of Ingres'. Beraldi refers to his print of *La Chapelle Sixtine* (1836: after the painting of 1814, National Gallery of Art, Washington) as 'a very great piece, capital and celebrated; one of the masterpieces of lithography as translation' (pl. 74).[59] The accolade is well merited, and it is a fea-

74 Jean-Pierre Sudre, lithograph (1833) after Jean-Dominique Ingres, *La Chapelle Sixtine*, 1814. 78.9 × 91.5. Musée Ingres, Montauban.

ture of Sudre's superfine use of the crayon that a photograph of the lithograph is virtually impossible to distinguish from a black-and-white photograph of the painting. Beraldi himself notes the striking effect of top lighting above the papal throne, and makes what he hopes is not an 'irreverent' comparison with Daumier's satirical view of the Chambre des députés, *Le Ventre Législatif*.[60] But lithography did not gain, even at Sudre's hands, the prestige of engraving. He himself remained outside the Academy (where there were of course no places for lithographers), and also (as Beraldi notes) unrewarded by the Légion d'honneur.

Lithography lent itself superbly to vivid commentary on contemporary events. However, its very identity as a medium capable of rapid and spontaneous effects militated against the development of a critical language suitable for evaluating it. By contrast, the well-ingrained notion of burin engraving as translation – the idea which George Sand debates in her own fashion – provided the critic with historically based concepts for the systematic discussion and evaluation of the reproductive printmaker's art. The particular form of excellence proper to such work could be defined through the very constraints placed upon it in terms of its relation to the original, and its intrinsic difficulties of technique. Nicolas Ponce (1746–1831) expressed the matter succinctly in a definition that was published in 1828, at the end of his long life as a distinguished engraver, and quoted verbatim in Perrot's manual of 1830:

> The engraving . . . is not a copy of the painting. It is a translation of it, which is different. The aim of these two arts is to imitate nature; if the engraver does not imitate it directly, it is because the slowness of his procedures does not allow him to; but very often he himself has recourse to nature, when the picture that he is translating presents him with false or doubtful forms. Composition and line [*trait*] are the only things that the engraver can translate literally; but the effect, the colour and the harmony of a print are almost always dependent on his genius. Having only, for the rendering of all these objects, equivalents that are often insufficient, the engraver is obliged to make up for it by his intelligence, all the more so as painting sometimes only produces its effect through the kinship and variety of colours, and the engraver, who has only black and white, is obliged to create the effect and harmony of his print.[61]

It is helpful to juxtapose this passage with another substantial quotation in order to appreciate how Charles Blanc, writing in 1876, puts his former training as an engraver to use in describing the feat of translation accomplished in Calamatta's *Voeu de Louis XIII*:

> Ingres, so they said, if he had known how to hold the burin, would do no better; he could not be more like himself.
>
> We were able to judge for ourselves, two years ago, when the *Voeu de Louis XIII* was exhibited with all of Ingres's works at the Ecole des Beaux-Arts. The straightforwardness of the effect, in the original painting, allowed the engraver to depart from a very deep tone to lead the eye up to the shining light produced by the pure white. It is however remarkable that the firmest shadows, and the most resolved ones, are obtained with only two cuts or even with one cut. Thus the Virgin's mantle, which had to be kept a bit dark to bring out the brilliance surrounding the central group, is attacked with a single cut, just a little crossed in some of the shadows, that is of an admirable simplicity and pride and produces the desired tone, without stifling the

transparency of the paper. The finer draperies, the dress of the Madonna and her sleeves are treated with lines and points of different degrees of depth, in such a way as to figure a soft and delicate material without getting too far away from the sobriety assumed by the painter. As for the flesh tones, the engraver has used fine, precious work, such as would have suited even a more savoury form of painting than that of Ingres; he has expressed them with light cuts, separated by a rosary of dots, by way of inter-cuts. He has thus avoided that disagreeable lozenge, stopped by a cut, which Italian engravers from the decadent period so often worked with. In certain passages, above all in the secondary figures, those of the two seraphim who hold apart the altar curtains, Calamatta has not made his burin follow the routine curves, but brusquely traced a direct path, accentuating the male austerity of the original. Sometimes he achieves the charm of certain half-tones, with no other resource but the drypoint, a process little used in France, but familiar to Italian engravers and happily employed by Raphaël Morghen.[62]

Blanc's felicitous and exact description was carried out in the uniquely favourable circumstances of a direct comparison between the print and the original painting. It vindicates the engraver's fidelity to Ingres in the very process of showing how the exigencies of translation forced Calamatta into novel combinations of engraving techniques: how he avoided the grosser clichés of tradition through the sustained purity of his cuts, and supplemented the basic work of the burin with the more delicate scratches of the drypoint where a half-tone was needed. Blanc's description of the flesh tones is specially felicitous. Moreover, that system of 'light cuts, separated by a rosary of dots, by way of inter-cuts' is precisely what gives Calamatta's subsequent work, such as the portrait of George Sand to be discussed shortly, its distinctive softness of tone in portraying the skin. Calamatta certainly proves himself to be a virtuoso in adapting his austere language to new expressive possibilities touched off by the development of contemporary painting. In terms of translation theory, his success tallies closely with the criteria posited by Rudolf Pannwitz (and recommended by Benjamin) for the successful translator: 'Particularly when translating from a language very remote from his own he must go back to the primal elements of language itself and penetrate to the point where work, image, and tone converge. He must expand and deepen his language by means of the foreign language.'[63]

Yet the very exactitude of Blanc's assessment, delivered in such ideal circumstances, makes it imperative for us to look at Calamatta within the wider field of print production. In order to put some of the basic features of his engraving style in context, it will be helpful to adduce a few comparative examples that display his different techniques in relation to those of his contemporaries and predecessors. What can hardly be doubted, in respect of the *Voeu de Louis XIII*, is the fact that Ingres himself was confirmed in his judgement that Calamatta would be his interpreter *par excellence*. His letters, which become more affectionate and expansive from 1837 onwards, try to nudge the engraver in the direction of taking on more of his cherished works. One of these, dating probably from the late summer of 1842, records the amazing, but from Ingres's point of view extremely 'enervating', success of his portrait of *Ferdinand-Philippe, duc d'Orléans* (pl. 75).

The circumstances of this work's appearance were indeed extraordinary. Ingres had been commissioned to paint the portrait of the eldest son of Louis-Philippe, the heir to the

75 Luigi Calamatta, engraving (1845) after Jean-Dominique Ingres, *Ferdinand-Philippe, duc d'Orléans*, 1842. 74 × 60.8.
Musée Ingres, Montauban.

throne, whose charm and popularity stood in stark contrast to his father's deficiency in both these domains. The duc d'Orléans had been a generous patron of Ingres, commissioning him to paint the *Antiochus and Stratonice* (1840: Musée Condé, Chantilly) as a pendant for his earlier purchase of Delaroche's *Assassination of the Duc de Guise* (1834: Musée Condé, Chantilly). The portrait was however barely completed when the young sitter was killed in a carriage accident on 13 July 1842. This gave it a sudden, incalculable value for the royal family and for many in the nation at large, resulting eventually in a spate of authorised copies. It also incited Ingres to call on his engraver, Calamatta, for a timely printed version to satisfy the inevitable demand. Ingres was in a state of disarray, with a likely profit of 100,000 francs shimmering before his eyes, but nothing to start from: 'not even a passable drawing which could have served me, with a fault in the pantograph, so that what I have is no good'. With his mechanical method of transcription, the Pantographe Gavard, giving up on him, Ingres simply put his faith in Calamatta: 'So, dear friend, yours is as always the first choice obviously and in my own great interest and happiness.'[64]

Calamatta responded with two projects, a short-term and a long-term one. The latter followed the inevitably slow pace of the burin engraver and resulted in the print of 1845, which, though less complex in its pictorial effects than the work after the *Voeu de Louis XIII*, exhibits a similar control of the gradations from dark to shining white, and lends the tragic young prince an iconic afterlife. The former, however, was completed according to Ingres's fervent wish within the year 1842, and promptly published and distributed by Maison Goupil. The printing technique was a mixed one, which Calamatta had used before in his *Paganini*, after a drawing by Ingres, exhibited at the Salon of 1831. It is described in Beraldi as 'burin and crayon facsimile', which prompts a short detour into the earlier history of engraving techniques.[65]

Crayon-manner engraving, as it is known in the context of British printmaking, is a derivative of the stipple technique developed in France from the mid-eighteenth century onwards. The original purpose of the stipple was to reproduce the effects of chalk or crayon on rough paper, through a close grouping of dots which established tone and texture. The crayon manner, as developed for example by late eighteenth-century British engravers, was an attempt to simulate the spontaneity of the draughtsman. When combined with colour printing, it provided a striking equivalent to the relaxed and elegant manner of contemporary portraiture. For example, John Hoppner, who succeeded Reynolds in the last years of the century as the most fashionable English portrait painter, was ably interpreted by the engraver Charles Wilkins (1750–1814), in such prints as *Lady Charlotte Duncombe* (pl. 76). This work, belonging to a series of 'Ladies of Rank and Fashion', was intended to combine the finish of painting with some of the freedom of drawing. It is to be emphasised, however, that it is not a *coloured* print like the costume works by Mercuri, where colouring has been added by hand. The colour tones are the result of the stipple method, applied with a mace-head or *mattoir*, and of successive impressions of the differently inked plate.[66]

Calamatta's *Paganini*, of course, uses the crayon manner for a rather different kind of effect (pl. 77). The intention is not, in fact, to infringe upon the domain of painting, but to reproduce the special characteristics of Ingres's exquisitely graded draughtsmanship. In particular, the combination of burin to define the fine contours of the face, and

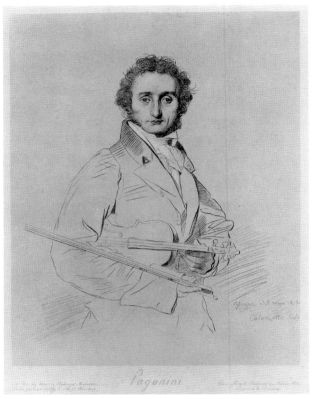

76 Charles Wilkins, crayon-manner colour print (*c*.1800) after John Hoppner, *Lady Charlotte Duncombe*, *c*.1797. 26 × 20. Private Collection.

77 Luigi Calamatta, crayon-manner engraving (1831 Salon) after drawing by Jean-Dominique Ingres of Paganini, *c*.1818. 46.5 × 37.1. Musée Ingres, Montauban.

stippled texture produced by the *roulette* to counterfeit the sweeping lines of the violinist's instruments and clothing, replicates the range of Ingres's pencil techniques. The parallel lines carved by the burin are just perceptible in the shaded side areas of Paganini's face. The softer lines, however, must be examined with a magnifying glass before their textures resolve into closely grouped grey dots.

This fine engraving, however, encountered a problem which was part and parcel of its conspicuous success in 'standing in for' an Ingres drawing. It was shown at the 1831 Salon simply as 'Portrait de Paganini' by Calamatta, in the engraving section.[67] Possibly this was the version *avant toute lettre* cited by Beraldi, though it may have been the second, signed version, or the third with Paganini's name added, or the fourth with the address of the publisher, Rittner (Goupil's future partner). The distinctions are potentially important because it is only at the second stage that the print acquires the legend: 'Ingres del. Roma 1818 / Calamatta Sculp'. There is indeed a drawing which corresponds quite closely to Calamatta's image, but this is firmly inscribed 'Ingres del. /Roma 1819' (Louvre). There is also a tracing apparently by Ingres (Metropolitan Museum, New York) that is even closer, and might well have been taken from an earlier drawing dated 1818. But the

78 Luigi Calamatta, engraving (1836) of George Sand, possibly after Eugène Delacroix. 12 × 9.6. Musée des Beaux-Arts, Lyons.

79 Auguste Blanchard *père*, engraving (1810) after portrait of Queen Hortense of Holland by Anne-Louis Girodet, *c.*1804. Musée des Beaux-Arts, Lyons.

hypothesis of two, differently dated drawings from 1818 and 1819, both showing approximately the same composition, seems a tenuous one. It is just as likely that Ingres adapted the tracing in view of the engraving by Calamatta, and perhaps also misinformed him about the date.

A more serious issue of authorship arises in relation to the outstanding portrait engraving by Calamatta which survives as a souvenir of his early meetings with George Sand. In this case, the claim asserted by the engraver is more explicit. The fine proof on *chine collé* illustrated here (Musée des Beaux-Arts, Lyons) bears the printed legend: 'Paris 1836. Disegnato e inciso da me. Luigi Calamatta' (pl. 78). There is, however, no doubt that the image derives quite closely from a small portrait (now apparently lost) painted by Delacroix in November 1834, and fully documented in his journal, since the sittings were the occasion of their first serious meeting. George Sand – who had just shorn her long hair and sent the off-cuts to her cooling lover, Alfred de Musset – had poured out her heart to Delacroix at the three sittings.[68] Calamatta was employed to engrave the work for publication in the *Revue des deux mondes* in July 1836, and it has been suggested very plausibly that he needed additional sittings to convey her new growth of hair and

substantially recovered state of health. But the omission of Delacroix's name seems to have caused offence, all the more so as subsequent portraits of George Sand were compared unfavourably with Calamatta's moving record.

This little contretemps illustrates the tightrope on which reproductive engravers were liable to tread when they forsook the accredited task of translating from named and known works of art. It may also betray a notion of authorship held by Delacroix that was fundamentally different from that of Ingres. But an equally significant context in which to assess the quality of Calamatta's portrait is surely the tradition of small portrait engravings to which it belongs. Auguste Blanchard *père*'s portrait engraving of Queen Hortense (daughter of the Empress Josephine and wife of Napoleon's brother, Louis King of Holland) is taken from a painting by Girodet, and belongs to the collection of small prints published around 1810 as the *Galerie Napoléon* (pl. 79). It is a skilful, but probably quite rapidly finished, example of burin engraving which displays the stipple technique with workmanlike effect. It is, however, quite explicitly, no more than a black-and-white notation for a painting. Calamatta's *George Sand*, on the other hand, has a visual depth and psychological interiority that support his defence that the image is essentially his own. The large dark eyes that were universally noted as Sand's most mesmerising feature are hauntingly conveyed through the spare sobriety of the medium.

It may be argued that Calamatta's most successful works were, in fact, the more small-scale, informal portraits, and not the large burin engravings over which he lavished so much time. Charles Blanc inclined to this point of view when he praised the initial, 1842 version of the *Duc d'Orléans* as 'plus aimable' compared with the 1845 engraving. Blanc felt that the latter work, being 'finished entirely with the burin, [lacked] lightness and brilliance', and he extended this criticism to much of Calamatta's later work.[69] He was, however, willing to make an exception for the prodigious achievement of the *Mona Lisa* (pl. 1), which was published at the same time as Mercuri's *Jane Grey*, and must have occupied its author for an even greater period, if we count from the time when the initial drawing was made. Calamatta's autobiographical notes leave no doubt that it was during the first period of his arrival in Paris, probably around 1828, that Ingres's influence was exerted to gain him access to Leonardo's masterpiece. The drawing that later hung in the studio, in Charles Blanc's account, was already completed and had received an enthusiastic response from Ingres and Taurel by early 1829, at the latest, since Calamatta began engraving from it in the summer of that year, during a return visit to Italy.[70]

In the interval of nearly thirty years which elapsed before the completion of the project, the techniques of engraving had developed considerably, in parallel with the research into metal-coated surfaces and processes for developing the image which were being conducted by Daguerre and his peers. It has already been noted that the plate of Calamatta's *Mona Lisa* was reputedly the first copper plate to be successfully steel-coated, with an enormous consequent gain in durability and consequently in the number of prints produced.

What has not been mentioned is the nail-biting story of this experiment, as told by the leading engraver of the end of the century, Félix Bracquemond. The electro-plating process would not work on the first attempt, and it was feared that the many years of

Calamatta's work invested in the copper plate might be lost for good.[71] A similar technical problem had also affected his portrait of *Lamennais*, in 1847, when it was decided to use his copper plate for an unprecedented experiment in galvano-plastic reproduction. The aim was to produce another, identical plate by direct contact. But, when Calamatta's friend, Lucio Quirico Lelli, wrote to his old teacher, Francesco Giangiacomo, in Rome, on 14 February 1847, it appeared that the process had failed, and the two plates were firmly welded to one another![72] A solution was evidently found, for the print was published in the same year. But Calamatta's pupil, Léopold Flameng, testified that a series of 'singular-looking proofs' were taken, whilst the indentations on the plate were still blocked by deposits of metal from the bath.[73]

Calamatta was therefore, willingly or not, a front-runner in the drive for technical improvements and increased profitability which took hold of print publishers in the mid-century. His own high standards of craftsmanship were not compromised, but already, by the time that the youthful promise of the *Mona Lisa* drawing had been translated into its definitive form in a burin engraving, the fashion had swung in the direction of more informal modes of printmaking. Félix Bracquemond, who was in his mid-twenties when he witnessed the tense process of the *aciérage* of the *Mona Lisa*, was to be the leader of a revival of the etching process. Léopold Flameng, born in Brussels of French parents in 1831, studied with Calamatta and became one of the most able *burinistes* of the next generation. But, according to Beraldi, he never acquired Calamatta's complete confidence, as if the master had foreseen that he would on occasions 'desert the practices of severe burin engraving to pass into the etching camp'.[74]

Calamatta's legacy to printmaking was therefore an equivocal one. What he achieved as an artist was largely the fruit of his long-term friendship and collaboration with Ingres. Thus it was subject to the interminable doubts and revisions that were a feature of Ingres's creative life, and impinged sharply on those charged with reproducing his paintings. At an early stage, Ingres evidently promised him the right to engrave the most prominently placed and prestigious of all his works, the *Apotheosis of Homer* (Louvre), which had been removed from its original site as a ceiling painting in the Louvre after 1830, and was placed on show in the Musée du Luxembourg. Ingres, however, insisted that the engraving should reproduce a second version, in the form of a drawing, which would include a number of additional figures. He alluded to the project in encouraging terms in various letters to Calamatta, including one dated 8 January 1858. But he only finally completed the drawing in 1865, too late for Calamatta to contemplate undertaking the engraving.[75]

The sequence of major works by Ingres reproduced by Calamatta which had begun with the *Voeu de Louis XIII* did, however, conclude with one, specially significant addition. Ingres's painting *La Source* attracted enormous attention when it was unveiled and shown for the first time in 1856. Although it derived from a study after the antique which Ingres had begun in Rome before 1825, it fulfilled the highest requirements of contemporary Parnassian taste, and was specially praised by Théophile Gautier. In a letter of 4 January 1859 in which he wrote tantalisingly of the gossip about 'Homer and his engraver', Ingres also took care to return the 'beautiful drawing' of *La Source*, which Calamatta had done as a preparation for his engraving. But perhaps this was no longer a time when such a drawing could call attention to itself as a uniquely powerful index of the

original, in the way that Calamatta's drawings after the *Voeu de Louis XIII* and the *Mona Lisa* seem to have done. Ingres felt constrained to enclose as well 'a photographic print of *La Source*', on the grounds that several features of the drawing did not live up to the standard of his painted figure.[76]

* * *

As this incident demonstrates, by 1859 Ingres certainly set store by photography as a faithful record. But at what point had he begun to make use of it? And how does his relationship with photographers compare, and differ, with those instanced in the previous chapter? Without any doubt, he was quick to realise that the process could be utilised for the purposes of documentation. As early as 1842, he announced to his friend Gilibert that he was having 'daguerreotypes taken' of a work, in advance of the final varnishing and showing to the public.[77] None of these early reproductions has survived. However there is a stray daguerreotype by Désiré Millet in the collections of the Musée Ingres at Montauban, which shows a view of his studio, with a female nude in the foreground, and the seated version of *Madame Moitessier* visible in the background. From internal evidence, it has been suggested that this dates from around 1852, and may have been motivated by a wish to retain an image of the former work (for which his first wife had modelled) when he married for the second time in that year, and sold the painting. The image is, however, essentially a view of the studio, with the work itself not at all effectively positioned despite its prominence.

From the early 1850s, there is accumulating evidence that photographers visited Ingres's studio, where, using the collodion wet plate process, they made records that could be considered more acceptable reproductions. It has been argued that Charles Marville's photograph of the *Self-portrait* (1804) must date from around 1851, since it shows this work in a state which had been significantly altered by the end of the year.[78] A further photograph by Marville, possibly of *Homer and his Guide* (Royal Collection, Brussels) completed in 1862, is recorded as having been given by Ingres to his friend Charles Stürler in the 1850s.[79] Whatever the precise date of this photograph, it is clear that Marville 'systematically' photographed Ingres's drawings in the early 1860s, and exhibited them with the Société française de photographie in 1865, before placing them on sale in 1867 after the painter's death.[80]

Marville was a photographer with an established reputation by the early 1860s, but he was by no means specialised in the reproduction of paintings. Among the international medallists rewarded at the London International Exhibition of 1862, he is cited for his 'épreuves photographiques d'objets antiques, paysages etc.'. But the only medallist cited for 'la reproduction excellente des peintures et autres objets d'art' is Robert Bingham. Since Bingham was universally credited at the time with having brought this branch of photography to a state of unparalleled excellence, it is worth noting his contacts with Ingres, though these seem to have been far from satisfactory.

As has been recorded in the previous chapter, Goupil made an unprecedented investment in photographic reproduction, and in the skill of Bingham, when he commissioned the catalogue raisonné of Delaroche's work for publication in 1858. Hardly had he launched this project, however, when, in October 1858, he published the first ten plates

in his new *Galerie photographique*, also photographed by Bingham, and including three works by Delaroche, two by Ary Scheffer, one by Horace Vernet and an *Odalisque* by Ingres. This was the so-called *Grande Odalisque* (1814, Louvre), which had been included in the selection of Ingres's work at the Exposition Universelle of 1855, and by 1858 belonged to Goupil's own collection.[81] The venture was followed up by a further set of reproductions taken from the paintings in the 1859 Salon, with Bingham working under the direction of the painter Louis Martinet. In its issue of 26 March 1859, *La Lumière* announced that this project was already under way, and, on 20 August, it recorded the inclusion of 'an Odalisque, by M. Ingres' in the set already published.[82] It is more than likely that the references are to the same photograph by Bingham, and highly probable that the photographic sessions took place without any direct involvement from Ingres himself.

Goupil's *Galerie photographique* represented an important stage in the marketing of photographic reproductions of works of art. Ingres's work was priced at 8 francs, for the print on china paper (*chine*), mounted on Bristol board, with engraved titles. This was cheaper than any of the three Delaroche photographs, which included *Marie-Antoinette* and *Hérodiade* at 12 francs, and the panoramic view of the *Hémicycle des Beaux-Arts* at 30 francs. But the discrepancy could be accounted for simply by differences in overall scale.[83] The price compares favourably with that of the *lithographies à deux crayons* after Courbet and Greuze quoted in the same price-list at 5 francs for the basic print and up to 15 francs for various coloured versions. In a price-list issued five years earlier, Mercuri's little *Sainte Amélie* engraving had been priced at 18 francs, and 24 francs for the version on *chine*.[84]

Whether Ingres had any financial stake in these publications is doubtful. But it seems as though he must have responded well to Bingham's initiative, and offered him the chance to reproduce one of his most cherished compositions: a *reprise* of the *Antiochus and Stratonice* originally commissioned by the duc d'Orléans, which he was in the process of completing in the summer of 1860, at Meung-sur-Loir (pl. 80). In a letter of 1841 written to Calamatta, he had claimed long before that the *Stratonice* was 'ingravable – à cause de sa forme'.[85] Whatever Ingres may have meant by this, Bingham was given the opportunity of photographing the second version. A print of the photograph, mounted on board, is preserved among the private papers held in the Musée Ingres. There is, however, no clear evidence that it was ever exhibited or published.[86]

This may well be the result of Ingres having rejected as unfaithful to the original work a photograph that distorted its values disconcertingly in the process of reproduction. The problem that Ingres's highly sophisticated neo-Hellenic palette had brought to light was the limited spectral sensitivity of the photographic medium.[87] This limitation had the result of making blues appear as whites, reds appear too dark, and other potentially unfortunate transliterations upsetting the balance of the composition. A comparison between the original painting (Anonymous loan, Philadelphia Museum of Art) and two photographs – one the print by Bingham from the Musée Ingres and the other taken recently – highlights some striking cases of discrepancy (pls 80, 81, 82). For example, the careful delineation of the form of the chair in the right foreground, with its blue cloth tonally akin to the green bed-curtain, has been obscured by the whitening of the blue cloth, to a point where it no longer contrasts with the chair leg. The yellow pigment through

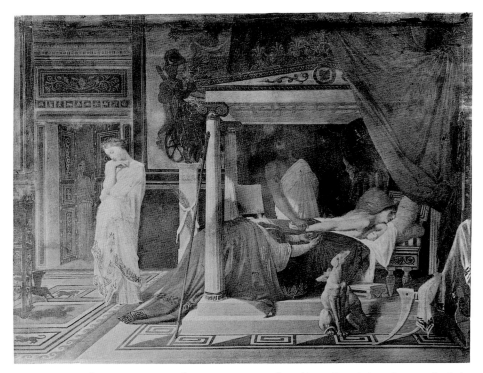

80 Robert Jefferson Bingham, albumen print (*c.*1860) of Jean-Dominique Ingres, *Antiochus and Stratonice*, 1860. Musée Ingres, Montauban.

which Ingres has picked out the gilding of the bed canopy appears in a dark tone that offers no contrast to the back wall, and the values of the medallion in the centre have been neatly reversed.

It is easy to imagine that Ingres would have been disconcerted by this bizarre transformation. It is also easy to understand why Bingham often preferred to photograph from engravings, as in the reproduction after Alphonse François's engraving of *Marie-Antoinette* (pl. 56). In a photograph after an engraving, the tonal values had already, of course, been converted into an equivalent scale in black and white before the photographer set to work. There were, needless to say, many works by Delaroche, Scheffer and Horace Vernet which Bingham did photograph after the original paintings, transforming them in a way that was accepted as being aesthetically valid. The repeated accolades that he received from the photographic fraternity testify to this. However, the resistance of a painting like *Stratonice* to photographic translation is precisely an index of the structural role played by colour in Ingres's archaeologically ambitious neoclassical works. *Stratonice* had proved to be not merely 'unengravable' but also 'unphotographable', at least for Ingres's lifetime and in the current technical state of the medium.

That this was certainly not the case with all of Ingres's works is proved by the example of the *Grande Odalisque*. As stated before, Bingham had published a photographic print of this painting in 1858, when it was in the possession of the Goupil gallery. It subsequently passed into the collection of the Princesse de Sagan, and this is the note of ownership that accompanies its appearance in one of the most sumptuous photographic albums of the early 1860s, now in the possession of the Getty Research Institute.[88] The album has been catalogued under the name of Paul Berthier, whose blind-stamp appears

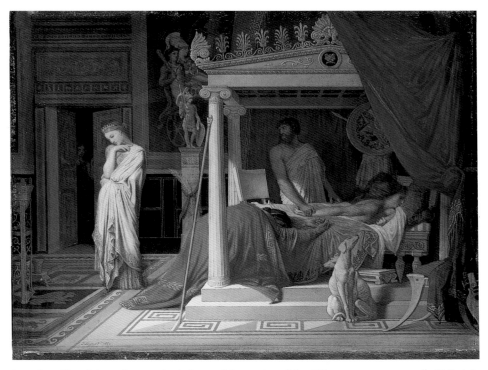

81 Jean-Dominique Ingres, *Antiochus and Stratonice*, 1860. Oil on canvas, 35 × 46. Philadelphia Museum of Art, Anonymous loan.

82 Black-and-white photograph of pl. 81.

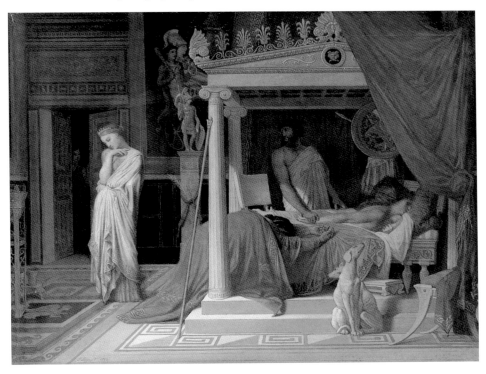

83 Paul Berthier (possibly in collaboration with Alphonse Poitevin), carbon print (*c.*1862) of Jean-Dominique Ingres, *Grande Odalisque*, 1814. 13 × 22.5. Getty Research Institute Special Collections, Los Angeles.

on several of the plates, and it seems likely that he was responsible for the exquisitely subtle rendering of the *Grande Odalisque*, which in its revelation of background detail in the upholstered panels considerably improves upon most present-day reproductions (pl. 83). But it is more than likely that, in the case of this print, he was working in collaboration with the so-called 'third man of photography', Alphonse Poitevin. As early as 1861, Poitevin was using a carbon print process (the 'procédé Poitevin') in photographs exhibited at the Société française de photographie, and he is also known to have reproduced some of Berthier's glass negatives of Chartres Cathedral through photolithography.[89]

Compared to Bingham, whose training seems to have been exclusively in the techniques of photography and whose special province was art reproduction, Berthier had a professional background in academic painting. Born in Paris in 1822, he exhibited at the Salon of 1848, and in June 1849 he appears to have received a state-sponsored commission from Charles Blanc for a copy of Correggio's *Mystic Marriage of St. Catherine* in the Louvre.[90] By 1860 he was building up a modest reputation as a professional photographer, and would cover in his subsequent career domains as diverse as classical sculpture, nude portraiture, the landscapes of Switzerland and the Forest of Fontainebleau, and Egyptian archaeology. Already at the 1859 exhibition of the Société française de photographie, however, he had contributed reproduction photographs, including several of work by Ingres's former pupil, Hippolyte Flandrin.[91] The honourable mention that he received at the London International Exhibition of 1862 was for his 'reproduction

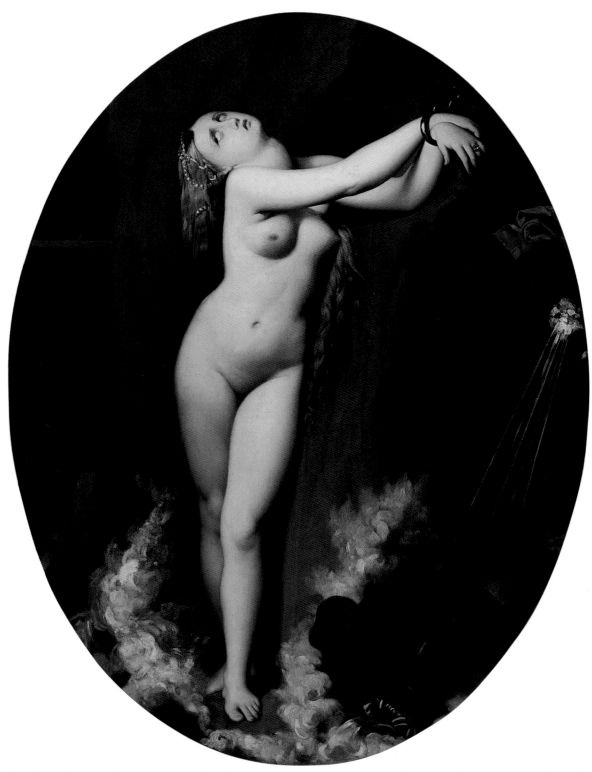

84 Jean-Dominique Ingres, *Angelica*, 1859. Oil on canvas, 100 × 74. Museu de Arte de São Paulo Assis Chateaubriand, São Paulo, Brazil.

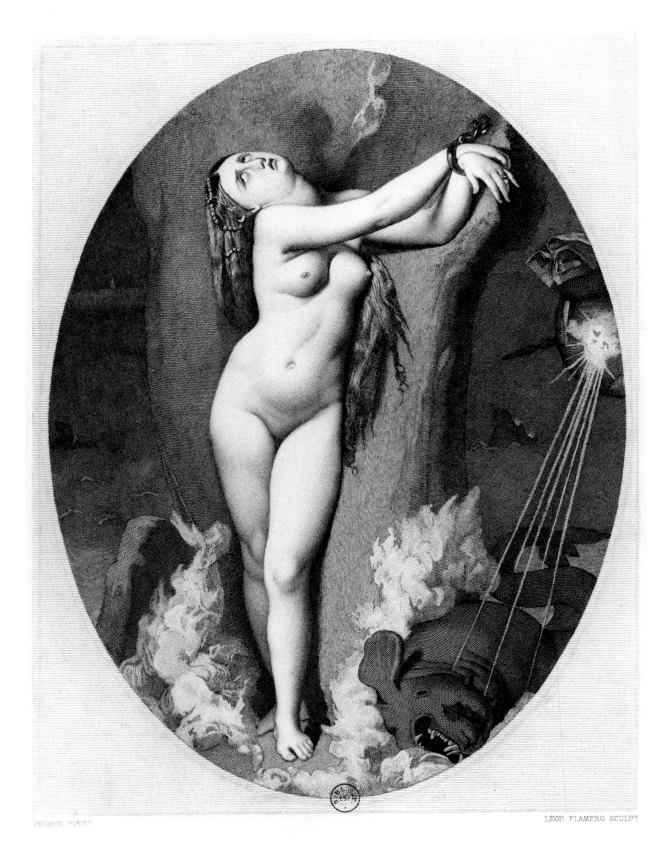

INGRES PINXT

LÉOP. FLAMENG SCULPT

L'ANGÉLIQUE

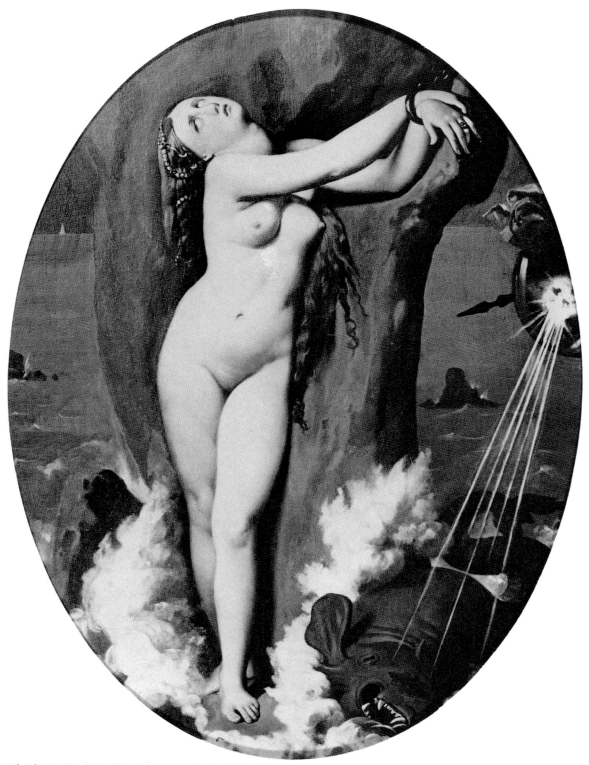

86 (*above*) Paul Berthier, albumen print (*c.*1863) of pl. 84. 25.5 × 19. Private Collection.

85 (*facing page*) Léopold Flameng, engraving (1863) after Jean-Dominique Ingres, *Angelica*, 1859. 26 × 17. Bibliothèque Nationale, Paris: Département des Estampes.

excellente d'objets d'art', and might have taken into account some of his prints from the Soltykoff collection album.[92]

The connection with Flandrin may well have paved the way for Berthier's further links with Ingres and his circle. He is known to have photographed Ingres's portrait of *Luigi Cherubini* (1842), in the Musée du Luxembourg.[93] It was also Ingres's former pupil and dealer, Etienne-François Haro, who published his fine albumen print of the final version of *Roger freeing Angelica*, dated and signed in 1859. Haro believed Ingres's painting (pl. 84) to have been begun as early as 1818, as is shown by his written inscription on the reverse. He had himself already become its owner by 1863, when Léopold Flameng published his engraving in the *Gazette des Beaux-Arts* (pl. 85), and Charles Blanc took its appearance as the occasion for a brilliant encomium on Ingres's style.[94]

Haro was thus the publisher of Berthier's albumen print of the 1859 *Angelica* (pl. 86). Indeed it is tempting to conclude that he commissioned the photograph of this cherished work not long after the publication of the engraving, or at any rate with Flameng's achievement firmly in mind. Despite contemporary views of the incommensurability of engraved and photographic reproductions, it is difficult not to see Berthier's work as equivalent in aesthetic value, despite its inevitable points of difference. In Flameng, the virtuosity of the engraved line is always apparent, forming a kind of grille which draws attention to the labour of transcription. On the other hand, there is no palpable effect of distance: the far horizon against which the painted Angelica is profiled appears in the engraving to be unambiguously inscribed upon the surface of the paper. Berthier's photographic print, slightly larger than the engraving, is much more attentive to the plastic values of the painted surface, which it reproduces with a strong impression of *matière*: it succeeds in conveying the volume of air between the foreground figure and the background, so that the faraway ship on the horizon seems distant indeed. Flameng lacks the graphic means to manage the burst of light from Roger's shield at the right-hand border, whilst Berthier successfully brings out the dazzle of the armour and the menace of the spear.

Is it justifiable to go much further than this, as Ivins does in one of his most trenchant comparisons between old engraving and the 'new vision' of photography? Ivins affirms categorically that such engravings were 'attempts . . . to represent objects by stripping them of their actual qualities and substituting others for them'.[95] By contrast, the photograph 'was able to give detailed reports about the surfaces, with all their bosses, hollows, ridges, trenches and rugosities, so that they could be seen as traces of the creative dance of the artist's hand'. In Ivins's case, the argument is overdetermined by the supposition that Manet is the great painter whose 'creative' hand is to be detected through the faithful transcription of the photograph: in other words, there is a *facture* of the brush that is irreducible to the engraver's terms. Yet no one, least of all Manet himself, ever supposed that Manet's paintings were destined for consecration in the form of burin engravings. Ingres, on the other hand, has been shown here to have borne that possibility constantly in mind. It is not at all fanciful to imagine that he would have recognised the characteristic form of mediation provided by Flameng's engraving to be an appropriate translation of the 'actual qualities' of his work.

What is incontrovertibly anachronistic in Ivins's comparison, however, is the supposition that photography was immediately and, so to speak, automatically qualified to

provide the 'new vision' that supplanted engraving. On the contrary, as has been shown here, it was specific photographers, not 'photography', that developed the expertise to reproduce visual works of art. These photographers had to contend, not only with the particular constraints inhibiting their efforts at successive stages in the technology of the photograph, but also with the disposition of connoisseurs (and artists) to evaluate their work in the light of the effects obtained through the varied techniques of engraving. As has been shown in the previous chapter, it was Robert Bingham who first unequivocally broke through both of these barriers, though his failure with *Antiochus and Stratonice* indicates that this achievement was never a *fait accompli*. To a great extent, it is the very existence of such a failure that brings back the complexity of the interaction between modes of reproduction in the period, since it testifies to the technical sophistication and aesthetic merit that photography was having to acquire, stage by stage. Henri Delaborde's thoughtful essay on the failure of photography to emulate engraving, which will be considered more fully in the next chapter, dates from 1856. But within two years, Delaborde himself was providing the text for the posthumous catalogue raisonné of his friend, Paul Delaroche, magnificently illustrated with Bingham's photographs. By this stage, it must have become evident that photography had at least partially succeeded in adapting its distinctive registration of the painted image to what Delaborde calls a 'fecund reproduction'.[96]

This chapter has shown that Ingres, for his part, was indeed preoccupied with the need to ensure the perpetuation of his oeuvre in the form of traditional engravings, but that his methods of working, and his inhibitions about producing the definitive version, frequently interfered with this objective. In his case, photography did not offer a great deal of help in resolving the problem. Though he certainly made frequent use of the photograph for purposes of record, there is no clear indication that he saw the new medium as potentially supplanting the burin engraving. Indeed, almost all the successful photographs of his paintings mentioned previously appear to have originated with the initiatives of the owners of those works, though in the case of Haro the owner also happened to be his dealer and a trusted confidant.

If we continue to follow the fortunes of Ingres's work in reproduction beyond his death in 1867, the tension produced by the continuing demand for reproductive engravings remains a persistent theme. However, this turns not so much on the issue of aesthetic value vis-à-vis photography, as on the conditions for assigning the legal right of reproduction, which were already discussed in the first chapter. Under the French copyright law of 1852, photographs were included with 'dessins, gravures, lithographies, médailles, estampes ou emblèmes' as material suitable for copyrighting. By 1863, the number of photographic reproductions of paintings registered at the Dépôt légal of the Bibliothèque Nationale easily surpassed the number of prints.[97] But this does not mean that engravings ceased to be important to the Ingres estate. In July 1868, eighteen months after the artist's death, Madame Ingres was placing an objection through her lawyer to an advertisement in which the Société française de gravure announced the imminent publication of Léopold Flameng's engraving of *Stratonice*. This protest evidently did not stop Flameng's print from being published, but a subsequent letter does seem to have prevented it from appearing also in the *Gazette des Beaux-Arts*, as the *Angelica* had done in 1863. This was a clear case of an important painting which Ingres had expected to have

engraved during his life time, and whose potential reproduction his widow would not have wished entirely to frustrate.[98]

Although this brief survey of Ingres's engagement with photography has to acknowledge his view of the priority of engraving, it does nevertheless demonstrate the service to artists performed on many levels by the new medium of reproduction. The new generation of rising painters would be quick to recognise and seize this potential, and once again the career of Robert Bingham provides interesting evidence for the photographer's rapidly evolving role. Around 1880 – ten years after Bingham's death – a dispute between the painter Ernest Meissonier and the dealer Ernest Gambart brought into relief the privileged position which he seems to have acquired as an intermediary between the artists and the world of print-dealing, where the financial stakes involved were still leading to acrimonious conflicts. Meissonier recounts how, many years before and after an offer to engrave his painting *La Confidence*, he had taken the trouble to have the work photographed by Bingham; he then made the print available to the young artist who was working on a drawing for the selected printmaker, Auguste Blanchard (the homonymous son of the engraver of Girodet's *Hortense*). This complicated arrangement involving a photographer, a draughtsman and an engraver, however, finally came to nothing. The deposition continues with a statement that he has not ceded to Gambart the right to engrave his well-known work, *La Partie d'échecs*, and that 'the photograph published by Mr Bingham was not done after the picture [then in Gambart's collection] . . . it was done after a drawing belonging to me that Mr Gambart saw me do in London after the painting which was still in my possession'.[99] Evidently the speed and accuracy of Bingham's photographic technique had its advantages in allowing artists to maintain control of their images, and ultimately to duplicate them with increased efficiency.

In this particular instance, Bingham was enlisted first of all as an intermediary in the process of preparing the engraving. Yet by 1860 he had succeeded in producing admired photographic reproductions of many of Meissonier's 'principal paintings'.[100] Meissonier was probably the French artist of the next generation who most successfully rivalled the national and international reputation of Delaroche. It was appropriate that the diffusion of his fame should be aided by the English émigré who had given unprecedented prestige to the photographic reproduction of paintings.

5

The Full Circle

ON 4 JUNE 1889, the *Journal des Arts* reported the formation of the jury which was to determine the award of prizes for the engraving section in the forthcoming Exposition Universelle. It was to consist of the Vicomte Henri de Delaborde, *secrétaire-perpétuel* of the Académie des Beaux-Arts since 1874, and now finally sporting the Napoleonic title awarded to his father, and four engravers: Auguste Blanchard, Félix Bracquemond, Léopold Flameng and Charles Waltner. Simply to recite the most basic details of their careers is to marvel at the degree of homogeneity – and at the same time the play of difference – within this select group.

Blanchard was the son and grandson of burin engravers, setting the seal upon the family's ascent from coats of arms, caricatures and vignettes to higher tasks when he was appointed to the Academy in 1887, taking the seat vacated by Alphonse François. Born in Paris in 1819, he had begun his career precociously in 1839 when Goupil published his engraving after Delaroche's *L'Ange Gabriel* (1835), and distinguished himself later through two prints after Ary Scheffer: *Faust et Marguérite* (1847) and *Le Christ rémunéra-teur* (1849). His reputation rested mainly on an acclaimed work commissioned by the State after one of the most prized Italian paintings in the Louvre, Correggio's *Jupiter and Antiope*. Among his later works, however, was the large engraving after Frith's *Derby Day*, published in London by Gambart in 1862.[1]

Léopold Flameng, the pupil of Calamatta whose name has already come up in connection with engravings after Ingres, had also acquired a reputation across the Channel, in his case for a series of large etchings after Frith's five paintings, *The Road to Ruin* (1877), published in 1882. Born in Brussels of French parents in 1831, he was well aware (so Beraldi tells us) that he was not the master engraver's favourite student, possibly because he was already suspected at an early stage of not holding to the creed of 'burinisme sévère'.[2] His friendship with Charles Blanc, however, helped him to become one of the major contributors of prints to the *Gazette des Beaux-Arts,* where his free etching technique and his 'caressing, clear work' with the burin were equally prized.[3] His engravings after Ingres, which comprised the early portrait of *Madame Devauçay* (1807) (pl. 87), the *Angelica* (pl. 85), and the more recent success, *La Source* (1856), were highly esteemed by connoisseurs like Beraldi. Half a generation younger than Blanchard, he was to succeed to his seat in the Academy in 1897.

If Blanchard and Flameng, with Delaborde, represent the older generation in the jury, the new generation is powerfully present in Waltner and Bracquemond, 'the two most celebrated names in French engraving today' according to Auguste Dalligny.[4] Waltner was originally the pupil of Achille Martinet, a burin engraver noted for the rigour of

87 Léopold Flameng, engraving (1867) after Jean-Dominique Ingres, *Madame Devauçay*, 1807. 24.5 × 18. Private Collection.

his technique who had produced many prints after Raphael, as well as serving the contemporary market by reproducing Delaroche, Scheffer, Vernet and Ingres.[5] Waltner, by contrast, had earned a reputation for achieving 'the extreme limit of freedom in execution', and violating all the conventions which had previously separated the different techniques. As Bracquemond remarked in his report to the jury of 1889, he 'brings together and appropriates to the reproduction of works of art all means, even those which before him were only used for original engraving and seemed incapable of being used elsewhere'.[6] Bracquemond himself, it should be added, achieved his own equally novel style not by reacting against a classical master, but by having no master at all. Born in Paris in 1833, he initially studied lithography, and spent a short period in the painting studio of a pupil of Ingres, before becoming the major force in the revival of the original etching technique, and inspiring artists of the stature of Corot and Théodore Rousseau to follow in his path. This did not stop him from being a prolific producer of reproduction prints after a wide variety of artists ranging from Holbein to Manet.[7]

It is tempting to regard the situation of French printmaking as seen from the perspective of 1889 as a surprisingly faithful symptom of the broader transformations in French art over the nineteenth century. Even engraving had experienced its modernist break. Indeed Bracquemond's famous etching after the *Portrait of Erasmus* by Holbein had earned the distinction of being refused at the Salon of 1863, but praised on its appearance in the Salon des Refusés.[8] The exhibition which took place exactly a century after the outbreak of the French Revolution was a suitable pretext for a historical analysis which classed the succession of engraving styles according to the rapidly shifting political climate of the times. In compiling his entry on Waltner, Beraldi speculated that Henriquel-Dupont was the typical 'engraver of the July Monarchy', who 'wished to reconcile order with liberty' and so challenged the 'ancien régime' of the burin, only to be superseded in his turn after the Revolution of 1848 by the 'complete freedom' of Waltner and his fellows.[9]

Yet Beraldi is not so crudely reductive in the very lengthy footnote, amounting to a short essay, that he publishes at the end of his ninth volume under the title 'L'estampe en 1889'. Beraldi was in fact himself attached as an art critic to the jury of the Exposition Universelle, though his status as a 'membre suppléant' implied restricted voting rights. In his essay, he took the widest possible view of the past of printmaking since the Revolution, and its future as it might extend into the coming twentieth century. His analysis was prompted by the proliferation of opportunities to see prints on exhibition in Paris in that particular year. Although he repeated the complaint made by Ambroise Tardieu nearly half a century before that printmakers were invariably disadvantaged by their hanging in the Salon, he was more buoyant about the two print exhibitions arranged in the context of the Exposition Universelle: a ten-year survey comprising 300 artists (180 of them French), and a centenary display covering the wider history of the medium.[10] Here was an unprecedented opportunity to comment on the manifold ways in which printmaking had adapted to the frenetic pace of the nineteenth century.

As a critic, historian and connoisseur of the print, Beraldi was perhaps understandably concerned to offer an optimistic reading of the situation. 'Has the print a brilliant future?', he asked in his concluding paragraph, and answered his own question: 'We may

firmly believe that it has, seeing it today so lively and so free.'[11] He rejects with confidence 'all the death horoscopes read over [printmaking] at the coming of photographic processes', and proclaims that the artists in the field are 'more numerous than ever'.[12] This is the result of a long-term and highly contested process of development that Beraldi aptly terms 'la politique intérieure de la gravure' – the internal politics of the medium. Printmaking has undertaken its 'march towards liberty, against the despotism of any reigning formula'. Under this general rubric can be classed all the episodic conflicts that have cropped up over the whole period: 'antagonism of ordered cutting and free cutting, of the burin and the etching, of the reproductive engraving and the free engraving, of the lithographer's lithograph and the painter's lithograph, of the solemn print for framing and the intimate print for the portfolio, etc.'.[13]

Nearly twenty years into the Third Republic, Beraldi seems to be offering us a 'Whig View' of print history in the century following the Revolution. In the course of these localised and particular conflicts, one thing has become certain: the reign of the *beau burin* is no more. No one will ever again be able to remake Bervic's prodigious *Enlèvement de Déjanire*, the engraving after Guido Reni that won for its author the *prix décennal* in 1802.[14] But is that such a bad thing, Beraldi asks? Recently deceased artists like Alphonse François and Auguste Blanchard – predecessors of Flameng in his Academy seat – have kept up the tradition of the classic engraving, whilst at the same time the new techniques of Bracquemond and Waltner have conquered Europe for the *eau-forte originale*. The abuses of etching are no doubt numerous, and the new medium trails off into 'pure scribbling'. But at least, at its best, it achieves the 'exquisite'. In any case, there is a compensation: 'the framed aquatint print, the pride of antechambers and dining rooms under Louis-Philippe, has absolutely vacated the scene'.[15]

Beraldi's end-of-century conspectus shows a clear line of development over the period. Yet, for our purposes, it leaps too far ahead in the stocktaking of a century of change. In order to complete the picture of a phase in that development which extends essentially from the 1820s to the 1860s, we need to take up an earlier vantage point. However, Beraldi points the way in this respect by singling out for comment the previous Exposition Universelle of 1855, which was also the first of its kind. This comprised the unprecedentedly broad survey of the visual arts that first elevated Ingres and Delacroix to the highest rank among French contemporary painters, and, as far as engravers were concerned, it was the finest hour of Louis Henriquel-Dupont.

The ascent of Henriquel to this unique position in the 1850s does indeed say a great deal about the position of engraving in the mid-century, as well as about the spectacular development of his own oeuvre by that stage. By 1853 he had completed probably the most ambitious engraving of modern times, his tripartite reproduction of Delaroche's *Hémicycle des Beaux-Arts*, and had received a *médaille d'honneur* at the annual Salon. Maison Goupil was sufficiently overwhelmed by the honour to abandon their previous project of publishing the critical responses to the work, and simply stated in their illustrated key to Delaroche's mural that Henriquel's engraving had been deemed 'the most remarkable work in the 1853 exhibition' and that 'this fact alone says more than all the appreciations and all the eulogies'.[16] Two years later, at the international Exposition Universelle, this outstanding recognition was capped when he exhibited a further engraving after Delaroche, *L'Ensevelissement du Christ*, and was awarded the *grande médaille*

d'honneur. Beraldi's characterisation of the significance of this event needs to be quoted in full:

> From then on, the burning question is resolved: engraving is not lost, with engravers like Calamatta (who was included quite rightly among the French engravers), Forster, Jules and Alphonse François, Martinet, quite outstanding for their ordered work; what is more, it has been shown that engraving can renew and revivify itself, in conformity with the very essence of French art, which is to change. It is the engraver of the *Hémicycle* who demonstrates this: his work, free without disorder, clear, witty, very French, deals a decisive blow to the academic school. Henriquel appears there in his glory; and in the sober distribution of prizes, he will deservedly receive the one medal of honour: another of the sensational prizes of the century for engraving. Let us recall which were given for painting: Ingres, Delacroix, Horace Vernet, Decamps, Meissonier. Beside Henriquel, Calamatta and Forster only received the *médaille de première classe*, with the lithographer Mouilleron.[17]

Beraldi's enthusiasm for the 'very French' character of Henriquel's style is here expressed in the context of a retrospective view of the nineteenth century. Yet his general remarks about the 'essence of French art, which is to change' suggest a much wider historical perspective. In fact, Henriquel becomes the token of a distinctively French ideology, which reconciles history with progress, and is revealed no less in the development of competing techniques of printmaking than in the showier representations of the Salon painters. That there is something to be said for this view goes without saying. Yet in order for it to be clarified and tested, Henriquel's own achievement needs to be set in the context of a brief account of French printmaking in the two centuries before the Revolution. Beraldi himself, understandably preoccupied in his 1889 essay with the century since 1789, had already contributed to this historical estimate when, with Baron Roger Portalis, he published the first scholarly catalogue of French eighteenth-century engraving in 1880.[18] But it is in the seventeenth century, initially, that we can observe the beginnings of the tradition to which Henriquel is annexed. At first distinct from their colleagues in the Académie des Beaux-Arts, the professional engravers effect a parallel enhancement of the status of their art, and by the middle of the next century, are closely allied with them. Indeed, as will be shown, engraving comes to represent a continuity of techniques and values that hardly exists in the more prestigious branches of the plastic arts.

* * *

Writing in 1856, with a distinct sense of family pride, the critic Alexandre Tardieu described the densely interwoven family connections that had provided France with her most long-lived and productive dynasty of artists. Of the three daughters of Daniel Horthemels, a Dutch-born bookseller in late seventeenth-century Paris, one had married Nicolas-Henri Tardieu, *graveur ordinaire du roi*, another Charles-Nicolas Cochin, *graveur du roi*, and a third Alexis-Simon Belle, *peintre ordinaire du roi*. All four of the sons of Nicolas Tardieu (1674–1749) subsequently produced lines of artists, most of them specialising in the different branches of engraving.[19]

Those descended from his second son (or possibly his brother), Claude, included Jean-Baptiste-Pierre (1746–1816) who was the first of the name to style himself *graveur-géographe*; he was followed in this branch of the profession by his brother, Antoine-François (1757–1852) who became exceptionally distinguished as a map-engraver, and handed on his skills to Ambroise Tardieu (1788–1841), the artist responsible for such triumphs of Romantic book production as the Atlas to Augustin Thierry's *Histoire de la Conquête de l'Angleterre par les Normands*.[20] However Pierre-Alexandre Tardieu (1756–1844), the slightly older sibling of Antoine-François, brought the most glory to the family: he was, in the words of his proud relation, 'the last to conserve, in our own time, the tradition (which was for him a family tradition) of the brilliant school of engraving of the seventeenth and eighteenth centuries'.[21] Raoul-Rochette, the *secrétaire-perpétuel* of the Academy and father-in-law of Calamatta, endorsed the point when delivering his eulogy on 3 May 1847, adding that his large plates were all 'de très-bons ouvrages', and almost all his smaller pieces 'des chefs-d'oeuvre'.[22]

It is perhaps significant that the Tardieu dynasty seems to have begun through marriage to a woman of Dutch origins. The northern tradition of engraving had first established itself in the Low Countries, and as early as 1604 the authoritative *Book on Picturing* by Karel van Mander – a northern counterpart to Vasari's *Lives* of 1568 – had placed reproduction prints 'among the highest achievements of northern art'.[23] In particular, the Haarlem painter and engraver, Hendrik Goltzius (1558–1617), had established a new standard of virtuosity in such reproductions, contriving (as Walter Melion has expressed it) to '[subsume] invention itself into the process of imitation' and earning the epithet of Proteus for his adroit changes of style.[24] Virtuosity combined with fidelity was also the keynote of the work of the first French-born engraver to make his mark in the early modern period, Claude Mellan (1598–1688), whose print of most enduring fame was a *Sainte Face* (1649) derived from a single, uninterrupted line traceable to the highlight on Christ's nose.[25] In Ivins's analysis, this innovation of using parallel lines with little or no cross-hatching qualified him to take an initiatory role in the 'search for system' that continued to dominate French engraving throughout the seventeenth and eighteenth centuries, reaching its 'final degradation' in the nineteenth.[26]

Mellan's origins were in the northern French town of Abbeville, and, as with the Tardieu family, a craft basis in the trade of *chaudronnier* (coppersmith) seems to have been at the origin of his art. His reputation as the first great native engraver was, however, secure by the end of the seventeenth century, when the Flemish-born Gérard Edelinck (1640–1707) adapted his self-portrait print as a young man, dated 1635, for Charles Perrault's official compendium, *Les Hommes illustres du siècle de Louis XIV* (pl. 88). This must have been at the very beginning of the tradition whereby a noted engraver of one generation was commemorated by an eminent successor, as in Henriquel's portrait, after Ingres, of Alexandre Tardieu (pl. 27). Edelinck has, however, chosen to emphasise his own identity in the process of making this act of homage. Not only has he maintained the reversal from left-facing to right-facing in relation to Mellan's original image, but he has also considerably lightened its linear texture in consonance with the changing visual sensibility of the period. The strands of hair, in particular, are much more freely and finely drawn.[27]

With Edelinck, as already mentioned in the previous chapter, we arrive at a substantial figure, in whom nineteenth-century artists and connoisseurs of engraving still held

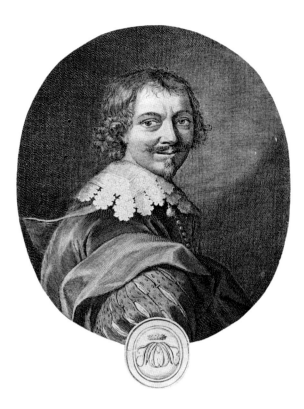

88 Gérard
Edelinck, engraving
after self-portrait by
Claude Mellan,
1635. Published in
Charles Perrault, *Les
Hommes illustres du
siècle de Louis XIV*
(1696–1700).
24.5 × 18. Private
Collection.

a stake. Whether typified as the faithful copyist (as George Sand would have it), or more
generously characterised as the purist *par excellence* in Delaborde's account, Edelinck still
served as a significant point of reference. In Delaroche's *Hémicycle*, he joined the 'artists
of all ages' as the sole northern engraver admitted to the pantheon, twinned in close prox-
imity with the legendary Marco Antonio Raimondi, the engraver of Raphael. No doubt
it was Edelinck's own notable success in reproducing Raphael that inspired this pairing.
His engraving after the *Holy Family of Francis I* (a work with an honoured place in the
collection of the Louvre since the Empire) inspired one of Delaborde's most furious
diatribes against the 'servile result' obtained, by comparison, through the medium of
photography.[28]

 Edelinck, being born in Antwerp, suggests a pattern for the development and renewal
of French engraving by contact with the Low Countries that had shifted direction, and
indeed turned right round about, by the following century. A hundred years later, as we
have seen, an Italian engraver like Paolo Toschi would train with Bervic, and first make
his reputation in France, before returning to reanimate the print culture of his native city
of Parma. Calamatta and Mercuri, both initially trained in Rome, clearly became aware
of the finer potential of burin engraving through their Parisian contacts, before they left
to broadcast the technique, at the new capital of Brussels in Calamatta's case, and back
in his native Rome in Mercuri's. Taurel took the experience of a Prix de Rome scholar
formed in Bervic's studio to Amsterdam, where he was appointed Director of Engraving
in the Academy of Fine Arts by the King of Holland in 1828.

By the Restoration period, therefore, French engraving was able to demonstrate a surprising, indeed unique continuity of the traditional methods, which qualified Paris-trained artists to be the leading school in continental Europe. Their main challenge seems to have come not from the historic centres of the technique, but from the upstart printmakers of Great Britain, whose development of heterodox new media like crayon-manner engravings and mezzotint were initially kept at arm's length by a generation still in awe of Bervic. In the eighteenth century, however, French printmaking maintained its productive dialogue with the northern schools. Undoubtedly the dominant figure in the mid-century period was the German-born engraver, known in France as Jean-Georges Wille (1715–1808), who received the accolade of being admitted into the Académie des Beaux-Arts in 1761. Wille was, for Beraldi, the indispensable link with the 'traditions of great engraving', and he numbered among his most favoured students the French-born Bervic.[29]

There is a rare opportunity to glimpse Wille's significance for his contemporaries in the writings of the most original art critic of the age, Denis Diderot, who happened to share a garret with him in his youth. Wille was one of two engravers who lived at some time in close proximity to Diderot, the second being another German artist, Johann Martin Preisler, who left to take up a post at the court of the King of Denmark and (in Diderot's estimation) became 'nothing'; Wille, by contrast, became 'the finest engraver in Europe'.[30] This judgement seems not to have been made lightly, since Diderot's conviction of the uniqueness of Wille is borne out in his estimate of a particular reproductive engraving, the *Itinerant Musicians*, in his review of the Salon of 1765: 'He's the only one capable of wielding the burin so that it achieves an effect of strength as well as pliancy; and he's the only one who knows how to execute small heads.'[31] This remark is made in the context of a less favourable judgement on the work of a student of Nicolas Tardieu, Jean-Philippe Lebas, who is chided for delivering 'a mortal blow to fine engraving . . . with a style that's all his own'. Lebas has, however, also collaborated with one of Tardieu's distant relatives, Charles-Nicolas Cochin, and the group of prints after Joseph Vernet's *Ports of France* that are the fruit of this collaboration get the critic's limited sign of approval: 'Cochin executed the figures and they're the best things in them.'[32]

Diderot's comments on Wille leave us in no doubt of the high esteem in which he was held as an artist, and it is clear that he does not confine himself to Wille's prowess as an engraver. A self-portrait, also shown in the Salon of 1765, is described as being worthy of comparison with Rubens, Rembrandt or Van Dyck: 'When one has seen this Wille, one turns one's back on other portraits, even those by Greuze.'[33] This is high praise indeed. And it certainly seems as if Wille's wish to be taken with the utmost seriousness as an artist spilled over into his conception of the reproduction print. When he completed his rendering of *La Gazettière hollandoise*, after the Dutch seventeenth-century artist Gerard Ter Borch (pl. 89), he noted almost dismissively in his journal of 3 July 1760: 'I have brought out my *Gazettière hollandoise*, which I engraved after a picture by Terburg {sic} which was not one of the best.'[34]

It should be noted that these exquisitely finished prints, often of approximately the same size as the originals, gave a new and (it would seem) an assertively independent status to the reproduction – a point underlined by the fact that it was Wille himself who chose the prominently engraved titles. *Gazettière hollandoise* was a title that could

89 Jean-Georges Wille, engraving *avant la lettre* (1760) after Gerard Ter Borch, *La Gazettière hollandoise*, c.1650. 38.5 × 16.5. Private Collection.

be extrapolated from the heading 'Gazette d'Amsterdam' in the publication which the pensive young woman (possibly based on the artist's sister) is holding in her lap. The word itself is, however, not generally used in the female form, and Wille's coinage underlines the absorptive character of the image by implying that the woman's head is full of gossip. (Cf. Littré's example: 'C'est la gazette du quartier.') It was in fact Wille who saddled a very much more famous Ter Borch with the highly tendentious title *L'Admonition paternelle*, when he engraved it in 1765, thus setting off a debate about the meaning of this provocative little brothel scene that Goethe was one of the first to enter.[35]

By the middle of the nineteenth century, Wille's engravings after the Dutch masters had secured their position both as independent works of art and as factors in the continuing prestige attached to the Dutch school. Wille had taken care to release prints *avant la lettre*, that is to say, before the title, dedication and artist's names were added, and in the case of the *Gazettière hollandoise*, it is noteworthy that the first state shows clear differences from the second, *avec la lettre*. The marbled inner edge of the window frame is more clearly marked in the former, and the sharp shadow cutting in from the left has almost disappeared in the later proof. Such refinements enabled the prints of Wille to mount in price. A proof *avant la lettre* of the *Gazettière* fetched 141 francs in 1843 – almost as much as the 150 francs to be asked for Henriquel's vast tripartite engraving of the *Hémicycle*. The *Admonition paternelle* reached prices over 1,000 francs in the same period, again for the *avant la lettre* version.[36]

Wille's engravings after Dutch *genre* paintings had the advantage of catching both the vogue for such work in the mid-eighteenth-century period, and the returning fashion for such subjects a century later. The life of his pupil Bervic, however, spanned a period of French history in which the visual arts, as well as all other aspects of social and cultural life, registered the pressures of the political situation. The nineteen works which, in Beraldi's list, constitute his entire oeuvre include not one example which comments in any direct way on the events of the Revolution and Empire, and indeed nothing connected in any obvious sense with the rise of the School of David. Significantly, his most celebrated engraving after a contemporary painter was based on the *Education d'Achille*, the highly acclaimed work which secured Jean-Baptiste Regnault's election to the Academy in 1783. Regnault's closest brush with revolutionary iconography was his *La Liberté ou la Mort* of 1795, a work which has been variously described as 'one of the most perfect examples of the illustration of revolutionary ideas' and as a 'cold allegory' that contrasts strikingly with the pathos of David's *Death of Joseph Bara* (1794).[37] Bervic faithfully reflected Regnault's stylistic dependence on the Bolognese School when he chose to engrave as a pendant to *Achille* the noted painting by Guido Reni, *L'Enlèvement de Déjanire*, later to hang with the *Mona Lisa* and the religious works of Raphael in the Salon Carré of the Louvre.[38] With these two prints so clearly evocative of the traditions of the French Academy, he nonetheless carried off the *prix décennal* – the supreme award given to a printmaker during the first ten years of the century – and (in Beraldi's terms) ensured that 'the great traditions of French engraving did not sink in the revolutionary tempest'.[39]

It would, however, be wrong to portray this supreme engraver as being quite unaffected by the course of events. The feat of the *Laocoon* – which by its author's own admission drew too much attention to its own virtuosity – may qualify in our eyes (in

accord with my previous suggestion) as a 'cold allegory' of engraving technique. But the reproductions after portraits, which form a major part of his pre-revolutionary work, indicate by their subtle, fastidious manner, as well as by their choice of subjects, Bervic's connection with some of the liberal and enlightened figures who were unsuccessfully attempting to set the Bourbon monarchy on the path of reform.

In 1783 he engraved the portrait of Gabriel Sénac de Meilhan, after the painting by Joseph Duplessis, whose half-length figure compositions of sitters like the Finance Minister Jacques Necker were to have an influence on David's later portrait style (pl. 90).[40] Sénac de Meilhan was a friend of Turgot, and occupied the administrative post of Intendant of the northern province of Hainault. Author of a 'poème lubrique' under the promising title of *La Foutromanie* (1775), he had sufficiently cooled with his maturity to publish *Considérations sur la richesse et sur le luxe* in Amsterdam in 1787. Portalis and Beraldi capture the tone of Bervic's engraving in a way which acknowledges its specific technical accomplishment through a term like 'softness' (*moëlleux*) at the same time as giving credit for its refined attention to visual and psychological detail. It is a 'portrait that captivates through the softness of the face, which first of all draws the attention, through the elegant simplicity of the silk costume, through the sobriety of the accessories of which the principal one is a little table which would be the delight of fanciers of curiosities'.[41]

Portalis and Beraldi can be excused for seeing this print as a token of the *ancien régime*. It is 'in pure Louis XVI style', and the furnishing accessories have become desirable antiques. No attention is paid to the voluminous architectural plans which roll, in an admittedly negligent fashion, from the 'little table' and must presumably have been included as an index of the Intendant's planned fortifications for the city of Valenciennes, which commissioned the engraving. Sénac de Meilhan himself comes across to the print connoisseurs of the end of the next century as 'an amiable man, but without strength of character, a refined but sceptical mind'.[42] How different, indeed, from the effect of character produced by the notorious half-length portrait painted half a century later by David's pupil, Ingres, when the unruly course of French history has produced a new type for the man of action, adapted to the age of the triumphant bourgeoisie, in *Monsieur Bertin* (1832)!

Yet, just as there is a direct line of development from Duplessis, through David, to Ingres as portrait painter, so there is a clear affiliation between Bervic the engraver of a 'pure Louis XVI style' painting, and his pupil Henriquel as the engraver of Ingres's *Monsieur Bertin*. Bervic's study with Wille had enabled him to see fine reproductive printmaking as an artistic pursuit of the highest international importance. Up to the Revolution, he had no doubt continued to develop the European connections that his master had built up. The fine first state of *Sénac de Meilhan* illustrated here is dedicated in his own hand to Christian Bernhard Rodde (1725–1797), the Director of the Akademie der Künste in Berlin from 1783 and himself a distinguished painter and etcher. Yet, as the letter quoted in chapter 1 makes clear, Bervic himself would have no truck with the engraving *à l'eau-forte* that his colleagues used to bring contemporary subject matter to quite rapid publication. His own solemn and unremitting dedication to the art of the burin during the period of the Revolution and Empire can be seen in the light of his determination to sustain a level of lonely excellence in this arduous technique. By com-

90 Charles-Clément Balvay (known as Bervic), engraving *avant la lettre* (1783) after Joseph Duplessis, *Gabriel Sénac de Meilhan*, *c.*1775. 51 × 36.5. Private Collection.

parison, any question of the choice of subjects to reproduce had only a minor importance, and an adherence to the academic and classical tradition needed no justification.

This is simply an extrapolation of the argument which Beraldi implies when he insists that Bervic ensured the transition from eighteenth-century to modern engraving. His historical argument rests upon the patriarchal succession from Wille, through Bervic, to Henriquel-Dupont, and, up to 1892, the long-lived Henriquel is still there to testify to this succession, not only through his own productions but through the eminent burin engravers formed by his instruction as Professor at the Ecole des Beaux-Arts, from 1863 onwards. Henriquel, indeed, shows in his correspondence with Delaborde a continuing preoccupation with the future of fine engraving in the educational system, and its appropriate recognition within the Académie des Beaux-Arts. We find him 'absorbed' in the election to the Academy of his former pupil, Alphonse François, in 1873, and (perhaps apropos of his own earlier election) raising the difficult question of the distribution of the four allotted places between the different branches of the engraver's art.[43] One of the most revealing indications of his concern for the transmission of appropriate skills comes in a letter of the early 1860s which concerns William Haussoulier, a former student of Delaroche who was accomplishing the perilous transition from painting to burin engraving. Henriquel is apprehensive that he will fail in the task of reproducing the works of Leonardo's pupil, Bernardino Luini, not least because of the inadequacy of the photograph intended to help him in his work:

> M. Galichon has showed me a photograph which should help M. Haussoulier for the tracing that he needs to do for his drawing; the photographic print is much too big, this awkward proportion would certainly affect the good execution of the engraving, in my view it would be a failure. You know that M. Haussoulier is not very practised in the handling of the engraving, you know also that his execution, which is not lacking in intelligence and knowledge above all, would become empty and hollow if he were obliged to spin it out over a large surface; the paintings of Luini are distinguished much more by a sense of exquisite delicacy than by a strong execution. Is that not a further reason for remaining within a very restricted frame? . . . I regret more and more that my suggestion of dividing the commission of the two Luinis between M. Haussoulier and my pupil Levasseur was not followed.[44]

Henriquel's comments give a tantalising glimpse of the considerations which he applied to the success of an engraving in an age in which photography had become a tool for the artist. About the debutant engraver, however, he was perhaps too apprehensive. Haussoulier not only published his print of Luini's *Adoration of the Shepherds* with the Société française de gravure, but shortly afterwards became one of the most successful of the new generation recruited to the reproduction of the works of Ingres. His large engraving after Ingres's drawing for *Romulus, vainqueur d'Acron* (Ecole des Beaux-Arts, Paris) was well received at the Salon of 1866.[45] But Henriquel's pupil Levasseur also benefited from his master's patronage, and perhaps had a special claim to it.[46] As an engraving student who had originally enrolled at the age of fifteen with François Girard, the protagonist in France of the English mezzotint (*manière noire*), he had made his own decision early in life to change techniques, and entered Henriquel's studio in 1846. In 1853 he engraved Buttura's drawing of Delaroche (pl. 57). His burin engravings after Delaroche, Scheffer,

Vernet, Gérôme and Bouguereau, as well as old masters of the French School like Mignard and Poussin, maintained the classic manner traceable to Bervic up to the last years of the century.

<center>* * *</center>

After examining briefly the French engraving tradition in which he was credited with so central a place, we must now turn to the works that supported Henriquel's reputation. Louis-Pierre Henriquel-Dupont was born in Paris on 13 June 1797, the son of a fencing master from the East of France. Named Henriquel, he later added the name of Dupont in recognition of Mme Dupont, the female relative who brought him up.[47] At the age of fourteen, he entered the studio of Guérin, the 'refined classic' (in Charles Blanc's words) who 'brought together all those who were going to revolutionise painting: Champmartin, Géricault, Eugène Delacroix, Ary Scheffer'.[48] Three years later, however, he left to study engraving in the studio of Bervic, where he remained until 1818. His rapid progress in the use of the burin was signalled when he entered for the Prix de Rome in engraving in 1816 and 1818. However, on both these occasions, he failed to win; in the former competition, the *grand prix* went to Joseph Coiny, the son of an industrious printmaker who had collaborated with Duplessi-Bertaux under the Empire, and in the latter to Calamatta's future patron, André Taurel. Both these prize-winners had also studied under Bervic.[49]

Beraldi decisively interprets the dialectic of Henriquel's early training: 'This double failure decided his career and made his fortune.'[50] A curious parallel can be found in the experience of his exact contemporary, and future model, Paul Delaroche, who was placed no higher than fifth in the competition for *paysage historique* in 1818, and did not otherwise enter for the Prix de Rome.[51] There can be little doubt that the pressures of competition among young artists in the period immediately following the Restoration were intense, and that the studio system itself was under great strain. Even supposing that all the young artists were gifted enough to make a career for themselves, commented Géricault in a text written at the time: 'is it not dangerous to see them all study together for years under the same influence, copying the same models and following in some sense the same route?'.[52] Géricault, of course, has prospective painters and sculptors primarily in mind, and his comments cannot necessarily be transferred directly to the craft of print-making. But it is arguable that the highly intensive technical disciplines of engraving, focused in the formidable figure of Bervic himself, would have produced an even more compulsive 'anxiety of influence'.

This is at any rate what Beraldi implies. Of the two fellow students who survived triumphantly in the competition, Taurel never fulfilled the promise of his early career, and made his mark, after his removal to Amsterdam in 1828, essentially as a teacher. Coiny the younger, who died in 1829, was defined by Beraldi as 'an engraver who did not engrave', passing on his most ambitious plates for finishing to Calamatta and Paolo Toschi.[53] Henriquel himself toiled in the studio of Bervic, making copies after Goltzius and Edelinck as well as the official *académies de concours* which were drawn and engraved after the male model. But his failure to shine according to the criteria of this 'classic instruction' was, in Beraldi's terms, a happy escape from a system which proscribed origi-

L'ESPERANCE

Deßiné et Gravé par Aug.te Boucher Desnoyers d'après le Tableau de Raphaël Peint en Grisaille, qui est Exposé dans la Galerie du Musée Napoléon.

URBINAS NATUS AnnoDomini MCDLXXXIII

Se trouve à Paris chez l'Auteur, rue de Touraine N.o 9, près l'Odéon.

91 Auguste Boucher-Desnoyers, engraving (1808) after Raphael, *Hope*, from the predella of *The Entombment*, 1507. 31 × 46.5. Private Collection.

nality.[54] Released from the burden of academic orthodoxy by his perceived shortcomings, Henriquel was able to open himself up to the new impulses which flooded French print publishing during the Restoration, taking his orientation (again according to Beraldi) from the decidedly unorthodox practices of British engravers.[55]

The significance of Henriquel's bid for independence can be judged not only against his contemporaries, but also against his immediate predecessors in the hard school of engraving, who might have had a claim to succeed Bervic and Alexandre Tardieu as the acknowledged masters of the art. Auguste Boucher, later Baron Desnoyers, is the most obvious case in point. Born in Paris on 19 December 1779, he began to study print-making when he was only ten years old, but until his late teens his technique was the stipple engraving favoured for *galant* genre subjects under the Directoire.[56] He then entered the studio of Tardieu, and, in 1801, when he was twenty-two, he provided the engraved medallion of the Société des Amis des Arts that appeared on a new edition of Bervic's engraving after Mérimée's *L'Innocence*.[57] Two years later, his reputation was made by his print after Raphael's *Belle Jardinière*, one of the works which held pride of

place in the new Musée Napoléon installed in the Louvre. He continued to dedicate himself principally to the masterpieces of the Italian Renaissance, then present at the Louvre in particular abundance because of Vivant Denon's acquisitive cull of the treasures of the Low Countries, Germany and Italy. His rendering, around 1808, of the three grisaille panels from Raphael's Baglione altarpiece of 1507, later returned to the care of the Vatican, demonstrates what Beraldi was to call his pure draughtsmanship and harmonious engraving technique (pl. 91).[58] Such prints were a resource for painters as well as for connoisseurs, and it is not difficult to assess their importance for artists like Ingres and Delaroche, who fostered the cult of Raphael in the second quarter of the century.[59]

Desnoyers's eminence was recognised when, in 1816, the fourth engraver's seat in the Academy was offered to him – a mark of recognition which, as Henriquel later conceded, received 'general approbation'.[60] The traditional title of 'graveur du Roi', an apt honour for the engraver of the Baron Gérard's *Napoléon*, was granted to him by the first returning Bourbon monarch, and he was made Baron by the second in 1828. However, the new regime saw no significant additions to his existing work, which consisted in repeating the same successful formula until as late as 1846, when he produced his last major print after Raphael's *Sistine Madonna*. One can sympathise with Ingres in thinking that he was the ideal choice for the engraving of the *Voeu de Louis XIII*, as mentioned in the previous chapter. But it is hardly an exaggeration to say that Desnoyers's reproduction of contemporary artists began and ended with the eminently safe Baron Gérard.[61]

There is one further printmaker of the generation before Henriquel and Calamatta who should be mentioned in this connection. Joseph-Théodore Richomme was born in 1785, and, having won the Prix de Rome for engraving in 1806, was launched upon a career in which reproductive prints after Raphael Madonnas once again predominated.[62] At the Salon of 1814, where he received a medal, his engravings after the *Loreto Madonna* and Raphael's *Adam and Eve* were specially noted by Landon amongst an unprecedentedly large showing of prints. Landon was enthusiastic about the style of the latter, which appeared to him to be 'one of the best productions of modern engraving', reminiscent of the 'pure, noble and suave manner of [the eighteenth-century Italian engraver] Raphaël Morghen'.[63] This comparison, however, betrays the degree to which Richomme's technique recalled a recent, and soon to be discredited, phase of taste. Henri Delaborde, whose contempt for the photographic image has already been unambiguously conveyed, still felt that a photograph might be 'less compromising' in the reproduction of Raphael's *Stanze* or Leonardo's *Last Supper* than the 'deceitful imitations, works of a weak or deliberately unfaithful burin' of a printmaker like Morghen.[64]

Richomme was at least more adventurous than Desnoyers. He engraved both *Henri IV et ses enfants* (1817) by Ingres, and its pendant, *La Mort de Léonard de Vinci* (1818), the former being published in 1835 by the Maison Goupil.[65] However he does not appear to have carried this commercial opportunity much further. It should be borne in mind that fine printmakers traditionally marketed their own works. Desnoyers's engraving after Raphael's *L'Espérance* carries the proud legend: 'Se trouve à Paris chez l'Auteur rue de Touraine No. 9, près l'Odéon.' Richomme was no doubt one of the most eminent of the many printmakers who came too late to adjust to the new possibilities provided by Goupil. In a letter countersigned by Quatremère de Quincy as Secretary of the Academy

around 1830, he pleaded indigence, while requesting an official bursary for his young son, Jules. Listing the honours which he had received from the State, including his place in the Academy and the Légion d'honneur awarded in 1824, he concluded wryly: 'The arts which lead to honours for those who profess them with some success do not often favour them in respect of fortune.'[66]

The young Henriquel clearly had no taste for the dedicated calling of the purist engraver. Indeed, on leaving Bervic's studio, he flung himself impetuously into the publishing milieu of the early Romantic period. His first work (after a portrait of his father the fencing master, dated 1818) was a frontispiece for Didot's new edition of Voltaire's *La Henriade*, based on the vast painting by Gérard, *L'Entrée de Henri IV à Paris*, which had made its mark at the 1817 Salon. This came out in 1819, and for the next five years Henriquel continued to work industriously in book publishing, engraving vignettes after artists like Alexander Desenne and Achille Devéria. His links with the Devéria family – Eugène the painter of *La Naissance de Henri IV* (1827 Salon) and Achille the draughtsman, lithographer and son-in-law of the lithographic publisher Motte – were specially significant. Charles Blanc noted the beginnings of their contact in the early 1820s, when Henriquel was also embarking on a more weighty project: 'Henriquel-Dupont, who was then engraving his beautiful plate after Van Dyck [*Une Dame et sa fille*] in the Louvre, without realising that he was himself, Henriquel, a master, used naively to bring his proofs and take the advice of Achille Devéria.'[67]

Naive or not, Henriquel enabled his talent to thrive through the *troc* of this exciting period, maintaining at the same time a strong sense of the validity of his earlier training. In 1822 he was collaborating with the illustrious Girodet on a vignette of *L'Amour et Psyche*.[68] Not long afterwards he began to draw and engrave his own subjects: a portrait of Montaigne for an 1826 edition of the *Essays* which would have called to mind the 1818 work by Tardieu; another of the architect and engraver Charles Normand (1827), who provided the bulk of the line engravings for Landon's *Annales du Salon*; a third of Mme Feuillet de Conches (1826), the wife of Delaroche's friend, who claimed to have introduced the painter to the Maison Goupil around 1830. For a brief period he cultivated lithography, most strikingly with his print of Louis-Pierre Louvel, the assassin of the duc de Berry, whom he had drawn 'on the Place de la Grève, mounting the scaffold on 8 June 1820'.[69] However, his most significant addition to the resources of the burin was the use of aquatint, which enabled him to use tonal effects characteristic of wash drawing for the appropriate subject matter.[70] A *Scène de naufrage* (1826), after a lost painting by Delaroche from the previous year, was his first ambitious essay in this acid-based technique.[71]

Henriquel's productive, if eclectic, activity throughout the 1820s bore fruit in his submission to the 1831 Salon, the first of the July Monarchy. Here his group of six prints included at least two aquatints, an untitled portrait (possibly that of Normand) and a second of the Turkish General Hussein-Pacha, after Guérin's student Champmartin. It also included a 'Figure en pied, d'après M. Ingres', which can be identified as an engraving after Ingres's portrait of Monseigneur de Latil, the Archbishop of Reims.[72] This presupposed no special connection with Ingres, however, as the work was commissioned for a collective publication commemorating the coronation of Charles X at Reims. Most ambitious of all these prints by far was the engraving after Louis Hersent's *Return of*

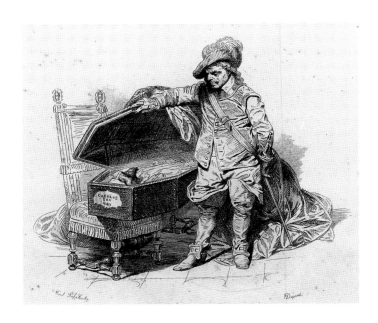

92 (*right*) Louis Henriquel-Dupont, etching
(1833) after Paul Delaroche, *Cromwell*, 1831
Salon. 12 × 14.5. Private Collection.

93 (*below*) Louis Henriquel-Dupont, aquatint (1833 Salon) after Paul Delaroche, *Cromwell*, 1831 Salon. 31 × 40. British
Museum, London: Department of Prints and Drawings.

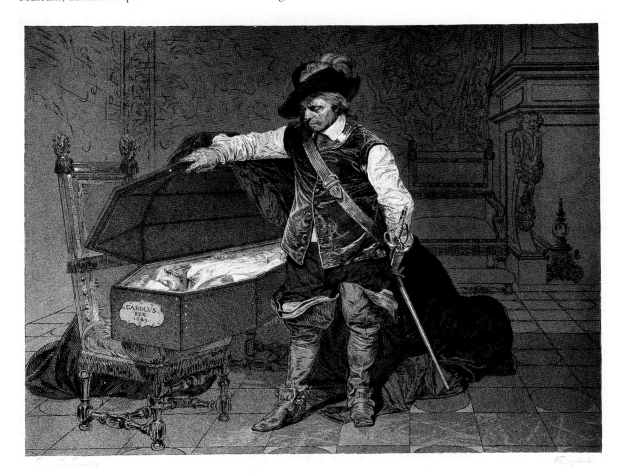

Gustave Vasa (1819). Hersent was a former student of Regnault who had sprung to prominence at the 1817 Salon with his *Louis XVI distribuant des aumônes*. Both in the latter work, and in the subsequent painting of the return from exile of the great Swedish king, he pioneered the depiction of modern historical subject matter which would later be termed 'genre historique' (a hybrid between genre and history painting). Henriquel undoubtedly established his reputation with this classically engraved work, which appeared in 1831, more than a decade after the first appearance of the original painting at the Salon. In Beraldi's account, he displeased only one person, who was the artist himself! Hersent evidently 'did not recognise his painting, to which the print was superior'.[73]

Henriquel got an immediate chance to build on this success at the 1831 Salon when he was commissioned by Goupil to reproduce Delaroche's *Cromwell*, a late arrival at the exhibition which had gained enormous public success.[74] However, his decision over the appropriate techniques for reproducing this large oil painting with its Rembrandtesque colouring suggests a remarkable openness to the character of the original. Henriquel in fact created two distinct works, one of them a small, refined etching in vignette form which was published in Charles Lenormant's *Artistes contemporains* in 1833 (pl. 92), and

94 George Maile, mezzotint (1833) after Paul Delaroche, *Cromwell*, 1831 Salon. 21.5 × 24. Private Collection.

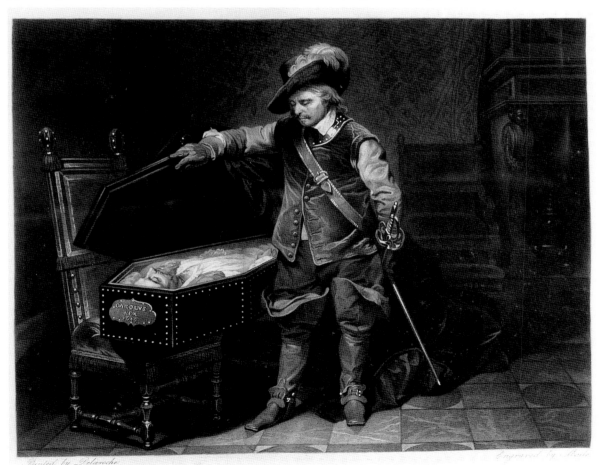

the other the print for Goupil, which was shown at the 1833 Salon (pl. 93). Yet he seems to have changed his mind over the finish of the latter, which began as an etching, went through several intermediary states, and finished up as an aquatint.[75] It was presumably the aquatint that was greeted somewhat ambiguously by the noted critic Auguste Jal when it was exhibited in 1833:

> The young artist has successes in more than one genre. As an engraver, he has been placed among the able by his beautiful print of the *Gustave Vasa*, after Hersent. This year, here he is exhibiting the *Cromwell*, after Paul Delaroche. It is a piece full of vigour and colour, not in the genre of *Gustave Vasa*, but in the mezzotint manner [*manière noire*]. It is tiresome that great engraving, what we must call classical engraving, has so little chance today . . . there are hardly any more collectors and no large resources in the budget.[76]

Jal's comments are quite puzzling in one respect. He appears to make no distinction between mezzotint and aquatint, admittedly the 'two most common forms of tonal intaglio prints'.[77] The exactly contemporary steel mezzotint of *Cromwell* by the English engraver George Maile demonstrates the difference (pl. 94); it shows how almost solid black areas have been produced by the rocker, as opposed to the sudden transitions of tone which Henriquel has achieved by stopping out adjacent areas. However, the more substantial point at issue in Jal's commentary, and the one most relevant here, involves the perilous position of 'classical engraving': that is, the type which entails a labour-intensive use of the burin. Jal is fully justified in pointing to the crisis caused by the recent withdrawal of state funds previously attributed to the long-term projects carried out by engravers like Bervic and Tardieu. He later acknowledges the desperate plight of traditional engraving 'unprotected, and engaged in an impossible struggle with lithography'.[78]

In effect, the 'protection' accorded to reproductive engraving had declined very significantly after the fall of the Empire, and was not to be reinvigorated by the artistic policy of the July Monarchy. When Charles Blanc drew up a report on the state of the long-established 'Chalcographie' or print-selling department in the Louvre after the Revolution of 1848, he found that there was a history of growing inertia in the commissioning, cataloguing and selling of such reproductions. This lack of official commitment was clearly demonstrated by the receipts of the department, which declined from a total of 8,788 francs in 1803 to 2,615 francs in 1820, and had reached a paltry 924 francs in 1847, the year before Blanc compiled his report.[79]

Jal could not have predicted in 1833 that the Maison Goupil would spring to the aid of the burin engravers, and that Henriquel would be one of the major beneficiaries of this privatisation of the printmaking industry. He was probably not an obvious choice for a major assignment in the early 1830s. Mercuri had been charged first with the *Sainte Amélie* and then with the *Jane Grey* by the end of 1835. But the delay with the former had probably already roused suspicions about his reliability.[80] Henriquel continued to win public acclaim for his diverse artistic talents, even exhibiting his pastels in the 1835 Salon.[81] In the following year, he was duly commissioned by Goupil to engrave *Strafford* (pl. 95:1835, Private Collection, UK), Delaroche's next major composition after *Jane Grey*, which showed the betrayed minister of Charles I receiving the blessing of Archbishop

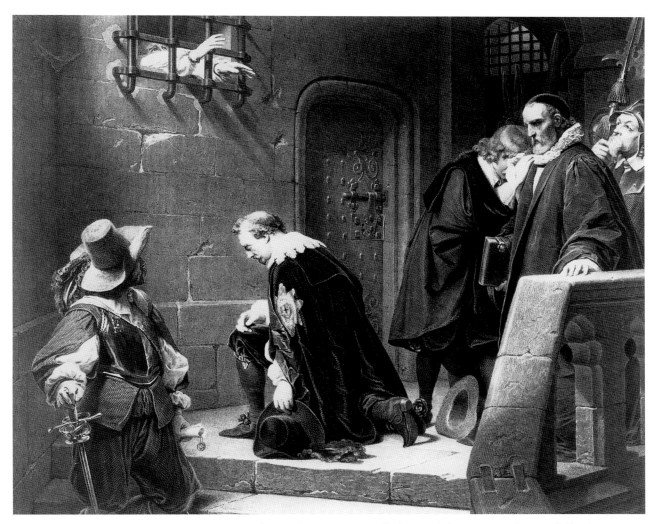

95 Louis Henriquel-Dupont, engraving (1840) after Paul Delaroche, *Strafford*, 1837 Salon. 41 × 50. Private Collection.

Laud on his way to execution in the Tower of London. As mentioned in chapter 1, this painting was the first for which Delaroche's reproduction rights were ceded in a formal contract, and Goupil undertook to pay him 1,500 francs, of which 500 francs was to be payable immediately, and the remaining 1,000 francs on publication.[82]

Strafford was already the property of one of Britain's wealthiest and most well-born collectors when it was exhibited to the Parisian public in the Salon of 1837. Its negative reception was probably one of the factors that caused Delaroche to abandon the Salon from that year onwards. But Henriquel's engraving, a genuine exercise with the burin which owed nothing to new techniques, was ready for publication by 1840, and kept alive the memory of Delaroche's image when the painting had departed to the other side of the Channel. In fact, it was probably the first of his works for which the claim that the print improved upon the original was convincingly made. Théophile Gautier had been merci-

96 Detail of pl. 95.

less in his condemnation of the plastic values of the painting in his Salon review: 'this canvas seems to have been painted with ink, with neutral colouring and with wax . . . there would have to be a richer palette than his to disguise this monotony'.[83] Twenty years later, reviewing the retrospective exhibition of Delaroche's work held after his death at the Ecole des Beaux-Arts, Gautier was still categorical in his distaste for the painting: 'The *Strafford* offends the eye by its abuse of blacks, which have a distressing waxy tone.' But he made a complete exception for Henriquel's work: 'These faults disappear in the engraving, which allows only the clever arrangement of the composition to be seen.'[84]

It is not easy to accept Gautier's criticism of the 'abuse of blacks' in the painting of *Strafford*. In fact, the work in its present state conveys a remarkable virtuosity in Delaroche's treatment of the variegated, but predominantly black clothing materials that underline the differing ranks and roles of the participants. The velvety texture of the cloak of the kneeling Strafford contrasts with the silken folds of that which covers his grieving younger brother, and the rougher weave of the gown of the cleric; the reddish cloth in the costume of the soldier in the left-hand corner is both contrasting in colour and cruder in weave. But whatever may have influenced Gautier's perceptions – as regards the state of the painting at the time, or the conditions of exhibition – there is no doubt that the print by Henriquel reproduces these compared and contrasted textures with exceptional success (pl. 96 and frontispiece). One could almost speak of a weave in the linear patterns traced by the burin, which has enabled this compositional and constructive feature to be clearly brought out.

·SAINTE·CECILE·

97 François Forster, engraving (1840) after Paul Delaroche, *Sainte Cécile*, 1837 Salon. 61 × 47. Private Collection.

98 Early state
of pl. 97.

This dramatic scene, with its sequence of period costumes and its stage props of stone, iron, steel and wood, could almost be seen as a test case for the engraver's skill as a 'translator' of different material surfaces through the spare resources of line. In this respect, it proves an interesting comparison with another major print after Delaroche also published by Goupil in 1840, the *Sainte Cécile* (pl. 97:1836, Victoria & Albert Museum, London). Both *Strafford* and *Sainte Cécile* had been exhibited as paintings in the 1837 Salon. However, while *Strafford* was in every sense the continuation of the historical genre manner so successfully pursued in *Cromwell* and *Jane Grey*, *Sainte Cécile* reflected Delaroche's journey to Italy in 1834/5, and his intensive study of early Renaissance painting. There is more than an echo in this pious image of the patron saint of music with two attendant angels of the enthroned figure in Giotto's celebrated *Ognissanti Madonna* (Uffizi). The appointed engraver, François Forster, has had to reproduce Delaroche's rather laboured attempts at a trecento brilliance of colour and precious materials through a fastidious attention to the possibilities of densely engraved line. Indeed an early proof of the print shows the saint suspended, not beneath a bright blue sky, but beneath a cluster of burin marks, reminiscent of a group of finger-prints, which he has tried out in anticipation of the elaborate engraved border (pl. 98).

As Perrot had underlined in a quote published in his *Manuel du graveur*: 'The able engraver makes up for the diversity of the colours in a painting by the variety of his style; it is these difficulties, overcome by very thankless means . . . that constitute the ability of the engraver.'[85] Forster has indeed had a very different problem to resolve than Henriquel, with his range of monochromes. In addition to mosaic-encrusted throne and marble pavement, he has been given intense hues of colour to reproduce in the deep green lining of the saint's cape, and the pink robe of the foremost angel (pl. 99). Unable to compete with this chromatic contrast (which is indeed an unhappy feature of the original painting), he has animated the print with the extreme ingenuity of his textured surfaces. The lining of the saint's cape develops almost an optical sheen as a result of what seem to be moiré effects of line, whilst the angel's robe has a herringbone texture visibly denser than the fine parallel tracings on her wings (pl. 100).

This comparison is also useful in that Forster was perhaps the only engraver close enough to Henriquel in generation to achieve a comparable reputation. Born in 1790, he received the first Prix de Rome for engraving in 1814, and was elected in 1844 to the seat in the Academy left vacant by Alexandre Tardieu (five years before Henriquel succeeded Richomme). His print after *Sainte Cécile* was a rare exception of a reproduction after a contemporary artist, in an oeuvre devoted largely, like that of Richomme, to the Italian masters and the official painters of the Empire, such as Gérard.[86] Beraldi characterises him as a kind of paragon of the classic engraver, with a 'firm and elegant burin' and a 'glacial correctness' which extended from his art to his person.[87] Indeed he had the great misfortune to be mistaken, by most of his fellow countrymen, for an Englishman! It suggests a certain acuteness of judgement in Goupil that he entrusted Delaroche's most frigid painting to this particular engraver, who arguably succeeded in redeeming it from aesthetic failure.

Forster cuts a fascinating figure in Beraldi's account as an example of an engraver who developed his technical prowess at the expense of his subjects – whose 'beautiful cuttings' displayed the feats of engraving for engraving's sake.[88] In this respect, he was certainly the opposite of Henriquel, who conspicuously refrained from fetishising technique, and subordinated his technical means to the achievement of an appropriate match with the style of his subject. Although Forster's *Sainte Cécile* is the exception that proves the rule, one can surely say that the empathetic way in which Henriquel entered into the spirit of *Strafford* has no parallel in the former. In one respect, he has decisively improved the narrative coherence of Delaroche's painting while remaining faithful to its intentions. Heine wrote disparagingly in 1841 of the incongruous visual effect of Laud's two protruding hands, 'not at all dissimilar to two wooden arms of a signpost at the crossing of a large road'.[89] This is certainly not an unfair observation about the effect of the painting as it is at present, where the motif is necessarily viewed from several feet below, and the darkness of the embrasure virtually conceals the archbishop's face from view. But it has been remedied in Henriquel's print, where the anguished eyes are clearly picked out, and project a more human significance onto the fluttering hands (pl. 101).

This raises the important question of how far Henriquel was liable to be type-cast, as a result of his very success in interpreting Delaroche, and placed in a different category from his immediate seniors, such as Forster, Richomme and Desnoyers. Certainly it seems that this was so from the point of view of Ingres, who manifested a clear sense of dis-

99 (*over page*) Detail of pl. 97.

101 Detail of pl. 95.

crimination between different styles of engraving in replying to Henriquel's request to reproduce his *Odalisque à l'esclave* (1839, Fogg Art Museum, Cambridge, Mass.). The unpublished letter is especially revealing in its evidence of the comparative estimates of Henriquel and Calamatta which Ingres held in 1840:

> Here is another regret to convey to you and a regret which is all the more sincere as I was very sensitive to the commitment which you showed in offering me the guarantee of your talent to present my work to the public. But at the same time as I received your letter and that of your editors, I received one from Calamatta who made the same request; he has interpreted my paintings too well for me not to regard myself as engaged towards him not only to satisfy his requests, but perhaps to wait for them before giving my word to others . . . I would even have wished to be able on this occasion to offer Calamatta another picture than the Odalisque in order to reserve for you the execution of this plate which I believe to be particularly adapted to the genre of expression of your talent, but I was caught off guard by the timing.[90]

There is no reason to doubt Ingres's sincerity here. He had received a serious proposition from a noted engraver with whom he had worked before, accompanied by a commercial undertaking from Goupil which would have been financially advantageous. Several months later, in a letter to Calamatta dated 20 April 1841, he raised the question of whether he might not 'throw to another, to Dupont' the task of reproducing the new *Odalisque* painted for his friend, Marcotte.[91] In hoping to relegate this 'genre' subject to Henriquel, Ingres was of course trying to tempt his friend Calamatta into accepting the task of engraving his major, cherished achievement, the Apotheosis of Homer. As explained in the previous chapter, this ploy did not meet with success. Calamatta never engraved the *Homer*, and indeed never got round to engraving the Marcotte *Odalisque*. What presumably came out of this inconclusive contact between Ingres and Henriquel, however, was the fine reproduction of *Monsieur Bertin* (1832, Louvre), which the latter

100 (*previous page*) Detail of pl. 97.

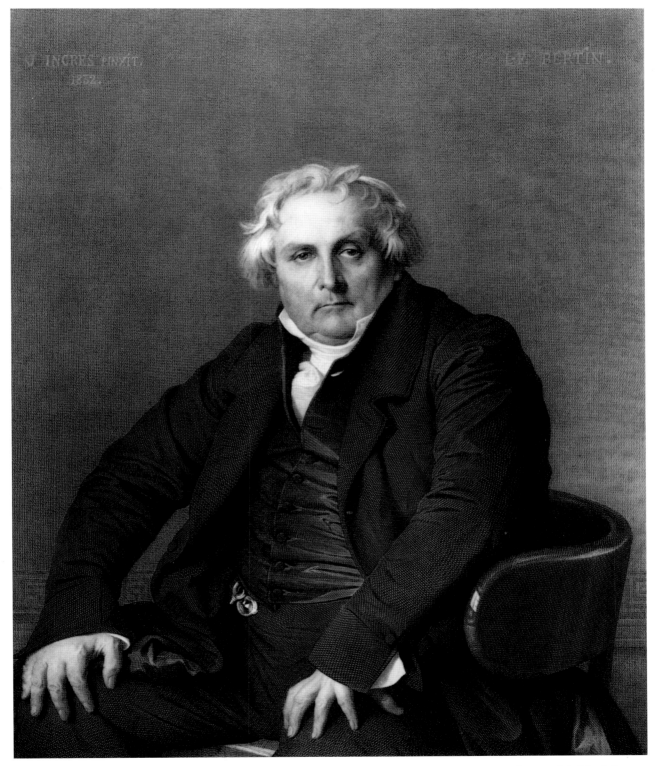

102 Louis Henriquel-Dupont, engraving (1844) after Jean-Dominique Ingres, *Monsieur Bertin*, 1832. 65.7 × 46.8. Musée Ingres, Montauban.

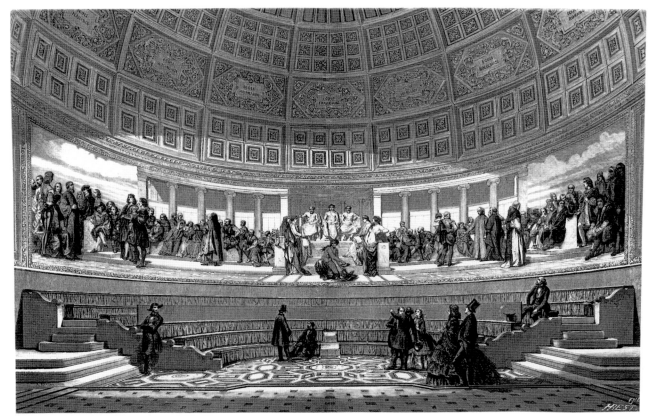

103 Paul Delaroche, *Hémicycle des Beaux-Arts*, 1841. Wood engraving after a drawing by A. Marc published in *L'Illustration*. Bibliothèque Nationale, Paris: Département des Estampes.

brought to completion in 1844 (pl. 102). With his clear sense of the hierarchy of the genres, Ingres was no doubt content for Henriquel to tackle one of his portraits, which he consistently regarded as minor achievements beside his history paintings.[92] Henriquel, however, produced a tour de force which strikingly emulated the achievements of his master Bervic in half-figure reproductive portraiture.

By 1844 Henriquel had established himself as an engraver of the first rank, who was not afraid to exercise his talents on the work of contemporary artists.[93] In addition to his prints after Ingres and Delaroche, he had completed in 1842 (once again for the Maison Goupil) a reproductive engraving of Ary Scheffer's *Christus consolator* (1837 Salon). However, it was the three-part engraving after Delaroche's *Hémicycle des Beaux-Arts*, the vast semi-circular wall painting inaugurated in July 1841 (pl. 103), that confirmed his position, and that of Delaroche himself, on a European scale. Between 1845 and the final publication of the prints in 1853, Henriquel was primarily occupied with this exceptionally demanding assignment. As stated at the beginning of this chapter, the exhibition of the prints at the 1853 Salon won him a *médaille d'honneur*, whose financial accompaniment he generously declined.[94] This was to be followed two years later by a *grande médaille d'honneur* at the 1855

Exposition Universelle. As Delaroche had long since ceased to exhibit at the Salon, and sent no works to the Exposition Universelle, Henriquel had effectively taken on the task not simply of reproducing his paintings, but of standing in for the absent master at these highly public occasions. The need for critical comparisons between the respective achievements of the painter and the printmaker was, by the same token, made all the more imperative.

There can be no doubt that the *Hémicycle* prints required an innovatory approach, as regards both the financing of the work and the technical means used for its realisation. As mentioned in chapter 1, Delaroche showed his sensitivity to the financial burden undertaken by Goupil when he accepted the very modest sum of 500 francs (a third of the payment made for *Strafford*) in return for the grant of reproduction rights. This trans-action took place as early as 1839. However Delaroche also felt obliged to subsidise the production of the prints in a more direct way. The letter written by his cherished pupil, Charles Jalabert, on the occasion of the law suit brought against the Maison Goupil in 1878, testifies to the generosity with which he helped the project on its way. Evidently Delaroche spent 'almost double' the sum that he received from the State for the *Hémicycle*, and successfully petitioned for an additional sum to defray his expenses; 'but he wished for this sum to be employed in a subscription without which the engraving of the *Hémi-cycle* could not be undertaken by its publisher'.[95]

Quite apart from the financial need to maintain Henriquel over this long period, the dif-ficulty of the project was initially a technical one. It was, of course, customary for an engraver to work from a preliminary drawing which alone (as in the case of Calamatta already men-tioned) might require a period of several months' exhaustive study. The production of a painted copy reduced in size, either by the artist or by his studio assistants, was a means of facilitating this initial stage of the engraving process. The *Hémicycle*, however, was a very large painting, no less than 3.9 metres high and 24.7 metres in length, and it was in a semi-circular format. What form was the engraving to take, given that the proportions of approximately 1:6 would be highly unsuitable for printing on a single copper plate?

Here again, Delaroche appears to have gone to very great pains to ensure that his engraver had the best and most suitable material to work with. His own elaboration of the design for the project had involved a careful oil study in a long rectangular format (35 × 212 cm, Musée des Beaux-Arts, Nantes). When the wall painting was complete, he arranged for a pupil to do a version of the composition, again in a rectangular format, which he himself subsequently retouched. This is the work purchased in Paris in the 1870s by the founder of the Walters Art Museum, Baltimore, which indeed bears the signature of Delaroche and the date 1853. However, Eugène de Mirecourt's near-contemporary account of Delaroche spending three wintry weeks in this process of retouching for Henriquel's benefit, in the presence of the work itself, should perhaps be taken as a conflation of two episodes in the history of the same painting. The account books of Maison Goupil record what is very probably the same work, sold on for the first time in 1860, as by 'Béranger d'après Paul Delaroche', and this attribution fits the other available facts. Charles Béranger, who was a favoured pupil of Delaroche and actually exhibited a painting based on one of his master's drawings at the 1839 Salon, died in 1853. It seems highly likely that the work returned at that point to Delaroche's posses-sion, and that most of the retouching (and the consequent dating) took place then as a direct consequence of the change of hands.[96]

This instance of the work painted by the pupil, after the master, for the benefit of the reproductive engraver – and then finally signed by the master in such a way as to confuse future generations – is yet another proof of the complexity of artistic relationships in the first age of mechanical reproduction. But it also provides the occasion to begin our examination of the critical response to Henriquel's achievement, over a wide geographical field, in the decades that followed. It is interesting to note that Edward Strahan, writing of the 'Art Treasures of America' around 1880, cast some doubt on the visual evidence for Delaroche's intervention in the painting of the Walters *Hémicycle* (pl. 111), though his legitimate pride in his country's possession of 'such a masterpiece' prevented him from seriously questioning Mirecourt's account. His comparison, though based on memory alone in the case of the original wall painting, is exact and revealing:

> Comparing the Baltimore duplicate with a vivid recollection of the great work in its place at the Paris School, I find that Delaroche's linear precision of drawing – amounting in the Dupont engraving to a mathematical theorem – still exists in a great degree in the Paris painting, while it is scarcely seen at all in Mr Walters' specimen, which exchanges this accuracy of habit for a comparatively broad and generalized touch. I have never happened to see one of Delaroche's small-scale pictures so loosely brushed as in the present specimen . . .[97]

In this interesting judgement, the engraving can be seen as a guarantee of the work's original *disegno*: the 'linear precision of drawing' has been realised in no more than 'a great degree' in the final painted version, whereas the engraver can express it with the precision of a 'mathematical theorem'. The 'loosely brushed' reproduction almost entirely fails to convey Delaroche's 'accuracy of habit'. A not dissimilar point had been made by the Italian critic, Giuseppe Rovani, in the very year of the engraving's publication, though in this case the advantage of seeing the original work in its Parisian location was given much greater prominence:

> If the marvellous values of concept, style and draughtsmanship [*disegno*] are evidently revealed in the three very beautiful engravings which Dupont has made of it, in such a way that anyone who observes them can arrive at a broad and clear idea of the importance of this work which is Delaroche's largest and most pondered . . . we can be assured that those other values that have been fleshed out with the brush and with colour cannot be seen except by observing the work itself, where every figure, every painter is reproduced with the special mode of colouring which distinguishes right from the start the manner either of the school or of the individual.[98]

In Charles Blanc's article on the engraving of the *Hémicycle*, published seven years later, it is remarkable what resistance he maintains to this seemingly obvious point that at least some of the qualities of Delaroche's work can be observed only *in situ*. He begins by suggesting an appropriate complementarity between the roles of the two media: 'if the fortune of a painting calls and commissions the engraver, the engraver in his turn increases and propagates the fortune of the painting'.[99] But in arguing that Henriquel's engraving has 'consecrated the fortune' of the *Hémicycle,* Blanc implies much more than mere distribution and diffusion. 'When we see it again on the copper plate of the engraver, the composition of Paul Delaroche seems to us even more worthy and more elevated.'[100]

104 (*facing page*) Louis Henriquel-Dupont, engraving (1856) after Paul Delaroche, *Moïse exposé sur le Nil,* 1853. 42.5 × 31. Private Collection.

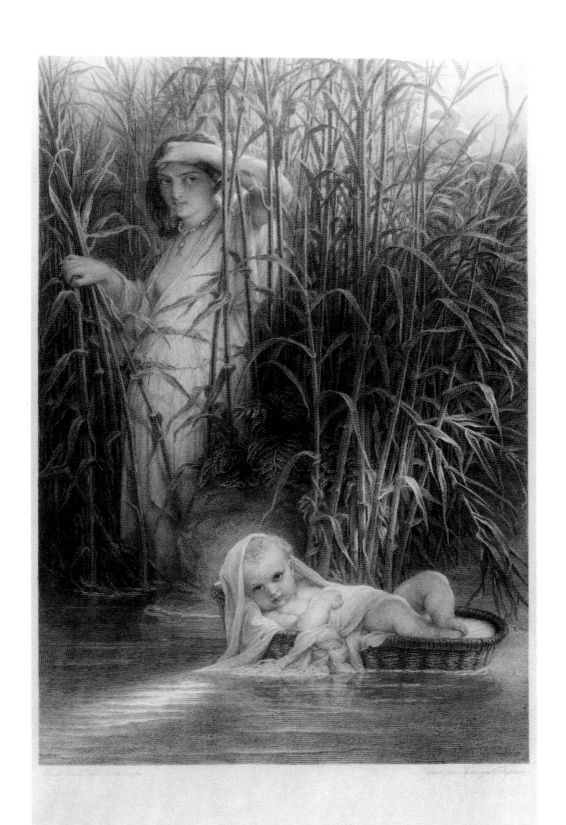

MOÏSE EXPOSÉ SUR LE NIL

Henriquel's 'translation' — for it is still this concept that underlies Blanc's estimate of the engraver's ability — scores through its combination of 'cleverness . . . suppleness [and] wit', and through an 'economy of system [that] lets the paper work for itself'.[101]

Blanc is taking note of an aesthetic impact that is indeed very striking, if we compare the three-part engraving to the precedents of *Strafford* and *Monsieur Bertin* in Henriquel's former work. In place of the dramatic chiaroscuro gradations of the latter, reminiscent of the manner of Bervic, we have an effect of luminous transparency, with the white paper indeed contributing to the creation of an overall brilliance. Beraldi refers to this aspect of Henriquel's style as his 'free work' and informs us that the engraving was 'almost entirely executed by etching, with a light reprise by the burin'.[102] This affirmation may be misleading, as several areas of the plate have quite clearly been worked hard with the burin, such as the central figure of Fame in the middle section. But it does undoubtedly indicate Henriquel's willingness to abandon traditional shibboleths in the interests of a fresh and lively rendering. Perhaps Blanc was thinking back to the slightly chilling figure that Delaroche presented on his visits to Calamatta's studio, when he described Henriquel's achievement as a liberation of the painter's own inner nature in the following terms:

> In this way the print seems to have been bitten by the painter himself on a day of good humour, and instead of being tight, deliberate and tense as Paul Delaroche's execution sometimes is, the engraving is easy, brilliant and all the more spiritual in that the spirit of the master is preserved there in its freshness, being caught and fixed straight off.[103]

Blanc is crediting Henriquel with having revealed the 'spirit' of Delaroche in a way that the artist himself was rarely capable of doing. A year before, in the first edition of the *Gazette des Beaux-Arts,* he had prepared the way for this assessment in his criticism of what transpired to be Henriquel's last engraving after Delaroche, published in 1856, the year of the painter's death (pl. 104). *Moïse exposé sur le Nil* (after Delaroche's now lost painting of 1853) was in Blanc's view 'one of the most charming studies that Paul Delaroche made, inspired a little by Poussin'. Henriquel's print, however, had brought out the best in it, allowing the composition to 'take on a harmony that the painting did not possess, being a little reddish and feeble'.[104]

` Blanc's comments made in the few years following the publication of Henriquel's engravings after Delaroche are understandably dominated by close comparisons between the reproduction and its original. When, in 1867, he comes to publish his most systematic study of the visual arts, his *Grammaire des arts du dessin,* he has room for a broader judgement on Henriquel's work that brings out his originality by reference to the great tradition of engraving. Henriquel does not in fact figure in the index of the *Grammaire,* but he is there nonetheless when Blanc begins to review the ways in which hair has been represented by the great printmakers. Edelinck is mentioned as one example of an artist prone to 'detailing the hairs, engraving them, so to speak, one by one'. But 'the eminent artist who so magnificently engraved the *Hémicycle* of Paul Delaroche followed a contrary system: he translated hair with a sustained lightness, through cuts that were relatively spaced out and, instead of counting the hairs as if they were combed with a fine comb, assembled them in little masses and produced the same illusion for the look, because the

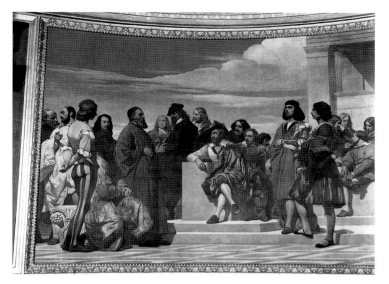

105 Paul Delaroche, *Hémicycle des Beaux-Arts*, 1841. Oil and wax on wall, 390 × 2470. Ecole des Beaux-Arts, Paris. Detail of far left-hand section showing painters: from the left, Correggio, Veronese, Antonello da Messina, Murillo, Van Eyck (seated), Titian, Gerard Ter Borch, Rembrandt, Van der Helst, Rubens, Velázquez, Van Dyck, Caravaggio, Giovanni Bellini, Giorgione, Ruysdael, Potter, Claude and Gaspar Poussin.

106 Louis Henriquel-Dupont, engraving (1853) after Paul Delaroche, *Hémicycle des Beaux-Arts*, 1841. Left-hand print of three. 53 × 112.5. Private Collection. Detail.

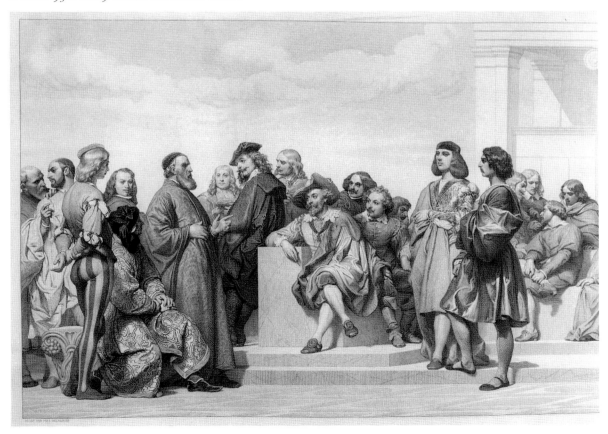

eye . . . makes up for the fineness of detail'. Here Blanc seems almost to be making a psychological point that anticipates Gombrich's *Art and Illusion*, but his way of summing it up is typically his own: 'So it is right to say that the artist is always *true* when he grasps the *spirit* of things.'[105]

Inevitably there is no space here to write of the wider significance of Delaroche's tableau of 'Artists of all ages', realised in the novel panoramic form of the *Hémicycle*.[106] Nor is it possible to do full justice to the most lengthy and authoritative early commentary on the achievement of the engravings, by the lifelong friend who was also perhaps Delaroche's most faithful and judicious critic, Henri Delaborde. It is, however, necessary to make the point that Delaborde did not hold as tenaciously as Blanc (or Gautier) to the view that Delaroche needed to be saved from the consequences of his own pictorial errors. He approved very strongly of Henriquel's print after *Strafford*, but not for the reason that it merely compensated for the painting's defects. 'What Gérard Audran did sometimes for the pictures of Lebrun,' he argued, 'M. Henriquel-Dupont did for the picture of M. Delaroche; he managed to translate it faithfully, while bringing it to its final conclusion, and adding a certain new quality without for all that transforming it.'[107] The reference to the *grand siècle* gives a reassuring historical context to the judgement, which is all the more subtle because of its tentative character. Moreover, Delaborde's way of characterising the handling of the burin in the *Strafford* print shows that it is the intrinsic texture of the incised lines that achieves this 'certain new quality':

> Beside the parts that are broadly executed, certain others – like the flesh, the hair, the pieces of armour – are treated so delicately, that the process cannot be detected, and and we recognise only the appearance of a supple body, silken or inflexible, where there is nothing but cuttings that cross in different directions, and furrows more or less deep.[108]

Delaborde is at his most illuminating as a critic, however, when he detects and describes the precise choices that Henriquel has had to make as a result of the drastic change in scale between the *Hémicycle* and the three prints (pls 105 and 106, 107 and 108, 109 and 110). In the amphitheatre of the Ecole des Beaux-Arts, he justly remarks, the eye roves widely and has 'time to forget the diversity of expressions and costumes, in a word the contradictory appearance of the represented objects'.[109] On the other hand, the relatively small scale of the three prints allows the eye to take them in at a single glance, and forces upon the engraver the task of creating a harmonious sequence devoid of such striking local contrasts. Delaborde sums up the way in which Henriquel adjusts to this difference, first of all in relation to the two flanking prints (pls 106, 108):

> Here, as with the brush of M. Delaroche, every painter, architect and sculptor keeps the physiognomy of his times, every detail of adjustment keeps its own relief and its essential appearance; only whilst diversifying its procedures has the burin of the engraver managed to keep throughout an even serenity, so to speak, and thanks to this constant reserve in handling . . . no dissonance comes to disturb the general harmony. Thus, the two groups which finish the composition on the right and the left, and which needed to be somewhat isolated from the rest by virtue of the place that they occupy, are nonetheless united to the other parts through the firm gradation of the work. The figure of Poussin and, at the other extreme, those of Antonello da Messina and Van

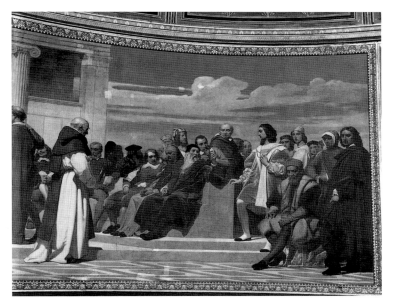

107 Paul Delaroche, *Hémicycle des Beaux-Arts*, 1841. Oil and wax on wall. 390 × 2470. Ecole des Beaux-Arts, Paris. Detail of far right-hand section showing architects: from the left, Bramante, Mansart, Vignola; and painters: Fra Angelico [standing between Mansart and Vignola], Holbein, Le Sueur, Orcagna, Sebastiano del Piombo, Dürer, Leonardo da Vinci, Domenichino, Fra Bartolommeo, Mantegna, Giulio Romano, Raphael, Perugino, Masaccio, Michelangelo, Andrea del Sarto, Cimabue, Giotto and Nicolas Poussin; the two engravers, Raimondi and Gérard Edelinck, are in the background between Vignola and Holbein.

108 Louis Henriquel-Dupont, engraving (1853) after Paul Delaroche, *Hémicycle des Beaux-Arts*, 1841. Right-hand print of three. 53 × 112.5. Private Collection. Detail.

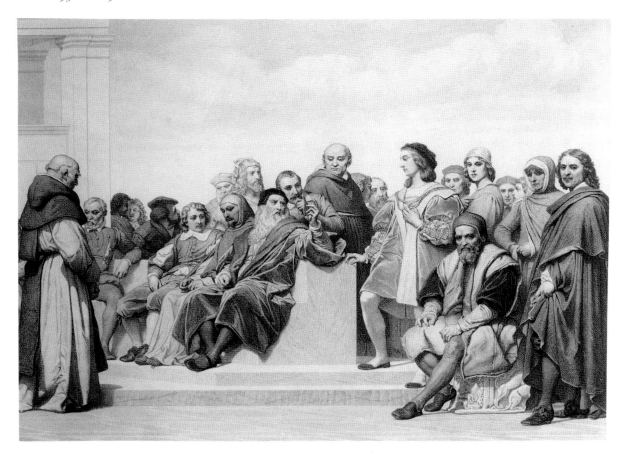

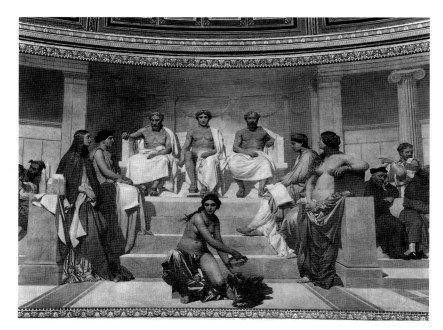

109 Paul Delaroche, *Hémicycle des Beaux-Arts*, 1841. Oil and wax on wall. 390 × 2470. Ecole des Beaux-Arts, Paris. Detail of central section showing, from left to right, Gothic art, Greek art, Ictinus, Apelles, Phidias, Roman art, the Renaissance and the Genius of the Arts (in centre).

110 Louis Henriquel-Dupont, engraving (1853) after Paul Delaroche, *Hémicycle des Beaux-Arts*, 1841. Central print of three. 53 × 65.5. Private Collection.

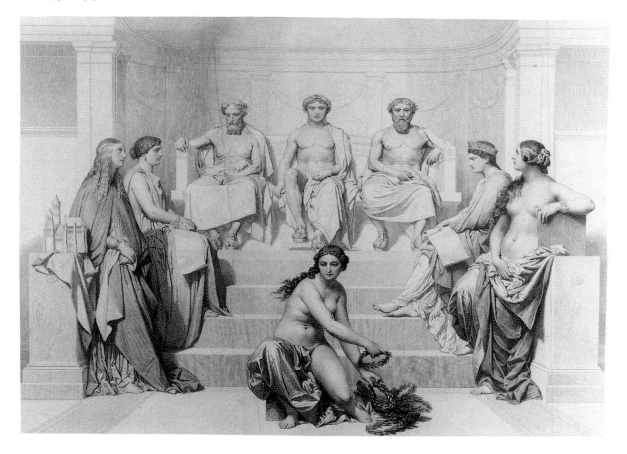

Eyck are accentuated with a rigour which is attenuated in the modelling of the neighbouring figures. As these approach the centre, the copper is less energetically scoured, the cuts have more lightness and suppleness, and through this progressive modification, the work arrives in imperceptible stages at the delicacy and smoothness of the figures placed in the middle.[110]

This is a descriptive commentary that can be checked in the closest terms if we compare photographs of the print with those of the wall painting *in situ*, even though the latter cannot possibly reproduce the effect of breadth of field that makes Delaroche's vivid local contrasts acceptable. To the extreme left of Henriquel's left-side print, Antonello and his seated neighbour Van Eyck – two pioneers of the technique of oil painting – stand out firmly from the rest of the adjacent group, but do not detract from the steady gaze fixed upon the spectator by Murillo, from above Van Eyck's head. It must be conceded that Van Eyck's averted profile no longer comes across at all in the painting, possibly because of the damage which it sustained through a fire in 1855. To the extreme right of the right-side print, the figure of Poussin is no longer singled out by the almost uniform darkness of his robe, which in the painting contrasts vividly with the green and red tunic of Giotto standing beside him. It is in the accentuation of Poussin's figure to compensate for this loss of colour contrast, however, that we can pick up more clearly than anywhere else in the print the intricate parallel marks made by the burin.[111]

Delaborde also has interesting points to make about the central section of the *Hémicycle*, where the task of the engraver has been not to realise the gradations of a longitudinal section, but to manage the steep recession from the foreground to the enthroned figures of Ictinus, Apelles and Phidias, classical exponents of the arts of architecture, painting and sculpture (pl. 110). He is right to single out for comment the prominent figure of the 'Génie des Arts' in the foreground, which epitomises the use of the *Hémicycle* for the ceremonial distribution of prizes. Delaroche himself experienced considerable difficulty in painting this central figure, and he decided to give her prominence by darkening her skin tone in relation to the marble steps and the other nude bodies.[112] Henriquel, however, uses his own particular resources: 'the figure of the woman who distributes the crowns is detached from the background by the lively accentuation of light effects, instead of being, as in the painting, more strongly tinted than the steps that rise behind her'.[113] On the steel-coated copper plate, this quality of luminosity, especially visible in her silken drapery, is reflected in the dense scoring of the engraver's line.[114]

While remaining strictly within the terms of the metaphor of reproductive printmaking as translation, Delaborde is able to comment extensively on Henriquel's achievement in the *Hémicycle*. The prints demonstrate for him the narrow boundary between liberty and licence, since the integral transpositions made by Henriquel are not the result of arbitrary or subjective decisions. They arise from the very nature of the material, and the processes used to reproduce it. Engravers 'can only, following the example of M. Henriquel-Dupont, try to complete the text and sometimes to render its meaning by an indirect expression, if there is no equivalent in their own idiom, but they should only have recourse to this extreme method in cases of absolute necessity and never forget that their very emancipation must have the appearance of submission'.[115] One feels that there is an agenda here, in the criticism of the future secretary of the Académie des Beaux-

Arts and biographer of Ingres, that transcends the specific case of reproductive engraving. Henriquel has become exemplary of a printmaking tradition which, in its very precariousness, signals the predicament of academic art as a whole in the mid-century.

As Delaborde warms to his theme, the strategic importance of his support for reproductive engraving becomes amply clear. He even reproaches Delaroche for confining the engravers included in the *Hémicycle* – Raimondi and Edelinck – to a 'humble place' in the composition, opining that Henriquel himself must have felt slighted by this visual 'ostracism'![116] Perhaps the most telling indication of his *parti pris* can be found in his closing defence of the engraver against the challenge of photography. Although the very practice of burin engraving can appear as an 'anachronism', Delaborde concedes, it is in fact in the front line of defence against the specious new invention. 'Despite the most judicious dissertation on the excellence of engraving, a heliographic proof will retain in the eyes of many people all its authority and prestige: placed in view of a print like the *Hémicycle*, it will enable them to see clearly what is inadequate and false so to speak at the bottom of the brute truths formulated by the daguerreotype.'[117] Writing in 1853, Delaborde persists in viewing the engraving as the touchstone of visual truth. But as far as photography went, he still had to reckon with the challenge of Robert Jefferson Bingham.

<p style="text-align:center">* * *</p>

As the accredited photographer of Delaroche's work after his death in 1856, Bingham necessarily had to feature the *Hémicycle* as far as he was able. Yet a view of the panoramic half-circle of the wall-painting *in situ* was far beyond his technical capacities; indeed it continues to pose a challenge even to the photographer of the present day. Bingham began by reproducing the preparatory sketches for the *Hémicycle* from the Clarke de Feltre collection in the Musée des Beaux-Arts, Nantes. The only work approximating to the final composition included in the *Oeuvre de Paul Delaroche* published by Goupil in 1858 was therefore one taken from the paper study glued onto canvas where Delaroche recorded his first thoughts in 1836.[118] Bingham's photograph of this study was seen and approved by Ernest Lacan, the editor of *La Lumière,* in September 1857. However Lacan was remarkably quick to endorse the view that the novel catalogue raisonné would not usurp the role of traditional reproductive engraving. 'We believe that in no respect can one compare engraving to photography,' he asserted, 'but we must admit that we feel a strong satisfaction in thinking that one day we shall find all the works of the great artist in M. Bingham's portfolio . . .'[119]

Lacan seems to be valuing Bingham's achievement primarily for its archival utility, and ducks out of the kind of direct, and damning, comparison that Delaborde had previously made. This was indeed an appropriate judgement for the illustrated catalogue, in which the excessive width of the study for the *Hémicycle* had in any case been seriously constrained by the portrait format. Bingham's next venture for Goupil was, however, the more ambitious 'Galerie photographique' which has already been mentioned in chapter 3. In this case, he chose to photograph not the Nantes study of 1836, but the painting of the finished Hémicycle prepared for the use of Henriquel-Dupont in 1841, probably by Charles Béranger, and repainted and signed by Delaroche himself in 1853 (pl. 111). Here

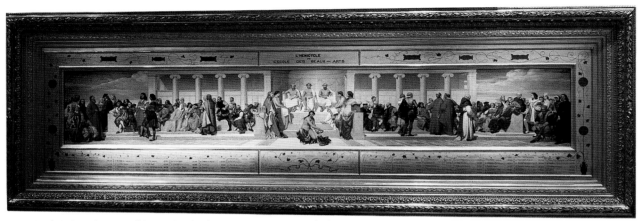

111 Paul Delaroche (possibly with Charles Béranger), *Hémicycle des Beaux-Arts*, *c.*1841: repainted and signed 1853. Walters Art Gallery, Baltimore.

was a composition on a flat surface which, apart from a few happy embellishments by Delaroche himself, related closely to the semi-circular wall-painting in the Ecole des Beaux-Arts. The photographic print was not confined to a puny 3.5 × 21.2 cm, as before, but covered dimensions of 9 × 58 cm, giving an image approximately seven times as large (pl. 112). Its price was easily the highest among the first ten prints published in the *Galerie*; indeed, at 30 francs, it ran close to the unit cost of 50 francs for each of the three *Hémicycle* prints by Henriquel.[120]

Bingham's *Hémicycle* photograph was published well in time for the exhibition of the Société française de photographie in the Palais des Champs-Elysées in April–July 1859. The third showing of this group, it was also the first in which photography was placed parallel to the painters, engravers and lithographers exhibiting at the annual Salon. Long negotiations with the *Direction des Beaux-Arts* had produced the compromise that the photographers would show, if not in the same space as their colleagues, at least under the same roof. Louis Figuier, who acerbically greeted this arrangement as being like the summoning of 'two parties in litigation', was one of the first to salute Bingham's now unchallenged skill in the photography of paintings, and gave special praise to his *Hémicycle.*[121]

Over the years that Bingham was working in France, between his arrival in the early 1850s and his death in 1870, photography was gradually and progressively establishing itself in technical, institutional and ultimately critical terms. Although the photography of the outside world anticipated in Niépce's experiments seems incomparably more interesting to us today, the photography of paintings brought to a high level of accomplishment by Bingham had a pivotal role in this process, precisely because it existed on a border line. A turbulent sea scene photographed by Le Gray, or a cathedral façade photographed by Le Secq, was in a sense incommensurable with other existing means of representing nature and culture. By contrast, Bingham's photography of paintings inevitably provoked comparison with the mediating role that engraving had hitherto played. And it began finally to gain some credit in this difficult comparison. In a report

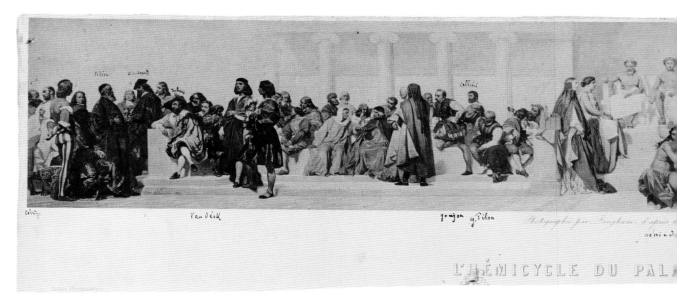

112 Robert Jefferson Bingham, albumen print (1858) of Paul Delaroche, *Hémicycle des Beaux-Arts* (pl. 111), *c.*1841. 9 × 58. Annotatio in blue ink indicate the figures of Correggio, Van Dyck, Jean Goujon, Benvenuto Cellini, the Genius of the Arts, Erwin von Steinbac Fra Angelico, Dürer, Leonardo da Vinci, Raphael, Michelangelo and Nicolas Poussin. Private Collection.

of the fourth exhibition of the Société française de photographie, published in *La Lumière* in May 1861, Bingham's reproduction of *Les Amateurs de gravures* by Meissonier was singled out for special praise. It was 'a jewel: never [would] a reproduction by engraving be able to approach it'.[122] But the reviewer went on to mention the notorious lack of sensitivity to the differentiation of the colours of the spectrum that had probably caused Bingham's *Stratonice* after Ingres to be aborted. If photography insisted on 'translating both yellow and red into black', the human face was bound to 'seem smeared, without the photographer being able to do anything about it'.[123]

In terms of translation, photography still had a lot to learn in the 1860s. By comparison with the superfine gradations which Henriquel has employed to interpret Delaroche's wall-painting, Bingham's tonalities appear a little crude. One has only to compare the monotonous effect of the grouping of Michelangelo, Giotto and Poussin at the right-hand edge of the photograph with the subtle differentiations achieved by Henriquel's burin. Yet Bingham's photograph, in its panoramic sweep, does offer a remarkable equivalent to the viewing experience of the semi-circular prospect, which is highly successful on its own terms. Henriquel's three prints had to be assembled in an elaborate and weighty tripartite frame, which anticipated the triptych form assumed by many painters during the Symbolist period.[124] By contrast with this quasi-religious treatment, which elevated Delaroche's great work to the level of a modern masterpiece, we may imagine that the photograph by Bingham helped to bring out the pedagogic element implicit in Delaroche's programme. The example illustrated here has clearly been pinned to the wall, unframed, and (it would seem likely) in an artist's studio, since an idiosyncratic series of pen inscriptions provides identification for a number of the historical figures included.

The photography of paintings, and other works of art, has by the beginning of the twenty-first century been functionally inserted into the publishing process, so that we

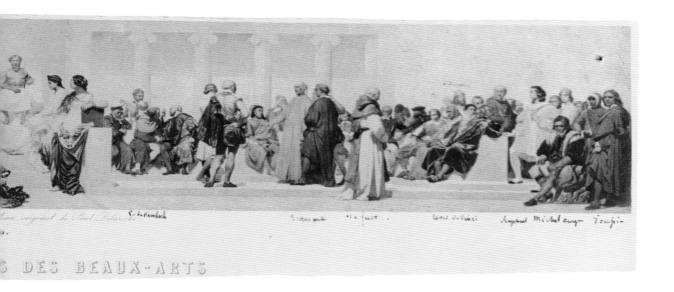

rarely venture to ask for the name of the photographer responsible for a particular print, or assess their quality in any but pragmatic terms. Over the same period, the nineteenth-century tradition of fine reproductive engraving – virtually extinct as a practice by the time of Henriquel's death in 1892 – has almost disappeared from view, even as an object of historical study. The effect that this book has tried to achieve could be compared to one of those stereoscopic images that were coming into vogue in the 1860s. In showing printmaking, painting and photography coexisting in closely parallel planes, as it were, it has attempted to configure a space of *troc* that existed simultaneously with the emerging codes of modern visuality. Looked at from another point of view, the alignment of Delaroche, Henriquel and Bingham seems to prefigure the present cultural phase, in which the new printing techniques associated with digitisation are beginning to reassimilate the photographic image.[125] To this extent, the exceptional status of the photograph, however much it persists in the histories of recent years, may eventually come to seem something of a historiographical curiosity.

This is a speculative point, however, and my study makes no claim to be in any way predictive. It is enough that the historical account should enable us to look at the full range of works represented here with new eyes.

Notes

Introduction

1 Quoted in Beraldi, 1981, X, pp. 29–30. The original place of publication is *Gazette des Beaux-Arts*, 1, January–March 1859, pp. 163–7.

2 See Mitchell, 1994, pp. 11–34. Mitchell anticipates that, in encountering this theoretical challenge, art history will move from a position of marginality to 'intellectual centrality'; it will achieve this by developing a 'broad, interdisciplinary critique' and drawing upon the experience of the new discipline of film studies (p. 15). While agreeing with his basic argument, I would hold that the historical investigation of the development of a new visual culture in the nineteenth century still has a long way to go. At the present stage, film historians share with art historians the need to revisit the reproductive technologies of the period.

3 Baxandall, 1985, p. 53.

4 Ibid., p. 48.

5 The partnership of Jean-Baptiste-Adolphe Goupil and the German-born Joseph-Henry Rittner, originally for the purpose of print-dealing and publishing, was set up by a deed of 23 March 1829. Their connection with Paul Delaroche dated from 1830. Rittner died in 1840, and the partnership was dissolved. By the end of 1841, however, the house had taken on a new lease of life through the partnership of Théodore Vibert, the son-in-law of the engraver Jean-Pierre Jazet, who had made his reputation through reproducing the paintings of Horace Vernet, among others. From 1846, the firm directed its prints increasingly towards an international market, covering the United States as well as the major European countries. After Vibert's death in 1850, the name of the enterprise reverted from Goupil, Vibert et Cie to Goupil et Cie. For a detailed account of their activities in the period covered by this study, see Bigorne, 2000.

6 Blanc, 1889, p. 621: 'nous ne saurions en parler ici sans nous souvenir avec reconnaissance des maîtres éminents, Calamatta et Mercuri, qui nous ont appris les lois et les secrets de leur art'.

7 See Georgel, 1998, p. 87.

8 For the remarkable record of the *Gazette* in this respect, see Sanchez and Seydoux, 1998. For the list of works in the *Musée des copies*, see Duro, 1985, pp. 283–313.

9 Blanc, 1889, p. 621: 'La gravure en taille-douce est par excellence la gravure classique, celle qui a rendu le plus de services en éternisant les ouvrages des grands maîtres, et celle qui a produit elle-même le plus de chefs-d'oeuvre.'

10 For a dyspeptic view of the significance of this revival, see Ivins, 1996, p. 100. Ivins is broadly right in insisting that etching had been part of the engraver's stock-in-trade for centuries, and that the 1860s saw 'not a revival of the craft of etching at all but the adoption of the technique by a group of rather poor draughtsmen and incompetent technicians who in one way or other managed to gain the attention of the public'.

11 Beraldi, 1981, VIII, p. 77.

12 See Griffiths, 1996, p. 55.

13 Charles-Clément Balvay, the burin engraver known by the name of Bervic, was born in Paris in 1756 and died there in 1822. His role as the most eminent representative of the transitional phase between eighteenth- and nineteenth-century French print culture will be invoked on a number of occasions in the chapters that follow. The Italian engraver Paolo Toschi, who produced the striking portrait illustrated here (pl. 3), was his pupil between 1809 and 1819, and is known to have completed his unfinished print after Poussin's *Testament d'Eudamidas*. For a general estimate of his career and a bibliography of early sources for his life and works, see Roux, 1933.

14 Benjamin, 1992, p. 66. See the original German text in Benjamin, 1966: 'die Stahlstiche dieses Buches sind von dem grössten französischen Zeichner entworfen und von den grössten Stechern ausgeführt worden'.

15 Beraldi, 1981, VII, p. 5. Guillaume-Sulpice Chevallier, known as Gavarni, was born in Paris in 1804 and died in Auteuil in 1866. His cousin, the painter Prosper Lafaye, will feature prominently in chapter four.

16 Beraldi gives his date of birth (Paris 1790) and then passes to listing his work without comment. See Beraldi, 1981, X, p. 186.

17 Benjamin, 1992, p. 213.

18 Ivins, 1996, pp. 1–2.

19 The chapter headings in Ivins, 1996, directly reflect the argument in which classic engraving is viewed as a technique constrained by rigid and arbitrary rules, whilst the innovations of the nineteenth century (lithography and photography) result in the removal of 'syntax' and the coming of a 'new vision'. They are, from chapter four onwards: The Tyranny of the Rule – The Seventeenth and Eighteenth Centuries; The Tyranny Broken – The Nineteenth Century; Pictorial Statement without Syntax – The Nineteenth Century; New Reports and New Vision – The Nineteenth Century.

20 All of these photographers were included with Bingham in the medal awards for the International Exhibition of Photography at London in 1862.

Chapter 1

1 Benjamin, 1992, p. 212: cf. Benjamin, 1974, p. 474. Benjamin's categories remain useful for positioning an enquiry of this kind. However, it is worth noting that there has been a discernible shift in the interest attached to studies of the concept of reproduction over the last quarter-century. Typical of the earlier type of study is the informative special number of *Revue de l'Art* (21, 1973) devoted to 'Copies, répliques, faux', which is written essentially from a connoisseur's point of view and focuses especially on the ever popular topic of forgery. Indicative of a new approach which takes into account the specificity of the period and the complexity of the issues is a more recent article in the same journal by the Director of the Musée Goupil, Bordeaux: see Lafont-Couturier, 1996.

2 White, 1999, p. 99.

3 Benjamin, 1992, p. 215.

4 Beraldi, 1981, X, p. 30.

5 See Bibliothèque historique de la Ville de Paris, Fonds Sand, J 36, ff. 28–30. According to this autobiographical account, the engraving was begun in Italy, during a stay in Loro (Marche).

6 Benjamin, 1992, p. 212. Benjamin's 'third parties' are 'gewinnlüsterner Dritten' (Benjamin, 1974, p. 474).

7 See Schnapper, 1973, p. 21, where he refers to these three paintings by Guérin as 'les admirables réductions', and relates Guérin's practice to earlier examples in the French academic tradition dating back to the reign of Louis XIV. See also the dossier in the Musée des Beaux-Arts, Bordeaux. Walter Johnston's son, David Johnston (1789–1854), was subsequently Mayor of Bordeaux, and the paintings entered the civic collection after his death. A letter relating to the purchase of two of the works describes them as having originally been bought at 'un prix fort élevé' (Dominique Vadon-Medina, *Recherches sur Jean-Marie-Osian Gué Peintre 1809–1877*, unpublished MA thesis, October 1997, Université de Bordeaux III, I, p. 160).

8 The best guide to the sequence of events in the few years after 1814, which at any rate clarifies the earlier part of the sequence, is the detailed chronology of Granet's life during that period in Néto, 1995, pp. 255ff. This includes the quotation from his unpublished memoirs relative to the decision to continue the series: 'Obligé de remettre mon tableau au comte de Saint-Leu, j'eus la pensée d'en faire un pareil, mais avec des variantes'. The suggestion that the Lyons picture may be the work originally shown at the 1826 Salon of Cambrai is made in *Les Salons retrouvés* (1993), p. 131. See also Bann, 1999, pp. 35–52, for an account of the historical and psychological factors underlying Granet's pictorial production.

9 For a persuasive account of the development of the concept of the 'photogenic' in the period, see Ortel, 2000.

10 See Supplément (unpaginated) to *Revue des Beaux-Arts*, 2ème série, 11, 15 June 1889.

11 See letter of Delacroix to unnamed correspondent (Getty Research Institute, 860470): 'Je viens de terminer la répétition que vous m'avez demandé du tableau de Médée. Des retards qui n'ont pas dépendu de moi ont tenu surtout à l'absence de l'original qui eut pu

abréger mon travail. Mais vous aviez eu la bonté de me dire que vous ne seriez pas étonné des légères variantes qui peuvent se trouver dans ce travail, auquel j'ai du reste apporté tous mes soins.' The original of *Médée furieuse*, dated 1838, is in the Musée des Beaux-Arts, Lille, while the 1862 version is in the Louvre. A further variant of the 1838 work, done in collaboration with Andrieu, was painted in 1858, and is now destroyed. See Delacroix, 1975, pp. 106, 129, 133.

12 This does not mean that Delacroix was not unusual, among the artists studied here, in his attitude to the 'copy'. Richard Shiff is right to point out that he belongs at the other end of the spectrum from Ingres, in respect of his view of originality, and its consequences for artistic practice (see Shiff, 1983, pp. 114–17). It is the contention of this chapter, however, that even Delacroix's insistence on individual artistic mastery gains its transgressive significance from the fact that it arises within a culture where the opposition between 'original' and 'copy' was consistently blurred.

13 Quoted in Ewals, 1996, p. 43: 'C'est une répétition moins chaude de couleur, mais plus serrée de dessin et de modelé, faite par Scheffer lui-même et à laquelle il travaillait encore dans ses dernières années'. Evidently Burty was not alone in noting the inferiority of the first painting. Scheffer's biographer, Mrs Grote, noted yet another, smaller replica (now in the collection of the Mead Art Museum, Amherst), as 'surpassing in point of execution the first Francesca' (quoted in Trapp, 1987, p. 29).

14 Burty, 1859, p. 211 (extract republished in Rouillé, 1989, pp. 307–9): 'La photographie est impersonnelle; elle n'interprète pas, elle copie; là est sa faiblesse comme sa force, car elle rend avec la même indifférence le détail oiseux et ce rien à peine visible, à peine sensible, qui donne l'âme et fait la ressemblance'.

15 Burty, 1859, p. 211: 'Nul doute que, dans un temps très court, elle ne tue cette gravure et cette lithographie de pacotille, éditées sans conscience pour les besoins des âmes peu délicates . . .'.

16 Burty, 1859, p. 211: 'M. Henriquel-Dupont . . . nous a donné quelque chose de plus complet que l'original, en rendant à cette composition la puissante unité que sa coloration peu épique lui enlève par places'.

17 For a complete catalogue of the works of Delaroche as reproduced by the Maison Goupil, see Renié, 1999, pp. 200–18, and pp. 173–99.

18 Ewals, 1996, pp. 117–18.

19 Getty Research Institute, 900239-1, ff. 40, 46.

20 Ackerman, 1986, p. 30.

21 Getty Research Institute, 900239-1, f. 11. For further discussion of this work, see chapter 5.

22 See Reinaud, 1903, pp. 101–2.

23 Bibliothèque Nationale, MS NAF 16800, f. 34 (letter dated 12 Feb. 1849): 'Goupil m'a montré hier sa répétition de votre Cromwell, il n'y a que vous au monde qui puissiez refaire ainsi d'idée, un tableau fait depuis longtemps et dont les détails sembleraient avoir dû s'échapper de votre souvenir.'

24 Quoted in Moulin, 1967, p. 27. It should be noted that this classic study of the French art market does not deal with the earlier period of the existence of the Maison Goupil.

25 It is important to emphasise that this distinction cuts across the conventional distinction between 'high' and 'popular' art, at least in so far as it has been taken for granted in most versions of the prelude to Modernism. For example, Lorenz Eitner is on familiar ground in his essay on 'popular art and modern tradition in nineteenth-century French painting' when he dismisses Carle Vernet and Guérin as 'unlikely mentors' for Géricault, and yet argues that the 'novelty' of lithography 'brought high and low artists together into a democracy of experimentation' (Eitner, 1990, pp. 55–6). The present, more catholic account of printmaking in relation to painting will hopefully avoid this type of strained antithesis. In his subtle analysis of the work of a painter of the next generation to those featured here, Ernest Meissonier, Marc Gotlieb nuances the argument by claiming that his subject is 'modern' without being 'modernist'. This judgement does indeed seem very exact in relation to Meissonier's stance, but in the first half of the century it is perhaps impossible to separate out the two strands with the same degree of clarity (see Gotlieb, 1996, pp. 169–70).

26 It is certainly possible that Delaroche attended as a student the popular lectures given by Cousin at the Sorbonne between 1815 and 1821. These formed the basis of his later publications in aesthetics. See Bann, 1997, p. 78.

27 Cousin, 1858, pp. 179–80: 'le fond du beau, c'est l'idée; ce qui fait l'art, c'est avant tout la réalisation de l'idée, et non pas l'imitation de telle ou telle forme particulière'.

28 See Bann, 1997, p. 78.

29 Cousin, 1858, p. 190: 'Le problème de l'art est d'arriver jusqu'à l'âme par le corps.'

30 See Carcopino, 1968, pp. 144–7 for a general account of the aesthetic philosophy of Lamennais.

31 See McWilliam, 1993, p. 161 and *passim*, for the ferment of ideas in the period of the July Monarchy in France, and its implications for artistic communication.

32 Mondzain, 1996, p. 69.

33 Douzinas and Nead, 1999, p. 43.

34 See Benjamin, 1992, pp. 218–19.

35 For a broad overview of questions of authorship and copyright at the beginning of the period covered by this study, see Scott, 1998 and Scott, 2000.

36 Landon, 1812, I, p. 7: 'Je pouvais encore faire remarquer aux juges que mes planches, réduites au *trait*, n'étant point la copie des estampes terminées de M. Didot, mais simplement l'extrait des compositions originales, et ces originaux étant alors la propriété d'un tiers, le propriétaire seul aurait eu le droit de me poursuivre, si toutefois mes extraits eussent pu être considérés comme la contrefaçon de ces dessins.'

37 Landon, 1812, I, p. 8: 'L'ouvrage de M. Landon intitulé *Annales du Musée* est un journal où il rend, et où il doit nécessairement rendre compte de toutes les productions des beaux-arts qui sont exposées aux regards du public . . . Ce compte, tel qu'il le présente, est aux arts ce qu'en littérature l'extrait d'un ouvrage est à l'ouvrage lui-même.'

38 Landon, 1814, p. 20: 'Nous ne donnerons pas l'analyse du tableau de M. Monsiau. L'inspection seule du *trait* gravé suffit pour en faire sentir l'ordonnance . . .'.

39 See Gusman, 1929, for the proliferation of wood-block printing in France throughout the 1830s.

40 Gautier, 1994, p. 267: 'Le *Voeu de Louis XIII* a été popularisé par la belle gravure de Calamatta; il est donc inutile de le décrire ici en détail.'

41 Vernet, 1841, p. 8: 'Le peintre a deux moyens de tirer de son tableau des avantages pécuniaires, savoir: La vente du tableau même, Et la cession du droit de graver. On ne contestera pas sans doute qu'un peintre, qui a cédé à une personne le droit de graver son tableau, n'en reste pas moins propriétaire du tableau. Il est évident qu'il peut le vendre à un autre individu, sans que le graveur soit fondé à se plaindre. En agissant ainsi, le peintre transporte deux objets distincts, savoir: Un objet intellectuel consistant dans le droit de reproduire le tableau par la gravure; Et un objet matériel consistant dans la toile que son pinceau à [sic] su animer.'

42 Ingamells, 1986, II, p. 265. Jazet's arrangement, involving a direct payment from printmaker to painter, stands out as unusual in a period when print publishers (in particular the Maison Goupil) were taking a lead in financing such reproductions. It probably reflects the special popular appeal of Horace Vernet's oriental and hunting scenes – and indeed those of his father Carle, whose paintings in this vein Jazet was still reproducing in the 1860s. It should, however, be recalled that he published several prints with Goupil and that his son-in-law, Théodore Vibert, became Adolphe Goupil's partner in 1841. As a result, his previous prints became part of the stock-in-trade. See *Gérôme et Goupil*, 2000, p. 164. For Jazet's reputation as a 'popular' engraver, who sacrificed quality of execution to speed of delivery, see the interesting estimate in Beraldi, 1981, VIII, pp. 223–8.

43 Vernet, 1841, p. 14. See Scott, 1998, for the ramifications of this act, described succinctly as 'a product of the convergence of capitalism and democracy'.

44 Vernet, 1841, p. 17: 'La gravure est le moyen de propager et d'éterniser l'oeuvre du peintre. N'est-ce pas la gravure, en effet, qui est la plupart du temps l'agent le plus actif de la réputation du peintre? La gravure est, pour ainsi dire, au tableau, ce que l'impression est au manuscrit: c'est elle qui le multiplie, c'est elle qui le propage et le popularise; c'est elle qui éternise l'oeuvre; c'est elle qui immortalise le génie du peintre.'

45 Valentin, 1844, p. 47: 'sa sublime fresque de la Cène, que toute l'Europe connaît, et que la gravure a immortalisée . . .'.

46 Vernet, 1841, p. 18: 'Que de chefs-d'oeuvre, faute d'avoir été gravés, sont à jamais perdus! Combien d'autres l'eussent été sans le secours de la gravure!'

47 Rovani, 1853, p. 157: 'Ora corre buonamente un quarto di secolo da che il nome del pittore De la Roche per consenso dell'universalità siede in cima a tutti i pittori viventi.' I am indebted for this reference to Giuseppe Mastruzzo.

48 See Vernet, 1856, p. 159.

49 Procès, 1878, I, p. 7. It is interesting to note that the defending lawyer, Léon Cléry, was the son-in-law of Adolphe Goupil.

50 Procès, 1878, I, p. 6. These comments were based on the signed statement of no less than fifty-two painters and engravers introduced at

an earlier stage of the trial. The signatories included thirteen painters from the Academy (Meissonier, Robert-Fleury, Bouguereau, Hébert, Cabanel, Cogniet, Gérome etc.), and five engravers from the Academy (including Martinet, Alphonse François and Edouard Girardet) as well as a roll-call of thirty-two less senior engravers (see *Procès*, 1878 2, pp. 42–4).

51 For the financial agreement relating to *Strafford*, see *Procès*, 1878 2, pp. 34–5. For the details relating to the modest sum received for the right to engrave the *Hémicycle*, see *Procès*, 1878 4, p. 14.

52 *Procès*, 1878 2, p. 24: 'Le corps, c'est le tableau; l'âme, c'est la propriété artistique, c'est la composition, c'est ce que l'on a appelé l'effort du génie, la création supérieure'.

53 *Procès*, 1878 2, p. 51: 'Vous faites appel à mes souvenirs en ce qui concerne les préoccupations de M. Paul Delaroche relativement à la gravure de ses oeuvres. Cette préoccupation était constante, l'on pourrait presque dire aiguë. Son esprit naturellement chagrin avait l'inquiétude de l'avenir au moins autant que celle du présent. Il comprenait que l'avenir d'un peintre ne va à la foule qu'au moyen de la diffusion par la gravure et que la foule, aujourd'hui, c'est la postérité demain. Il sentait enfin que la gravure était le seul moyen de garantir sa gloire contre la disparition de ses oeuvres, leur anéantissement par le feu, ou simplement par les amateurs dont les galeries sont nécessairement fermées au public. Il répétait souvent à ce propos qu'il voulait, par la gravure, élever, de son vivant, un monument à sa mémoire'.

54 See Shiff, 1983, p. 121. Shiff is commenting on the figure of an incomplete circle, with 'original' and 'copy' occupying adjacent positions where the line breaks; this seems to him to define the relation of the two concepts, if we are willing to abandon the modernist insistence on 'difference in objects that are very much alike', and the consequent obsession with 'authenticity and the detection of forgeries' (p. 120).

55 Cf. Nietzsche, 1956, p. 212.

Chapter 2

1 Valentin, 1844, p. 139.

2 See Blanc, 1898. The three accounts are extracted from the original publication by Blanc (see Blanc, 1861–76).

3 See Diderot, 1995, pp. 69–74, for his laudatory comments on the work exhibited in the Salon of 1765.

4 See Comment, 1999, p. 78, for the connection between Joseph Vernet's work and this emerging tradition of visual spectacle. The link between his grandson, Horace, and the pioneer of panoramas, Charles Langlois, is also mentioned in this study (pp. 47–50).

5 See Bann, 1997, pp. 117–18.

6 Stendhal, 1966, p. 130. The episode of rejection which led to Horace Vernet gaining considerable publicity from mounting a personal exhibition of his works is carefully recounted in Chaudonneret, 1999, pp. 102–5.

7 Blanc, 1898, pp. 140–1: 'Le projet de Louis-Philippe était de faire peindre dans le palais de Louis XIV les fastes de notre histoire, surtout de notre histoire moderne, et certainement, de tous les artistes qui devaient participer à une telle entreprise, aucun n'y était plus propre que le peintre de la *Barrière de Clichy*. Notre histoire, si on la lit dans nos grands historiens, est une *histoire-bataille*, suivant le mot de Monteil, et la bataille, qui fut si longtemps le génie de la Gaule, était aussi le vrai talent d'Horace Vernet.'

8 Deleuze, 1990, p. 100.

9 Siegfried, 1993, p. 236.

10 Marrinan, 1991, p. 179.

11 Marrinan, 1991, p. 186.

12 Quoted in Johnson, 1993, pp. 132–3.

13 The full title of the collection is: *Tableaux historiques des campagnes d'Italie suivis du Précis des opérations de l'Armée de l'Orient, des détails sur la cérémonie du Sacre, des Bulletins officiels de la Grande Armée et de l'Armée de l'Italie dans tout le cours de la dernière guerre d'Allemagne, jusqu'à la paix de Presbourg.*

14 *Tableaux*, 1806, title-page: 'Les vues ont été pour la plupart prises sur les lieux mêmes, et les Estampes sont gravées d'après les dessins originaux de Carle Vernet.'

15 Blanc, 1898, p. 70ff: 'Déja il s'était essayé à ce nouveau genre, en composant une suite de dessins sur les campagnes d'Italie, que Duplessi-Bertaux se chargea de graver. On y remarquait l'exactitude des mouvements, une facilité rare à les rendre à la fois justes et pittoresques. Tous ces dessins ont une physiognomie locale. La nature des terrains, l'aspect de la montagne, y sont très bien observés. Les premiers plans se composent toujours de groupes spirituellement arrangés . . . Sans avoir besoin, comme Van der Meulen, de supposer le spectateur en ballon, Vernet place

le point de vue assez haut pour développer les lignes stratégiques, les diverses pentes des montagnes.'

16 See Beraldi, 1981, X, pp. 198–9; XI, pp. 5–6. His comments on the work of the 'bon ouvrier-graveur en paysage' Pillement are revealing: 'Pillement préparait les fonds de paysages pour les graveurs; il leur livrait les planches couvertes de ce gros travail vermiculé (qui rend si grossiers les fonds des estampes du commencement du siècle) . . .'. In this case, however, he and his colleague seem to have intervened after the foreground work.

17 Bibliothèque de l'Institut, Fonds Delaborde, MS 2164, f. 16, letter of Bervic (Charles-Clément Balvay *dit*), dated Paris 1804: 'Il est bien vrai que j'ai dit à Mademoiselle Sellier qu'il me paraissait difficile d'envoyer une planche vernie à 300 lieues, sans qu'il arrivât des accidents au vernis; et que si vous vouliez envoyer la mesure du cuivre avec le dessin, je me chargerais de le faire faire et de le remettre à Pilment [sic] qui le vernirait et graverait le paysage: que pour le trait je me chargerais de le calquer. Ce que je ne puis faire c'est l'eau-forte des figures, je n'en ai aucunement l'habitude et je le ferais très mal. Mais comme je juge qu'il serait bon que les petites figures du fond soyent faites à l'eau-forte je pourrrais en charger un graveur nommé *Pocquet* qui grave très bien les petites figures à l'eau-forte'.

It is worth noting that Bervic himself does not seem to have entirely avoided the problems involved in this collaboration of techniques. Pillement was involved in the treatment with 'eau-forte' of the landscape background to Bervic's *L'Innocence* (1798, after the painting by Léonor Mérimée), and was accused of having 'fallen into exaggeration' in his picturesque treatment, reminiscent of the English engraver William Woollet. (See Roux, 1933, p. 474).

18 See Ivins, 1996, pp. 89–90, and plates 73–7. Ivins illustrates six different engraved versions of the head of Laocoon, dating from 1527 to 1804. His conclusion is that there is only 'a vague family resemblance between them'. However, he does not seriously entertain the possibility that one version may convey the properties of the original sculpture better than another – and he does not illustrate Bervic's print.

19 See Adhémar and Lethève, 1954, VII, p. 202.
20 Beraldi, 1981, II, p. 181.
21 See Beraldi, 1981, VI, p. 69; Adhémar and Lethève, 1954, VII, p. 202.

22 *Tableaux*, 1806, pp. 45–8: the despatch to the Directoire in Paris is dated Livorno, 10 Brumaire An 5 and signed by the *commissaire* of the Republic.
23 Nelson, 1845, II, p. 292: letter of 21 October 1796 (29 Vendémiaire An 5).
24 The central place occupied in Bonaparte's planning by the 'descente en Corse' is clearly attested by the comte de Ségur in his memoirs: see Ségur, 1873, I, p. 275.
25 See Beraldi, 1981, XII, p. 191; Blanc, 1898, p. 73.
26 Beraldi, 1981, XII, p. 191.
27 Beraldi, 1981, II, p. 58.
28 For this family history, see Tardieu, 1856, pp. 49–68; for further details on Alexandre, see Galichon, 1863, pp. 215–22.
29 See Bibliothèque de l'Institut, Fonds Delaborde, MS 2164, f. 134, letter from Alexandre Tardieu to the Mayor of the 11ème arrondissement: 'j'ajouterai que ma santé est encore plus faible cette année qui doit être le terme de mes soixante ans'.
30 Beraldi, 1981, XII, p. 74.
31 Beraldi, 1981, XII, p. 72.
32 See Mellerio, 1936, p. 14.
33 Quoted in Mellerio, 1936, p. 29.
34 See for example his *Le repos du monde*, dated 1818, which shows Cupid relaxing and admiring the ripples on the surface of a pond; the quality of line is hesitant and poor, as if Guérin distrusted the facility of the crayon (Bibliothèque municipale de Nantes, Collection Labouchère, Livre I, f. 42 verso).
35 Lagrange, 1863, p. 302.
36 See Sanchez and Seydoux, 1999, I, p. 315: among Engelmann's *produits lithographiques* are included 'dessins de M.rs Vernet père et fils'. Carle also contributed two prints to Lasteyrie's collection of offerings (p. 316).
37 Durande, 1863, p. 325.
38 Bibliothèque Nationale, Département des Estampes, L.c.205.
39 *Explication*, 1831, p. 215.
40 Ingres, 1991, p. 3.
41 For the details of Charlet's early life, see his biographer and cataloguer: La Combe, 1856; also the excellent entry in Beraldi, 1981, IV, pp. 98–136.
42 See illustration in Bann, 1997, p. 42. Charlet is numbered 21, in the right-hand lower corner.
43 La Combe, 1856, p. 227.
44 La Combe, 1856, p. 6.
45 Delacroix, 1862, p. 238: 'Charlet travaillait continuellement, moins pour augmenter ses

minces ressources que pour céder au besoin impérieux de produire . . . Il se dégoûtait souvent d'une oeuvre commencée et se trompait même quelquefois sur la valeur de ce qu'il avait jeté sur la pierre ou sur le papier . . . La pratique de la lithographie, où les retouches sont presque impossibles et enlèvent toujours au dessin une partie de sa fraîcheur, le portait, quand il était mécontent, à recommencer son dessin sur une pierre différente. Dans le tableau, au contraire, où la toile plus complaisante se prête facilement aux repentirs du maître, Charlet arrivait plus difficilement encore à se satisfaire.'

46 La Combe, 1856, p. 219.

47 Delacroix, 1862, p. 240: 'Devant cette pierre entièrement blanche, sur laquelle il traçait à peine quelques points pour se reconnaître, il lui arrivait souvent de commencer son dessin par une tête ou toute autre partie, qu'il finissait presque sans y revenir. Le caractère, le mouvement semblaient lui venir d'eux-mêmes, et il les accusait avec autant de sûreté que s'il eût rendu un modèle posé devant lui . . .'.

48 Delacroix, 1862, p. 240: 'il les avait cherchés et découverts: il s'était attablé avec eux, il avait surpris dans leurs confidences et sur leur visage tout ce qu'il fallait pour donner la vie à son dessin; il ne s'était pas séparé de son invalide, de son cuirassier ou de son hussard qu'après se l'être approprié en quelque sorte . . .'.

49 See Delacroix, 1998, p. 78 for his first lithographs, dating from 1819, and described with justice in this catalogue as 'conventional and without real originality'.

50 Quoted in Géricault, 1991, p. 288.

51 Delacroix, 1862, p. 241: 'Charlet est de la lignée de ces immortels railleurs qui s'attaquent au ridicule ou au vice plus sûrement que les prédicateurs de vertu.'

52 Delacroix, 1961, p. 69.

53 La Combe, 1856, p. 46.

54 La Combe, 1856, p. 88. His comment no doubt also applies to the engraving after Charlet's *Le Joueur*, by Reynolds's pupil, George Maile (see p. 99).

55 Bibliothèque Nationale, Département des Estampes, K6 15.

56 The engraving by Vogel is included in Bibliothèque municipale de Nantes, Collection Labouchère, I, f. 60 (obverse). The catalogue of the 1833 Salon laconically features the painting as 'Dragon de la garde impériale' (see Sanchez and Seydoux, II, 1999, p. 320).

57 Musset, 1836, p. 152: 'Les corbeaux voltigent sur la neige, pleine de formes humaines.'

58 Anon., 'Salon de 1836', in *L'Artiste*, XI (1836), p. 85

59 Lyons, 1877, n.p.: 'Dans cette foule de malheureux manquant de tout, les gardes sont confondus. Généraux, officiers et soldats, la plupart sans armes, se distinguent à peine par des restes d'uniformes en lambeaux. Sur le premier plan, un juif est atteint d'un coup de fusil au moment où il pillait un caisson abandonné renfermant l'or destiné à la solde des troupes. On voit ça et là dans la campagne des débris d'affûts de canons et des cadavres que la neige recouvre en en conservant la forme'.

60 Delacroix, 1862, p. 239: 'Ce n'est pas un épisode, c'est un poème tout entier . . . c'est l'armée d'Austerlitz et d'Iéna, devenue une horde hideuse, sans lois, sans discipline, sans autre lien que le malheur commun'.

61 Delacroix, 1862, p. 239: 'Dans cette toile semée de détails poignans, rien ne distrait l'esprit de la puissante unité de la conception, et l'exécution en est pleine de nerf et de vérité malgré ces tâtonnemens dont nous avons parlé. Ce qui conserve aux tableaux de Charlet autant de franchise qu'à ses autres oeuvres, c'est qu'au lieu de retoucher des morceaux séparés ou de les compléter, il aimait mieux recommencer entièrement de grandes parties, et retrouvait ainsi pour finir tout l'entrain qu'il avait apporté en commençant.'

62 Baudelaire, 1968, p. 117: 'je me rappelle avoir vu dans les ateliers de Paul Delaroche et d'Horace Vernet de vastes tableaux, non pas ébauchés, mais commencés, c'est-à-dire absolument finis dans de certaines parties, pendant que certaines autres n'étaient encore indiquées que par un contour noir ou blanc'.

63 Delécluze, 1836, 3 March: 'personnes curieuses de savoir si ce spirituel auteur de tant de lithographies et d'aquarelles ferait également bien usage de la peinture. Qu'elles se rassurent. M. Charlet a fait un fort bon tableau.'

64 *Revue des Lyonnais*, 1842, p. 70: 'par un effort d'adresse, aucune de ces heureuses qualités n'a perdue à ce changement ambitieux, mais elles ne suffisent pas à un peintre d'histoire.'

65 La Combe, 1856, p. 99: 'J'aurais donc pu penser que si l'Institut admettait un homme de genre, je pourrais avoir quelques suffrages; mais si tout membre de l'Académie doit être peintre d'histoire ancienne, je n'ai que faire de me refroidir les pieds.'

66 See Archives de l'Institut, Paris, 5 E 25, for the correspondence relating to the succession of Carle Vernet, and the minutes of the election meetings. Charlet's short letter of 16 December 1836 read: 'La mort de Carle Vernet laissant vacante une place à l'Institut, je viens vous prier de vouloir bien m'admettre au nombre des Candidats, si toutefois vous jugez que par mon oeuvre je mérite cet honneur.'

67 Beraldi, 1981, XII, p. 212: 'Comme sujet, il va droit au soldat, mais sans pouvoir le pousser à l'épique comme l'ont fait dans leurs lithographies Géricault et Charlet.'

68 Blanc, 1898, p. 111: 'Mais là où Charlet et Géricault mettaient un accent passionné, une émotion dramatique, un sentiment fier, libre, quelquefois amer, Horace n'apportait qu'une pointe d'esprit, une intention libre et passagère, un trait comique sans causticité, sans aigreur et même sans malice . . . Son crayon léger effleurait la pierre, mais avec une sûreté qui étonnait Géricault. Il excellait à poser un soldat sur ses pieds, et du premier coup il lui imprimait le mouvement voulu, il le caractérisait par un geste qui allait droit au but, je veux dire à l'expression probable.'

69 Blanc, 1889, p. 660: 'Horace Vernet n'ose insister sur la pierre; il y trace, en l'effleurant, des silhouettes peu ombrées de lanciers en vedette, de soldats à la maraude ou de braconniers . . . Vient un maître puissant et fier, Géricault: celui-ci, rudoyant la pierre d'une main magistrale, y fait piétiner et bondir les robustes montures du soldat et du peuple . . .'.

70 Blanc, 1889, p. 661: 'A l'inverse des lithographies de Vernet, celles de Géricault, les premières du moins, sont grossoyées; le crayon y est écrasé avec une impetuosité brutale . . .'.

71 Baudelaire, 1968, p. 61: 'Pour définir M. Horace Vernet d'une manière claire, il est l'antithèse absolue de l'artiste.'

72 Durande, 1863, p. 63: 'plus tard, il n'eut qu'à reporter sur la toile les impressions qu'il avait ressenties pendant cette terrible journée pour produire un de ses meilleurs tableaux, un de ceux où la note est le plus juste, où la composition est en même temps simple et grandiose'.

73 Stendhal, 1959, p. 51.

74 La Combe, 1856, p. 92.

75 See Markham, 1963, pp. 212, 230.

76 Quoted in Blanc, 1898, pp. 141–2: Delaborde originally published this text in *Revue des deux mondes*, 1 March 1853.

Chapter 3

1 Gernsheim, 1955, p. 40.

2 See Ivins, 1996, pp. 113–34, and Barthes, 1982, pp. 10–13. For the coming of the photograph as an 'anthropological revolution', see Barthes, 1982, p. 35. For a stimulating recent critique of many subsequent attempts to locate the identity of photography within its historical context, see Batchen, 1997, pp. 5–21. Batchen justifiably tries to deflect attention from the question: 'Where and when did photography begin?' (p. 24). But his decision to focus instead on the question of when 'the *desire* to photograph emerge[d] and began insistently to manifest itself' (p. 36) runs the risk of ignoring the cultural and historical specificity of this 'desire' by enfolding it within a Foucauldian discursive formation. As Joel Snyder sagely notes, in his review of Batchen's study: 'We have read this story before. It is the details that will make it compelling' (Snyder, 1999, p. 542). My own approach involves, to some extent, a return to the question that Batchen deflects, but from a point of view no longer proleptically focused on the technology and ontology of the photograph.

3 Nadar, 1994, p. 9: 'Quand le bruit se répandit que deux inventeurs venaient de réussir à fixer sur des plaques argentées toute image présentée devant elles, ce fut une universelle stupéfaction dont nous ne saurions nous faire aujourd'hui l'idée, accoutumés que nous sommes depuis nombre d'années à la photographie et blasés par sa vulgarisation.'

4 See Gernsheim, 1982, p. 34.

5 See in particular the lavishly illustrated and minutely documented volume, Jay 1988. The correspondence of Niépce over the crucial years 1825–1829 can be found in Niépce, 1974.

6 Scharf, 1975, p. 36.

7 Gernsheim, 1956, p. 79.

8 Gernsheim, 1955, p. 54; repeated in Gernsheim, 1982, p. 45, with the difference that 'hysterically' has been altered to 'in bewilderment'.

9 Gernsheim, 1982, p. 45.

10 Jay, 1988, p. 141. He acknowledges, on the other hand, the excellent auspices under which the collaboration begins: 'Niépce est heureux de l'aide de Lemaître. Il en est flatté. Il redit avec beaucoup de simplicité qu'il n'aurait pas osé le déranger, paralysé par la crainte de paraître indiscret . . . il y a dans les

rapports de Niépce et de Lemaître quelque chose de délicat et de sympathique qui laisse augurer une collaboration féconde . . .' (p. 136).

11 See Jay, 1988, pp. 145ff and Niépce, 1974, for the extraordinary story of the other Niépce, whose quest for a perpetual motion machine led him to London, where he eventually died. Nicéphore's journey to London in 1827–8, in the course of which he presented his work to members of the British scientific establishment, was partly undertaken to rescue this sick brother.

12 See McCauley, 1999, pp. 80–90, for a shrewd analysis of the way in which Niépce's original interest in the technology of reproduction paralleled the aristocratic patronage of the medium of lithography during the Restoration period. The focus is inevitably on the role of Charles de Lasteyrie which will be considered below.

13 See Jay, 1988, pp. 24–5, for cultivation of pastel, and Fouque, 1867, p. 49, for Isidore Niépce's testimony: 'mon père fit des essais de gravure et de reproduction de dessins à l'instar de la Lithographie, récemment importée en France et qui l'avait frappé d'admiration'.

14 See Fouque, 1867, p. 49: 'Des pierres cassées, destinées à réparer la grande route de Chalon à Lyon, et qui provenaient des carrières de Chagny, lui parurent susceptibles, par la finesse de leur grain, d'être utilement employées à la Lithographie.'

15 Fouque, 1867, p. 49. Jay makes no mention of the interest in music engraving, but confirms that the decision to abandon lithography was announced in a letter of 6 August 1817 (Jay, 1988, p. 67).

16 See catalogue Les Bois gravés chalonnais, Musée Denon, Chalon-sur-Saône, 1999, Preface by André Laurencin.

17 Archives de l'Institut, Académie des Beaux-Arts, Registre des procès-verbaux des séances 1826–36, f. 345 (séance of Saturday 29 March 1834). The strong argument put forward in support of this process was that it involved indigenous materials, and did not rely on Bavarian stones.

18 The print bears the inventory number 067 in the collection of the Musée Ingres, Montauban, and is included in the catalogue of the exhibition of prints after Ingres held at Châtellerault in 1991 (see Ingres, 1991). It reproduces the drawing for Henri IV et ses enfants now in the Metropolitan Museum, New York, and bears the inscriptions 'Ingres

inv. e pinx./ à Monsieur Thévenin Gravé en 1819' and 'Essais de Gravure Hélio-chimique Thévenin Rome No 56 Botteghe Oscure.'

19 Gernsheim, 1982, p. 34.

20 See Jay, 1988, pp. 31–3 (letter of 5 May 1816): the 'first photographic apparatus in the world', now in the Musée Niépce, is also illustrated here.

21 See Niépce, 1974, p. 38 (letter of 17 January 1827), where reference is made to this first contact 'around eighteen months ago', and Jay, 1988, p. 115 ff. for the detailed analysis of these experiments.

22 Niépce, 1974, p. 43 (letter of F. Lemaître, 7 February 1827): 'La planche représentant la Sainte Famille est assez bien venue sous le rapport des contours et de la pureté des tailles; mais on aurait de la peine à en obtenir une épreuve qui, je suis assuré, ne viendrait que par places . . .'.

23 Niépce, 1974, pp. 43–4: 'Celui des deux portraits qui est le mieux gravé, c'est à dire le plus profondément, donnerait à l'impression l'épreuve d'une planche usée par un fort tirage. Toutes les tailles sont bien marquées, surtout celles des demi-teintes du camail et de la toque, qui sont d'un résultat satisfaisant. Mais celles des ombres sont tout à fait confondues, pas assez creuses et toutes arrondies . . . elles devraient, au contraire, être de vive arrête; plus la gravure est de vive arrête, plus elle est belle et pure et elle donne alors de bonnes épreuves . . .'.

24 The set of images mentioned here, from the collection of the Musée Niépce, is illustrated in Jay, 1988, pp. 132–3. The print from the Gernsheim Collection mentioned below is illustrated, and discussed, in Bann, 1995, pp. 127–9.

25 Fouque, 1867, p. 124. The estimate is repeated, and endorsed, in Jay, 1988, p. 113.

26 Explication, 1831, p. 186, item 2564: the other works that he exhibited, all contained in a single frame, were by the comte de Forbin, Tony Johannot and the Dutch artist Knip. The original painting of Michallon's Mort de Roland is in the Louvre: an oil sketch, formerly in the collection of the Musée des Beaux-Arts, Orléans, has been missing since 1925.

27 Beraldi, 1981, VI, p. 149; Fortier is described there as 'de la plus infime spécialité'. Beraldi's entry on Lemaître himself is short and purely descriptive. He is introduced as 'graveur au travail serré, lithographe et marchand d'estampes'. Beraldi also notes that he ceased to

produce work in 1855, fifteen years before his death in 1870.

The absence of any comment by Beraldi on the technique of the print after Michallon may imply that he had not seen it. Certainly it would appear to be one of Lemaître's most ambitious and experimental works, involving as it does a variety of etching techniques, including the scraping of the plate with a sharp point to leave a pattern of brilliant white highlights on a dark ground.

28 *Courrier français*, 1839, 268, p. 1: 'Il nous paraît seulement très clair, d'après la déclaration de M. Daguerre lui-même, que jamais M. Niépce, dans ses essais répétés, n'avait fait une gravure d'une épreuve obtenue dans la chambre noire. Quand même il l'eût produite avec M. Lemaire [sic], la chose était restée inconnue'.

29 See Gernsheim, 1982, p. 191. Lemaître is, however, referred to as 'notre collègue' in a report on Poitevin's photolithographic process published in the *Bulletin de la Société française de la photographie* in February 1857 (see Rouillé, 1989, p. 314).

30 The Romanesque Church of La Daurade, in Toulouse, was on the site of the existing Ecole des Beaux-Arts. The mistaken orthography, coupled with the fact that the print is not mentioned by Beraldi, raises the possibility that it was not published.

31 The fact that the prints were clearly selected for these purely functional reasons casts doubt on the plausibility of Anne McCauley's suggestion that their subject matter reflected Niépce's political views: that 'he was a devout man whose choice of prints to reproduce from his own stock and those bought cheaply from Lemaître followed a conservative, Catholic bent' (McCauley, in Niépce, 1999, p. 87). In any case, she omits to mention the work about to be discussed, after Charlet, who was certainly neither Catholic nor conservative.

32 See Allemand-Cosneau and Julia, 1999, p. 202, and p. 283 (ill. 4a).

33 See Hunnisett, 1998, p. 299. Beraldi's entry for Maile casts him in an unfavourable light as one of the engravers with new techniques 'invading' the Salon in the 1830s. See Beraldi, 1981, IX, pp. 200–1.

34 Perrot, 1844, p. 157.

35 Niépce, 1974, p. 134 (letter of 12 October 1829): 'dans cet état de choses ce procédé n'aurait nul succès dans les arts, je veux dire seulement sous le rapport de la gravure, car la découverte n'en paroîtroit pas moins extraor-

dinaire; mais quand on pense que le moindre élève avec le sécour de la chambre noire peut dessiner et poser quelques teintes et avoir un résultat non moins exact, il est certain qu'il faut, pour faire remarquer ce procédé, une perfection quelconque, qui ne pourroit se rendre autrement'.

36 Niépce, 1974, p. 136: 'Nous avons remarqué que les deux faces de maison qui doivent dans la nature être parallèles et opposées se trouvent dans votre sujet éclairées en même tems, cela est un contre-sens d'effet. Bien que les objets se trouvent éclairés par derrière ou obliquement, deux faces parallèles et opposées ne peuvent pas être éclairées en même tems. Nous avons attribué cette circonstance à la durée de l'opération, pendant laquelle le soleil a dû nécessairement changer de direction.'

37 Niépce, 1974, p. 137 (letter of 23 October 1829): 'Je vous ferais toutefois observer que ma planche n'est point gravée, mais simplement noircie sans l'intervention d'un acide quelconque.'

38 Niépce, 1974, p. 145: 'J'ai vu aussi M. Lemaître. Je ne lui ai pas caché que je ne croyais pas la chose assez avancée pour s'occuper des moyens de gravure et qu'en second lieu, selon moi, le secours du burin ne deviendrait nécessaire qu'autant qu'il serait impossible de parvenir autrement; en effet, aussitôt qu'il serait indispensable d'y mettre le talent d'un graveur, la découverte perdra tout son intérêt. La nature a ses naivetés, qu'il faut bien se garder de détruire; il s'agira seulement de la choisir, en raison de la possibilité des moyens; la grande habitude que j'ai de me servir de la chambre noire vous offrira à cet égard ce qui est nécessaire.'

39 Niépce, 1974, p. 148 (letter of 27 November 1829).

40 See the exceptionally interesting analysis of Daguerre's contribution to the development of the photographic lens in Roquencourt, 1998, p. 35.

41 See George Eastman House, Rochester, N.Y., Print Collection, B 781, 84: 362, ff. 1–30, for the notebook in which this journey is recorded.

42 Niépce, 1974, p. 54: 'J'avais oublié de vous dire, dans ma dernière lettre, qu'au moment même où je croyais ne plus avoir à l'avenir de relations avec Mr Daguerre, il m'a écrit et m'a envoyé un petit dessin très élégamment encadré, fait à la seppia et terminé à l'aide de son procédé. Ce dessin, qui représente un intérieur, produit beaucoup d'effet, mais il est

difficile de déterminer ce qui est uniquement le résultat de l'application du procédé, puisque le pinceau y est intervenu. Peut-être, Monsieur, connaîtriez-vous déjà cette sorte de dessin que l'auteur appelle dessin-fumée, et qui se vend chez Alphonse Giroux.'

43 See George Eastman House, Cromer collection, 82.1579.1. Cromer's annotations clearly demonstrate that this work has been included to show the relative crudity of the process in its popular form.

44 See George Eastman House, Cromer collection, 84.369.1: 'Dessin à la sépia assombri par place avec une carte lors de la fumigation' (inscription by G. Cromer on reverse). Cromer also refers in his annotations to the letter of 3 April 1827 from Niépce to Lemaître quoted in note 42, and there is good reason to suppose that this particular work (dated *c*.1830 in the collection) in fact dates from 1826/7. A closely comparable example, differing mainly in the intensity of the smoke traces, was sold at Sotheby's, London, on 1 July 1977, and bears the date 1826.

45 Tissandier, 1874, p. 62: 'Paul Delaroche a vu Daguerre, il lui a arraché des mains une plaque impressionnée par la lumière. Il la montre partout en s'écriant: "La peinture est morte à dater de ce jour".'

46 *Courrier français*, 1839, no. 11, Friday 11 January (report of meeting of Academy of Sciences on 7 January 1839): 'On a beaucoup parlé depuis quelque temps à Paris d'une découverte fort surprenante de M. Daguerre, l'habile artiste et auteur des *Diorama*, laquelle découverte devait bouleverser tous les procédés connus de la peinture.'

47 'Horace Vernet / Le soir du 27 janvier 1839, encore tout impressionné au sortir de l'Académie, où il avait entendu le rapport sur la découverte, connue alors sous le nom de Daguerréotype, les personnes assemblées dans le salon de M. I. auxquelles il fait part de cette nouvelle ne pouvaient comprendre les résultats si extraordinaires qu'on paraissait espérer d'une pareille invention.

Paul Delaroche/ Intervint en cherchant par des comparaisons sensibles comme par exemple: la possibilité de fixer les images réfléchies dans une glace sur papier ou tout autre corps offrant l'aspect d'une gravure: l'étonnement augmentait en raison de la démonstration comprise.'

I am grateful to Eric Bourgougnon, of the Musée français de la photographie for having arranged the transcription of this text.

48 *Courrier français*, 1839, no. 11, Friday 11 January: 'Les académiciens ont été surtout frappés de deux vues intérieures de Paris, l'une prise du Pont-des-Arts et l'autre du Pont-Saint-Michel'.

49 I should stress that the dossier concerning the painting in the Musée Carnavalet does not reveal the aristocratic background of the Irisson family, and refers simply to Augustin-Guillaume and his wife Dorothée Allard who lived at this address. However, the brief biography of Maurice d'Irisson in Vapereau's *Dictionnaire des contemporains* (1893) gives him this title of comte. His entry in the *Dictionnaire de biographie française* (vol. 18, 1994) makes it clear that this must be the same family, since all three Christian names, and the mother's maiden name, coincide: it also speaks of him 'descending from an old Gascon family'. The Irisson d'Hérisson may well have dispensed with their title in the period of the July Monarchy.

50 The quotation is given in its original form in note 46.

51 *Courrier français*, 1839, no. 11, Friday 11 January: 'Essayons de faire connaître, au moins dans leur partie non secrète, les procédés à l'aide desquels M. Daguerre semble menacer l'art du dessin d'une révolution totale . . . Elle consiste simplement en ceci: il a trouvé le moyen d'obliger la lumière elle-même à se faire artiste, et à reproduire sur un fond donné les détails d'un vaste paysage avec toute la merveilleuse délicatesse d'un tel pinceau.'

52 See note 48.

53 *Courrier français*, 1839, no. 11, Friday 11 January: 'M. Biot s'étant trouvé dans cette nouvelle galerie de dessins de lumière avec le célèbre peintre d'histoire M. Delaroche, a appris à ses collègues que cet artiste non-seulement partageait toute l'admiration des académiciens, mais qu'il pensait de plus que ce genre fournirait à l'étude de la distribution des jours les effets les plus instructifs qu'il serait presque impossible de rendre évidens aux élèves par tout autre moyen.'

54 Cromer, 1930, pp. 115–16: 'Le peintre trouvera donc dans ce procédé un moyen prompt de faire des collections d'études qu'il ne pourrait obtenir autrement qu'avec beaucoup de temps et peine et d'une manière bien moins parfaite quel que fût d'ailleurs son talent . . . Le graveur non seulement n'aura rien à redouter de l'emploi de ce procédé, mais encore il arrivera à en multiplier les résultats par les

moyens de son art. Les études qu'il aura à graver seront pour lui du plus grand intérêt.'

The text in Cromer's article is transcribed from the original manuscript now in the collection of George Eastman House (MS AC D339 acc. 9810), and presents only one minor discrepancy. As Cromer points out, Arago excised the specific reference to the engraver's dividend from photography, and thus blurred the distinction which Delaroche seems keen to emphasise between the two branches of visual art.

55 See Bann, 1997, p. 117–18 for an account of the stages leading to this decision.

56 *Courrier français*, 1839, no. 62, 3 March, p. 4.

57 *Courrier français*, 1839, no. 223, 11 August, p. 4.

58 *Courrier français*, 1839, no. 27, 27 January, p. 4.

59 *Courrier français*, 1839, no. 80, 21 March, p. 4. The occasion of the article is the publication by Goupil of two reproductive prints after Léopold Robert by Zachée Prévost, a former pupil of Bervic.

60 *Courrier français*, 1839, no. 44, 13 February, p. 2.

61 *Courrier français*, 1839, no. 58, 27 February.

62 *Courrier français*, 1839, no. 232, 20 August, p. 3: 'L'annonce de la publication des procédés du daguerreotype avait attiré un vaste concours d'auditeurs et de membres de l'Institut dans la salle de l'Académie des Sciences. M. Arago a tenu la parole en développant les mystères de cette invention en une improvisation très lucide, qui a captivé au plus haut point l'attention de l'assemblée, où tous nos savans et artistes s'étaient donné rendez-vous.' A full account of Arago's speech was published in the issue of 21 August.

63 *Courrier français*, 1839, no. 251, 8 September, p. 3.

64 *Courrier français*, 1841, no. 181, 30 June, p. 1.

65 *Illustrated London News*, 1851, 26 July. The columnist adds, in the spirit of Anglo-French rivalry already generated by the invention: 'The high degree of sensibility which has been attained has been due to the experiments of others, principally Englishmen.'

66 For a searching investigation of this perennial theme, see Johanne Lamoureux, 'Delaroche et la mort de la peinture', in *Word & Image*, January–March 2000.

67 This interpretation is supported by the fact that Vallery-Radot was able to locate an oil sketch for the painting, in which the gathering was more restricted than in the painting, and notably excluded Vernet and Delaroche. See the useful summary of his findings by Jacques Wilhelm in the dossier at the Musée Carnavalet. For the reasons already given, however, I do not agree with the conclusion that Lafaye has inappropriately dated the event to January 1839.

68 Champlin and Perkins, 1888, III, p. 4.

69 'Nicéphore Niépce / Est le premier qui a rempli les deux conditions nécessaires à fixer l'image de la chambre obscure . . . Daguerre, en s'associant avec lui pour exploiter les avantages de la découverte n'avait apporté à la Société que son talent personnel de [sic] la connaissance pratique du peintre mise en évidence par les travaux du Diorama, car la perfection des images de la chambre obscure tout à fait étrangère à l'invention de l'héliographie avait pour auteur WOLLASTON et quant à l'achromatisme du verre, à l'artiste Ch. CHEVALIER.'

70 Tissandier, 1874, p. 73: 'La photographie est bien une science française'; p. 62: 'L'art de Raphaël et de Michel-Ange n'était pas tué; il venait de trouver, au contraire, dans les inspirations d'un grand inventeur, de nouvelles ressources, et la Science venait de tendre la main à l'Art!'.

71 The question is however posed, and answered with a resounding affirmative, by the critics of the next generation, such as Robert de la Sizeranne, who published in 1899 the study *La Photographie: Est-elle un art?* (Paris, 1899), and introduced in the following year a volume on contemporary photography which he described, in obvious deference to Charles Blanc, as a *Grammaire des Arts de la photographie*. See Sizeranne, 1899, and Bourgeois, 1900, p. 4.

72 See Hamber, 1996, pp. 12–13.

73 Quoted in Delacroix, 1998, p. 49: 'Heureusement que, toute fragile qu'elle est, la peinture, et à son défaut la gravure, conserve et met sous les yeux de la postérité les pièces du procès.' As Sophie Bobet-Mezzasalma correctly notes in the article from which this quote is taken, Delacroix paid lip service to the principle that great engravers were necessary to 'translate' the work of painters for posterity. However, he did little to secure the services of such engravers, or indeed of the new reproduction photographers, during his life time. Most of the engraved reproductions of his work appeared posthumously (pp. 43–9: 'Les estampes d'interprétation d'après Delacroix').

74 I am indebted to Marc Gotlieb for this point.

75 See Delacroix, 1998, pp. 51–5: 'Un album de photographies d'Eugène Delacroix'.

76 George Eastman House, Rochester, N.Y.: AC D332. Acc.1102. Letter of Delacroix to unnamed correspondent: 'J'ai éprouvé un bien grand regret de ne pas m'être trouvé chez moi quand vous avez pris la peine d'y passer pour m'apporter les magnifiques épreuves photographiques auxquelles j'attache un si grand prix. Je suis très heureux de vous devoir ces beaux échantillons qui sont des trésors pour un artiste, et que le bonheur de la découverte met à leur portée.'

77 See Fried, 1990, esp. pp. 278–83.

78 Quoted in Hamber, 1996, p. 192.

79 See Courbet, 1996. Letter of Courbet to Haro dated 3 March 1864, à propos of *Tête de femme au chat*: 'Maintenant, je désirerais aussi que la photographie fût faite par Bingham.' Letter of Courbet to Haro dated 15 March 1864: 'car je désirerais que Monsieur Bingham me fasse une photographie mais mieux réussie que celle qu'il m'a faite des *Curés*: qu'il prenne sa revanche'.

80 See Janis, 1987, pp. 24–30, for the early development of his career.

81 Janis, 1987, p. 31.

82 Quoted in Janis, 1987, p. 29.

83 See Hamber, 1996, p. 235, note 25. It is also suggested by Hamber that photographs taken on this occasion may have been exhibited at the 1849 Exposition Nationale des Produits de l'Agriculture et de l'Industrie in Paris (see pp. 253–4 and p. 292, note 4).

84 See Ewals, 1995, p. 291 for the history of the painting.

85 The Bingham family of Binghams Melcombe in Dorset is of Saxon origin, and originated in Sutton Bingham, Somerset. Robert Bingham, Bishop of Salisbury (d. 1246), belonged to the same family, and the holders of the Melcombe property customarily took the names Robert or Richard. See McCalmont, 1915, p. 163. The dates 1825–1870 are proposed for Robert Bingham in Hamber, 1996, p. 192. A brief biography in Matthews, 1973, pp. 9–10, describes him as having been 'assistant to the chemist and scientist Prof. Michael Faraday'. However, this appears to be the result of a confusion between the Royal Institution, where Faraday worked, and the quite separate London Institution, to which Bingham was attached. I am assured by Dr Frank James, the editor of Faraday's letters, that there is no mention of Bingham in his correspondence.

86 See Bingham, 1850, p. 67. I have not been able to establish a date for the first edition of this work. There is, however, a copy of the fourth edition, dated 1847, in the Special Collections of the Getty Research Institute.

87 See editorial articles in *La Lumière*, no. 21, 29 June 1851, p. 82; no. 23, 29 May 1852, p. 91; and no. 41, 13 October 1855, p. 161: 'Les avis sont très-partagés relativement à ces grandes épreuves. On leur trouve généralement beaucoup de vigueur, un effet artistique très-puissant; nous avons entendu des peintres les comparer à de beaux et vigoureux dessins à l'estompe. D'un autre côté, on leur reproche d'exagérer les défauts de l'epiderme, de grossir les traits et de manquer de netteté. Pour nous, il nous semble qu'ils ont une supériorité marquée sur tous les essais de ce genre qu'on a tentés jusqu'à ce jour . . .'.

88 See Stirling, 1847. Illustrated with 66 photographs of works of art taken and printed by Talbot's assistant, Henneman, at Reading, this three-volume set is indubitably the first photographic survey devoted to the history of art. It was however only produced in 25 copies. The photographs are salt paper prints, taken from calotype negatives, and have considerably deteriorated with time. A set exists in the Talbot archive, National Museum of Photography, Film and Television, Bradford.

89 *La Lumière*, no. 23, 23 June 1859, p. 89: 'Il serait superflu d'insister dans ce journal sur les difficultés que présente une pareille entreprise, elles sont connues de tous les practiciens; mais il semblerait qu'elles n'ont pas existé pour l'habile artiste dont nous parlons.'

90 *La Lumière*, no. 47, 20 November 1858, p. 187: 'Les belles reproductions des chefs-d'oeuvres de la peinture et particulièrement celles faites d'après les tableaux de Paul Delaroche, par M. Bingham, ornent maintenant l'atelier des artistes.' The notice continues: 'J'ai vu chez l'un d'eux des épreuves fort remarquables, dues au talent de M. Le Gray.'

91 *La Lumière*, no. 13, 31 March 1860, p. 49. Ernest Lacan notes: 'Les reproductions des principales toiles de Meissonier, par M. Bingham, qui a déjà reproduit avec tant de succès tout l'oeuvre de Paul Delaroche, d'Ary Scheffer . . . et une grande partie des tableaux qui ont figuré au dernier salon.'

92 Quoted in Rouillé, 1989, pp. 241–2: 'Quelque exacte que soit une gravure, elle ne donne pas d'une manière irrécusable et mathématique l'oeuvre du maître. On ne peut s'y

fier absolument. Dans la reproduction la plus fidèle se glisse toujours quelque chose de l'individualité du copiste, aussi M. Goupil, religieux jusqu'au bout pour son maître de prédilection, a-t-il eu recours à la photographie afin d'obtenir un fac-similé définitif des toiles et des dessins qu'il admire; entreprise immense et pleine de difficultés, car le soleil est un ouvrier plus capricieux qu'on ne croit . . . il n'est pas toujours juste et ment quelquefois comme un homme, ce divin soleil!'

93 Quoted in Rouillé, 1989, p. 243: 'Sentant qu'elle avait à lutter contre Mercury [sic], Calamatta, Henriquel-Dupont, Blanchard, Forster et l'élite du burin, la photographie s'est piquée d'honneur, et pour répondre à la confiance de M. Goupil, elle a vraiment fait merveille, même dans l'excès de son zèle elle a changé en très beaux tableaux des toiles assez médiocres . . . Chaque toile est ainsi reproduite avec des hasards et des bonheurs qu'on a de la peine à ne pas croire intelligents.'

94 I am grateful to Dr Anthony Hamber for pointing out Bingham's novel achievement in this respect (letter of 23 June 1995).

95 See the interesting treatment of the issue of 'photogenic quality' in the criticism of Gautier in Ortel, 2000.

96 Rouillé, 1989, p. 243: 'Par exemple, avec une belle gravure et une bonne photographie on a le maître presque entier, et c'est le résultat que sans doute M. Goupil a voulu obtenir.'

97 Mirecourt, 1855, p. 49: 'Sa tête est un meuble à tiroirs. Il ouvre, regarde, et trouve chaque souvenir en place.' For the anecdote of the holster, see pp. 49–51.

98 Blanc, 1898, p. 136: 'L'oeil d'Horace était comme le verre de l'objectif photographique, il en avait les propriétés étonnantes, mais aussi, comme l'instrument de Daguerre, il voyait tout, il reproduisait tout, et cela sans choix, sans préférence. Il répétait le détail aussi bien que l'ensemble, que dis-je? beaucoup mieux, car le détail usurpait toujours une importance exagérée . . .'.

99 See Gooch, 1959, pp. 247–9.

100 See Comment, 1999, p. 50.

101 Blanc, 1889, p. 609: 'Ils ont cru sentir qu'il serait ridicule de transfigurer des militaires qu'on avait pu rencontrer dans les rues de Paris, entre deux batailles, et sans hésiter entre la fadeur d'une allusion et l'énergie du vrai, photographié cette fois par l'esprit, ils ont trouvé piquant de peindre l'héroïsme en capote et en képi, comme ils ont trouvé juste

d'illustrer, en même temps que les chefs populaires, ce grand homme collectif qui est le régiment. Par malheur, un tel respect des bulletins et des rapports prête une importance excessive aux petites vérités, aux petites choses, aux boutonnières, aux courroies, aux aiguillettes, aux passe-poils, aux boutons de guêtre, sans que l'artiste ait la faculté d'oublier ces détails et de les taire, parce que l'intérêt actuel de son oeuvre est à ce prix.'

Chapter 4

1 Sand, 1971, pp. 276–7: 'Le hasard d'un portrait que Buloz fit graver pour mettre en tête d'une de mes éditions me fît connaître Calamatta, graveur habile et déjà estimé, qui vivait pauvrement et dignement avec un autre graveur italien, Mercuri, à qui l'on doit, entre autres, la précieuse petite gravure des *Moissonneurs* de Léopold Robert. Ces deux artistes étaient liés par une noble et fraternelle amitié. Je ne fis que voir et saluer Mercuri, dont le caractère timide ne pouvait guère se communiquer à ma propre timidité. Calamatta, plus Italien dans ses manières me fut vite sympathique, et peu à peu notre mutuelle amitié s'établit pour toute la vie./ J'ai rencontré en vérité peu d'amis aussi fidèles, aussi délicats dans leur sollicitude et aussi soutenus dans l'agréable et saine durée des relations . . . Calamatta, aimable compagnon dans le rire et dans le mouvement de la vie d'artiste, est un esprit sérieux, recueilli et juste, que l'on trouve toujours dans une bonne et sage voie d'appréciation des choses de sentiment.'

2 Sand, 1971, p. 277: 'La gravure est un art sérieux en même temps qu'un métier dur et assujettissant, où le procédé, ennemi de l'inspiration, peut s'appeler réellement le génie de la patience. Le graveur doit être un habile artisan avant de songer à être artiste. Certes, la partie du métier est immense aussi dans la peinture, et dans la peinture murale particulièrement elle se complique de difficultés formidables. Mais les émotions de la création libre, du génie, qui ne relève que de lui-même, sont si puissantes, que le peintre a des jouissances infinies. Le graveur n'en connaît que de craintives, car ses joies sont troublées justement par l'appréhension de se laisser prendre à l'envie de devenir créateur lui-même.'

3 Sand, 1971, p. 277: 'J'ai entendu discuter beaucoup cette question-ci, à savoir: si le

graveur doit être artiste comme Edelinck et Bervic ou comme Marc-Antoine et Audran: c'est-à-dire s'il doit copier librement en donnant essor à son propre génie; en un mot, si la gravure doit être l'exacte reproduction ou l'ingénieuse interprétation de l'oeuvre des maîtres.'

4 Delaborde, n.d., p. 7: '. . . ne pourrait-on dire, sans offenser la gloire de ces grands maîtres, qu'il y a du peintre chez Audran, du sculpteur chez Marc-Antoine . . . Par les conceptions de l'intelligence comme par les pratiques de la main, Edelinck, au contraire, demeure en toute occasion étranger à ce qui n'est pas expressément du domaine de la gravure.'

5 Sand, 1971, p. 278: 'Pour ma part, si j'étais chargée de ce soin et qu'il me fût permis de choisir, je ne choisirais que des chefs-d'oeuvre, et je me plairais à les rendre le plus servile-ment possible, parce que les défauts des maîtres sont encore aimables ou respectables. Au contraire, si j'étais forcée de traduire un ouvrage utile, mais obscur et mal écrit, je serais tentée de l'écrire de mon mieux, afin de le rendre aussi clair que possible; mais il est bien probable que l'auteur vivant me saurait très mauvais gré du service que je lui aurais rendu, car c'est dans la nature des talents incomplets de préférer leurs défauts à leurs qualités./ Le malheur d'avoir trop bien fait doit arriver aux graveurs qui interprètent, et il n'y a peut-être qu'un peintre de génie qui puisse pardonner à son copiste d'avoir eu plus de talent que lui.'

6 It should be borne in mind that the concept of 'translation', as used by French critics in their discussion of printmaking, varied according to the different philosophies of art that were implicitly involved. Segolène le Men has drawn attention, in her important article on 'Printmaking as a metaphor for translation', to the differing positions of Charles Blanc and Philippe Burty in this respect. However, this polarisation becomes acute particularly at the time of the crisis of printmaking in the 1860s when Burty, for example, becomes a supporter of etching, as opposed to burin engraving. My main concern is with the earlier period. See Le Men, 1994, pp. 88–108.

7 See letter from Camille Bonnard, published in *Gazette des Beaux-Arts*, 1859, IV, September–December, pp. 186–7: 'Je rencontrai alors un jeune homme obscur, sans appui, qui sortait de l'école de Saint-Michel, où il s'était distingué par les plus brillantes dispositions,

et qui aspirait à devenir un des premiers pein-tres de notre époque . . . Je lui offris, au lieu d'aller péniblement gagner vingt-cinq ou trente centimes par heure chez quelque obscur graveur, en s'y livrant au travail mécanique de rentrer des tailles, de se consacrer exclusive-ment à la gravure de mes costumes; ce serait pour lui une occasion de se faire connaître et d'utiliser d'une manière plus agréable à son talent, en attendant qu'il pût obtenir les commandes qu'on lui avait fait espérer de quelques tableaux d'autel. Mercuri avait une antipathie extrême pour l'art qui l'a cepen-dant placé à si juste titre au rang des plus célèbres graveurs. Il accepta, mais à contre-coeur, et dans l'espoir de laisser bientôt pointes et burins pour reprendre des pinceaux et la palette. Triste, apathique, mécontent de tout, se laissant aller à tous les décourage-ments, manquant à la fois de résolution et d'énergie, Mercuri devint mon compagnon de tous les instants; je l'encourageais, je l'excitai, mais sans pouvoir triompher de cette mollesse de caractère qui faisait mon désespoir et entra-vait la marche regulière de ma publication.' This somewhat jaundiced view of the col-laboration has to be matched with the more tactful language of Bonnard's prefaces (see Beraldi, 1981, X, p. 29).

8 Bonnard, 1859, p. 187: 'Tandis que je passais de longues journées dans les bibliothèques, dans les cloîtres, dessinant, recueillant les matériaux que je lui préparais, il restait inerte et pensif en présence d'un cuivre qu'il aurait pu terminer en quelques heures.'

9 Beraldi notes this instance, but does not list J. J. Leroy among his engravers. He does, however, list a Louis Leroy, an etching spe-cialist of the right period and profile who might well be connected to Mercuri's col-laborator, if not the self-same person (see Beraldi, 1981, IX, pp. 155–6).

10 Listed in Beraldi, 1981, X, p. 28. There is a well-preserved example in Bibliothèque municipale de Nantes, Collection Labouchère, Livre 1 bis.

11 See Bann, 1997, pp. 165–7, and pp. 206–7, 212.

12 Viel-Castel, 1831, p. 269: '. . . *les Moissonneurs* de M. Robert, chef-d'oeuvre d'exécution, et qui, avant l'arrivée du nouveau-venu [*Cromwell*], attirait presque seul l'attention de la foule . . .'. Delaroche's *Cromwell* was listed in the second supplement to the catalogue.

13 Viel-Castel, 1831, p. 269: '[Robert] a pris son tableau tout fait, par quelque beau soir d'été,

dans les campagnes de Rome où tout est sujet pour les peintres . . .'.

14 *Courrier français*, 1839, no. 80, 21 March, p. 4: 'M. Mercuri a fait un chef-d'oeuvre, comme on n'en trouve pas d'exemple dans les anciens maîtres. C'est une petite merveille qui n'avait pas besoin, pour passer à la postérité, de cette valeur extraordinaire que les circonstances lui ont donné. Mais c'est un ouvrage tout à fait à part, non seulement à cause de la dimension, mais encore en raison des procédés employés par M. Mercuri, procédés inusités dont lui seul a eu le secret. Il faudrait donc, pour que les deux ouvrages puissent entrer en parallèle, que M. Mercuri n'eût pas le mérite de la difficulté vaincue, difficulté immense, puisqu'il s'agissait de donner un air de grandeur à des figures aussi petites que la tête d'une épingle, et de conserver leur caractère de pureté grave et de majestueuse élégance à ces profils imperceptibles de femmes romaines, dernières limites du possible en ce genre. Telle que la pratique M. Mercuri, la gravure a tous les avantages du dessin, sans perdre aucun de ceux qui lui sont propres; elle a autant de douceur que le lavis; en restant bien plus ferme, elle est aussi moelleuse que le crayon, avec bien plus d'éclat.'

15 *Courrier français*, 1839, n.80, 21 March, p. 4: 'Celui-là est un Romain, il traduit avec passion, avec amour, cette page italienne où il retrouve les admirables physiognomies dont il a gardé le souvenir.' The comment is made in the course of Blanc's comparison with the 'French' approach of Prévost, and anticipates the conclusion: 'M. Mercuri a dépassé les limites, M. Prévost s'y est maintenu.'

16 Procès, 1878, 1, 2. From Goupil's side, it appears that Feuillet de Conches proposed the engraving of this portrait as a 'loss-leader' which would establish a connection with Delaroche.

17 See Allemand-Cosneau and Julia, 1999, p. 203, for the engravings after Delaroche by S. W. Reynolds and his pupil George Maile, which were sold over a long period by Goupil.

18 Bergeon, 1994, p. 43.

19 Beraldi, 1981, X, p. 31.

20 Quoted ibid.

21 Adhémar and Lethève, 1954, VIII, p. 65.

22 For a direct comparison between the two works, and its possible effect on Ingres, see Vigne, 1998, pp. 6–7.

23 See Bibliothèque de l'Institut, MS 2164, Fonds Delaborde, f. 30: letter dated 15 February 1873. Evidently Delaborde discouraged

him from submitting this recent work, but he persisted. François was elected to the seat at the Academy formerly occupied by Forster on 15 February 1873. François took care in this letter to acknowledge that he had been introduced to Delaborde by Delaroche: 'C'est encore une obligation que j'ai envers Monsieur Delaroche, car, c'est cet excellent Maître qui vous a intéressé à moi, c'est une raison de plus qui m'attache si respectueusement à son souvenir.'

24 Bibliothèque Nationale, Paris, MS NAF 16800, f. 30, letter of Demidoff to Delaroche dated 12 January 1835: 'J'ai passé dernièrement chez Mssrs Goupil et Rittner qui m'ont dit qu'elle [the engraving] n'était point encore commencée! Est-ce possible? Ensuite quels sont les arrangements que vous avez faits avec ces Messieurs et Mercuri? Car en ma qualité de propriétaire de l'original, je tiendrai assez à avoir le monopole de gravures de mon tableau. Eclaircissez-moi de grâce en tout cela, car je ne comprends encore rien.' The subsequent letter (f. 32), of 11 February 1835 shows that agreement has been reached: 'voilà ce qui a été décidé entre eux [Rittner and Goupil] et moi. Ces Mssrs s'engageront . . . de me réserver les 50 seules épreuves avant la lettre qui sont tirées et revêtues de mes armes. Après quoi ils vendront au public les gravures après la lettre.' Owing to the lapse of time before the engraving was produced, and Demidoff's removal from Paris to Florence, it is very doubtful whether this arrangement was in any way respected.

25 The contract is reproduced in Procès, 1878, 2, pp. 34–5, where it is dated March 1836. Although Delaroche had already arranged to sell the work to the Duke of Sutherland, it was to remain in France until after the 1837 Salon. Henriquel-Dupont thus had ample time to prepare a drawing for his engraving.

26 See Bergeon, 1994, pp. 51 ff. for the intermittent reports on the progress of the work over this long period.

27 Ibid., p. 62.

28 Ibid., p. 67: 'M. Delaroche a vu l'épreuve, il est fort content de ce qu'il y a de fait, comme nous, en regardant le résultat de bientôt *dix-huit années*, il ne pouvait s'empêcher de regretter qu'un artiste de votre talent ait produit si peu quand il était capable de faire si bien.'

29 Ibid., p. 68: 'L'aspect général de votre gravure est toujours un peu le même, c'est-à-dire qu'il manque de fraîcheur, il semble que la planche

est fatiguée ou que l'impression en est mauvaise.'

30 Ibid., pp. 72–4.

31 Ibid., p. 73: 'Nous ne saurions donc trop insister sur l'effet des deux bras qui ont été l'objet de la critique générale des artistes qui se sont réunis pour admirer cette planche et qui ont tous trouvé ces deux bras trop lourds. Est-ce la faute de Mr Delaroche, il le craint et s'en remet au talent de M. Mercury [sic].'

32 Quoted from *L'Artiste* in Beraldi, 1981, x, p. 32: 'La planche de M. Mercury [sic] donne l'idée d'un tableau beaucoup plus parfait que l'original qu'elle représente. Le dessin de la gravure est plus ferme, plus savant, plus magistral. Le burin a presque partout corrigé le pinceau; un travail fin, serré, variant selon les objets qu'il doit rendre, donnant sa valeur à chaque chose, éteignant les clairs trop vifs et comme ferblantés de la peinture, nourrissant les ombres de fines hachures, a fait disparaître les défauts qui nous avaient si fort choqué jadis et rendu insensible au mérite réel de l'oeuvre . . . les mains tendues de Jane Gray [sic] ne sont plus des mains de cire . . .'. It is worth adding that Gautier would have been able to refresh his memory of the original painting when it was shown in Delaroche's retrospective exhibition of 1857, whilst the criticisms conveyed by Goupil had no such direct standard of comparison.

33 The third and fourth states of the engraving attribute the drawing to Auguste de Saint-Aubin, and the fifth and last to J. B. Lemort.

34 See Beraldi, 1981, vi, p. 166.

35 Beraldi, 1981, x, p. 32.

36 Quoted in Bergeon, 1994, p. 81: 'La nouvelle planche gravée par M. Mercurj [sic] se ressent trop de cette propension à l'extrême analyse. Si l'on examine les détails un à un, nul doute qu'on apprécie le soin et le talent avec lesquels chaque objet est rendu, chaque accident de la forme étudié et défini; mais que l'on cherche, entre ces mille détails, le point qui doit déterminer l'effet et résumer l'esprit de la scène, le regard ne sait où se prendre. Tout le sollicite, rien ne l'arrête. La figure de Jane Grey, dont il fallait accuser l'importance principale par l'unité d'aspect, est elle-même morcelée et comme interrompue dans sa physionomie générale. Le visage, le cou, les bras, sont chargés de travaux si compliqués, que le modelé disparaît presque sous les demi-teintes, tandis que certaines parties de la robe, celles qui recouvrent les genoux par exemple, brillent d'un éclat assez vif pour s'isoler com-

plètement du reste . . . Dira-t-on qu'il faut imputer ce manque d'harmonie au modèle, qu'on ne saurait sans injustice rendre le graveur responsable des erreurs commises par le peintre? L'excuse serait insuffisante.'

37 Beraldi, 1981, iv, p. 49: 'Calamatta a été l'un des heureux du monde de la gravure, ce monde où d'ordinaire la carrière est si difficile et si ingrate: rien ne lui a manqué en fait de succès et d'honneurs.'

38 See Blanc, 1876, p. 101: 'Les grands artistes, en particulier, ont eu des interprètes dignes d'eux'; p. 102: 'Oui, Ingres et Calamatta étaient faits l'un pour l'autre'.

39 Ibid., p. 107: 'Enfin Calamatta, après deux ou trois concessions qui lui avaient été arrachées par des cajoleries ou des emportements, s'était refusé à toute amélioration, et avait déclaré net qu'il abandonnerait sa planche plutôt que de recommencer ainsi partiellement, toutes les fois qu'il prendrait fantaisie à Ingres de perfectionner sa composition'.

40 Bibliothèque historique de la Ville de Paris, Fonds Sand, J 132, letter postmarked Brussels, 28 May 1839. A later letter gives news of the printing of the engraving after Delaroche's portrait of Guizot by Chardon: Mercuri has taken the precaution of keeping a proof from the finished plate before consigning it (J 134, letter dated 24 January 1840, f. 3).

41 Ibid., J 136, letter dated Paris, 11 December 1841.

42 Getty Research Institute, Los Angeles, 910034, undated letter to Cardinal Tosti: 'Senti con sorpresa e pena l'esilio del nostro eccellente amico Camporese. Non ha certo altra colpa di quella che hanno ogni giorno ventiue miglioni d'Italiani: giusta o falsa questa è l'oppinione della Nazione . . . è una gran disgrazia per Roma di non esser . . . la testa d'Italia.' Pietro Camporese (1792–1873) was a noted Roman architect who joined the liberal opposition in the 1850s, and went into exile in 1861. He supported Garibaldi, and was involved with attempts to involve Napoleon III in the national cause. See the entry in *Dizionario biografico degli Italiani* (Rome: Treccani, 1974), vol. 17, pp. 590–2.

43 Bibliothèque historique de la Ville de Paris, Fonds Sand, J 36, f. 3 (manuscript in the hand of Lina Calamatta, 'translated or copied from a notice compiled by Luigi Calamatta himself'): 'Et moi petit poisson je dus faire le voyage de Jonas. Je perdis naturellement le procès que j'intentai à la boutique des prêtres

qui fut jugé par les prêtres sous le gouvernement des prêtres.'

44 Ibid., f. 6: 'Je me mis à la gravure avec le nouveau et célèbre professeur Riccioni qui nous fit faire en peu de temps de grands progrès. Je finis le premier la première gravure, c'était une copie d'une Madame de Betellini, je la terminai à 16 ans. Ce travail fit un certain effet à cause de ma jeunesse et la brièveté du temps que je mis à le graver.'

45 Ibid., ff. 10–11. Marchetti had no window space available in his studio, but allowed the young student to establish himself in the stairway, where he completed a plate of 'Le Christ et Saint-Pierre'. Thorvaldsen was struck by his 'dessin soigné et fini' after classical statuary.

46 Ibid., f. 13: 'Quand je vis ces tailles profondes et luisantes, cette manière de graver toute autre que notre manière romaine, la fièvre me prit, il me sembla impossible de réussir et je tremblais de gâter son travail.' For details on the career of André Taurel, see Beraldi, 1981, XII, pp. 82–4. He married the daughter of the Director of the French Academy in Rome, Charles Thévenin, and was consequently the brother-in-law of the young Thévenin later to study with Calamatta.

47 Ibid., f. 12.

48 Ibid., f. 17: 'Je remarquai dans le Voeu de Louis XIII les qualités essentielles pour la gravure, fermeté du dessin et variété des objets.'

49 Ibid., f. 15: 'Ingres vint habiter chez Taurel . . . je lui cédai ma petite chambre et j'allai dans la cuisine.'

50 Blanc, 1876, p. 105: 'Plusieurs artistes se présentèrent pour consacrer par la gravure le succès du maître; mais Ingres, qui avaient en peinture des idées italiennes, fut porté à donner la préférence à Calamatta, indépendamment de l'amitié qu'il avait pour lui.'

51 Fonds Sand, J 36, f. 19: 'Ingres espérait que Desnoyers demanderait à graver son tableau, heureusement pour moi, le Baron ne daigna pas s'en occuper; alors furieux contre les grands graveurs Ingres me dit: Nous le ferons.' Auguste Boucher-Desnoyers (1779–1857) was an obvious choice for Ingres, having made his reputation under the Empire with widely acclaimed engravings after Raphael. A pupil of Alexandre Tardieu, he also had the honour of making the official print after the Baron Gérard's portrait of the Emperor Napoleon. During the Restoration and the July Monarchy, however, he confined himself chiefly to engraving after Poussin and the Italian masters of the Renaissance (see pl. 91), and his interpretations of contemporary painters were limited to painters who had made their reputation under the Empire, such as Gérard and Guérin.

52 Ibid., ff. 18–19: 'Le jour fixé j'avais terminé un des grands rideaux. Ingres vint et . . . c'est un des jours heureux de ma vie. Il regarde le dessin – me regarde et regarde autour de la chambre comme pour voir si un autre n'avait fait ce qu'il voyait, tant il était surpris et content. Au bout de cinq mois de travail le dessin était fini. Ingres me dit: Je ne puis vous le payer mais je ne veux pas non plus vous le laisser, pour cela vous vous contenterez de 600 francs. J'étais archi-payé par les éloges et les encouragements qu'il me donnait. Personne mieux que lui ne sait stimuler et enivrer un artiste, il sait vous élever au-dessus de la médiocrité moderne et il vous ouvre les yeux pour vous faire voir en face nos vrais Dieux Phidias et Raphaël.'

53 Ibid., f. 22: 'Je me remis à ma grande planche où je dus effacer environ une année de travail pour des erreurs de tailles et un peu pour un accident d'eau-forte. J'espérais beaucoup de cette oeuvre Bourbonnière [sic] et le ministre de la Maison du Roi m'avait tout promis, certainement ma fortune était faite si la Révolution de 1830 n'était pas arrivée. Elle me ruina mais cela ne m'empêcha pas de l'accueillir avec un enthousiasme frénétique.'

54 Ternois, 1980, p. 79: letter from Ingres to Calamatta, dated Rome, 28 September 1837. Ingres had been made a *chevalier de la Légion d'honneur* after the Salon of 1824, when the *Voeu* was shown in public for the first time. For the patronage of the Restoration period, and the role of the *ministre de la Maison du Roi*, Sosthène de la Rochefoucauld, see Chaudonneret, 1999, pp. 122–8.

55 See the discussion in Ingres, 1968, pp. 93–4, and Ingres, 1967, pp. 158–61.

56 Quoted ibid., pp. 160–1, from note in the handwriting of Ingres, originally cited by Delaborde: 'Une grande ombre vengeresse est projetée sur le mur et s'y dessine comme un fantôme.'

57 Beraldi, 1981, XI, p. 42: '[La gravure] a dû coûter d'autant plus de travail, que M. Ingres était extrêmement fatigant pour les interprètes. Il se retouchait lui-même pendant la gravure, apportant chaque jour quelque correction faite sur des calques: une draperie dont il voulait changer les plis, un mouvement de bras à modifier, un contour à raffiner, etc.'.

58　Magimel, 1851, n.p. (Preface): 'Ce n'est qu'après une longue résistance, dont chacun appréciera le motif; ce n'est qu'à la suite de très-vives sollicitations que M. INGRES m'autorise à publier cet ouvrage.' The collection is described as 'une collection générale et chronologique qui donnât, par un nomenclature des travaux de M. INGRES, une juste idée de l'emploi de sa vie.'

59　Beraldi, 1981, XII, p. 63: 'très grande pièce, capitale et célèbre, un des chefs-d'oeuvre de la lithographie de traduction./ Sans être irrévérencieux, nous rappellerons ici l'analogie qu'on a trouvée pour l'effet d'éclairage par la lumière du haut, entre cette pièce fameuse et le *Ventre Législatif* de Daumier.'

60　Daumier's lithograph commemorates the parliamentary session of 1834, while Sudre's lithograph (Musée Ingres, Montauban, Inv. 026) appears to be dated 1833 on the proof (though ascribed to 1834 by Beraldi). Although Beraldi does not perhaps imply that Daumier was copying Sudre, the reference to a famous work already in circulation would be quite consistent with his practice.

61　Perrot, 1844, p. 9: 'La gravure . . . n'est point une copie de la peinture, elle en est une traduction; ce qui est différent. Le but de ces deux arts est d'imiter la nature; si le graveur ne l'imite directement, c'est que la lenteur de ses procédés ne lui permet pas; mais très-souvent il a recours lui-même à la nature, lorsque le tableau qu'il traduit lui présente quelques formes fausses ou douteuses. La composition et le trait sont les seules choses que le graveur puisse traduire littéralement; mais l'effet, la couleur et l'harmonie d'une estampe tiennent presque toujours à son génie. N'ayant, pour rendre tous ces objets, que des équivalents souvent insuffisants, le graveur est obligé d'y suppléer par son intelligence, d'autant mieux qu'un tableau n'ayant quelquefois de relief et d'effet que par l'accord et la variété des couleurs, le graveur, qui n'a que le noir et le blanc, est obligé de créer l'effet et l'harmonie de son estampe.'

62　Blanc, 1876, pp. 111–12: 'Ingres, disait-on, s'il savait tenir le burin, ne ferait pas mieux; il ne serait pas plus semblable à lui-même./ Nous avons pu en juger, il y a deux ans, lorsque le *Voeu de Louis XIII* a été exposé avec tous les ouvrages d'Ingres à l'Ecole des beaux-arts. La franchise de l'effet, dans la peinture originale, autorisait le graveur à partir d'un ton très-soutenu pour conduire l'oeil à la lumière éclatante produite par le blanc pur. Il

est remarquable, cependant, que les ombres les plus fermes, les plus résolues, sont obtenues avec deux tailles seulement ou même avec une seule taille. C'est ainsi que le manteau de la Vierge, qu'il fallait tenir un peu foncé pour faire briller la gloire lumineuse qui environne le principal groupe, est attaqué avec une seule taille, à peine croisée dans quelques ombres, mais d'une simplicité, d'une fierté admirables, et qui produit tout le ton voulu, sans étouffer la transparence du papier. Les draperies plus fines, la robe de la Madone et ses manches sont traitées avec des lignes et des points de diverses profondeurs, de manière à figurer une étoffe moelleuse et délicate sans trop s'écarter pourtant de la sobriété que s'était imposée le peintre. Pour ce qui est des chairs, le graveur a usé d'un travail fin et précieux, tel qu'il aurait pu convenir même à une peinture plus savoureuse que celle d'Ingres; il les a exprimées avec des tailles légères, séparées par un chapelet de points, en guise d'entretailles. Il a ainsi évité le désagréable losange, bouché par un trait, que les graveurs de la décadence italienne ont tant de fois mis en oeuvre. En quelques passages, surtout dans les figures secondaires, celles des deux séraphins qui écartent les rideaux de l'autel, Calamatta, au lieu de faire suivre à son burin les sinuosités de la routine, lui trace brusquement une marche directe, accusant l'austérité mâle de l'original. Quelquefois il arrive au charme de certaines demi-teintes, sans autre ressource que celle de la pointe sèche, procédé peu usité en France, mais familier aux graveurs italiens et heureusement employé par Raphaël Morghen.'

63　Benjamin, 1992, p. 81. Benjamin notes that 'the Romanticists virtually ignored translation in their theoretical writings' while at the same time continuing to testify in 'their own great translations to their sense of the essential nature and dignity of this literary mode' (p. 76). The persistence of the theory of translation in respect of reproductive engravings (whose link with translation in its literary sense George Sand's comments have already raised) perhaps adds a new dimension to Benjamin's characterisation of the 'Romantic' scene.

64　Ternois, 1980, pp. 82–3: 'Mais de tout cela, rien, pas même un dessin passable qui ait pu me servir, avec un vice du panthographe, tellement que je n'ai rien de bien . . . Alors, cher ami, à vous toujours le premier choix bien entendu et à mon grand intérêt et bonheur.'

65 See Beraldi, 1981, IV, p. 62.

66 See Gascoigne, 1998, p. 114.

67 Explication, 1831, p. 181, item 2306.

68 See Jack, 1999, pp. 246–7. For a discussion of the circumstances of Calamatta's commission, and Delacroix's resentment at the apparent plagiarism, see Sand, 1954, pp. 19, 26.

69 Blanc, 1876, p. 116: 'Des deux portraits du duc d'Orléans d'après Ingres, le plus aimable, selon nous, est celui qui semble imiter un dessin facile et rapide à la mine de plomb, tel que le peintre aurait pu le faire en se jouant, et les amateurs, j'imagine, le préféreront au premier portrait du même prince, qui, terminé entièrement au burin, manque de légèreté et de brillant.'

70 Fonds Sand, J 36, ff. 29–30. Calamatta describes vividly his difficulty in completing the initial drawing. However: 'A force de petites améliorations, au bout de deux mois de travail assidu je finis par être content de mon dessin et grande fut ma surprise quand je vis l'admiration des artistes que j'estimais le plus. Ingres et Taurel ne tarissaient pas, mais il faut ajouter qu'ils m'aimaient beaucoup.'

71 Bracquemond's story, told with great gusto, is quoted in Beraldi, 1981, IV, pp. 57–9.

72 Getty Research Institute, 900171, letter from Lelli to Giangiacomo dated Brussels, 14 February 1847.

73 See Beraldi, 1981, IV, p. 61.

74 Ibid, VI, p. 101: 'le maître pressentait-t-il que l'élève, tout en devenant lui-même un très habile graveur en taille-douce, déserterait les pratiques d'un burinisme sévère pour passer dans le camp de l'eau-forte?'.

75 See Ternois, 1980, p. 95. The letter dated Paris, 8 January 1858 includes the mention of the *Jesus among the Doctors* (Musée Ingres, Montauban) which he hopes to finish 'pour me rendre libre de donner 4 mois à l'homère que j'emporterai à Meung si Dieu, comme je l'espère me vienne en aide'. The *Jesus* was finally signed in 1862.

76 Ibid., p. 98, letter of 4 January 1859: 'Je vous envoie . . . dans la crainte que vous ne l'ayez pas l'épreuve photographie de la Source. Elle pourrait bien faire pour le trait de votre planche . . .'.

77 See Hamber, 1996, p. 188, where the fact that photography is scheduled before the varnishing is taken as an early sign of the specific difficulties of reproducing paintings through the new technique.

78 See Ingres, 1968, p. 88, for a plate of Marville's photograph, together with the *Self-portrait* as it is now (Musée Condé, Chantilly), and a replica relating to the first state of the painting. The dating of Marville's photograph is however complicated by the fact that the existing print must itself be a copy, since it was produced by a process not available in 1851.

79 See Hamber, 1996, p. 188. It is suggested by Hamber that Marville might have photographed the famous *Apotheosis of Homer*, then in the Galerie du Luxembourg. However, it seems much more likely that this was a smaller composition, possibly the 1862 painting, based on the central figure of the *Apotheosis*, which was certainly being reworked in Ingres's studio around 1860. For this work, see Condon, 1984, pp. 115, 198. An alternative possibility is that Marville photographed the large, revised drawing of the *Apotheosis* (1865) already mentioned in note 75. However, if this is the case, the gift to Stürmer could hardly have been made in the 1850s. Marville's photograph does differ from the final state of the drawing in a number of details, but the drawing is generally believed to have been brought to its final state in 1864–5, after a gap of two decades (see entry by Daniel Ternois in Ingres, 1967, p. 206).

80 See Hamber, 1996, pp. 188–9.

81 See *Publications nouvelles de la Maison Goupil et compagnie*, January 1859 (Archives du Musée Goupil, Bordeaux) for the listing of the edition, in which the *Odalisque* was no. 6. It is worth noting that Ingres's paintings in the 1855 exhibition had been splendidly photographed, together with the other works in the exhibition, in a series of large prints devoted to the different galleries, which remain anonymous. See the bound volume entitled *Exposition universelle 1855* (Getty Museum Photographic Collections, 84 XA 432 10). The *Grande Odalisque*, however, comes off particularly badly, being hung low on the wall, and in poor light, under the dramatic *Apotheosis of Napoleon I* (1853).

82 *La Lumière*, no. 13, 26 March 1859, p. 51: 'Nous avons émis à cette place, il y a à peine quelques semaines, l'idée d'un ouvrage dont nous nous prouvions l'intérêt et l'utilité. Il s'agissait d'un album destiné à contenir les reproductions photographiques des chefs-d'oeuvre de l'Exposition. Nous apprenons avec un grand plaisir que cette idée n'a point été perdue, et que M. Bingham, dont le nom est célèbre en photographie, a entrepris cette

tâche. Son album des oeuvres du Salon formera un splendide recueil, et sera placé sous la direction d'un peintre de talent, M. Louis Martinet.' The subsequent issue of 20 August 1859 (no. 34, p. 135) lists only five of the ten plates that have appeared by that stage, and Ingres's *Odalisque* is the only one that may duplicate the earlier Goupil series.

83 See *Publications nouvelles de la Maison Goupil*. The dimensions of the two smaller prints after Delaroche are 34 × 22 cm, and 29 × 20 cm respectively, whilst that of the *Odalisque* is 14 × 24 cm.

84 See *Hémicycle*, 1853, p. 11.

85 Ternois, 1980, p. 81, letter of 20 April 1841: 'la Stratonice est ingravable . . . à cause de sa forme'.

86 Although the photographic print is appropriately mounted on board, there is no sign of Bingham's monogram, usually printed in red in the corner of the image, or of his stamp, which is a version of the arms of the Bingham family of Binghams Melcombe. There is however the name and address of his studio – Bingham, rue de la Rochefoucauld – on the mount.

87 See Hamber, 1996, pp. 81–3, for a clear exposition of this problem.

88 See Getty Research Institute, Special Collections, 90.R.35: album entitled 'Objets d'art de la collection du Prince Soltykoff', vol. I. The sale of Soltykoff's remarkable collection of medieval, Renaissance and Byzantine art took place at the Hôtel Drouot in April 1861, and the need for a full illustrated record is noted in the catalogue (see *Soltykoff*, 1861, p. 1). This photographic survey presumably took place shortly afterwards, before the dispersal of the objects. The appearance of a number of paintings in the album, including the *Grande Odalisque*, must presumably mean that they were also in the Soltykoff collection, although they do not appear in the catalogue.

89 For biographical details on Berthier and Poitevin, see dictionary entries in Voignier, 1993. Poitevin is here characterised as 'troisième homme de la photographie' and 'more than Daguerre the continuer of Niépce's project' (p. 207). Poitevin was a more regular exhibitor than Berthier at the meetings of the SFP, and in May-August 1861 was showing 'Impressions photographiques au charbon' (see Place, p. 45). Roger Taylor has inspected the print of the *Grande Odalisque* and suggests that it may well be an early carbon print.

90 See Georgel, 1998, p. 182. The name is transcribed as 'Jean Marcellin Berthier' rather than 'Paul Marcellin Berthier', but the date of birth matches, and there is a very high probability that this is the future photographer. Other basic details of his career given here are drawn from Voignier, 1993.

91 Among his photographs in the collection of the Département des Estampes, Bibliothèque Nationale, are a *Forêt de Fontainebleau* (c.1864), a *Nude* (c.1865), two views of a Greek *Kouros Head*, and several reproductions of Egyptian tablets with hieroglyphs. For the Flandrin entries, see Place, 1985, reprint of 1859, p. 7.

92 See the list of awards in *La Lumière*, 12th year, no. 14, 30 July 1862, pp. 53–4.

93 Details of Berthier's work are noted in Frizot, 1994, pp. 70, 90, 274; Frizot however implies that the reproductions of Flandrin's work dated from after 1865, whereas they are clearly featured in the catalogue of the 1859 exhibition of the Société française de photographie.

94 The status of the 1859 *Angelica* is discussed in Ingres, 1967, pp. 152–4, by Daniel Ternois, who does not believe that Haro's attribution is tenable. See Blanc, 1863, for the article 'Du Style et de M. Ingres'. Referring to Haro as the owner of this *Angelica*, Blanc proclaims it to be superior to the other versions that include the figure of Roger. He also commends the print 'si bien gravée par M. Flameng' (p. 18).

95 Ivins, 1996, p. 144. Ivins goes on to call this process 'an undertaking which is logically impossible'. It must be said, however, that such a definition could be applied to any theory of representation, or indeed translation, developed at any period.

96 Delaborde, 1856, p. 620. Delaborde uses the interesting concept of a 'reproduction féconde' to denote the possibility of multiplying prints, in which respect the engraving will have to compete with the photography of the future. He condemns the daguerreotype, by contrast, as being 'forcément stérile', being confined to one example. It goes without saying that this analysis just predates Bingham's success in adapting his derivative of the calotype process.

97 See Hamber, 1996, pp. 11–12 for comment on the legislation, which had no parallel in contemporary Britain. Anne McCauley has calculated the number of photographs deposited at the Bibliothèque Nationale by Goupil over the period, and records a peak of 574 in 1863 (see ibid., p. 30, note 24).

98 See Getty Research Institute, Special Collections, 820026, letter of 17 July 1868 from

M. Guillet, notaire (brother-in-law of Mme Ingres): the point is made that Ingres specifically reserved 'le droit de le faire graver et tous les droits d'auteur y attachés' when selling the work to the duc d'Orléans; that he had himself arranged with the artist Florence Pollet (1811–1883) to engrave it, but 'ce projet, par la faute de Mr Polet [sic] n'a pas réussi'. According to Beraldi, Pollet was 'distracted from engraving by watercolours' (Beraldi, 1981, XI, 19). Also letter of 2 January 1869, in which Mme Ingres informs the *Gazette des Beaux-Arts* that 'le droit de gravure {of *Stratonice*} lui appartient et qu'elle ne l'a cédé à personne.' Flameng published five prints in the *Gazette* over the year 1869. It was not until 1871, however, that he published his first print after Ingres in the period since the painter's death, and *Stratonice* never appeared there. See Sanchez and Seydoux, 1998, for details of print publications in the *Gazette*.

99 Getty Research Institute, 860047, N 8932, Deposition of Meissonier bearing on his relations with Ernest Gambart [dated c.1880]: 'Mr Gambart me proposa de faire graver la Confidence . . . J'acceptai et je commencai même à faire un dessin pour la gravure par un jeune homme . . . Mr Dufour Mantelle . . . Voulant au moyen de la photographie lui faciliter son travail je m'adressai pour la faire à Mr Bingham . . . chez lequel je fusse conduit par Mr Blanchard le graveur . . . qui travaillait alors pour Mr Gambart'; 'La photographie publiée par Mr Bingham n'a pas été faite d'après le tableau duquel je ne sache pas que Mr Gambart se soit desaisi en ma faveur, elle l'a été d'après un dessin à moi appartenant que Mr Gambart m'a vu faire à Londres d'après le tableau qui était encore à moi; ce dessin a été exposé publiquement au Salon de 1877.'

100 Bingham's first reproductions after the paintings of Meissonier were noted favourably in *La Lumière*, 31 March 1860, p. 49. The comment about Blanchard having been the intermediary between Bingham and Meissonier – referred by the latter to the period shortly after 1857 – may well point to this occasion as being their first meeting.

Chapter 5

1 Beraldi, 1981, II, pp. 86–94.
2 Ibid., VI, p. 101. For his engravings after Frith and Edwin Austin Abbey, see Beck, 1973, pp. 63–4, 69.

3 See ibid., VI, p. 110: 'ces petites planches d'un travail caressé et clair qui mirent en lumière, dans le public, le graveur et le journal'. Beraldi regards his engraving after Ingres's *Madame Devauçay*, published in 1867, as 'une des meilleures pièces de l'oeuvre' (p. 111). For a full documentation of Flameng's contribution to the *Gazette*, see Sanchez and Seydoux, 1998.

4 *Le Journal des Arts: Chronique de l'Hôtel Drouot*, Onzième année, no. 42, 4 June 1889, p. 1.

5 Beraldi, 1981, IX, pp. 231–3. It was Martinet who eventually, in 1877, fulfilled the project which was withheld from Calamatta during Ingres's lifetime of engraving the *Apotheosis of Homer*.

6 Beraldi, 1981, XII, p. 256: 'Waltner, par un travail des plus curieux, réunit et appropie à la reproduction des oeuvres d'art tous les moyens, même ceux qui avant lui ne servaient qu'à la gravure originale et semblaient ne pouvoir être employés ailleurs'. Bracquemond goes on to note 'une certaine parenté avec la manière noire' [mezzotint] in his 'genre personnel'.

7 See Beraldi, 1981, III, for the catalogue of his work, which fills an entire volume.

8 See Bénézit, 1999, II, p. 718.

9 Beraldi, 1981, XII, pp. 254–5.

10 Ibid., IX, pp. 255–71. Ambroise Tardieu had commented in his review of the Salon of 1841 that it was necessary to cross 'the narrow corridor in which the engravings are abandoned' in order to get to the 'inconvenient gallery to which the sculptors have been relegated' (*Le Courrier français*, 1841, no. 114, Saturday 24 April, p. 1). Given the pressure of space when the Salon took place at the Louvre, it was no doubt inevitable that painting should have pride of place. Beraldi however comments acidly on the 1889 Salon in the Palais de l'Industrie that the prints were shown in the last rooms, with no passage through, and that the hang was 'piled up' ('entassée').

11 Beraldi, 1981, IX, p. 271.

12 Ibid., pp. 266–7: 'A l'exposition de la fin de siècle, l'estampe nous apparaît fort vivante, en dépit de tous les horoscopes de mort portés sur elle à la venue des procédés photographiques: les artistes qui la produisent sont plus nombreux que jamais.'

13 Ibid., p. 260: 'Comme pour la vraie politique, l'histoire du siècle se résume en un mot: la marche vers la liberté, contre le despotisme de toute formule régnante. De là naissent toutes les luttes des partis que nous avons signalées à l'occasion: antagonisme de la taille rangée et

de la taille libre, du burin et de l'eau-forte, de la gravure de reproduction et de la gravure originale, de la lithographie de lithographe et de la lithographie de peintre, de l'estampe solennelle ou d'encadrement et de l'estampe intime ou de portefeuille, etc.'.

14 See ibid., II, p. 59.

15 Ibid, IX, p. 268: 'Comme la gravure remorquait autrefois la troupe des burins de pure mécanique, elle traîne aujourd'hui à sa suite celle des eaux-fortes de pur barbouillage. Qu'importe? l'exquis seul compte. /Il y a d'ailleurs une compensation: l'estampe d'encadrement à l'aquatinte, orgueil des antichambres et des salles à manger sous Louis-Philippe, a absolument vidé la place.'

16 *Hémicycle*, 1853, p. 8: 'Nous nous contenterons donc de rappeler que la gravure de l'Hémicycle des Beaux-Arts a été déclaré, par le jury chargé de distribuer les récompenses aux artistes, l'oeuvre le plus remarquable de l'exposition de 1853, et qu'en conséquence la médaille d'honneur et le prix de 4,000 FR. ont été décernés à M. Henriquel Dupont. Ce seul fait en dit plus que toutes les appréciations et que tous les éloges.' For the system of prizes awarded at the Salon from the period of the Restoration onwards, see Chaudonneret, 1999, pp. 122–30. From this period, also, the elevation of notable artists to the Légion d'honneur, which had begun under the Empire, was continued despite the successive changes in regime. Henriquel achieved an unprecedented honour here as well, being raised to the high rank of Commander in 1878 (see Beraldi, 1981, VIII, pp. 84–5).

17 Beraldi, 1981, IX, pp. 261–2: 'Dès l'abord, la question palpitante est résolue: la gravure n'est pas perdue, avec des graveurs comme Calamatta (que l'on comptait avec raison parmi les graveurs français), Forster, Jules et Alphonse François, Martinet, très remarquable dans le travail rangé; de plus, il est prouvé qu'elle peut se renouveler, se revivifier d'elle-même, conformément à l'essence même de l'art français, qui est de changer. C'est le graveur de l'*Hémicycle* qui le démontre: son travail, libre sans désordre, clair, spirituel, bien français, porte un coup décisif à l'école académique. Henriquel paraît là glorieusement; aussi dans la sobre distribution des récompenses, recevra-t-il justement la médaille d'honneur unique: encore une des récompenses sensationnelles du siècle pour la gravure. On se rappelle quelles furent celles de la peinture: Ingres, Delacroïx,

Horace Vernet, Decamps, Meissonier. A côté d'Henriquel, Calamatta et Forster n'eurent que la médaille de première classe, avec le lithographe Mouilleron.' Adolphe Mouilleron (1820–1881) is an interesting, though predictable, choice to have been ranked with these leading engravers in the 1855 prizegiving. He had sprung to prominence in the 1846 Salon with a number of lithographic reproductions after the paintings of Robert-Fleury, one of Delaroche's star pupils, and maintained a career in reproductive rather than 'original' lithography, using as his models old masters like Rembrandt as well as contemporary painters of historical genre. See Beraldi, 1981, X, pp. 152–7.

18 See Portalis and Beraldi, 1880.

19 See Tardieu, 1856, pp. 49–50. This genealogy differs from that given in Beraldi, 1981, XII, p. 71, where all but one of the sons in the generation after Nicolas are attributed to his brother, Pierre-Joseph, who had 26 children from two marriages. Ambroise Tardieu, the author of the earlier study, claims to be himself a member of the family (p. 68), but it may well be that Beraldi has the more accurate information.

20 See Thierry, 1839. Tardieu's superb maps, often involving copious historical material from the period, are proudly announced in title cartouches as 'dessinée et gravée par Ambroise Tardieu'. See Bann, 1996, pp. 95–104, for further discussion of this masterpiece of historical map-making. Tardieu also provides the plates illustrating the tools and techniques of the engraver for Roret, 1844 (see pl. 2).

21 Tardieu, 1856, p. 50.

22 Quoted ibid.

23 Melion, 1993, p. 48.

24 Ibid., pp. 57–65.

25 See Préaud, 1988, p. 47. Mellan's distinctive achievement is already stressed in his own period, as can be seen in Perrault, 1707. He is esteemed for being himself 'l'Auteur et l'Ouvrier de la plupart des Desseins qu'il gravoit' (p. 189); it is consistent with this skill as a draughtsman that the famous *Sainte Face* should be viewed as a virtuoso display of the possibilities of line: 'une tête de Christ dessinée . . . d'un seul et unique trait, qui commençant par le bout du nez, et allant toujours en tournant, forme très-exactement tout ce qui est représenté dans cette estampe, par la seule épaisseur de ce trait'(p. 190). In according Mellan this status of founding

26 See Ivins, 1996, p. 81. Ivins, however, attributes to the later seventeenth-century engraver Robert Nanteuil, whose development was 'an elaborate system of flicks and cross lines', the crucial role of anticipating the 'degradation' of the system.

father, I am not, of course, intending to depreciate the work of printmakers like the extraordinary Jean Duvet (c.1485–1561), whose series of twenty-three engravings on the theme of the Apocalypse belongs more to the end of the medieval tradition than to the beginning of the modern.

27 See Robert-Dumesnil, 1844, VII, pp. 300–1, and illustrations in Préaud, 1988, pp. 119–20.

28 For the placing of the *Holy Family* in the Musée Napoléon, see McClellan, 1994, pp. 141–2. For Delaborde's comment, see Delaborde, 1888, p. 6: 'Ce qui demeure ici [in the photograph] à l'état de résultat servile se montrera là [in the engraving] sous une apparence plus digne du modèle. D'un côte, le fac-similé brutal, sans sacrifices, sans les modifications que commandaient le changement des dimensions et l'indigence d'un coloris forcément réduit à deux tons; de l'autre, la ressemblance obtenue par des comparaisons scrupuleuses, par un sentiment réfléchi des beautés originales et des moyens particuliers au mode de reproduction'.

29 Portalis, 1882, p. 660: 'Au nombre de ces artistes étrangers devenus français, il faut au premier rang placer Wille. Par son talent, par l'école qu'il a tenue et dont l'enseignement continuait les traditions de la grande gravure, par ses nombreuses relations, il garde une place à part et prépondérante dans l'histoire de l'art dont nous nous occupons'; p. 693: '... l'un des préferés, celui qui devait continuer intacte la tradition de la gravure classique enseignée par le maître, Bervic'.

30 Diderot, 1995, I, p. 77.

31 Ibid., p. 183.

32 Ibid., pp. 182–3. Cochin (1715–1790) was a full member of the Academy from 1751 onwards, and between 1755 and 1770 acted as 'principal liaison officer between the academicians and the royal arts administration'.

33 Ibid., p. 104.

34 Quoted in Portalis, 1882, III, p. 673.

35 See Slive, 1995, p. 158: the present whereabouts of the *Gazettière* are not known, but it seems likely that it is one of the many works for which Ter Borch used his sister Gesina as a model.

36 Portalis, 1882, III, p. 702.

37 For the more generous view of Regnault as representing a refined and original alternative to the School of David, see David, 1974. For the more critical view, see Crow, 1995, p. 211.

38 For the hang of the Salon Carré in the mid-nineteenth century, see Gautier, 1898, pp. 346–7.

39 Beraldi, 1981, II, p. 59.

40 See entry on Duplessis (1725–1802) in the Macmillan Dictionary of Art.

41 Portalis, 1880, I, p. 188: 'Portrait séduisant par le moëlleux de la figure, qui attire tout d'abord l'attention, par l'élégante simplicité du costume de soie, par la sobriété des accessoires dont le principal est une petite table qui ferait les délices des amateurs de curiosités'.

42 Ibid.: 'Cette estampe harmonieuse et douce, d'un pur style Louis XVI, représente bien un homme aimable, mais sans vigueur de caractère, un esprit raffiné, mais sceptique.'

43 Bibliothèque de l'Institut, Fonds Delaborde, MS 2164, f. 82, undated letter in which he describes himself as 'absorbé par l'élection de François'. Also see f. 81 for an interesting discussion of the allocation of places to engravers. It appears that, of the three places in the Academy originally allocated after reorganisation in 1803, one was reserved for a medallist, another for a *graveur sur pierre fine* [precious stones] and the third for a printmaker, the last being originally occupied by Bervic. A fourth place was added by Louis XVIII after the Restoration in 1816, and its first occupant was Desnoyers. Henriquel himself succeeded the burin engraver Richomme in the place originally reserved for *pierre fine*. The burden of his letter, presumably written before his own election to this place in 1849, was that these distinctions should no longer be maintained slavishly, and it would be best if the Academy chose 'l'Artiste qui lui paraît le plus digne d'être nommé'.

44 Ibid., f. 71, undated letter probably from c.1863: 'Mr Galichon m'a montré une photographie qui devrait servir à Mr Haussoulier pour le calque qu'il doit faire pour son dessin; l'épreuve photographique est beaucoup trop grande, cette proportion disgracieuse nuirait certainement à la bonne exécution de la gravure, ce serait à mon avis chose ratée. Vous savez que Mr Haussoulier est peu exercé à la manoeuvre de la gravure, vous savez aussi que son exécution, qui ne manque pas d'esprit et

de savoir surtout, deviendrait vide et creuse, s'il était obligé de le délayer sur une grande surface; les peintures de Luini se distinguent beaucoup plus par un sentiment d'une délicatesse exquise que par une exécution forte. N'est-ce pas une raison encore de rester dans un cadre très restreint? . . . Je regrette de plus en plus que ma proposition de partager la commande des deux Luini entre Mr Haussoulier et mon élève Levasseur n'ait pas été écoutée.'

45 Beraldi, 1981, VIII, pp. 64–5.

46 See Bibliothèque de l'Institut, Fonds Delaborde, MS 2164, ff. 70, 87, where it seems as if Henriquel is arranging for Levasseur and Haussoulier to share the Luini commission. As these letters are not dated, however, it is not clear whether they represent his earlier suggestion, or a revised arrangement.

47 In the absence of any recent research on Henriquel's origins, I am relying here on the entry in the *Dictionnaire de biographie française*, as well as on the extensive listing in Beraldi, 1981, VIII, pp. 77–109. An obituary notice by his friend Feuillet de Conches was published in *L'Artiste*, May 1881, pp. 655–64. See also Courboin, 1928.

48 Blanc, 1876, p. 26. Delacroix was not to enter the studio until 1815, by which time Henriquel had left. However the other artists named would have been fellow students. See also Géricault, 1991, p. 266. The issue of the complexion of Guérin's studio is considered in an original and provocative way in Bruno Chenique, 'Le meurtre du père, ou les insensés de l'atelier Guérin'. See Chenique, 1997–8.

49 See Beraldi, 1981, V, pp. 30–3 for the two Coinys, and XII, pp. 82–3 for Taurel.

50 Ibid., VIII, p. 78: 'Ce double échec décide sa carrière et fait sa fortune'.

51 In Delaroche's case, however, this was at least in part out of deference to his elder brother, who entered without gaining the *grand prix* on several occasions up to 1819. For a further discussion of the competitive climate of the studios in this period, and its relevance to the concept of 'emulation', see Bann, 1997, pp. 35–41.

52 Géricault, 1986, n.p.

53 Beraldi, 1981, V, pp. 32–3. It is true that in Coiny's case ill health seems to have been a major factor in his lack of productivity.

54 Ibid., VIII, p. 89: 'si la plupart des bons élèves du commencement du siècle sont devenus depuis de très habiles et de très cor-

rects graveurs, qui ont fait honneur à notre école, il semble que l'enseignement classique leur ait malheureusement enlevé l'originalité'.

55 Ibid., p. 79: 'Sa voie fut indiquée par les burins anglais qui, après la paix de 1815, avaient pu pénétrer en France . . .'.

56 Ibid., V, p. 200.

57 See Bibliothèque Nationale, Estampes, Ef 118, f. 8: the inscription on the medallion indicates that it dates from 1801, three years after the original publication of the print.

58 Beraldi, 1981, V, p. 202: 'Les célèbres burins de Desnoyers, si purement dessinés, si harmonieusement gravés dans le sentiment des peintures . . .'. For the temporary presence of these works in the Louvre, see McLellan, 1994, pp. 141–2.

59 For example, Delaroche's *Les Joies d'une mère* (1843) seems close in conception to Raphael's *Charity* panel.

60 Bibliothèque de l'Institut, Fonds Delaborde, MS 2164, f. 81, undated letter to Henri Delaborde: 'une quatrième place avait été créée par ordonnance du Roi en faveur de M. Desnoyers, et je m'empresse de dire que cette nomination avait obtenu l'approbation générale'.

61 See Beraldi, 1981, V, pp. 205–6. Single works were also completed after Guérin and a handful of other contemporaries who had come to prominence during the Empire.

62 Ibid., XI, pp. 196–8.

63 Landon, 1814, p. 120: 'M. Richomme parait s'attacher à la manière pure, noble et suave de Raphaël Morghen . . .'.

64 Delaborde, 1888, p. 6: 'Il est clair que de bonnes photographies d'après les *Stanze* de Raphaël ou la Cène de Léonard, seraient moins compromettantes pour la gloire des deux maîtres que les estampes de Volpato et de Morghen, et nous préférions de grand coeur, à ces imitations trompeuses, à ces travaux d'un burin débile ou volontairement infidèle, des images qui offriraient au moins la garantie d'une exactitude mathématique.'

65 See Ingres, 1991, pp. 7–8.

66 Bibliothèque de l'Institut, Fonds Delaborde, MS 2164, letter from Richomme to members of the Conseil du Département de la Seine, countersigned by Quatremère de Quincy: 'Les arts en conduisant aux honneurs ceux qui les professent avec quelque succès ne les favorisent pas souvent sous le rapport de la fortune.' Whether or not Jules received his bursary, he later learned to draw and his

67 portrait of his father was later engraved (see Beraldi, 1981, XI, p. 198).

67 Blanc, 1876, p. 94.

68 There is a brief letter to him from Girodet dated 10 March 1822, in which, however, the painter asks for new proofs, and regrets that they have not met for six months. The delay seems to have been rectified, however, as there are are three states of the print dating from the same year. See Getty Research Institute, Special Collections, 870585: the letter is without an address, but the references to the recipient in the third person as 'Monsieur Dupont' leave no room for doubt that this is a stern note to the young printmaker. For details of the print, see Adhémar and Lethève, 1954, X, 283.

69 See Beraldi, 1981, VIII, pp. 92–3.

70 See Gascoigne, 1998, section 17, for a technical description of the process.

71 See Ziff, 1975, p. 276, for the listing of the painting, described as 'Shipwreck Scene from "Walladmor"'.

72 See *Explication*, 1831, p. 183, and Beraldi, 1981, VIII, pp. 93–4.

73 Ibid., p. 95. The comment allows Beraldi to expatiate on the difficulty that engravers experience with the artists after whom they work, and the advantages of choosing a long-dead painter. Hersent's *Return of Gustave Vasa*, which Beraldi mistakenly refers to as an 'Abdication', was destroyed during the burning of the Palais Royal in 1848. A replica however exists in the collection of the Mead Art Museum, Amherst, Massachusetts.

74 See the article of Delaroche's friend, Horace de Viel-Castel, in *L'Artiste*, I, 1831, p. 269, where reference is made to the public 'remaining silent for whole hours' in front of it.

75 See Beraldi, 1981, VIII, p. 95. Beraldi regarded the first state as 'the best'.

76 Jal, 1833, p. 91: 'Le jeune artiste a des succès de plus d'un genre. Comme graveur, il s'est placé parmi les hommes habiles par sa belle estampe du *Gustave Wasa*, d'après Hersent. Cette année, voilà qu'il expose le *Cromwell*, d'après Paul Delaroche: c'est un morceau plein de force et de couleur, non pas dans le genre de *Gustave Wasa*, mais à la manière noire. Il est fâcheux que la grande gravure, celle qu'il faut appeler classique, ait si peu de chance aujourd'hui . . . il n'y a presque plus d'amateurs et pas de fonds larges au budget.'

77 See the clear distinction in Gascoigne, 1998, 55j.

78 Jal, 1833, p. 103: 'Je vous ai dit tout à l'heure, à propos d'Henriquel Dupont, ce que souffre la gravure sans protection, et engagée dans une lutte impossible avec la lithographie.'

79 See Georgel, 1998, pp. 98–9 for an account of how Blanc attempted, in the brief period when he directed the artistic policy of the Republic, to review the art of reproductive engraving and, in his own phrase, 'to popularise the feeling for beauty' ('populariser le sentiment du beau').

80 See Bergeon, 1994, p. 44.

81 Ambroise Tardieu in *Le Courrier français*, no. 112, 24 April 1835: 'Les pastels de M. Dupont-Henriquel ont une grande délicatesse.'

82 See *Procès*, 1878, 2, pp. 34–5.

83 Gautier, 1994, p. 189: 'cette toile semble peinte avec de l'encre, de la teinte neutre et du cirage . . . il faudrait une palette plus riche que la sienne pour déguiser cette monotonie'.

84 Gautier, 1857, p. 79: 'Le *Strafford* afflige l'oeil par l'abus des noirs, qui ont un fâcheux ton de cirage . . . Ces défauts disparaissent à la gravure, qui ne laisse voir que la disposition habile de la composition.'

85 Perrot, 1844, p. 9: specific reference is made to Edelinck as one of the engravers to have proved himself in this way.

86 See Beraldi, 1981, VI, pp. 142–9.

87 Ibid., p. 143.

88 Ibid., pp. 143–4: 'Ceux qui aiment à chicaner et exigent absolument que les estampes donnent la sensation exacte, "religieuse" des peintures originales, lui reprocheront d'avoir conduit de belles tailles "qui ont l'air de se montrer pour leur compte avec l'unique intention de faire admirer" . . .'.

89 Quoted in Bann, 1997, p. 150.

90 Getty Research Institute, 860026, letter from Ingres to (Henriquel)-Dupont, postmarked 26 December 1840: 'C'est encore ici un regret à vous exprimer et un regret d'autant plus sincère que j'ai été très sensible à l'empressement que vous avez mis à m'offrir la Garantie de votre talent pour présenter mon oeuvre au Public. Mais en même temps que je recevais votre lettre et celle de vos éditeurs, j'en recevais une de Calamatta qui me faisait la même demande, il a trop bien interprété mes tableaux pour que je ne doive pas me regarder comme engagé vis-à-vis de lui non seulement à satisfaire à ses demandes mais peut-être même à les attendre avant que d'engager ma parolle {sic} ailleurs . . . J'aurais même désiré pouvoir en cette occasion offrir à Calamatta

un autre tableau que l'Odalisque pour vous réserver l'exécution de cette planche que j'estime plus particulièrement s'adapter au genre d'expression de votre talent, mais je fus pris au dépourvu par le temps.'

91 Ternois, 1980, p. 81: 'ce tableau n'est pas celui de mon coeur, c'est du genre . . . Pourquoi n'auriez-vous pas jetté cet ouvrage à un autre à Dupont par example qui trouverait pâture à son talent . . .'.

92 See Getty Research Institute, 860026, ff. 3–4, for a fascinating letter to his patron, comte Amédée de Pastoret, dated 9 December 1824, where he disparages his time-consuming 'petits tableaux' which 'quoique on ait fait vous rangent toujours dans le genre', while consenting a little grudgingly to paint Pastoret's portrait.

93 See Beraldi, 1981, VIII, p. 84, note 1 where this willingness to be 'mêlé à son siècle' is emphasised, to the disadvantage of one of the foremost engravers of the next generation, Ferdinand Gaillard (b.1834), who devoted himself almost exclusively to the old masters.

94 See letter from Henriquel-Dupont to Labouchère, c.1853, in Bibliothèque municipale de Nantes, Collection Labouchère, Book 1, 656,70. Henriquel relates that he tried to withdraw from consideration for the award, considering that he was himself a member of the Academy. However he saved the situation by dividing the prize of 4000 francs between the Association des artistes and a subsidy for the entry costs of the Salon. Labouchère comments: 'Un acte aussi noble est au-dessus de tout éloge'.

95 Procès, 1878, 2, p. 52: 'Le Ministre des Beaux-Arts lui offrit une augmentation de prix qu'il accepta; mais il voulut que cette somme fût employée à une souscription sans laquelle la gravure de l'*Hémicycle* ne pouvait être entreprise par son éditeur'.

96 For the account of Delaroche retouching the copy painted by 'les élèves de Delaroche', see Mirecourt, 1871, pp. 32–3. The identification with Charles Béranger (1816–1853) is likely because of his proven closeness to Delaroche as a pupil around 1840, when the *Hémicycle* was nearing completion. However it is also possible that the copy was made by his elder brother, Emile Béranger (1814–1883), who certainly worked with the Maison Goupil on similar reproductions in the 1860s, as well painting his own genre pictures.
 The entry in the Goupil account books reads as follows: 'L'Hémicycle des Beaux-Arts / Béranger d'après Paul Delaroche /[Cost price] 5000 francs Cadre / [Sale Price] 50,000 francs / à M. Gaillard de Grenoble/ [left] 15 April 1860.' (Getty Research Institute, 900239 – 1, f. 11, no. 99). An annotated copy of the sale catalogue of Delaroche's works, published by Drouot in 1857, suggests that the work was a 'réduction, faite en 1841 pour l'exécution de la gravure' which was 'entièrement repeinte en 1853 par M. Paul Delaroche, avec de notables modifications'. These 'modifications' can be detected, in particular, in the attention given to the allegorical figure of the Renaissance, who is noticeably more bejewelled. The fact that this work was sold to Goupil for the very large sum of 43,900 francs – compared with 36,000 francs for the *Jeune martyre chrétienne* – makes it virtually certain that the painting made for Henriquel, the work featured in the sale catalogue and the 'Béranger' featured in the account books are one and the same. This calculation takes into account the probability that the 5000 francs detailed as 'prix de revient' covers only the splendid gilded frame, incorporating a key to all the figures, that still accompanies the painting.

97 Strahan, 1880, p. 82. It is significant that Strahan was himself a former student of Delaroche's pupil Jean-Léon Gérome.

98 Rovani, 1853, p. 164: 'Se i pregi meravigliosi di concetto, di stile, di disegno appaiono evidentemente nelle tre bellissime incisioni che ne fece il Dupont, talchè ognuno che le osserva può farsi un'idea ampia e chiara e dell'importanza di quest'opera che è la più vasta e la più meditata di De la Roche . . . quegli altri pregi che s'incarnano col pennello e col colore, siamo assicurati che non si possono vedere che osservando il dipinto stesso, dove ciascuna figura, ciascun pittore è riprodotto con quel modo speciale di colorire che distingue di primo tratto o la maniera della scuola o quella dell'individuo'.

99 Blanc, 1860, p. 354: 'si la fortune d'un tableau appelle et commande le graveur, le graveur à son tour agrandit et propage la fortune du tableau'.

100 Ibid.: 'Quand nous la revoyons sur le cuivre du graveur, la composition de Paul Delaroche nous semble encore plus digne et plus haute.'

101 Ibid., p. 359: 'Que d'habileté, que de souplesse, que d'esprit dans sa traduction! . . . Une autre nouveauté remarquable dans la gravure d'Henriquel Dupont, c'est l'économie du système, c'est l'art de laisser travailler le papier.'

102 Beraldi, 1981, VIII, p. 82: 'son procédé le plus caractéristique est le travail libre, exécuté presque entièrement à l'eau-forte, avec légère reprise au burin'. My reservations about this description of the work on the *Hémicycle* engraving are shared by Pierre-Lin Renié, who has charge of the original plates.

103 Blanc, 1860, p. 360: 'De cette manière l'estampe semble avoir été mordue par le peintre lui-même en un jour de bonne humeur, et au lieu d'être serrée, voulue et tendue comme l'est quelquefois l'exécution de Paul Delaroche, la gravure est facile, brillante et d'autant plus spirituelle que l'esprit du maître y est conservé dans sa fraîcheur étant saisi et fixé du premier coup.'

104 Blanc, 1859, p. 188: '[Delaroche's composition] dans la gravure a pris une harmonie que n'avait pas la peinture, un peu rougeâtre et molle.'

105 Blanc, 1889, p. 629: 'Détailler les cheveux, les graver, pour ainsi parler, un à un, ce n'est pas le meilleur des procédés . . . De nos jours, l'éminent artiste qui a si magnifiquement gravé l'*Hémicycle* de Paul Delaroche a suivi un système contraire: il a traduit les chevelures avec la légèreté voulue, par des tailles relativement espacées qui, au lieu de compter les cheveux comme s'ils étaient peignés au peigne fin, les rassemblent par petites masses et font la même illusion au regard, parce que l'oeil . . . supplée la finesse du détail. Il est donc juste de dire que l'artiste est toujours *vrai* quand il saisit l'*esprit* des choses.'

106 For further information, see Bann, 1997, pp. 220–7; also the excellent recent essays, Allemand-Cosneau and Julia, 1999, pp. 105–29, which scrupulously detail the significance of the choice of artists and the influence upon subsequent projects, and Boyer, 1997, pp. 155–70, which analyses the historiographic implications of Delaroche's scheme.

107 Delaborde, 1853, p. 599: 'Ce que Gérard Audran avait fait quelquefois pour les tableaux de Lebrun, M. Henriquel-Dupont le fit pour le tableau de M. Delaroche; il sut le traduire fidèlement, tout en le complétant au fond, et y ajouter quelque qualité nouvelle sans pour cela le transformer.'

108 Ibid.: 'A côté de morceaux largement exécutés, certains autres, – comme les chairs, les cheveux, les pièces d'armure, – sont traités si délicatement, que le procédé ne se laisse pas deviner, et qu'on reconnaît seulement l'apparence d'un corps souple, soyeux ou inflexible, là où il n'y a que des tailles diversement entrecroisées, des sillons plus ou moins profonds.'

109 Ibid.: 'il a le temps d'oublier la diversité des expressions, des costumes, en un mot l'apparence contradictoire des objets représentés'.

110 Ibid., pp. 604–5: 'Ici, comme sous le pinceau de M. Delaroche, chaque peintre, architecte ou sculpteur garde la physionomie de son temps, chaque détail d'ajustement a son relief propre et son apparence essentielle; seulement, tout en diversifiant les procédés, le burin du graveur a su conserver partout une égale sérénité pour ainsi dire, et grâce à cette réserve constante dans la manoeuvre, à ce sentiment de mesure dans l'interprétation des effets partiels, aucune dissonance ne vient troubler l'harmonie générale. Ainsi, les deux groupes qui terminent la composition à droite et à gauche, et qui devaient s'isoler quelque peu du reste en raison même de la place où ils se trouvent, se relient cependant aux autres parties par la fermeté dégradée du travail. La figure de Poussin et, à l'extrémité opposée, celles d'Antoine de Messine et de Van-Eyck sont accusées avec une rigueur qui s'atténue dans le modelé des figures voisines. A mesure que celles-ci se rapprochent du centre, le cuivre est moins énergiquement fouillé, les tailles ont plus de légèreté et de souplesse, et en se modifiant ainsi, les travaux arrivent insensiblement à la délicatesse et à la douceur dans les figures placées au milieu'.

111 See Gotlieb, 2000, pp. 124–43, for a discussion of the reasons for placing Poussin in this crucial position, which Henriquel has perhaps also underlined in his own treatment.

112 See Allemand-Cosneau and Julia, 1999, p. 112.

113 Delaborde, 1853, p. 603: 'la figure de femme qui lance les couronnes se détache du fond par le vif accent des lumières, au lieu d'être, comme dans la peinture, plus fortement teintée que les marches qui s'élèvent derrière elle'.

114 See Renié, 1999, p. 191, for the illustration of the print and plate together; this does not however really convey the brilliant sheen arising from the burin marks on the latter.

115 Delaborde, 1853, p. 605: 'Ils peuvent seulement, à l'exemple de M. Henriquel-Dupont, essayer de compléter le texte et quelquefois en rendre le sens par une expression détournée, faute d'équivalent dans leur propre idiome, mais ils ne sauraient recourir à ce moyen extrême que dans les cas de nécessité absolue

116 Ibid., p. 602. The two engravers, visible just to the right of the furthest right-hand column, in the right-hand engraving, do indeed seem to have been included almost as an afterthought.

117 Ibid., p. 606: 'En dépit de la plus judicieuse dissertation sur l'excellence de la gravure, une épreuve héliographique gardera aux yeux de beaucoup de gens toute son autorité et son prestige: mise en regard d'une estampe comme *l'Hémicycle*, elle laissera voir claire-ment ce qu'il y a d'insuffisant et de faux pour ainsi dire au fond des vérités brutes que formule le daguerréotype.'

118 See Goddé, 1858, f. 898: the preliminary sketches for Leonardo da Vinci and the figures of the Middle Ages and the Renaissance are also included.

119 *La Lumière,* 7th year, no. 37, 12 September 1857, p. 145: 'Nous croyons que, dans aucun cas, l'on ne doit comparer la gravure à la pho-tographie; mais nous devons avouer que nous éprouvons une vive satisfaction en songeant que nous retrouverons un jour toutes les oeuvres du grand artiste dans le portefeuille de M. Bingham . . .'.

120 See *Publications nouvelles de la Maison Goupil et compagnie*, January 1859, Archives of the Musée Goupil, Bordeaux. When exhibited at the London Photographic Society in 1859, it was priced at 31/6.

121 See Rouillé, 1989, pp. 318–24, for the dis-cussion of the significance of this exhibition: the comments on Bingham's work are to be found in Figuier, 1860, pp. 44–5.

122 *La Lumière,* no. 10, 30 May 1861, p. 39: 'Son *Amateur de gravures* est un bijou; jamais reproduction par la gravure ne pourra en approcher . . .'.

123 Ibid.: 'du moment que la photographie traduit le jaune et le rouge en noir et rend chaque touche avec sa valeur photogènique, tous les visages doivent paraître barbouillés sans que le photographe puisse l'empêcher'.

124 A fine example of the framed set of prints, dating from this period, exists in the collec-tions of the Musée des Beaux-Arts, Orléans.

125 See the introduction by Therese Mulligan, Curator of Photography at George Eastman House, to the exhibition *Digital Frontiers: Photography's Future at Nash Editions* (George Eastman House publications, 1998): 'In ever greater measure, the arbitrary lines once separating photography from other art media are blurred . . .'. It is appropriate that photo-graphic practice should, in this respect, be in advance of much that is done in the name of photographic theory.

et oublier jamais que leur émancipation même doit avoir l'apparence de la soumission.'

Bibliography

I ARCHIVAL AND MANUSCRIPT SOURCES

Paris

ARCHIVES DE L'INSTITUT DE FRANCE

5 E 25: letters relating to candidature of Nicolas-Toussaint Charlet for the Institut; Registre des procès-verbaux des séances de l'Académie des Beaux-Arts, 1826–36.

BIBLIOTHÈQUE DE L'INSTITUT DE FRANCE

MS 2164 Fonds Delaborde: letters of engravers belonging to the Académie des Beaux-Arts (Bervic, Pierre-Alexandre Tardieu, François Forster, Alphonse François, Louis Henriquel-Dupont etc.) mainly to Henri Delaborde and his predecessors as Secretary of the Académie des Beaux-Arts.

BIBLIOTHÈQUE HISTORIQUE DE LA VILLE DE PARIS

Fonds Sand J 36: autobiographical manuscript by Luigi Calamatta in the hand of Lina Calamatta; J 131–136: letters of Paolo Mercuri to Luigi Calamatta.

BIBLIOTHÈQUE NATIONALE DE FRANCE

MS NAF 16800: letters received by Paul Delaroche.

Nantes

BIBLIOTHÈQUE MUNICIPALE

Collection Labouchère: prints and manuscripts relating to early nineteenth-century French painters.

Los Angeles

GETTY RESEARCH INSTITUTE

860470: letter from Eugène Delacroix to unknown recipient (ref. to *répétition* of his *Medea*)

860026: letter from Jean-Dominique Ingres to Louis Henriquel-Dupont and Amédée de Pastoret; letters written on behalf of Madame Ingres to Léopold Flameng.

860047: deposition of Ernest Meissonier on his relations with the dealer Ernest Gambart.

870585: letter from Anne-Louis Girodet to Louis Henriquel-Dupont (ref. to collaboration).

910034: letters from Luigi Calamatta to Cardinal Tosti and Lucio Quirino Lelli.

900171: letter from Lucio Quirino Lelli to Francesco Giangiacomo.

900239 – 1: Account books of Goupil et Cie 1846–1851–1861.

Rochester, N.Y.

GEORGE EASTMAN HOUSE

AC D 332 acc.1102: letter from Eugène Delacroix to unknown recipient (ref. to photography).

AC D 339 acc.9810: note submitted by Paul Delaroche to François Arago on the subject of the Daguerreotype.

Cromer collection, 84.369.1: works by Louis-Jacques-Mandé Daguerre with Cromer's annotations; 94.1498.1: album of work by Charles-Marie Bouton, collaborator of Daguerre.

II WORKS CITED IN THE TEXT AND NOTES

Ackerman, Gerald M., *The Life and Work of Jean-Léon Gérôme with a Catalogue Raisonné*, London: Sotheby's, 1986.

Adhémar, Jean and Lethève, Jacques (eds), *Inventaire du fonds français après 1800*, vols VI–XII, Paris: Bibliothèque Nationale, 1953–65.

Allemand-Cosneau, Claude and Julia, Isabelle (eds), *Paul Delaroche: Un peintre dans l'histoire*, Paris: Réunion des musées nationaux, 1999.

Balzac, Honoré de, *La Peau de chagrin*, with illustrations by Baron, Janet-Lange, Gavarni, François and Marckl, engraved in steel by Brunellière, Nargeot and Langlois, Paris: Delloye and Lecou, 1838.

Bann, Stephen, *The Clothing of Clio: A Study of the Representation of History in Nineteenth-century Britain and France*, Cambridge and New York: Cambridge University Press, 1984.

Bann, Stephen, *Romanticism and the Rise of History*, New York: Twayne, 1995.

Bann, Stephen, 'La carte comme ancrage historique', in Marie-Ange Brayer (ed.), *Cartographiques*, Paris: Réunion des musées nationaux, 1996, pp. 95–104.

Bann, Stephen, *Paul Delaroche: History Painted*, London: Reaktion Books, 1997.

Bann, Stephen, 'Envisioning Rome: Granet and Gibbon in dialogue', in Catharine Edwards (ed.), *Receptions of Rome in European Culture, 1789–1945*, Cambridge and New York: Cambridge University Press, 1999, pp. 35–52.

Barthes, Roland, 'Le message photographique' (1961) and 'Rhétorique de l'image' (1964) in *L'Obvie et l'obtus: Essais critiques III*, Paris: Seuil, 1982, pp. 9–42.

Baschet, Robert, *E.-J. Delécluze: Témoin de son temps 1781–1863*, Paris: Boivin, 1942.

Batchen, Geoffrey, *Burning with Desire: The Conception of Photography*, Cambridge, Mass., and London: MIT Press, 1997.

Baudelaire, Charles, *Journal*, trans. Walter Pach, New York: Grove, 1961.

Baudelaire, Charles, *Curiosités esthétiques*, ed. Julien Cain, Paris: Hermann, 1968.

Baxandall, Michael, *Patterns of Intention: On the Historical Explanation of Pictures*, New Haven and London: Yale University Press, 1985.

Beck, Hilary, *Victorian Engravings*, London: Victoria and Albert Museum, 1973.

Benjamin, Walter, *Illuminations*, ed. Hannah Arendt with an introduction, trans. Harry Zohn, London: Fontana, 1992 [1973].

Benjamin, Walter, *Gesammelte Schriften*, ed. Rolf Tiedemann and Herman Schweppenhäuser, Frankfurt: Suhrkamp, 1974.

Beraldi, Henri, *Les Graveurs du XIXe siècle*, 12 vols, reprint, Nogent-le-Roi: Laget, 1981 [1885–92].

Béranger, P. J. de, *Oeuvres complètes*, 4 vols, Paris: Perrotin, 1834.

Bergeon, Annick, 'Le temps ciselé: Correspondances autour d'une oeuvre gravée: artistes, critiques (1829–1859)', in *Etat des lieux* (Musée Goupil, Bordeaux), 1 (1994), pp. 37–88.

Bigorne, Régine, 'La maison Goupil avant Goupil et Cie *c.*1827–1850', in *Etat des lieux* (Musée Goupil, Bordeaux), 2 (2000), pp. 7–40.

Bingham, Robert J., *Photogenic Manipulation: Pt I containing the Theory and Plain Instructions in the Art of Photography or the Production of Pictures through Agency of Light*, 7th edition, London: George Knight, 1850.

Blanc, Charles, 'La Madona de l'Arc et les Moissonneurs, par M. Z. Prévost', *Le Courrier français*, 80 (1839), p. 4.

Blanc, Charles, 'Publications d'estampes: Moïse exposé sur le Nil, par M. Henriquel-Dupont', *Gazette des Beaux-Arts*, 1 (January–March 1859), pp. 188–9.

Blanc, Charles, 'L'Hémicycle de Paul Delaroche gravé par Henriquel Dupont', *Gazette des Beaux-Arts*, VII (October–December 1860), pp. 354–61.

Blanc, Charles, *Histoire des peintres de toutes les écoles*, Paris: Renouard, 1861–76.

Blanc, Charles, 'Du Style et de M. Ingres', *Gazette des Beaux-Arts*, XIV (1863–1), pp. 5–23.

Blanc, Charles, 'Calamatta 1802–1870', in *Les Artistes de mon temps*, Paris: Firmin-Didot, 1876, pp. 101–28.

Blanc, Charles, *Grammaire des arts du dessin*, 8th edition, Paris: Renouard, 1889 [1867].

Blanc, Charles, *Une famille d'artistes: Les Trois Vernet*, Paris: Laurens, 1898.

Bonnafous-Murat, Arsène, 'Prolégomènes à une histoire de la lithographie en France', in *Estampes modernes Henri M. Petiet: Commémoration du bicentenaire de la Lithographie*, Paris: PIASA Commissaires-priseurs, December 1999 n.p.

Bonnard, Camille, 'Lettre de l'auteur de l'ouvrage des *Costumes*, à un de ses amis', *Gazette des Beaux-Arts*, IV (September–December 1859), pp. 186–8.

Bourgeois, Paul (ed.), *Esthétique de la photographie*, with an *avant-propos* by Robert de la Sizeranne, Paris: Photo-Club de Paris, 1900.

Boyer, Sylvain, 'La Peinture de Paul Delaroche à l'Ecole des Beaux-Arts', *Bulletin de la Société de l'Art français*, année 1996, 1997, pp. 155–70.

Bryson, Norman, *Tradition and Desire in French Painting from David to Delacroix*, Cambridge and New York: Cambridge University Press, 1984.

Burty, Philippe, 'Exposition de la Société française de photographie', *Gazette des Beaux-Arts*, II (April–June 1859), pp. 209–21.

Carcopino, Claude, *Les Doctrines sociales de Lamennais*, reprint, Geneva: Slatkine, 1968.

Chalon-sur-Saône, *Catalogue: Les Bois gravés chalonnais*, Musée Denon, 1999.

Champlin, John and Perkins, Charles (eds), *Cyclopedia of Painters and Paintings*, New York: Scribners, 1888.

Chaudonneret, Marie-Claude, *L'Etat et les artistes: De la restauration à la Monarchie de Juillet 1815–1876*, Paris: Flammarion, 1999.

Chenique, Bruno, 'Le meurtre du père, ou les insensés de l'atelier Guérin', in *Le Temps des passions: Collections romantiques des musées d'Orléans*, exhibition catalogue, Orléans (Musée des Beaux-Arts), 1997–8, pp. 37–60.

Comment, Bernard, *The Panorama*, London: Reaktion Books, 1999.

Condon, Patricia, with Marjorie B. Cohn and Agnes Mongan, *In Pursuit of Perfection: The Art of J.-A.-D. Ingres*, exhibition catalogue, Louisville, Kentucky (The J. B. Speed Art Museum), 1983.

Courbet, Gustave, *Correspondance*, ed. Petra ten-Doesschate Chu, Paris: Flammarion, 1996.

Courboin, François and Roux, Marcel, *La Gravure française*, 4 vols, Paris, 1928–38.

Cousin, Victor, *Du Vrai, du beau et du bien*, 7th edition, Paris: Didier, 1858.

Cromer, G., 'Une pièce historique: l'original de la note du peintre Paul Delaroche à Arago au sujet du Daguerréotype', *Bulletin de la Société française de photographie et de cinématographie*, 3ème série, XVII (1936), pp. 114–18.

David à Delacroix: La peinture française de 1774 à 1830, exhibition catalogue, Paris (Grand Palais), 1974–5.

Delaborde, Henri, 'Beaux-Arts: l'Hémicycle du Palais des Beaux-Arts, gravé d'après M. Delaroche, par M. Henriquel-Dupont', *Revue des deux mondes*, 1853, pp. 590–607.

Delaborde Henri, 'La photographie et la gravure', *Revue des deux mondes*, 1 April 1856, pp. 617–38.

Delaborde, Henri, 'Gérard Edelinck', in Eugène Muntz (ed.), *Les Artistes célèbres*, Paris: Librairie de l'Art, 1888.

Delaborde, Henri, 'Paul Delaroche', *Revue des deux mondes*, 1 March 1857, pp. 5–32.

Delacroix: Le Trait romantique, exhibition catalogue, ed. Barthélemy Jobert, Paris (Bibliothèque Nationale), 1998.

Delacroix, Eugène, *Journals*, trans. Walter Pach, New York: Grove, 1961.

Delacroix, Eugène, 'Charlet', *Revue des deux mondes*, 1 July 1862, pp. 234–42.

Delacroix, Tout l'oeuvre peint, with an introduction by Pierre George, Paris: Flammarion, 1975.

Delécluze, E.-J., Salon review [signed 'D'], *Journal des Débats*, 3 March 1836.

Deleuze, Gilles, *The Logic of Sense*, trans. by Mark Lester, London: Athlone, 1990 [1969].

Diderot on Art, I, trans. John Goodman, 2 vols, New Haven and London: Yale University Press, 1995.

Didi-Huberman, Georges, ' "Figée à son insu dans une moule magique": Anachronisme du moulage, Histoire de la sculpture, Archéologie de la modernité', *Les Cahiers du Musée national d'art moderne*, Winter 1995, pp. 81–113.

Douzinas, Costas, and Lynda Nead (eds), *Law and the Image: The Authority of Art and the Aesthetics of Law*, Chicago and London: University of Chicago Press, 1999.

Durande, Amédée (ed.), *Joseph, Carle et Horace Vernet: Correspondance et biographies*, Paris: Hetzel, c.1863.

Duro, Paul, 'Le Musée des copies de Charles Blanc à l'aube de la IIIe République', *Bulletin de la Société de l'Histoire de l'Art français*, 1985, pp. 283–313.

Eitner, Lorenz, '"Subjects from Common Life in the Real Language of Men": Popular Art and Modern Tradition in Nineteenth-century French Painting', in Kirk Varnedoe and Adam Gopnik (eds), *Modern Art and Popular Culture: Readings in High and Low*, New York: Abrams, 1990.

Ewals, Leo, *Ary Scheffer 1795–1858: Gevierd Romanticus*, Dordrechts Museum, Zwolle: Waanders Uitgevers, 1995.

Ewals, Leo, *Ary Scheffer 1795–1858*, Paris: Réunion des musées nationaux, 1996.

Explication des ouvrages de peinture, sculpture, gravure, lithographie et architecture des artistes vivans, exposés au Musée royal, le 1er Mai 1831, Paris: Ballard, 1831.

Figuier, Louis, *La Photographie au Salon de 1859*, Paris: Hachette, 1860.

Foster, Hal, 'The Archive without Museums', *October* 77 (Summer 1996), pp. 98–119.

Fouque, Victor, *La Vérité sur l'invention de la photographie: Nicéphore Niépce, sa vie, ses essais, ses travaux*, Paris: Librairie des auteurs and Chalon-sur-Saône: Librairie Ferran, 1867.

Fried, Michael, *Courbet's Realism*, Chicago and London: University of Chicago Press, 1990.

Fried, Michael, *Manet's Modernism, or The Face of Painting in the 1860's*, Chicago and London: University of Chicago Press, 1996.

Frizot, Michel, *Nouvelle Histoire de la Photographie*, Paris: Bordas, 1994.

Galichon, Emile, 'Artistes contemporains: Pierre-Alexandre Tardieu', *Gazette des Beaux-Arts*, XIV (1863), pp. 215–22.

Gascoigne, Bamber, *How to Identify Prints*, London: Thames and Hudson, reprint 1998.

Gautier, Théophile, 'Exposition des oeuvres de Paul Delaroche au Palais des Beaux-Arts', *L'Artiste*, new series, I, 3 May 1857, pp. 77–80.

Gautier, Théophile, *Critique d'art: Extraits des Salons 1833–1872*, ed. Marie-Hélène Girard, Paris: Séguier, 1994.

Gautier, Théophile, *Bonjour, Monsieur Corot*, Preface by Marie-Hélène Girard, Paris: Séguier, 1996.

Georgel, Chantal, *1848: La République et l'Art vivant*, Paris: Réunion des musées nationaux, 1998.

Géricault, exhibition catalogue, Paris (Grand Palais), 1991.

Géricault, Théodore, *Des Ecoles de peinture et de sculpture et du prix de Rome*, Caen: L'Echoppe, 1986.

Gérôme et Goupil, exhibition catalogue, Bordeaux (Musée Goupil), 2000.

Gernsheim, Helmut, *The Origins of Photography*, London: Thames and Hudson, 1982 [1955].

Gernsheim, Helmut and Alison, *L. J. M. Daguerre 1787–1851: The World's First Photographer*, Cleveland and London: World Publishing Company, 1956.

Goddé, Jules (ed.), *Oeuvre de Paul Delaroche*, with an introduction by Henri Delaborde and illustrated with photographs by Robert J. Bingham, Paris: Goupil, 1858.

Gooch, Brison D., *The New Bonapartist Generals in the Crimean War*, The Hague: Martinus Nijhoff, 1959.

Gotlieb, Marc, *The Plight of Emulation: Ernest Meissonier and French Salon Painting*, Princeton: Princeton University Press, 1996.

Gotlieb, Marc, 'Poussin's Lesson: representing representation in the Romantic Age', in *Word & Image*, 16, 1 (January–March 2000), pp. 124–43.

Griffiths, Antony, *Prints and Printmaking: An Introduction to the History and Techniques*, London: British Museum, 2nd edition, 1996.

Gusman, Pierre, *La Gravure sur bois en France au XIXe siècle*, Paris: Editions Albert Morancé, 1929.

Hamber, Anthony, *'A Higher Branch of the Art': Photographing the Fine Arts in England 1839–1880*, Amsterdam: Gordon and Breach, 1996.

Hartung, Stefan, 'Victor Cousins ästhetische Theorie', *Zeitschrift für französische Sprache und Literatur*, CVII, 2 (1997), pp. 173–95.

Haskell, Francis, *History and its Images: Art and the Interpretation of the Past*, New Haven and London: Yale University Press, 1993.

Hémicycle des Beaux-Arts, Peinture murale exécutée par Paul Delaroche et gravée au burin par Henriquel-Dupont: Notice explicative, Paris: Goupil, 1853.

Hungerford, Constance Cain, *Ernest Meissonier: Master in his genre*, Cambridge and New York: Cambridge University Press, 1999.

Hunnisett, Basil, *Engraved in Steel: The History of Picture Production using Steel Plates*, Aldershot: Ashgate, 1998.

Ingamells, John, *The Wallace Collection Catalogue of Pictures: French Nineteenth Century*, London: The Wallace Collection, 1986.

Ingres, exhibition catalogue, Paris (Petit Palais), 1967.

Ingres, L'Opera completa, edited by Emilio Radius, with critical apparatus by Ettore Camesasca, Milan: Rizzoli, 1968.

Ingres, L'Oeuvre gravé dans les collections du musée Ingres de Montauban, exhibition catalogue, Châtellerault (Musée municipal), 1991.

Ivins, William M., *Prints and Visual Communication*, 9th paperback printing, Cambridge, Mass.: MIT Press, 1996.

Jack, Belinda, *George Sand: A Woman's Life Writ Large*, London: Chatto and Windus, 1999.

Jal, Auguste, *Les Causeries du Louvre: Salon de 1833*, Paris: Charles Gosselin, 1833.

Janis, Eugenia Parry, *The Photographs of Gustave Le Gray*, Chicago: University of Chicago Press, 1987.

Jay, Paul, *Niépce: Genèse d'une invention*, Chalon-sur-Saône: Société des amis du Musée Niépce, 1988.

Johnson, Dorothy, *Jacques-Louis David: Art in Metamorphosis*, Princeton: Princeton University Press, 1993.

La Combe, Joseph-Félix Le Blanc de, *Charlet: Sa Vie, ses lettres*, Paris: Paulin and Le Chevalier, 1856.

Lafont-Couturier, Hélène, 'La Maison Goupil ou la notion de l'oeuvre originale remise en question', *Revue de l'art*, 112 (1996–2), pp. 59–69.

Lafont-Couturier, Hélène, 'Le Mariage de l'art et de la raison commerciale', in *Etat des lieux* (Musée Goupil, Bordeaux), 2 (2000), pp. 41–70.

Lagrange, Léon, 'La lithographie', *Gazette des Beaux-Arts*, xv (1863–2), pp. 297–327.

Lamoureux, Johanne, 'Delaroche et la mort de la peinture', *Word & Image*, 16, 1 (January–March 2000), pp. 116–23.

Landon, C.P., *Salon de 1812*, Paris: Annales du Musée et de l'Ecole Moderne des Beaux-Arts, 1812.

Landon, C.P., *Salon de 1814*, Paris: Annales du Musée et de l'Ecole Moderne des Beaux-Arts, 1814.

Le Men, Ségolène, 'Printmaking as metaphor for translation: Philippe Burty and the *Gazette des Beaux-Arts* in the Second Empire', in Michael R. Orwicz, *Art Criticism and its Institutions in Nineteenth-century France*, Manchester: Manchester University Press, 1994, pp. 88–108.

Lemoisne, P. André, *Eugène Lami 1800–1890*, Paris: Goupil, 1912.

Lyons, *Catalogue du Musée des Beaux-Arts*, Lyons, 1877.

Magimel, Albert, *Oeuvres de J. A. Ingres, gravées au trait sur acier par A. Réveil*, Paris: Firmin-Didot, 1851.

Maleuvre, Didier, *Museum Memories: History, Technology, Art*, Stanford: Stanford University Press, 1999.

Markham, Felix, *Napoleon*, New York: Signet, 1963.

Marrinan, Michael, 'Literal/Literary "Lexie": history, text and authority in Napoleonic painting', *Word & Image*, 7, 3 (July–September 1991), pp. 177–200.

Marx, Karl, *The Eighteenth Brumaire of Louis Bonaparte*, Moscow: Progress, 1967.

Matthews, Oliver, *Early Photographs and Early Photographers: A Survey in Dictionary Form*, London: Readminster Publications, 1973.

McCalmont, Rose E., *Memoirs of the Binghams*, London: Spottiswoode & Co., 1915.

McCauley, Anne, 'Industrial Development, Political Economy, and the Invention of Photography in Restoration France', in *Nicéphore Niépce: Une nouvelle image; Actes du colloque 15/16 Janvier 1998*, Chalon-sur-Saône: Société des amis du musée Nicéphore Niépce, 1999, pp. 80–90.

McLellan, Andrew, *Inventing the Louvre: Art, Politics and the Origins of the Modern Museum in Eighteenth-century Paris*, Cambridge and New York: Cambridge University Press, 1994.

McLennan, Heather, 'Antiquarianism, Connoisseurship and the Northern Renaissance Print: New Collecting Cultures in the Early Nineteenth Century', in Martin Myrone and Lucy Peltz (eds), *Producing the Past: Aspects of Antiquarian Culture and Practice 1700–1850*, Aldershot: Ashgate, 1999, pp. 35–54.

McWilliam, Neil, *Dreams of Happiness: Social Art and the French Left 1830–1850*, Princeton: Princeton University Press, 1993.

Melion, Walter, 'Theory and Practice: Reproductive Engravings in the Sixteenth-century Netherlands', in *Graven Images: The Rise of Professional Printmakers in Antwerp and Haarlem, 1540–1640*, exhibition catalogue, Evanston: Northwestern University (Mary and Leigh Block Gallery), 1993, pp. 47–69.

Mellerio, André, and Louis de Nussac, *La Lithographie en France: Charles de Lasteyrie, son premier introducteur*, Brive: Imprimerie Lachaise, 1936.

Mirecourt, Eugène de, *Delaroche Decamps*, 3rd edition, Paris: Roret, 1871.

Mirecourt, Eugène de, *Horace Vernet*, Paris: Roret, 1855.

Mitchell, W. J. T., *Picture Theory*, Chicago: University of Chicago Press, 1994.

Mondzain, Marie-José, *Image, icône, économie: Les sources byzantines de l'imaginaire contemporain*, Paris: Seuil, 1996.

Montaigne, Michel de, *Essais*, nouvelle édition, 4 vols, Paris: Lefèvre, 1818.

Moulin, Raymonde, *Le Marché de peinture en France*, Paris: Minuit, 1967.

Musset, Alfred de, 'Salon de 1836', *Revue des deux mondes*, 15 April 1836, pp. 144–76.

Myrone, Martin, 'Graphic Antiquarianism in Eighteenth-century Britain: The Career and Reputation of George Vertue (1684–1756)', in Martin Myrone and Lucy Peltz (eds), *Producing the Past: Aspects of Antiquarian Culture and Practice 1700–1850*, Aldershot: Ashgate, 1999, pp. 35–53.

Nadar, *Quand j'étais photographe*, Paris: Seuil, 1994 [1900].

Nelson, Viscount, *Dispatches and Letters*, 2 vols, London: Henry Colburn, 1845.

Néto, Isabelle (ed.), *Granet et son entourage*, Archives de l'Art français, nouvelle période, XXXI, Nogent-le-Roi: Editions Jacques Laget, 1995.

Niépce, Joseph-Nicéphore, *Correspondances 1825–1829*, Rouen: Pavillon de la Photographie, 1974.

Nietzsche, Friedrich, *The Birth of Tragedy and The Genealogy of Morals*, trans. Francis Golffing, New York: Doubleday, 1956.

Noon, Patrick, *Richard Parkes Bonington 'On the Pleasure of Painting'*, New Haven and London: Yale University Press, 1991.

Ortel, Philippe, 'Poetry, the picturesque and the photogenic quality in the nineteenth century', *Journal of European Studies*, 30, 1, no. 117 (March 2000), pp. 19–33.

Perrault, Charles, *Les Hommes illustres qui ont paru en France pendant le XVII siècle*, new edition, The Hague: Matthieu Rogguet, 1707.

Perrot, A. M., *Nouveau Manuel complet du graveur*, new edition greatly enlarged by F. Malepeyre, Paris: Roret, 1844.

Place, Jean-Michel (ed.), *Catalogues des expositions organisées par la Société française de photographie 1857–1876*, Paris: Jean-Michel Place, 1985.

Portalis, Baron Roger, and Henri Beraldi, *Les Graveurs du dix-huitième siècle*, 3 vols, Paris: Morgand et Fatout, 1880.

Préaud, Maxime, *Inventaire du fonds français: Graveurs du XVIIe siècle*, Paris: Bibliothèque Nationale de France, 1988.

Procès de MM. Delaroche, Mme Veuve Vernet, Mme Marjolin-Scheffer contre MM. Goupil et Cie. Éditeurs, Paris: Tribunal Civil de la Seine, 1878.

Reed, Sue Welsh, *French Prints from the Age of the Musketeers*, exhibition catalogue, Boston (Museum of Fine Arts), 1998.

Reinaud, Emile, *Charles Jalabert: L'homme, l'artiste d'après sa correspondance*, Paris: Hachette, 1903.

Renié, Pierre-Lin, 'Delaroche par Goupil: portrait du peintre en artiste populaire', and 'Oeuvres de Paul Delaroche reproduites et éditées par la Maison Goupil', in Claude Allemand-Cosneau and Isabelle Julia (eds), *Paul Delaroche: Un peintre dans l'histoire*, Paris: Réunion des musées nationaux, 1999, pp. 173–99 and 200–18.

Revue des Lyonnais, anonymous article on Charlet, in vol. XV, 1842, p. 70.

Robert-Dumesnil, A. P. F., *Le Peintre-graveur français, ou catalogue raisonné des estampes gravées par les peintres et les dessinateurs de l'école française*, 11 vols, Paris: G. Warée, 1835–71.

Roquencourt, Jacques, 'Daguerre et l'optique', *Etudes photographiques*, 5 (November 1998), pp. 26–49.

Rosenblum, Naomi, *Une Histoire mondiale de la photographie*, Paris: Editions Abbeville, 1997.

Rouillé, André (ed.), *La Photographie en France: Textes et controverses: Une anthologie 1816–1871*, Paris: Macula, 1989.

Roux, Marcel, *Inventaire du fonds français: graveurs du dix-huitième siècle*, Paris: Bibliothèque Nationale, 1933.

Rovani, Giuseppe, 'L'Emiciclo della Scuola delle Belle Arti in Parigi dipinto di Paolo de la Roche', in Mariano Lombardi (ed.), *Albo artistico napoletano*, Naples: Stamperia e carterie del Fibuno, 1853.

Salons retrouvés (Les), Eclats de la vie artistique dans la France du Nord 1815–1848, Calais: Association des conservateurs des Musées du Nord-Pas-de-Calais, 1993.

Sanchez, Pierre, and Xavier Seydoux (eds), *Les Estampes de la Gazette des Beaux-Arts 1859–1933*, Paris: L'Echelle de Jacob, 1998.

Sanchez, Pierre, and Xavier Seydoux (eds), *Les Catalogues des salons*, I (1801–1819) and II (1819–1834), Paris: L'Echelle de Jacob, 1999.

Sand, George: Exposition organisée pour le cent cinquantième anniversaire de sa naissance, exhibition catalogue, Paris (Bibliothèque Nationale de France), 1954.

Sand, George, *Oeuvres autobiographiques*, Paris: Gallimard, 1971.

Scharf, Aaron, *Art and Photography*, Harmondsworth: Allen Lane, 1975 [1968].

Schnapper, Antoine, 'Editorial: "L'Age classique" ', *Revue de l'Art*, 21, 1973, pp. 17–22.

Scott, Katie, 'Art and Industry – A Contradictory Union: Authors, Rights and Copyrights', *Journal of Design History*, 13, 1 (2000), pp. 1–21.

Scott, Katie, 'Authorship, the Académie, and the Market in Early Modern France', *Oxford Art Journal*, 21, 1 (1998), pp. 27–41.

Ségur, Comte de, *Histoire et mémoires*, Paris: Firmin-Didot, 1873.

Siegfried, Susan, 'Naked History: The Rhetoric of Military Painting in Postrevolutionary France', *Art Bulletin*, LXXV, 2 (June 1993), pp. 235–57.

Shiff, Richard, 'Mastercopy', *Iris* (Paris), I, 2 (September 1983), pp. 113–27.

Sizeranne, Robert de la, *La Photographie est-elle un art?*, Paris: Hachette, 1899.

Slive, Seymour, *Dutch Painting 1600–1800*, New Haven and London: Yale University Press, 1995.

Snyder, Joel, Review of Batchen, *Burning with Desire*, *Art Bulletin*, LXXXI, 3 (September 1999), pp. 540–2.

Soltykoff: Catalogue des objets d'art et de haute curiosité composant la célèbre collection du prince Soltykoff, dont la vente aura lieu Hôtel Drouot, salle 7, les lundi 8 Avril et jours suivants, Paris, 1861.

Stendhal, *La Chartreuse de Parme*, Paris: Nelson, 1959.

Stendhal, *Du Romantisme dans les arts*, ed. Juliusz Starzynski, Paris: Hermann, 1966.

Stirling, William, *Annals of the Artists of Spain*, 3 vols, London: Ollivier, 1847.

Strahan, Edward [pseud. Earl Shinn], *The Art Treasures of America*, Philadelphia: G. Barrie, c.1880.

Tableaux historiques des campagnes d'Italie, Paris: Auber, 1806.

Tardieu, Alexandre, 'Notice sur les Tardieu, les Cochin et les Belle graveurs et peintres', in *Archives de l'art français: recueil de documents inédits*, Paris: J. B. Dumoulin, 1856, VII, pp. 49–68.

Ternois, Daniel (ed.), 'Lettres d'Ingres au graveur Luigi Calamatta', in *Actes du colloque international Ingres et son influence*, Montauban: Bulletin spécial des *Amis du Musée Ingres*, 1980, pp. 77–110.

Thierry, Augustin, *Histoire de la conquête de l'Angleterre*, 5th edition, atlas, Paris: Just Tessier, 1839.

Tissandier, Gaston, *Les Merveilles de la photographie*, Paris: Hachette, 1874 [1873].

Trapp, Frank (ed.), *Mead Art Museum Monograph*, 8–9, winter 1987–8, Amherst, Mass.: 1987.

Valentin, F., *Les Peintres célèbres*, 3rd edition, Tours: Mame, 1844.

Vernet, Horace, *Du Droit des peintres et des sculpteurs sur leurs ouvrages*, Paris: Imprimerie Edouard Proux, 1841.

Vernet, Horace, *Lettres intimes . . . pendant son voyage en Russie 1842 et 1843*, edited by Théophile Sylvestre, Paris, 1856.

Viel-Castel, Horace, de, 'Cromwell de M. Delaroche', *L'Artiste*, I, 22 (1831), pp. 268–70.

Vigne, Georges, 'Scandale au Salon de 1834!', in *Papiers d'Ingres*, Collections graphiques du Musée Ingres de Montauban, 20, 1998, pp. 1–9.

Vitet, L., *Oeuvre de Ary Scheffer reproduit en photographie par Bingham, accompagné d'une notice sur la vie et les ouvrages de Ary Scheffer*, Paris: Goupil, 1860.

Voignier, J. M., *Répertoire des photographes de France*, Chevilly-Larue: Le Pont de Pierre, 1993.

White, Hayden, *Figural Realism: Studies in the Mimesis effect*, Baltimore: Johns Hopkins University Press, 1999.

Wrigley, Richard, *The Origins of French Art Criticism*, Oxford: Oxford University Press, 1993.

Ziff, Norman, *Paul Delaroche; A Study in Nineteenth-Century French History Painting*, Ann Arbor Michigan: Xerox University Microfilms, 1975.

Index

Page numbers in *italics* refer to illustrations.

Académie des Beaux-Arts 44, 78, 93, 105, 109, 181,
 235n43
Académie des Sciences 104–5, 106–8, 110
aciérage 17, 100, 156–7
Adhémar, Jean 53
Apollinaire, Guillaume 5
aquatint 131–2, 185, 188
Arago, François 90–91, 104–05, 106–8, 110, 222–3n54
Arrowsmith, John 98, 133
art, philosophy of 28–9
Audran, Gérard 128
Auerbach, Erich 16
'aura', of a work of art 9, 16–17
Austerlitz, Battle of 51, 52–3
authorship issues, engraving 154–6

Balvay, Charles-Clément *see* Bervic
Barthes, Roland 89
Batchen, Geoffrey 219n2
battle paintings
 by Charlet 75–9
 development of 44–7
 engravings of 47–57
 by Vernet (Carle) 47–56
 by Vernet (Horace) 80–87, 122–4
Baudelaire, Charles 9
Baxandall, Michael 3–4
 troc 4–6
Benjamin, Walter
 on mechanical reproduction 15–16, 17–18, 30, 40
 on printmaking 7–9
Beraldi, Henri
 on engraving history 6–7, 171–3, 179–82
 on Lemaître 220–21n27
 on Mercuri 133–5
 on reproductive engraving 59–60
 on Vernet (Carle) 56–7
 on Vernet (Horace) 79
Béranger, Charles 199, 209, 238n96
Berthier, Paul 162, 166, 232nn90, 91, 93
 Angelica (albumen print of painting by Ingres) 165, 166

Grande Odalisque (carbon print of painting by Ingres)
 160–62, *162*
Bervic (Charles-Clément Balvay)
 career of 7, 57, 178–83, 212n13
 on engraving techniques 31–3, 50–51, 217n17
 portrait of *8*
 WORKS
 Enlèvement de Déjanire (engraving after Reni) 172
 Gabriel Sénac de Meilhan (engraving after Duplessis)
 179, *180*
 Laocoon (engraving after drawing by Bouillon) 51, 57,
 58, 178–9, 217n18
Bingham, Robert Jefferson
 career of 118–25
 family background 224n85
 and Ingres 158–60
 and Meissonier 168, 233n100
 photographs of Delaroche's works 119–20, 208–10
 status of 11
 WORKS
 Antiochus and Stratonice (albumen print of painting by
 Ingres) 159–60, *160*, 167, 232n86
 Hémicycle des Beaux-Arts (albumen print of painting by
 Delaroche) 13, 208–9, *210–11*
 Horace Vernet (albumen print) 122, *123*
 Marie-Antoinette (albumen print after engraving by
 François of painting by Delaroche) *121*, 160
Biot, Isaac 94
Biot, Jean-Baptiste 108
Blanc, Charles
 on battle painting 44, 47, 124
 on Calamatta's engraving 150–51
 on Calamatta's studio 1–2, 5–6, 16–17, 29
 on engraving developments 109–10
 on Henriquel-Dupont 200–04
 on lithographers 79
 on Mercuri 131–2
 popularisation of art 5–6, 188, 237n79
Blanc, Louis 29, 138
Blanchard, Auguste 168, 169
Blanchard, Auguste *père*, engraving of Queen Hortense of
 Holland 155, 156
Bobet-Mezzasalma, Sophie 223n73

Boilly, Louis-Léopold 67
Bonnard, Camille 129–31
Boucher-Desnoyers, Auguste *see* Desnoyers, Baron Auguste
Bouillon, Pierre, *Laocoon* (engraving by Bervic) 57, 58
Boussod et Valadon 28
 see also Maison Goupil
Bouton, Charles-Marie 102
Bracquemond, Félix 156–7, 169, 171
burin engraving *see* engraving
Burty, Philippe 24–5, 31, 214nn14–16
Buttura, Eugène, drawing of Paul Delaroche 122, *123*
Byzantine art 29–30

Cabanel, Alexandre, *Birth of Venus* 28
Calamatta, Lina 127, 143
Calamatta, Luigi
 career of 128–9, 141–58
 engravings by 12, 35
 and Ingres 141–2, 143–55, 157–8, 196
 studio of 1–2, 5–6, *6*, 127
 WORKS
 Ferdinand-Philippe, duc d'Orléans (engraving after Ingres)
 151–3, *152*
 George Sand (engraving possibly after Delacroix)
 155–6, *155*
 Mona Lisa (engraving after Leonardo) *x*, 1, 2, 17,
 100, 156–7
 Paganini (crayon-manner engraving after Ingres)
 153–5, *154*
 Voeu de Louis XIII (engraving after Ingres) 2, 141,
 142, 144–7, *146*, 150–51
Callot, Jacques 53
camera obscura 100–01, 114
Camporese, Pietro 143, 228n42
carbon printing (photolithography) 162, 232n89
Chardin, Jean-Baptiste 3–4
Charles X 22
Charlet, Nicolas-Toussaint 44
 and Académie des Beaux-Arts 78–9
 comparison with Horace Vernet 79
 lithography by 12, 66–75, 79, 83, 87
 paintings by 74–8, 84
 WORKS
 Déroute des Cosaques 69–70, *69*, 84
 Les Deux compagnons 70, *71*
 Episode de la campagne de Russie (painting) 75–7, *76*,
 83–4
 Episode de la campagne de Russie (*Retraite de Russie*)
 (lithograph) 75, 87
 Grenadier de Waterloo 70
 Infanterie légère montant à l'assaut 71, *72*, 81
 Le Joueur (mezzotint by Maile) 98, *99*
 Marche de troupes françaises dans les Pyrénnées 73–4, *74*
 Mendiants 70, *70*
 Merlin de Thionville à l'armée du Rhin 84, *84*
 Ouragan 83, *83*

Recrue à l'exercice 67–8, *68*
Vieille Armée française 73
Chevalier, Charles 114
Chevalier, François 95
Chevallier, Guillaume-Sulpice *see* Gavarni
Chevreul, Eugène 114
Cléry, Léon 215n49
Clichy, engagement at 80–81, *81*
Close, Chuck 138–9
Cochin, Charles-Nicolas 176, 235n32
Coiny, Joseph 182, 236n53
collodion (wet plate) process 118–19, 158
colour printing, crayon manner 153
colour translation, photographs of paintings 159–60
Condorcet, pictures of *54*, *55*, 137–8, *138*, *139*
Conyngham, Lord 22
copies
 distinguished from replicas 25–7, 216n54
 legal issues 30–40
copyright 35–40, 167
Corsica, 'Deliverance of' 55–7
Cotman, J. S. 102
Courbet, Gustave 116–17
Cousin, Victor 28–9, 214n26
crayon-manner engraving 153–4
Crimean War 87, 122–3
Cromer collection 102, 222nn43, 44

Daguerre, Louis-Jacques-Mandé
 collaboration with Niépce and Lemaître 11, 12, 90, 92,
 95, 96, 100–01
 dessin-fumée 102–3
 paintings by 101–2
 photography invention 90–91, 104–15
 WORKS
 diorama in the Church of Bry-sur-Marne 111, *111*
 Gothic Ruins 88, 102, 222n44
 Intérieur d'une chapelle de l'Eglise des Feuillants 101
 La Procession 103, *103*
 untitled painting 111, *111*
daguerreotype 9, 11, 37, 104–12, 158
Daumier, Honoré 9
David, Jacques-Louis 47, 101
 Death of Marat 22–3
Decaisne, Henri 27–8
Delaborde, Henri
 on *The Battle of Montmirail* 86
 and Delaroche 27, 167, 204–8
 on Edelinck 128
 on *Hémicycle des Beaux-Arts* 204–8
 on Mercuri's *Jane Grey* 141
 on photography 167, 232n96
Delacroix, Eugène
 on Charlet 68, 71–3, 77, 87
 on engraved reproductions 116, 223n73
 and photography 116

portrait of George Sand 155–6, 231n68
replica paintings 23–4, 213–14nn11–12
Delaroche, Paul 6
 engraved reproductions of his works 1, 2, 25–8, 33–5,
 38–40, 109
 in Lafaye's paintings 104–5, *106, 107,* 112–15
 and Maison Goupil 38–9, 133, 135–6
 photographic reproductions of his works 119–20,
 208–11
 and photography 11, 12, 37, 91–2, 104, 108–9
 portrait of 122, *123*
 Prix de Rome 182, 236n51
 WORKS
 Charlemagne crossing the Alps 27
 Cromwell (aquatint by Henriquel-Dupont) 186,
 187–8
 Cromwell (etching by Henriquel-Dupont) 186, 187–8
 Cromwell (mezzotint by Maile) 187
 Cromwell and Charles I 27–8
 Hémicycle des Beaux-Arts 198–209, *198, 203, 205, 206*
 Hémicycle des Beaux-Arts (engraving by Henriquel-
 Dupont) 13, *14,* 25, 39, 172–3, 198–208, *203,
 205, 206*
 Hémicycle des Beaux-Arts (repainted, possibly with
 Béranger) 199, 209, 238n96
 Jane Grey (engraving by Mercuri) 35, 38, 100, 119,
 129, *134,* 135–41
 Jane Grey (wood engravings) 33, *34*
 Moïse exposé sur le Nil (engraving by Henriquel-
 Dupont) 201, *202*
 Napoleon at Fontainebleau 26
 Princes in the Tower 26
 Sainte Amélie, Reine de Hongrie (engraving by Mercuri)
 126, 133
 Sainte Cécile (engraving by Forster) *191,* 192–3, *192,
 194, 195*
 Strafford 27, 39, 136, 188–90
 Strafford (engraving by Henriquel-Dupont) 136,
 188–92, *189, 190, 196,* 227n25
Delécluze, Etienne 77–8
Deleuze, Gilles 45, 82
Delpech 66, 70–71
Demidoff, Count Anatole 135–6, 227n24
Denon, Dominique-Vivant 60
Desnoyers, Baron Auguste 145, 183–4, 229n51
 Hope (engraving after Raphael) *183, 184*
dessin-fumée 102–3
Devéria family 185
Diderot, Denis 176
Didot, Pierre 31
Dudevant, Maurice 127, 143
Duplessi-Bertaux, Jean
 Bataille d'Austerlitz (engraving by Couché and Bovinet)
 51–2, *51*
 Délivrance de la Corse (engraving after Carle Vernet) 42,
 49, 52, *52, 53,* 54–6, *56*

engraving of the suicide of Condorcet 53, *54, 55*
Duplessis, Joseph, *Gabriel Sénac de Meilhan* (engraving by
 Bervic) 179, *180*
Durand-Ruel, Paul 22–3
Durande, Amédée 62, 80
Durieu, Eugène 116
Duvet, Jean 234–5n25

Edelinck, Gérard 128, 174–5, 202
 engraving after self-portrait of Claude Mellan 174, *175*
Eitner, Lorenz 214n25
Engelmann, 60–62, 217n36
engravers
 as artists or copiers 127–9, 237n73
 careers of 169–211
engraving
 aciérage 17, 100, 156–7
 authorship issues 154–6
 burin engraving 6, 10, 11–12, 57, 87
 comparison with photography 166–7, 232n96
 copyright issues 35–9
 crayon-manner engraving 153–4
 forgery issues 31–3
 history of 173–82
 importance of 6–7
 original 59–60
 and painting 47–57, 140–41
 photo-engraving (heliography) 93–5, 100, 115
 portrait engraving 155–6
 steel engraving 7, 9, 98–100
 techniques of 50–51, 57, 150–51, 153–4, 156–7,
 181–2
 tools 3, *4–5*
 translation issues 10, 150–51, 166, 226n6, 230n63
 see also reproductive engraving
etching
 revival 6, 157, 172, 212n10
 techniques of 50–51, 57
Ewals, Leo 25–6
Exposition Universelle (1855) 172
Exposition Universelle (1889) 169–71
Eylau, Battle of, painting by Gros 46

Figuier, Louis 209
Flameng, Léopold 157, 167, 169, 232–3n98
 Angelica (engraving after Ingres) *164,* 166, 169,
 232n94
 Madame Devauçay (engraving after Ingres) 169, *170,*
 233n3
Flandrin, Hippolyte 162, 166, 232n93
forgery, claims of 31–3
Forster, François, *Sainte Cécile* (engraving after Delaroche)
 191, 192–3, *192, 194, 195*
Fortier, Claude 96
Fouque, Victor 95
Fox Talbot, Henry 93–4, 110, 119, 224n88

François, Alphonse 135, 181, 227n23
François, Jules 135, 138

Gaillard, Ferdinand 238n93
Gambart, Ernest 168
Gautier, Théophile 35, 120–22, 136–7, 189–90
Gavarni (Guillaume-Sulpice Chevallier) 7–9, 213n15
Gazette des Beaux-Arts 1, 6, 7, 169
Géricault, Theodore 79, 182
Gernsheim, Helmut 89, 91–2
Gérôme, Jean-Léon 27
Girodet, Anne-Louis 156, 185, 237n68
Goltzius, Hendrik 174
Gotlieb, Marc 214n25
Goupil, Jean-Baptiste-Adolphe *see* Maison Goupil
Granet, François-Marius
 Choir of the Capuchin Church in the Piazza Barberini 20, 21
 replica paintings 20–22, 213n8
Griffiths, Antony 7
Gros, Antoine-Jean 46, 67
 Arabe du désert 62, 63
 Battle of Eylau 76
Guérin, Pierre-Narcisse
 lithography 62, 65, 217n34
 replica paintings 18–20, 22, 213n7
 studio of 182, 236n48
 WORKS
 Andromaque et Pyrrhus 19, 20
 Enée racontant à Didon les malheurs de la ville de Troie 19, 20
 Phèdre et Hippolyte 18, 20

Halévy, Fromenthal 28
Hamber, Anthony 115, 117
Haro, Etienne-François 166, 232n94
Hassoulier, William 181
Heim, François-Joseph 78
heliography *see* photo-engraving
Henriquel-Dupont, Louis
 awards to 172–3, 198, 234n16, 238n94
 career of 13, 171, 182, 185–208
 on future of engraving 181
 importance of 1, 6–7
 WORKS
 Alexandre Tardieu (engraving after drawing by Ingres) 61
 Cromwell (aquatint after Delaroche) 186, 187–8
 Cromwell (etching after Delaroche) 186, 187–8
 Hémicycle des Beaux-Arts (engraving after Delaroche) 14, 25, 39, 172–3, 198–208, 203, 205, 206
 Moïse exposé sur le Nil (engraving after Delaroche) 201, 202
 Monsieur Bertin (engraving after Ingres) 196, 197
 Strafford (engraving after Delaroche) 136, 188–92, 189, 190, 196, 227n25
Hersent, Louis 185–7, 237n73

Hoppner, John, *Lady Charlotte Duncombe* (crayon-manner print by Wilkins) 153, 154

Ingres, Jean-Dominique
 and Calamatta 1, 2, 13, 141–2, 143–55, 157–8, 196
 interference in engravings 147–9
 photographic reproductions of works 158–68, 231nn78, 79
 reproductions of his work 39, 145–9, 167–8, 185, 196–8, 220n18, 232–3n98
 WORKS
 Alexandre Tardieu (engraving by Henriquel-Dupont) 61
 Angelica 163
 Angelica (albumen print by Berthier) 165, 166
 Angelica (engraving by Flameng) 164, 166, 169, 232n94
 Antiochus and Stratonice 159–60, 161
 Antiochus and Stratonice (albumen print by Bingham) 159–60, 160, 167, 232n86
 Apotheosis of Homer (potential engraving by Calamatta) 157
 La Chapelle Sixtine (lithograph by Sudre) 149–50, 149
 Ferdinand-Philippe, duc d'Orléans (engraving by Calamatta) 151–3, 152
 Grande Odalisque 159, 160–62, 162, 231n81
 Henri IV et ses enfants (engraving by Richomme) 184
 Henri IV et ses enfants (heliograph by Charles) 93
 Homer and his Guide 158, 231n79
 Jesus among the Doctors 231n75
 Madame Devauçay (engraving by Flameng) 169, 170, 233n3
 Martyre de Saint-Symphorien 135
 Monsieur Bertin 179
 Monsieur Bertin (engraving by Henriquel-Dupont) 196, 197
 Odalisque 66, 67, 159, 231n81
 Paganini (crayon-manner engraving by Calamatta) 153–5, 154
 Self-portrait 158, 213n78
 La Source 157–8
 Tu Marcellus eris (engraving by Pradier) 147–8, 148
 Voeu de Louis XIII 144–5, 229n54
 Voeu de Louis XIII (engraving by Calamatta) 35, 141, 142, 145–7, 146, 150–51
Irisson family 105, 113, 222n49
Ivins, William
 on etching 212n10
 on *Laocoon* 217n18
 on photography 166
 on reproduction 10, 213n19, 232n95

Jal, Auguste 188
Jalabert, Charles 27–8, 199
Jay, Paul 90, 92
Jazet, Jean-Pierre 36, 109, 215n42

Johnston, Walter 18, 20, 213n7
Joly, Adrien-Jacques 31

La Combe, Joseph-Félix de 74–5
La Lumière 119
Lacan, Ernest 119, 208
Lafaye, Prosper
 career of 113–14
 *Conférence dans le salon de M. Irisson sur la découverte de la
 photographie* 90–91, 104–5, *106, 107*, 112–15,
 223n67
Lamennais, Abbé Félicité de 1, 29
Landon, Charles-Paul 31–3, 47
Langlois, Jean-Charles 216n4
 photographs of Malakoff 123, *124*
Langlois, Jérome 23
Lasteyrie, Charles de 60, 69, 217n36, 220n12
Le Gray, Gustave 11, 117–18
 Le Coupeur de Nappe (salt print after Scheffer) *25, 26*,
 117–18
Le Secq, Henri 117
Lebas, Jean-Philippe 176
legal issues, copies 30–40
Lejeune, Louis-François 46, 60
Lelli, Lucio Quirico 157
Lemaître, Augustin-François 11, 92, 94–102, 220–21n27,
 221n29
 Façade de l'Eglise de la Dalbade 96, *97*, 221n30
 Galerie de l'Hotel de Bôurgtheroulde 97, *98*, 100
 Mort de Roland (engraving after Michallon) *95, 96*,
 220–21n27
Leroy, J. J. (Louis) 131, 226n9
Levachez, *père et fils*, engraving of the suicide of Condorcet
 54, 55, 137, *138*
Levasseur, Jules-Gabriel 181–2
 engraving after drawing by Buttura of Paul Delaroche
 122, 123
lithography
 alternatives to 93
 by Charlet 66–75, 79, 83, 87
 development of 44, 60–62, 92–3
 printing of 65
 relationship with painting 75, 80, 87, 149–50
 status of 9, 66, 87
 styles of 79–80
Low Countries, engraving developments 174–5
Luini, Bernadino 181
Lyons School 101

McCauley, Anne 221n31, 232n97
Magasin pittoresque 33–5
Magasin universel 33–5
Magimel, Albert 148
Maile, George 98, 221n33
 Cromwell (mezzotint after Delaroche) *187*
 Le Joueur (mezzotint after Charlet) 98, *99*

Maison Goupil
 copyright issues 37–8, 215n42
 and Delaroche 38–9, 119, 133, 135–6, 198–9, 238n96
 Galerie photographique 159
 history of 133, 212n5
 influence of 3, 5
 and Ingres 158–9
 and Mercuri 133, 135–7
 replica paintings 27–8
 see also Boussod et Valadon
Malakoff 123–5
Manet, Edouard 166
manière noire see mezzotint
Marchetti, Domenico 144, 229n45
Marrinan, Michael 46–7
Martinet, Achille 169–71, 233n5
Marville, Charles 158, 231nn78, 79
'mechanical reproduction' 15–17
Meissonier, Ernest 168, 214n25, 233n100
Mellan, Claude 174, *175*, 234–5n25
Mercuri, Paul
 and Calamatta 1–2, 127, 142
 career of 13, 128–41
 WORKS
 Condorcet (engraving after drawing by J. P. Lemort)
 137–8, *139*, 141
 Costumes 130–31, *130*
 Jane Grey (engraving after Delaroche) 1, 2, 35, 38,
 100, 119, 129, *134*, 135–41
 Les Moissonneurs dans les Marais pontins (engraving after
 Robert) 1, 2, 131, *132*, 133
 Madame de Maintenon (engraving after Petitot)
 138–9, *140*, 141
 Sainte Amélie, Reine de Hongrie (engraving after
 Delaroche) 1, 2, *126*, 133–4, 159
mezzotint (*manière noire*) 98, 109, 188
Michallon, Achille-Etna, *Mort de Roland* (engraving by
 Lemaître) *95, 96*, 220n26
Millet, Désiré 158
miniature painting 138–9
Mirecourt, Eugène de 122, 199
Mitchell, W. J. T. 3, 212n2
Modernism 16, 214n25
Mondzain, Marie-José 29–30
Monsiau, Nicolas-André, *Prédication de St Denis* (engraving
 by Mme Soyer) *32, 33*
Montmirail, Battle of 85–6, *86*
Morghen, Raphaël 184
Mouilleron, Adolphe 234n17
Murat, Caroline 20
music, printing of 93
Musset, Alfred de 76, 77

Nadar 89–90
Nanteuil, Robert 235n26
Napoleon Bonaparte

battle paintings 46, 77, 85–6
 Corsica deliverance 55–7
Nargeot, Jean-Denis 9, 213n16
Naylor, John 26
Nelson, Horatio, retreat from Corsica 55–7
Niépce, Nicéphore
 collaboration with Daguerre 11, 12, 90, 92, 96, 100–03, 114
 collaboration with Lemaître 11, 92, 94–103, 221n32
 lithography experiments 92–3, 220n12
 photographic experiments 93–100
Nietzsche, Friedrich 41
Niquet, Claude, engraving by 50, 50

Odier, Edouard-Alexandre 75
Odiot, Claude 80
Ozanne, Jeanna Francesca 57

painting
 and engraving 47–57, 140–41
 miniatures 138–9
 and photography 11, 91–2, 104, 108–9, 112, 115–25, 139–40, 224n88
 replica painting (*répétition*) 18–30, 40
 reproductions of 3–4
 see also battle paintings
Pannwitz, Rudolf 151
panoramic photography 123, *124*
Pantographe Gavard 153
Petitot, Jean 138
photo-engraving, (heliography) 93–5, 100, 115
'photogenic' effect 22, 120
photography
 as art 115–25, 223n71
 colour translation 159–60
 comparison with engraving 166–7, 232n96
 copyright 167
 daguerreotype 9, 11, 37, 104–12, 158
 as 'death of painting' 11, 91–2, 104, 108–9, 115
 of Ingres's works 158–68
 invention of 9–10, 89–92, 104–15, 219n2
 Niépce's experiments 92–100
 and painting 91–2, 104, 108–9, 112, 115–25, 139–40, 224n88
 panoramic 123, *124*
 and printmaking 100–01
 reproduction photography 11, 25, 91–2, 115–25, 158–68, 208–11, 224n88
 waxed paper negatives 117
 wet plate process (collodion) 118–19, 158
photolithography *see* carbon printing
Picasso, Pablo 3–5
Picot, François-Edouard 78
Pillement, Victor, engraving by 50, 50, 217nn16, 17
Planche, Gustave 134
Poitevin, Alphonse 162, 232n89

Pollet, Florence 232–3n98
Ponce, Nicolas 150
popular art 214n25
Portalis, Baron Roger 179
portrait engraving 155–6
Pradier, Charles-Simon, *Tu Marcellus eris* (engraving after Ingres) 147–8, *148*
Pradier, James 38
Preisler, Johann Martin 176
Prévost, Zachée 131–2
printers, of lithographs 65
prints, sales of 188
Prix de Rome 182, 236n51
proof copies (*épreuves avant la lettre*) 137–8, 141, 178

Raimondi, Marco Antonio 117, 128, 175
Raoul-Rochette, Désiré 143, 174
Raoul-Rochette, Josephine 143
Raphael, engravings of his works 183–4, *183*
Realism 16
Regnault, Jean-Baptiste 178, 235n37
répétitions (replica paintings) 18–30, 40
replicas, distinguished from copies 25–7, 216n54
'reproducibility' 40
reproduction
 concepts of 15–17, 23–30, 40–41, 213n1
 legal issues 30–40
 mechanical 15–16
 philosophy of 29–30
 'photogenic' effect 22
 photographic 11, 25, 91–2, 115–25, 158–68, 208–11, 224n88
 by pupils 27
 replica paintings (*répétitions*) 18–30, 40
reproductive engraving
 as art or copying 40–41, 59–60, 127–9, 150–51, 226n6
 revision of original 147–9
 status of 3, 87, 169–211
Reynolds, S. W. 75, 98
Richomme, Joseph-Théodore 184–5
Rittner, Joseph-Henry 133, 212n5
Robert, Léopold 131–2
Robert-Fleury, Joseph-Nicolas 39–40
Rodde, Christian Bernhard 179
Rosa, Salvator 43
Rovani, Giuseppe 37, 200

Sand, George 1, 29, 127–9, 150
 engraving by Calamatta 155–6, *155*
Scharf, Aaron 91
Scheffer, Ary 1, 2, 6, 40, 117–18
 Le Coupeur de Nappe (salt print by Le Gray) 25, 26, 117
 Francesca da Rimini 24, 214n13
sculpture, reproduction of 38
Sénac de Meilhan, Gabriel 179, *180*

Senefelder, Aloys 60
Serangeli, Gioacchin Giuseppe 23
Shiff, Richard 41, 214n12, 216n54
Siegfried, Susan 46
Sizeranne, Robert de la 223n71
Snyder, Joel 219n2
Société française de photographie 209, 210
Société Héliographique 96
Soyer, Mme, engraving after Monsiau's *Prédication de St Denis* 32, 33
steel engraving *see* engraving
Stendhal 44, 82
Strahan, Edward 200, 238n97
Sudre, Jean-Pierre, *La Chapelle Sixtine* (lithograph after Ingres) 149–50, *149*, 230n60
surface, response to 47

Tableaux historiques des campagnes d'Italie 47
Tardieu family 173–4
Tardieu, Alexandre (critic) 109, 173
Tardieu, Ambroise 59, 174, 233n10, 234n20
 engraver's tools 4–5
Tardieu, Nicolas 59, 173
Tardieu, Pierre-Alexandre (engraver) 59, 174
 engraving of Montaigne after 'Cocaskis' 59, *59*
 portrait of 60, *61*
Taurel, André 144, 182, 229n46
Ter Borch, Gerard, *La Gazettière hollandoise* (engraving by Wille) 176–8, *177*, 235n35
Ternois, Daniel 147
Thévenin, Charles 1, 93
Thorvaldsen, Bertel 144
Tissandier, Gaston 104, 108, 114–15
Toschi, Paolo 143, 175, 212n13
 engraving of Bervic 8
translation, of engravings 10, 150–51, 166, 223n73, 226n6, 230n63
troc 4–6, 29, 37, 92, 102, 185, 211
Turin Shroud 29

Uccello, Paolo 45

Vallery-Radot, Jean 112–13
Vernet, Antoine 43
Vernet, Carle 12, 43–4
 battle paintings 47–56
 WORKS

Délivrance de la Corse 48–52
Délivrance de la Corse (engravings of) 42, 49, 50, 52, 52, 53, 54–6, 56
Hussard sabrant en sautant par dessus un affût 64, 65
La Tempête, d'après Joseph Vernet 62, 63
Vernet, Horace
 battle paintings 2, 80–87, 122–4
 career of 44, 216nn4, 6
 comparison with Charlet 79
 copyright 35–7, 40
 on engraving 9
 engravings of works 109, 215n42
 in Lafaye's painting 105, 107, 114
 lithography 62, 65, 79
 and photography 90–91, 108, 122–5
 portrait photograph of 122, *123*
 visual memory of 122
 WORKS
 Barrière de Clichy 80–81, *81*, 122
 The Battle of Montmirail 86, *86*
 Château de Ligny 85, *85*
 Gredin de sort! 81, *82*
 Hanau 87
 Jemappes 87
 Prise de la Tour de Malakoff 123, *124*
 Prise de la Tour de Malakoff (albumen print by Bingham) *125*
 Valmy 87
Vernet, Joseph (Claude-Joseph) 43, 216n4
 La Rade d'Antibes 48, *48*
 La Tempête 63
Vibert, Théodore 212n5
Vigne, Georges 66
Villemain, Abel François 35

Waltner, Charles 169–71
Waterloo, Battle of 82, 85
waxed paper negatives, photography 117
wet plate process (collodion), photography 118–19, 158
White, Hayden 16
Wilkins, Charles, *Lady Charlotte Duncombe* (crayon-manner print after Hoppner) 153, *154*
Wille, Jean-Georges 176–8
 La Gazettière hollandoise (engraving after Ter Borch) 176–8, *177*
Wollaston, William Hyde 114
wood engraving 33–5

Photograph Credits

Cliché Bibliothèque nationale de France: 1, 17, 25, 27, 47, 58, 85, 103; Photo Jon Carritt: 55; Paris, Ecole nationale supérieure des Beaux-Arts: 105, 107, 109; Photo Luiz Hossaka: 84; Musée des Beax-Arts de Lyon © Studio Basset – 69300 Caluire: 9, 39, 48, 70, 78, 79; cliché Ville de Nantes, Bibliothèque municipale: 30, 44; © Ville de Chalon-sur-Saône, France, Musée Nicéphore Niépce (Photo Gérard Bierry): 50, 51, 54, 61; Photothèque des musées de la Ville de Paris/cliché Andreani: 52; © Photo RMN: 15, 28, 40, 43, 60; Courtesy George Eastman House, Rochester, N.Y.: 46.

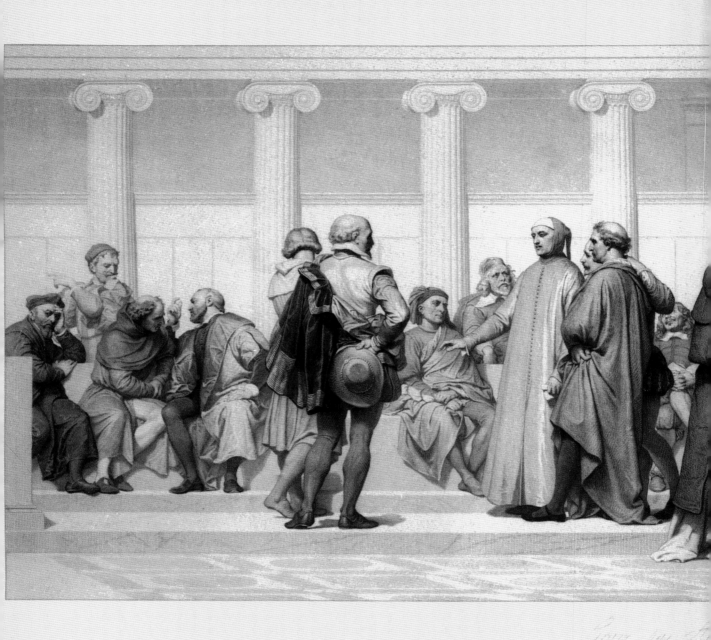